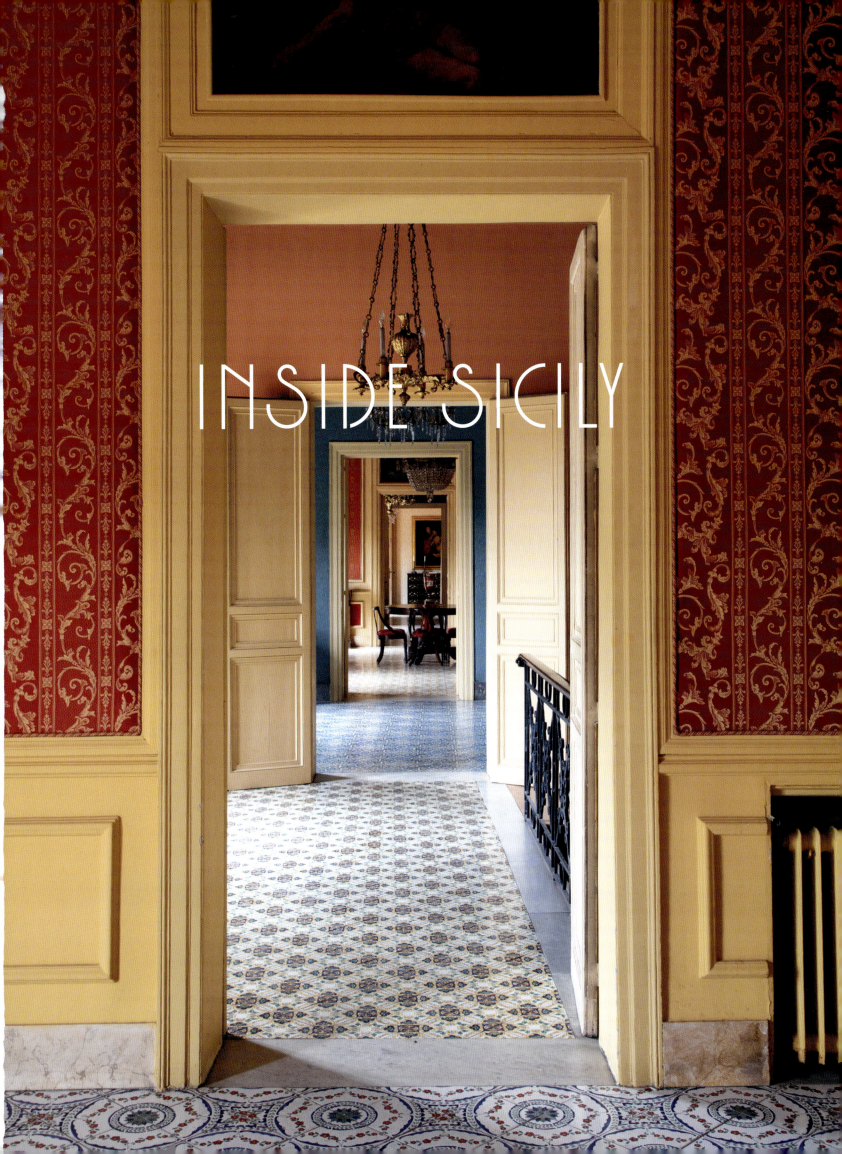
# INSIDE SICILY

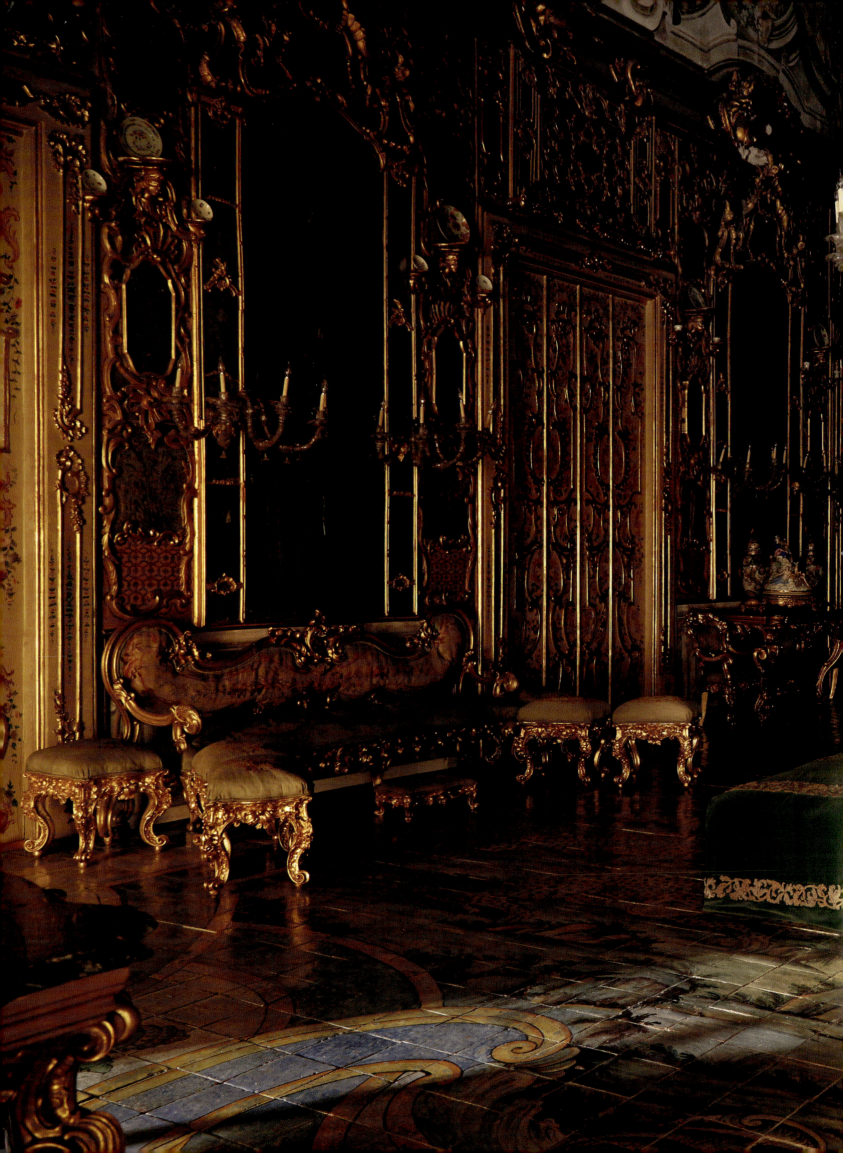

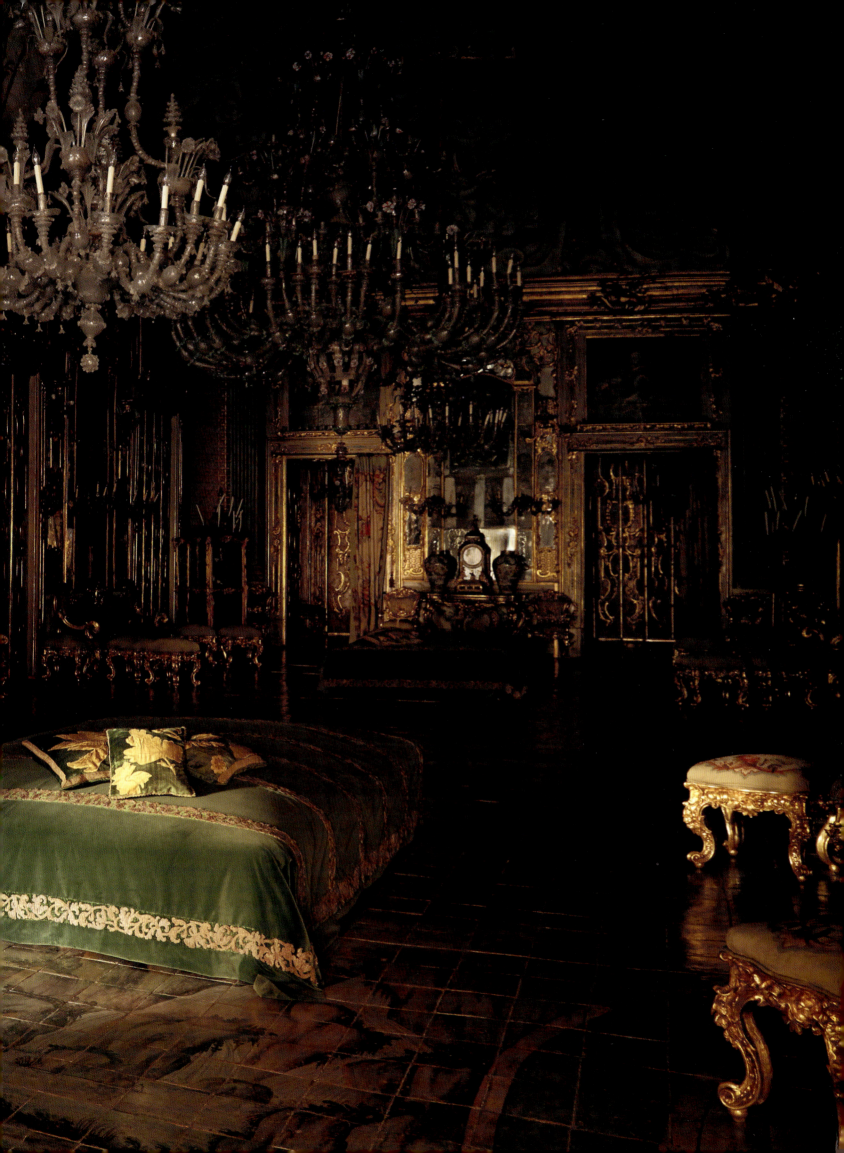

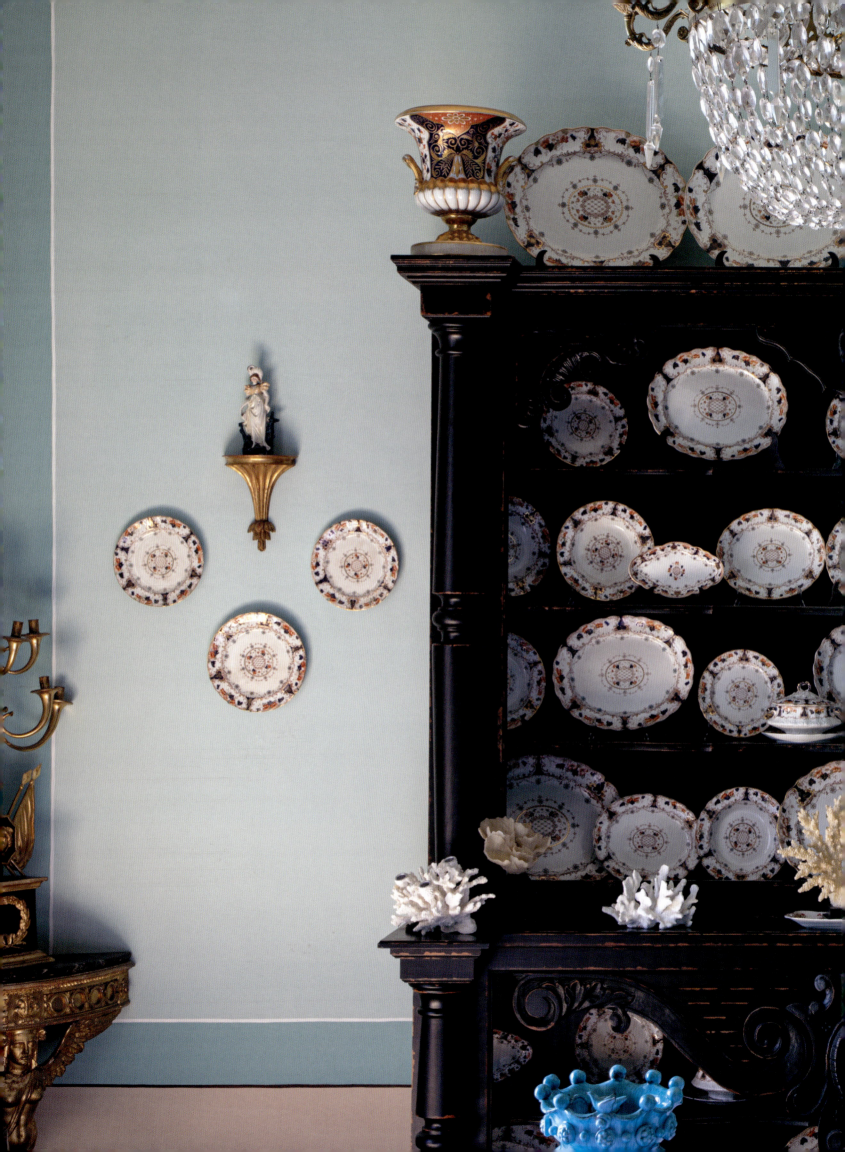

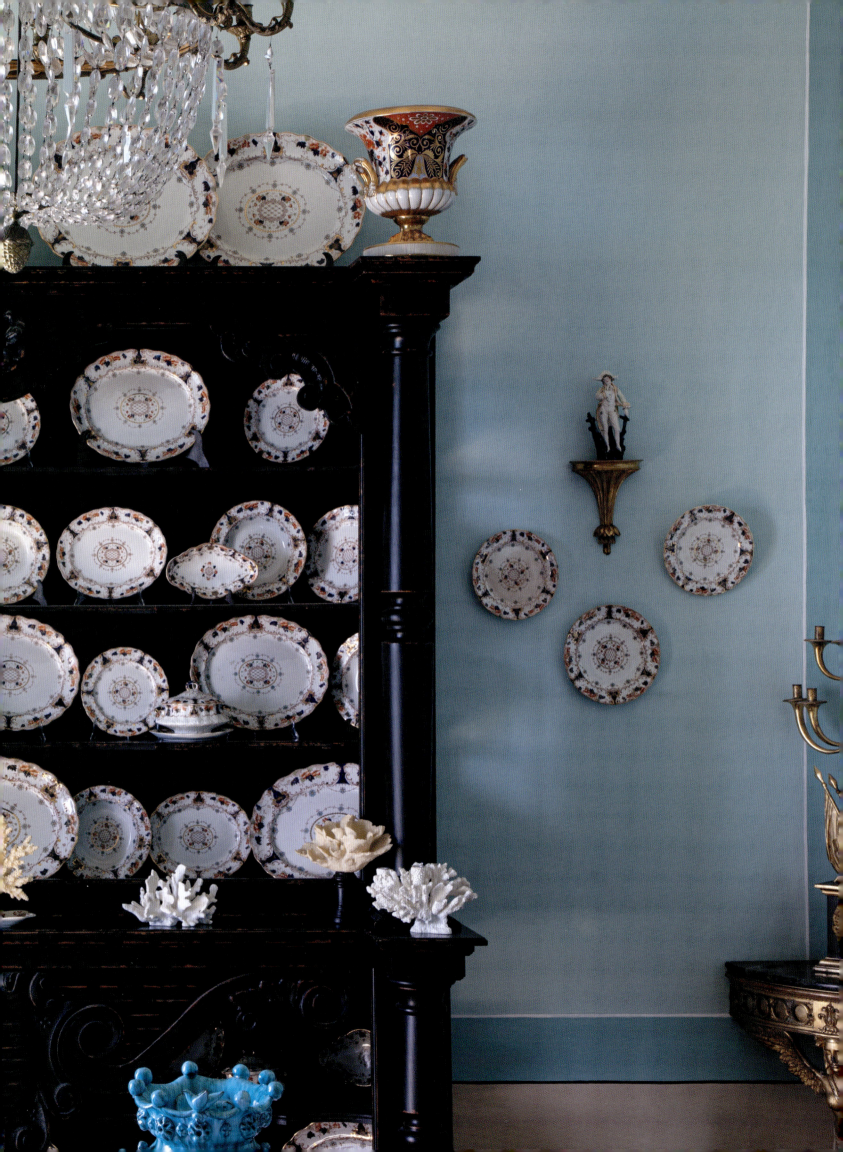

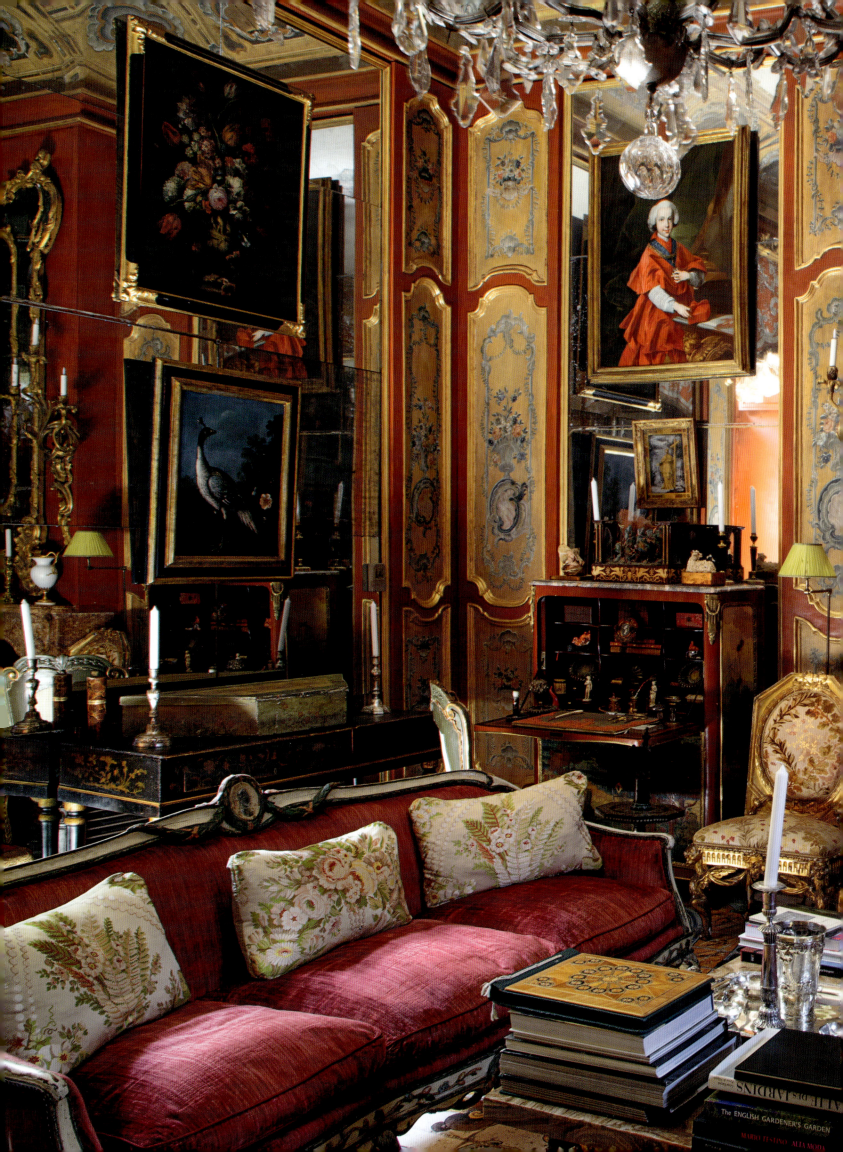

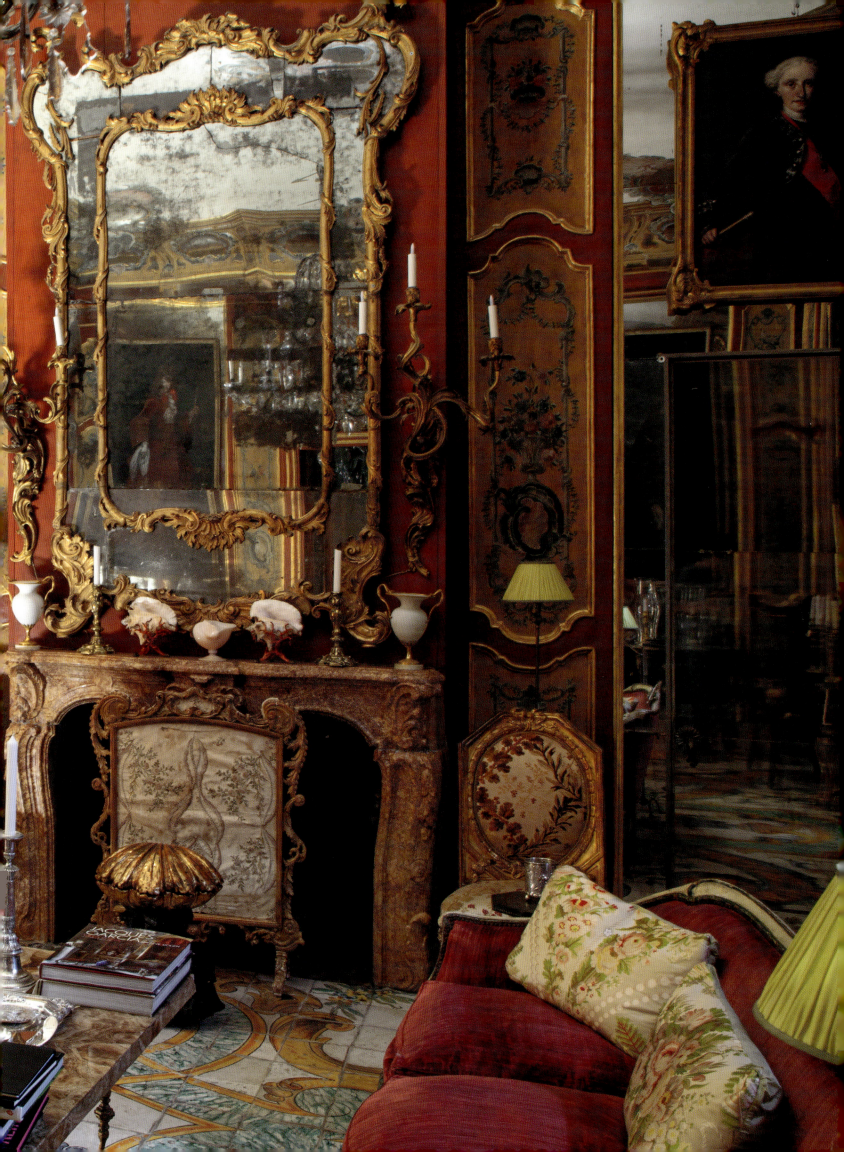

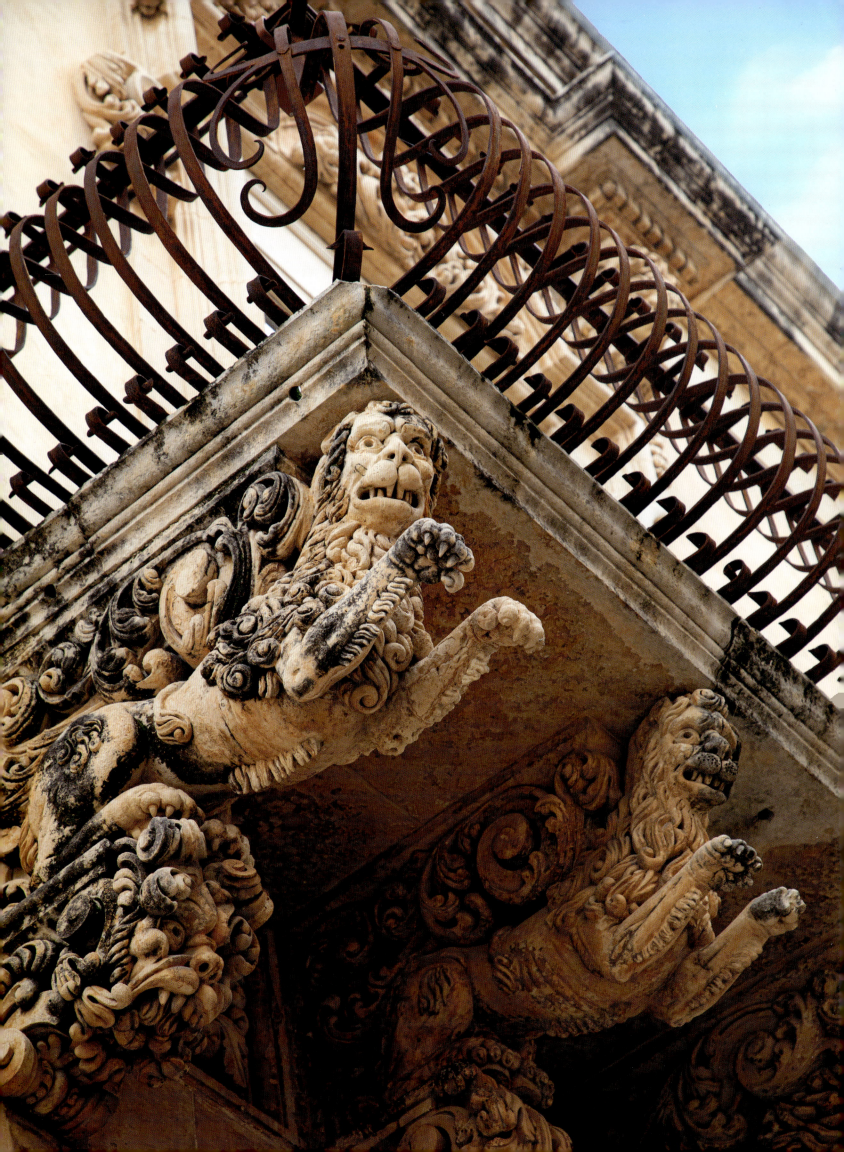

# INSIDE SICILY

CHRISTOPHER GARIS

PHOTOGRAPHY BY
GUIDO TARONI

VENDOME
NEW YORK · LONDON

# CONTENTS

INTRODUCTION 12

ORATORIO DI SANTA CITA 17

MUSEO DELLE MAIOLICHE 23

PALAZZO VALGUARNERA-GANGI 29

PALAZZO RESUTTANO NATHALIE HAMBRO 35

LIBERTÀ ROSELLINA & AGOSTINO RANDAZZO 47

VILLA MALFITANO FONDAZIONE WHITAKER 57

VILLA CHIARAMONTE BORDONARO ANDREA BORDONARO 69

VILLA BORDONARO AI COLLI GAIA PALMA CHIARAMONTE BORDONARO 83

VILLA PALAGONIA 97

CASTELLO DI FALCONARA BARONI DI BORDONARO 105

CONTRADA CONAZZO SARA PRATO 121

FEUDO DI CASTELLUCCIO LUCIO BONACCORSI & LUISA BONACCORSI BECCARIA 135

MANDARA VECCHIA ISABELLA VINCENZINI BOROLI 151

I PICCIOTTI FABIO SALINI 169

VILLA ELENA JACQUES GARCIA 179

PALAZZO ROCCA GORDON GUILLAUMIER 207

ORTIGIA ERNESTO SIGNORELLI 219

MASSERIA CARDINALE RICCARDO PRIOLISI & JOHN HOOKS 233

COMMENDA DI SAN CALOGERO ANDREA MATARAZZO 253

PALAZZO BISCARI RUGGERO & NICOLETTA MONCADA DI PATERNÒ 267

CASA CUSENI MIMMA & FRANCESCO CUNDARI 281

VILLA IONIA GLORIA VISCONTI DI MODRONE 291

CASA SOTTSASS BARBARA RADICE 303

CASA G MARCO & LUCHINO GASTEL 313

PANAREA VERDE & LUCHINO VISCONTI 323

ACKNOWLEDGMENTS 334

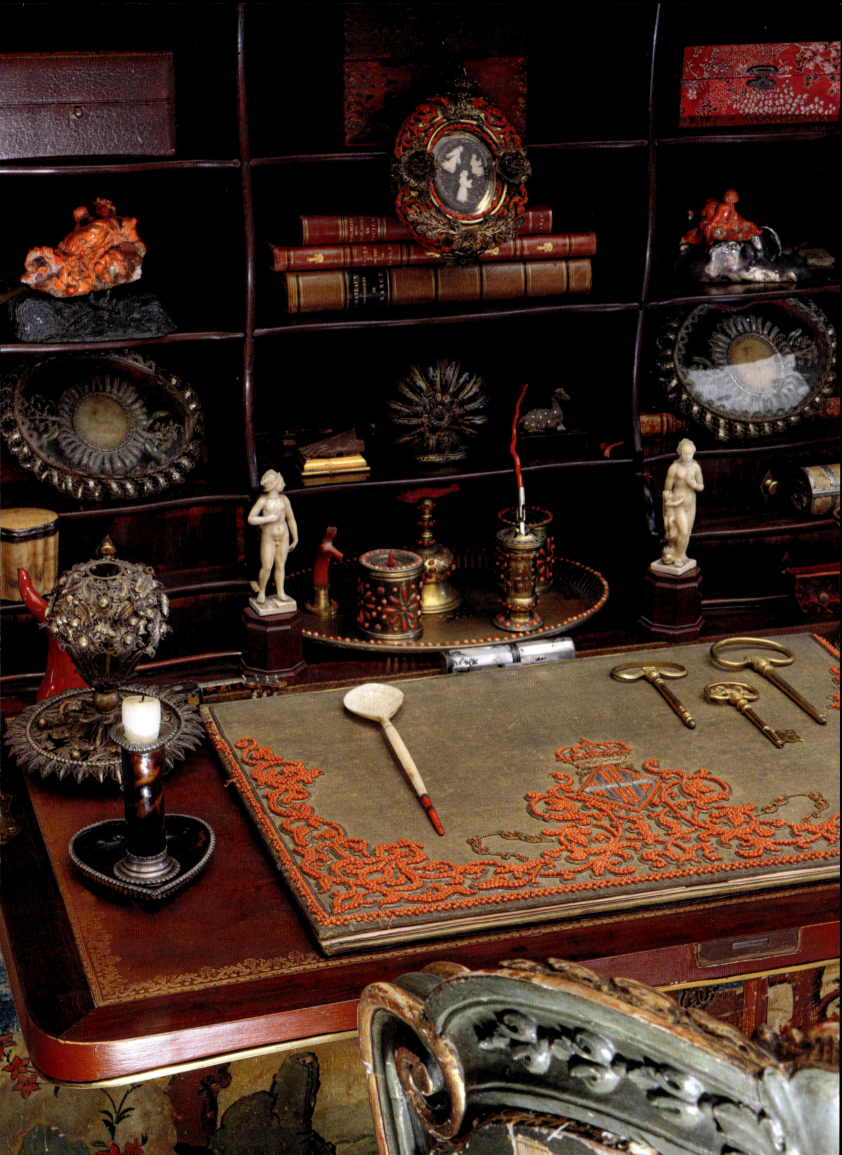

# INTRODUCTION

Guido and I first arrived in Sicily—landing in Catania—to begin photographing for this book shortly after both Etna and Stromboli erupted almost simultaneously. In the morning the city was covered in black dust that glittered in the sunlight. Unlike either sand or ash, it is both dark and reflective, distinctly its own. With water it starts to cake up, and the best the street cleaners can do is to brush it away.

My friend Alfio Bonaccorso, who runs the Taormina Book Festival, met us for dinner. "You just missed it!" he told us. "What an eruption! It was beautiful." I heard this refrain many times over the next few days. I was expecting people to lament the trauma of living next to such a disruptive neighbor, but the people of Catania (which is known as the Black City for the volcanic dust that has colored its buildings and streets over the centuries) talk of Etna's explosions the way Vermonters discuss the fall foliage or winter snows: occasionally disruptive but beautiful nonetheless.

Sicily isn't merely an island, but an archipelago, and that is fundamental to its identity. Surrounding the main island are the Aeolian Islands, named for the god of wind, clustered off the northeastern tip; to the northwest the Egadi Islands; and south, toward Tunisia and Libya, the Pelagie Islands. All these, together with Sicily's rich interior of robust farmland, craggy peaks, and Baroque cities, make it feel as though there is a vast country awaiting discovery. Sicily is a world unto itself, filled with contradictions and overlapping histories stretching back to antiquity. It is a land of conquest and conquerors, immigrants and emigrants. But most of all it is a place of beauty, with many stories to tell.

The homes, villas, castles, farmhouses, and palaces in this volume represent only a small portion of Sicily's diversity, but despite their differences, they have had similar challenges. They've been adapted to the climate through the use of such materials as stone and ceramic for cool, insulated interiors; their design elements often reflect the centuries-old cultural layering of Greek, Arab, Norman, and Baroque influences inherent to Sicily; and each was built or restored with a deep sensitivity to the natural landscape, whether that be volcanic, maritime, or agricultural.

The sleek, modern villa of Gloria Visconti di Modrone in Taormina (page 291), for instance, was designed with walls of screens and mirrors—elements drawn from Japanese tradition—to entice in or subdue the often blinding sun. Similarly, in Casa Cuseni (page 281) foreign designs were adapted to suit the local vernacular. The rustic simplicity of the summer homes in Filicudi (pages 303, 313) and Panarea (page 323), meanwhile, offers a sturdiness that withstands volcanic activity, and their stables—once essential features, since cars and mopeds came to the Aeolian Islands only in the last few decades—have been converted into bedrooms or outdoor showers. Finally, the overwhelming elegance of Jacques Garcia's Noto villa (page 179) lavishly explores a vast pan-Mediterranean history through art, architecture, and

decorative details that blend with the use of collecting as storytelling, which can be seen in many of these properties. All the owners share a love of the island, and whether they are Sicilian aristocrats or foreign creatives, that love is evident in their homes.

My own first encounter with Sicily's layered history came when I was fifteen, on a school trip that would shape my understanding of the island forever. I was living at the time in Viterbo, a small city north of Rome, and I set out with my classmates to discover the art and ancient history of the largest island in the Mediterranean. It is an overnight ferry crossing from Naples, and rough December seas caused us to arrive in Palermo nauseous and exhausted, but the blazing sun was rejuvenating. Before long we were eating mulberry granita and steaming *arancine* rice balls in the shade of a squat *Phoenix caneriensis* palm, delirious with this new landscape.

Since then, I have continued to return to Sicily, but memories of this youthful trip always find me when I arrive on the island. On a recent visit with my partner, Nicolò, we mounted the wide steps to the Palazzo dei Normanni (Norman Palace) in Palermo, and it was as though I could still hear our instructor, Santo Sanmartino: "…built by the Normans shortly after they conquered the Emirate of Sicily at the end of the eleventh century, the palazzo is the oldest royal residence in Europe."

Inside, beyond the exterior of honey-colored stone, fluted into columns and Arabic-looking arches, the golden Byzantine mosaic of the Palatine Chapel glittered in the morning light. The Normans employed local artisans, who at that time were largely Greek and Arab, and during the High Middle Ages (AD 1000–1300), the Norman kingdom of Sicily was a cosmopolitan crossroads for Muslim, Orthodox, and Catholic cultures—appropriately enough for this island in the geographic center of the Mediterranean. In both court and street, Palermo was buzzing with the sounds of French, Hebrew, Arabic, Latin, Greek, and every other language found between Cairo and Cadiz. Possibly because, as a student, my previous experience of Italy had been limited to the area around Rome, Sicily's rich mixture of non-Latin influences was awe-inducing and produced in me a lasting curiosity that ultimately resulted in this book. What I saw then set the stage for what I have continued to discover: that Sicily is by no means a monolith.

Crystal-clear water lapped at the sandy beach below Via Mura di Tramontana in Trapani as Nicolò and I enjoyed piles of curly *busiate* pasta drowned in a sauce of almonds, basil, fresh tomatoes, and pecorino cheese. Trapani, a densely populated promontory that juts out dagger-like from Sicily's west coast, was founded in the eleventh century BC by the Elymians, an ancient tribe said to have been refugees from the destruction of Troy. From the port of Trapani and their mountaintop fortress at Erice, they both coexisted and fought with the neighboring Phoenicians down the coast in the city of Motya.

It is a short drive from Trapani to the Lagoon of Marsala, in which is set the island of San Pantaleo, with its fortress of Motya. Making our way past clumps of swaying reeds down to the shore, we boarded a small barge that ferried us out to the island. From the shallow dock, a winding trail leads past lush vineyards of Grillo grapes to the house of Joseph Whitaker (1850–1936), an Anglo-Sicilian who led the excavations at Motya. What began for Whitaker in 1906 as a hobby led to the rediscovery of the ancient city and of countless artifacts, including Egyptian votives and the famed marble "Motya youth." This thriving city was first ravaged by the

Greek city-state of Syracuse in 398 BC, and overcome following the First Punic War, when Rome captured Sicily and established the first Roman province in 241 BC.

Whitaker grew up between Marsala (and the family's vineyards in Motya) and Palermo, and his family house, Villa Malfitano (page 57), was a center of Palermo's Belle Époque era at the turn of the twentieth century. Visiting it and other Liberty-style homes in Palermo over the years has given me context for the region's deep connection with England, and for the vast displays of archaeological collections that are to be seen in many of the properties in this book.

Venturing into Sicily's interior, there are pockets of forest reserves, ancient cities, such as Enna and Caltagirone, and vast stretches of rolling hills that have been a breadbasket for millennia. In the countryside of Piazza Armerina in central Sicily is the Villa Romana del Casale, a fourth-century estate that would have managed many acres of land that are still farmed to this day.

Massive, conical cypress trees led us down, on a recent visit, to where restorers have constructed a roof over the craggy walls of the single-story villa. After almost 600 years of Roman dominance in Sicily, these grand estates were built around the island just as Constantinople became the capital of the Eastern Roman empire. That raised the profile of the formerly neglected Sicily to a place of strategic importance; not only was it a natural stopping point between Rome and Constantinople, but also its innate blend of Latin, Greek, and North African traditions allowed it to function as an interlocuter between the different parts of the unwieldy empire. Had the Western Roman empire not fallen just 120 years later, Sicily might have continued to rise as an important Roman province.

In the grand villa, long parapets guided us above rooms of colorful mosaics, the richest and largest *in situ* collection in the world, depicting herds of ostrich being corralled on boats; elephants bedecked in armor; Prometheus receiving wine from Ulysses; bikini-wearing athletes; and giants fighting serpents. The color, variety, and bold decoration were captivating, and for once it was easy to see the house as it was, a *latifundium* (landed estate) similar, in a sense, to the nearby Contrada Conazzo (page 121), although considerably smaller. Despite being separated by millennia, these two estates, built around a central courtyard, would have been modern for their time, defensible against raiders, and seen as symbols of a forward-looking agricultural center.

My first trip to Sicily with Guido for this book was in August 2024. On our way to our first photo shoot, we stopped on the island of Ortigia, the historic center of Syracuse. Each with a hot *pane condito*—a round loaf stuffed with melted cheese and *prosciutto cotto*—in hand, we stopped for a moment at the Fountain of Arethusa. Ducks nibbled the grassy rays of papyrus stems (the only native ones found in Europe) that dipped into the freshwater pool on the edge of the sea.

It was extremely hot, but Syracuse's warren of tight streets kept the sun at bay. Every so often we would catch a glimpse of turquoise sea between the alleys, until the decadent limestone buildings parted and we followed the Piazza Minerva into the Piazza Duomo. We stood between the Palazzo Beneventano del Bosco, the architecture of which inspired some of the details of Andrea Matarazzo's office in the Commenda di San Calogero (page 253), and the Duomo, Syracuse's cathedral.

On the side of this towering temple, battered Doric columns partially emerge, occasionally showing their fluted trunks from behind a Byzantine-era patchwork

of stone walls. The front façade, which towers over the square, is High Baroque with layer upon layer of free and engaged columns. A huge earthquake in 1693 badly damaged the Norman façade, which was constructed after the building's conversion from a mosque back into a church in 1093, and this replacement by Andrea Palma is in keeping with similar styles found in the southeastern city of Noto, such as the layered columns and stonework details on the exterior of Villa Elena, the house of Jacques Garcia. As Guido and I marveled at the cathedral's hodgepodge of blended cultures dating back at least 2,700 years, it seemed to represent everything we would come to know about Sicily: a site of innovation, decoration, and the cross-pollination of ideas.

It was while we were putting this book together that I came to see clearly how today's Sicily is still deeply connected to its ancient roots. Once, after a long day of shooting in Palermo, Guido and I joined friends in the Vuccirìa, the city's old fish market. In the evening, as vendors pack up the remains of their catch and cats eye leftover sardines, street cleaners wash the stone bricks clean. With dinner behind us, we walked through the square, where industrious Palermitani were setting up makeshift bars and large amplifiers. Soon packs of twenty-somethings were lined up, following choreographed dance steps that suggested these spontaneous parties are a nightly occurrence. Looking up at the mostly abandoned buildings around the Vuccirìa, I was reminded that in Sicily, there is always another life beneath the surface.

A similar thing happened in Scicli, where I was speaking with a builder overseeing the construction of a wall, watching to see that the capstones were even. As the foreman shouted orders and made conversation with his workers, I turned to Guido to see if he could understand anything of what was being said. "They're either talking about food or about women," Guido laughed. Seeing our confusion, the builder confirmed that they were speaking in dialect: "What we speak in Scicli is completely different from Ragusano, or Modicano," he said, referring to cities only a few dozen miles away.

My understanding of Sicily has deepened over the years. My teenage introduction to its grandeur and contradictions has evolved into an ongoing exploration of its layered history, its ever-changing landscapes, and its unique ability to absorb and transform the influences of conquerors and visitors alike. Just as Sicily's language shifts from town to town, so too does its architecture, and each home shown here is a reflection of its particular place, history, and influences.

This book aims to capture a fraction of that complexity. It is not just a collection of beautiful homes; it is a testament to the way Sicily's past and present continue to intermingle. Whether aristocratic estates that have stood for centuries or newly imagined spaces that embrace the island's light and climate, each home tells a story of adaptation, continuity, and reinvention. The magic of Sicily is that it is never just one thing. It is an island of shifting perspectives, where each visit, each encounter, and each home reveals a different face. My hope is that this book allows you to find your own Sicily—whether through the grandeur of Baroque palaces, the simplicity of sun-bleached coastal retreats, or the vibrant life that pulses in its streets. This is an island of stories, and through these homes, we invite you to discover them.

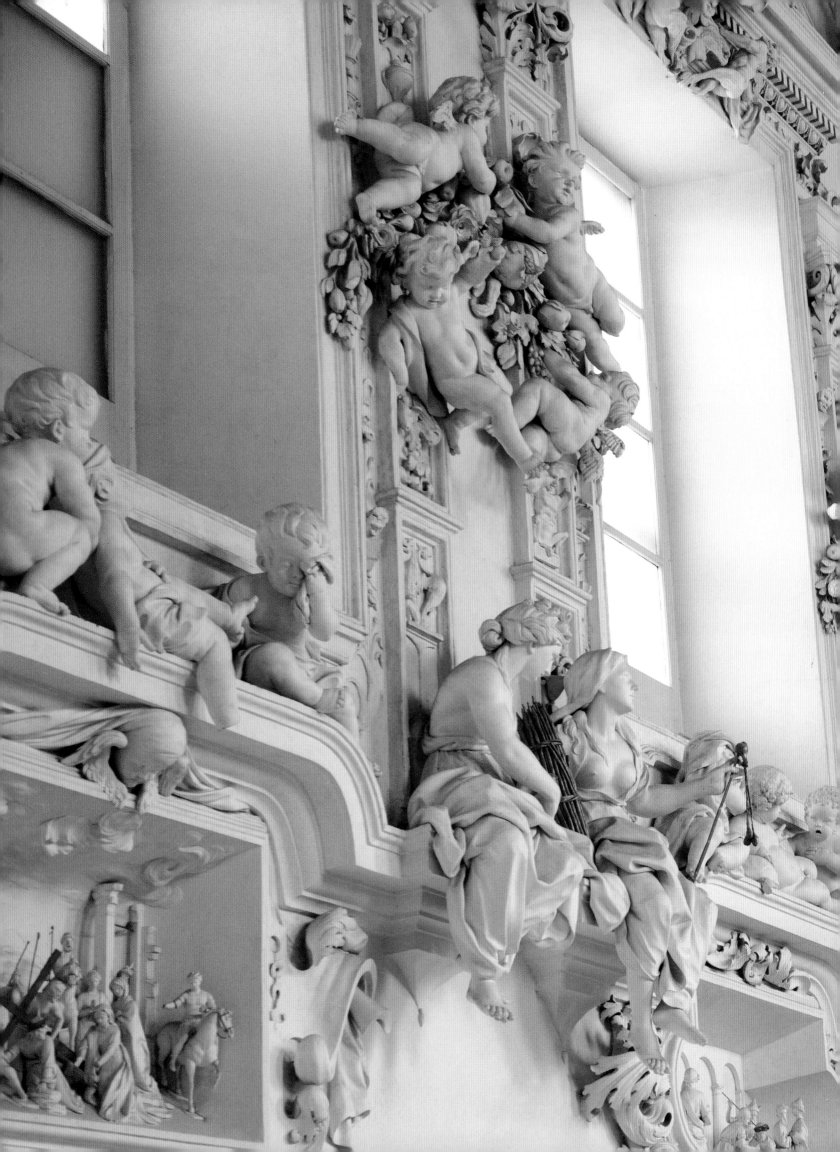

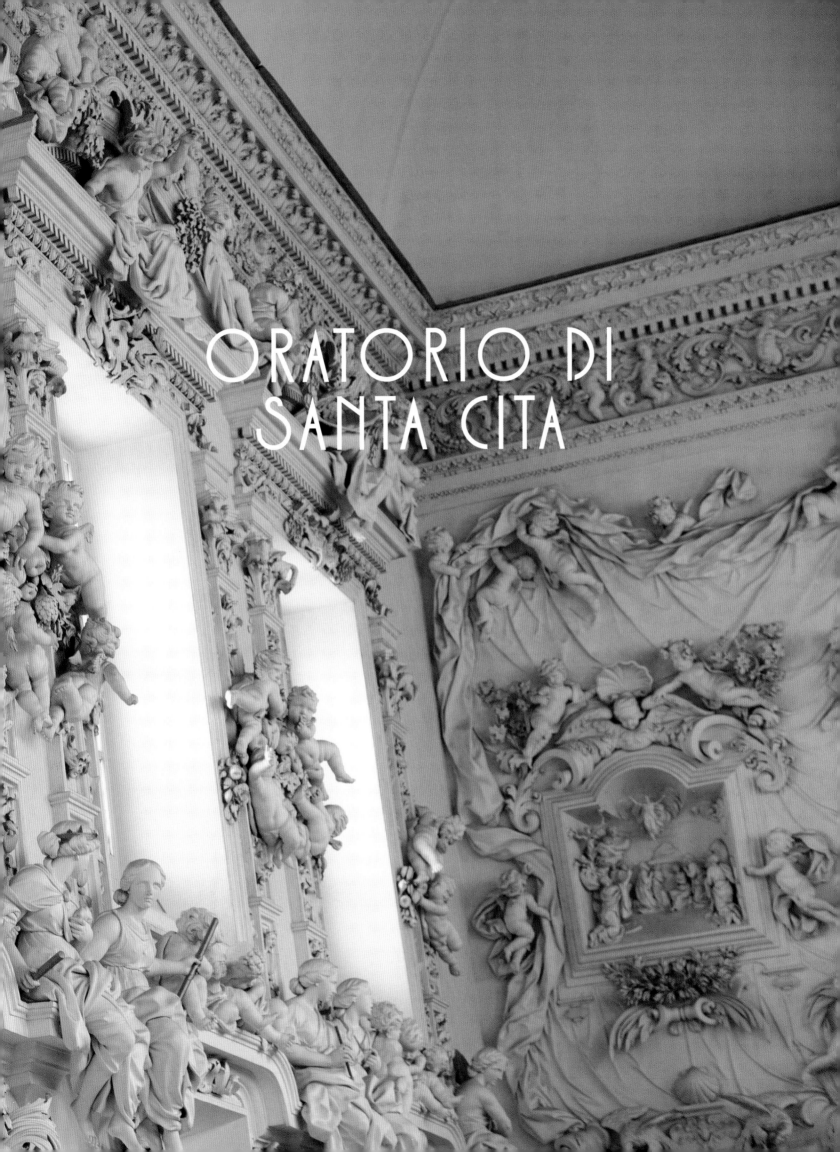

# ORATORIO DI SANTA CITA

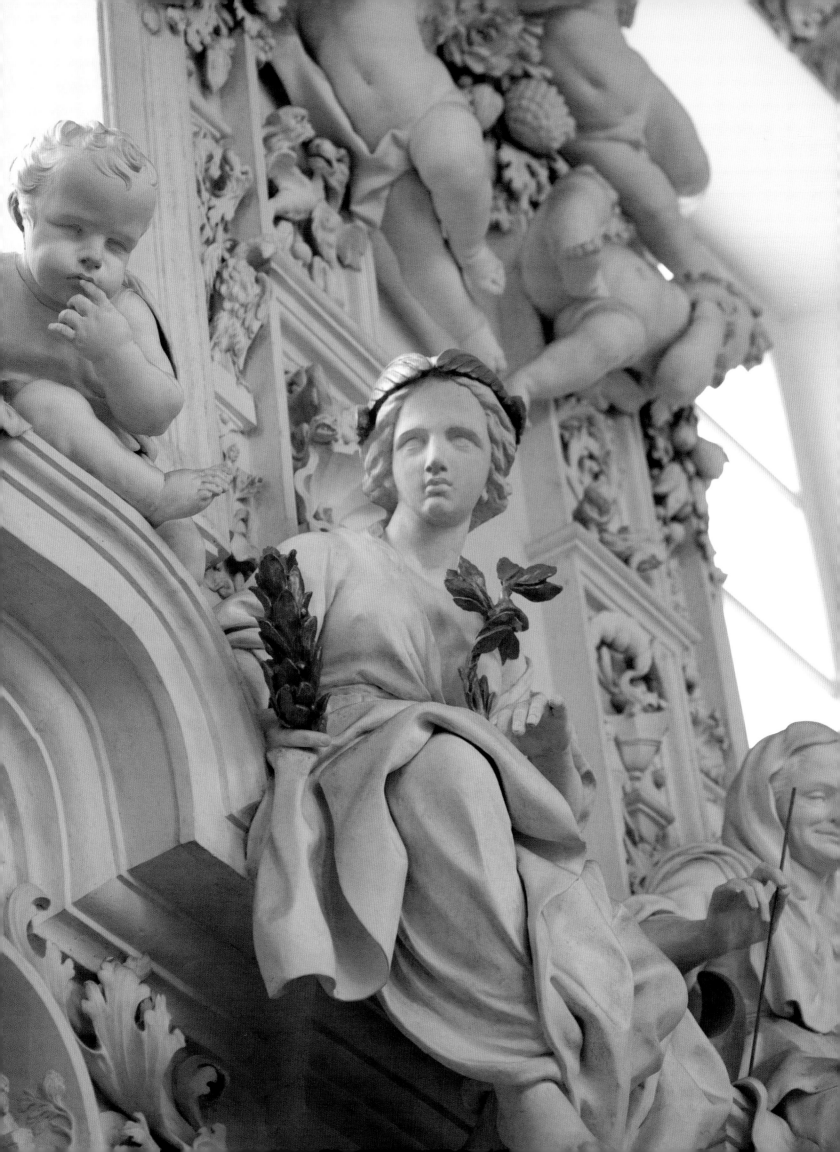

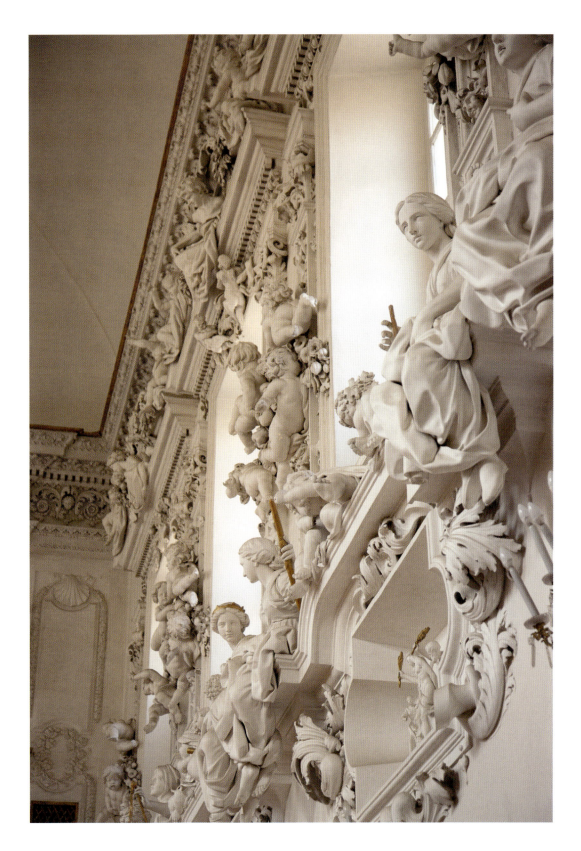

The Oratorio di Santa Cita in Palermo was built in 1590 and is notable for its extraordinary stucco work by Giacomo Serpotta (1687–1718). Although he supposedly never left Sicily, Serpotta rivaled the greatest Baroque sculptors in skill, elevating plaster to a medium of breathtaking sophistication. His playful putti, dramatic drapery, and the famed relief illustrating the Battle of Lepanto make this a masterpiece of Sicilian Baroque art.

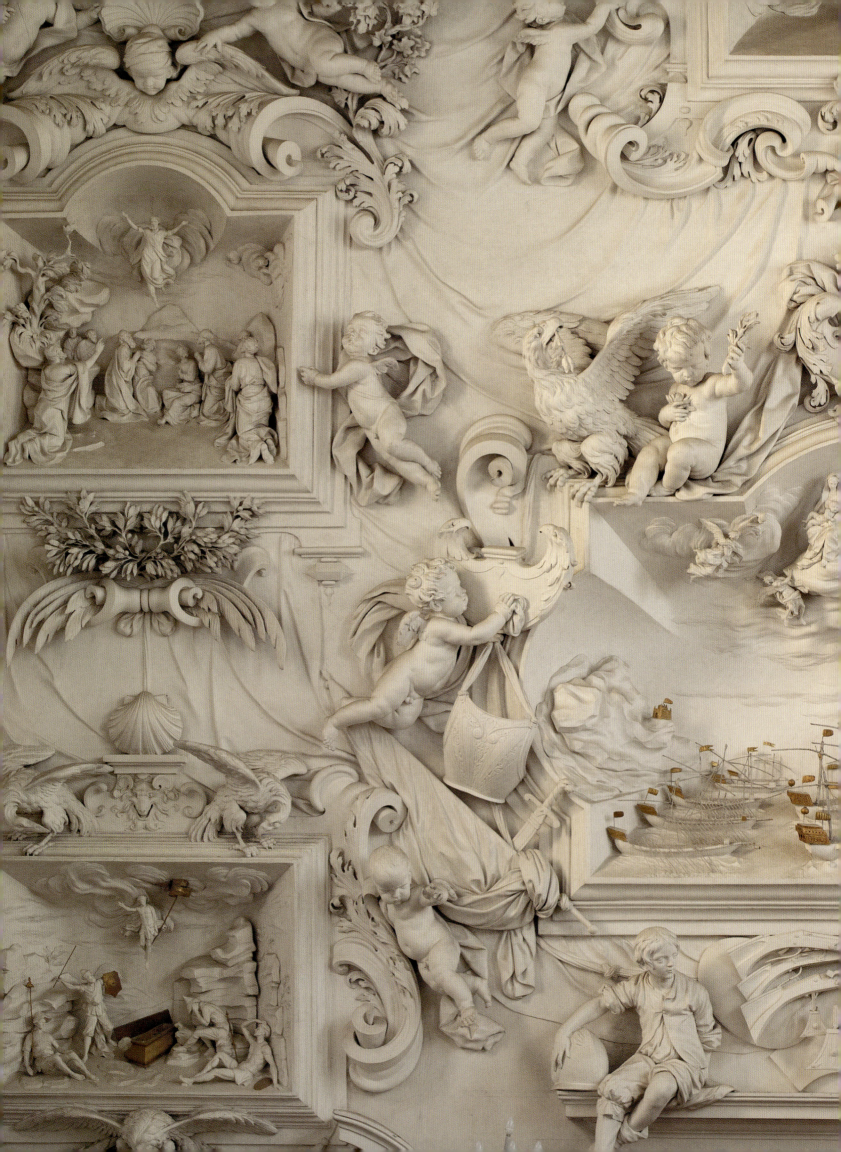

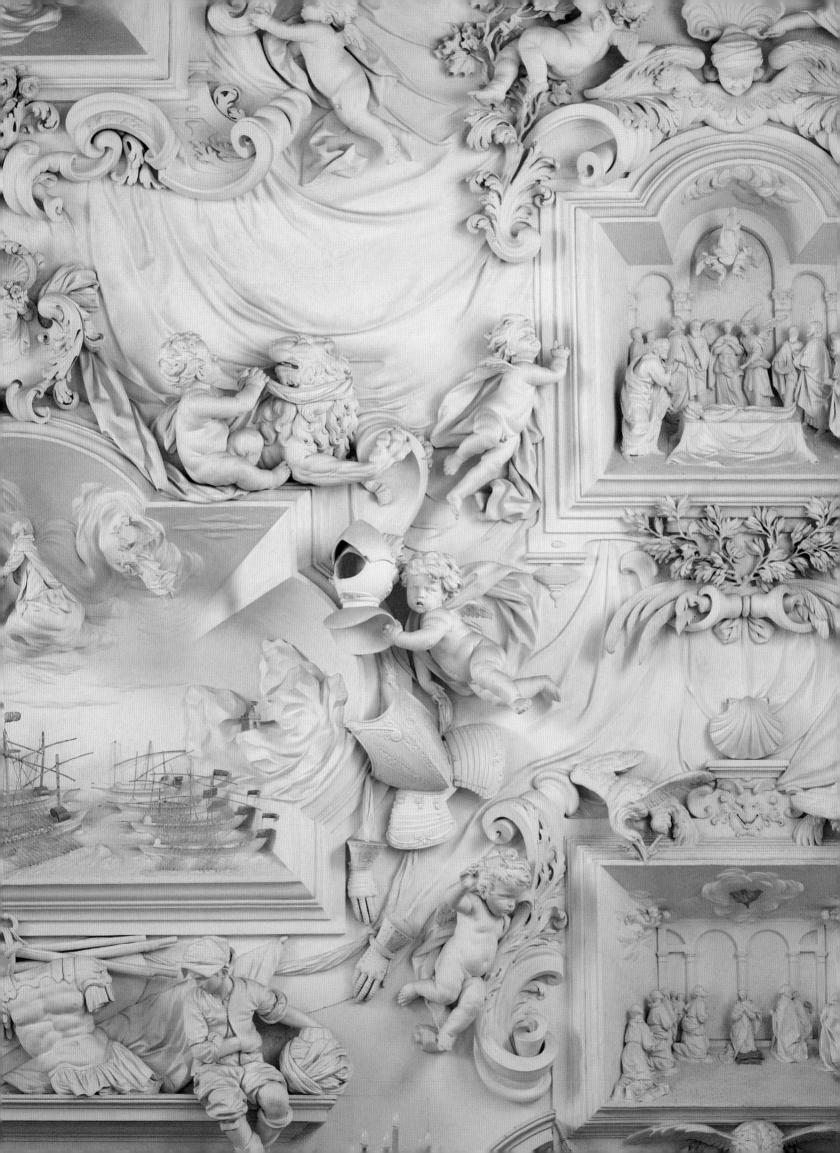

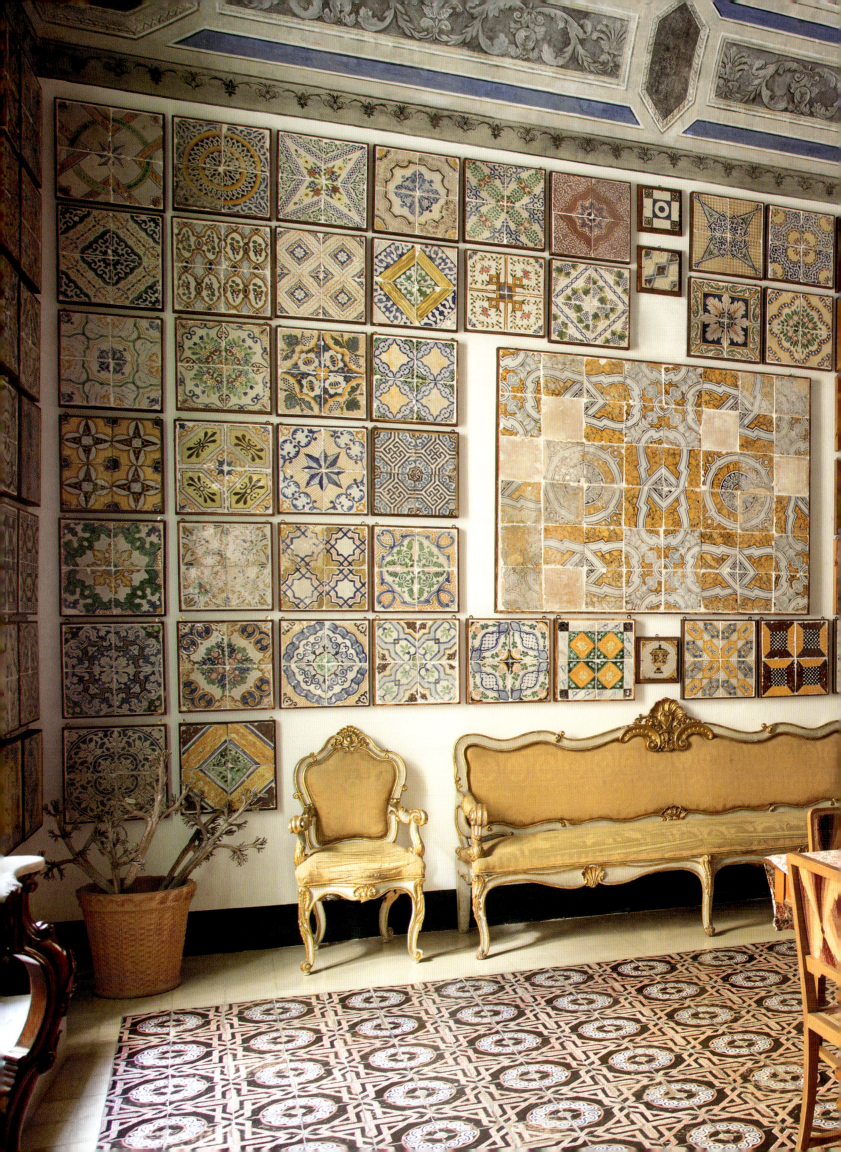

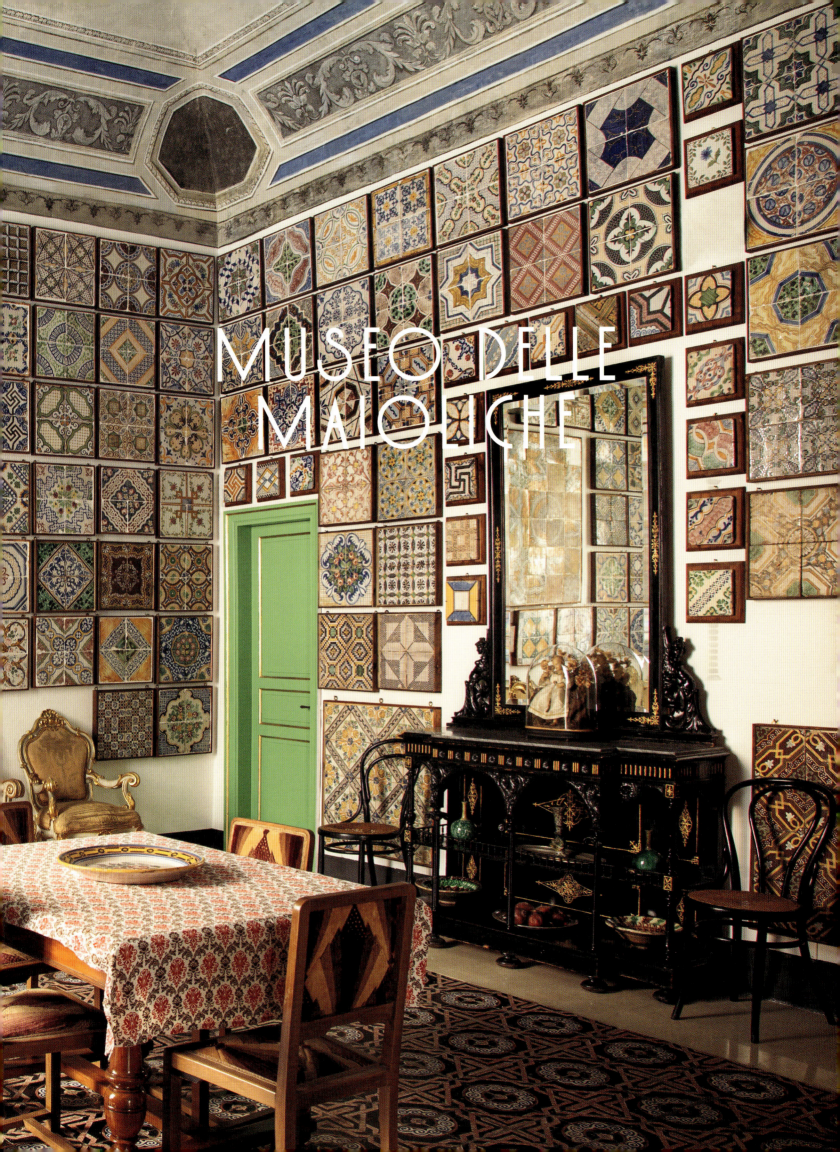

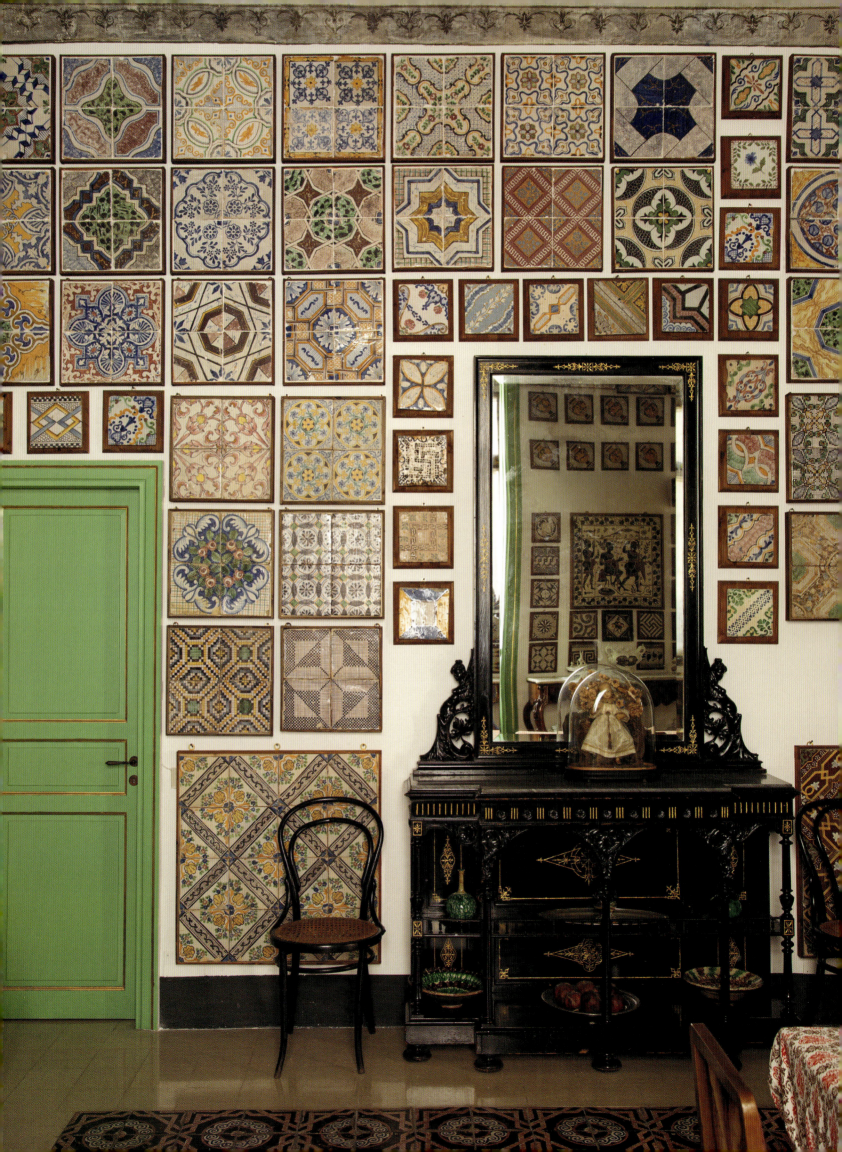

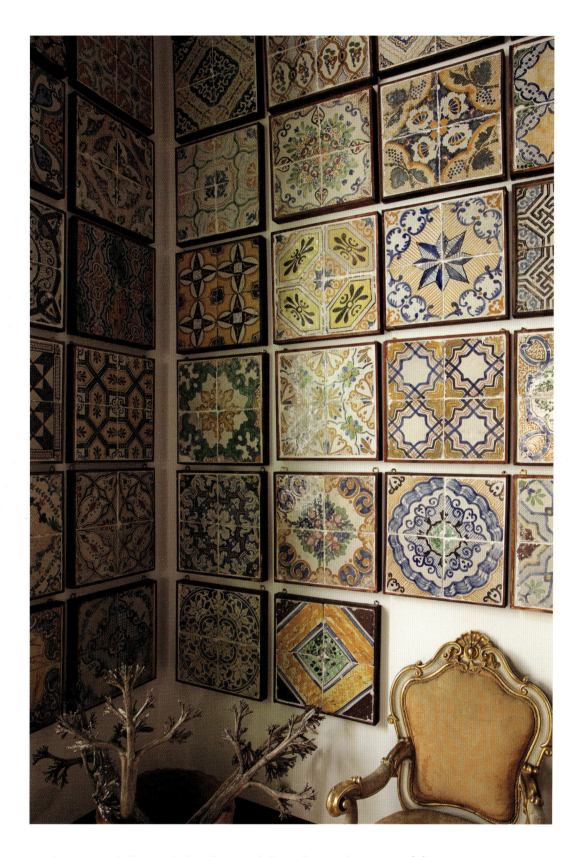

The Museo delle Maioliche "Stanze al Genio" is on the *piano nobile* (principal floor) of the sixteenth-century Palazzo Torre Pirajno in Palermo's Kalsa district. The museum features a collection of nearly 5,000 Italian maiolica tiles, dating from the fifteenth to the nineteenth centuries, displayed across nine rooms. The collection, which focuses primarily on tiles from Naples and Sicily, was assembled over thirty years by Pio Mellina and his collaborators, Antonino Perna, Luisa Masi, and Davide Sansone. This private museum offers a unique glimpse into Italy's rich ceramic heritage.

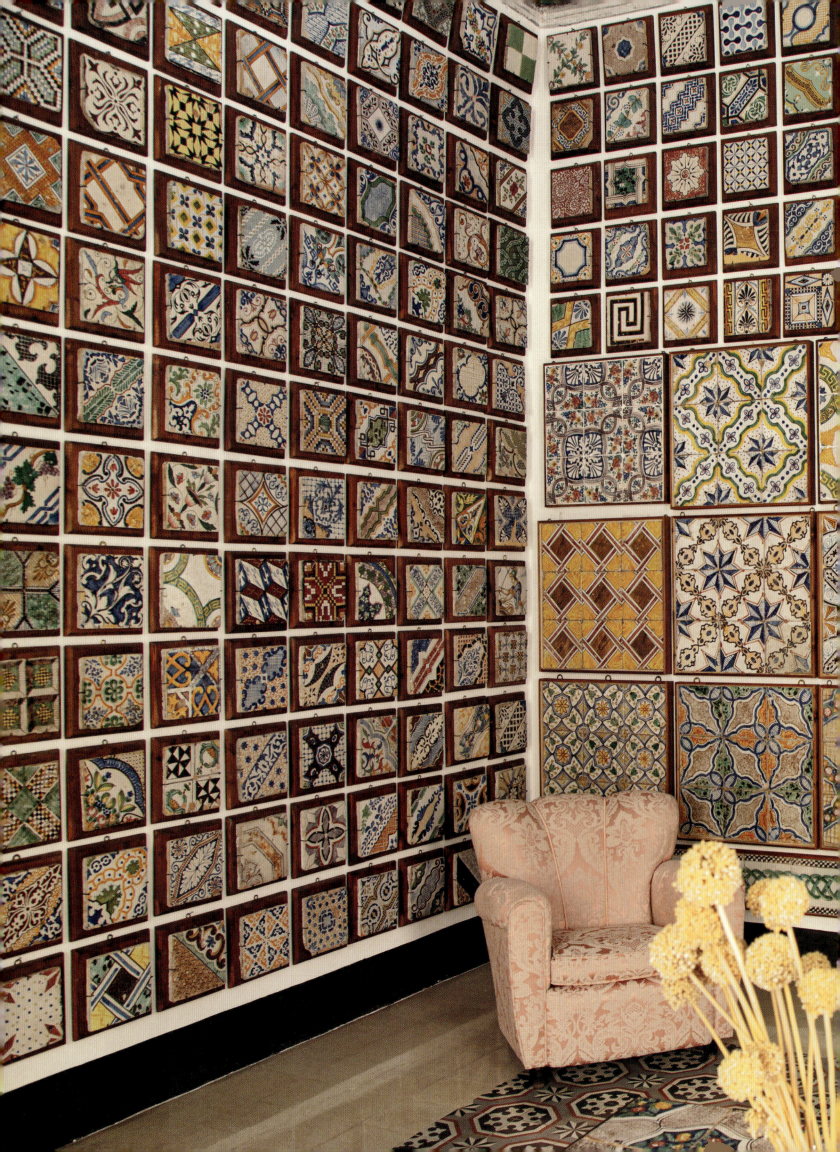

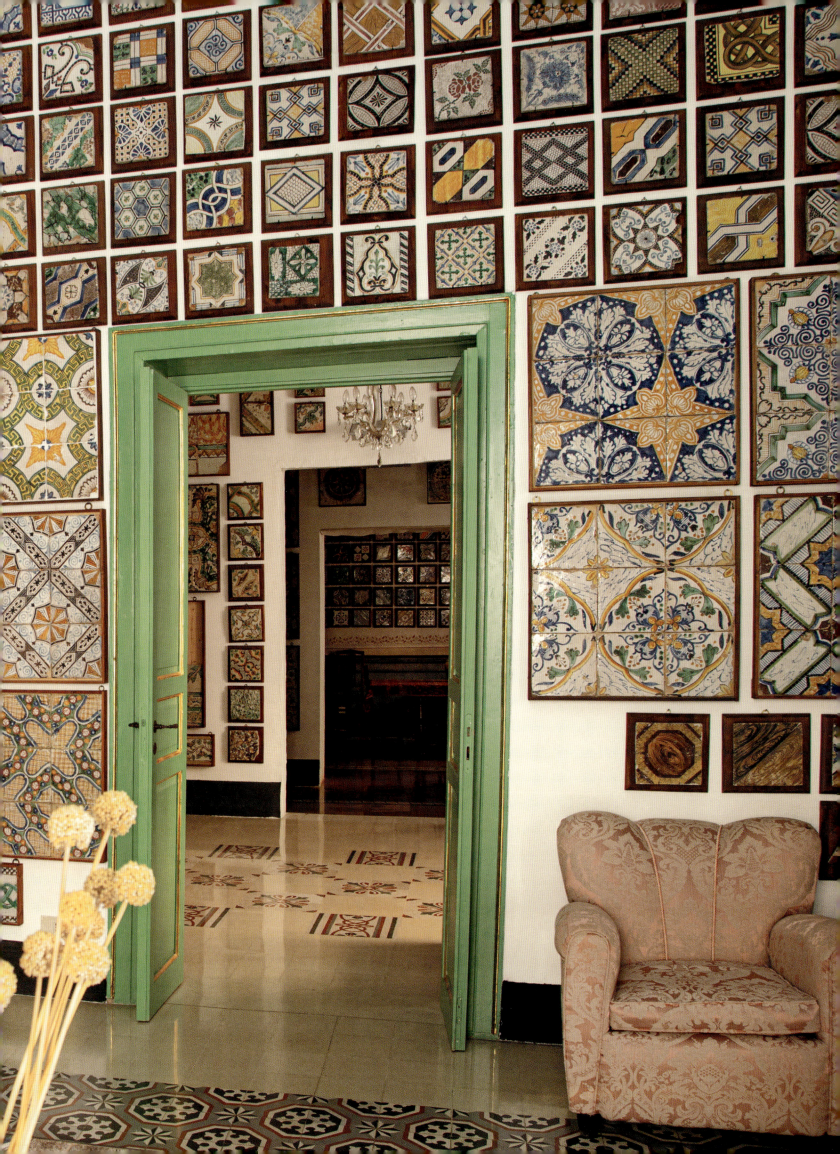

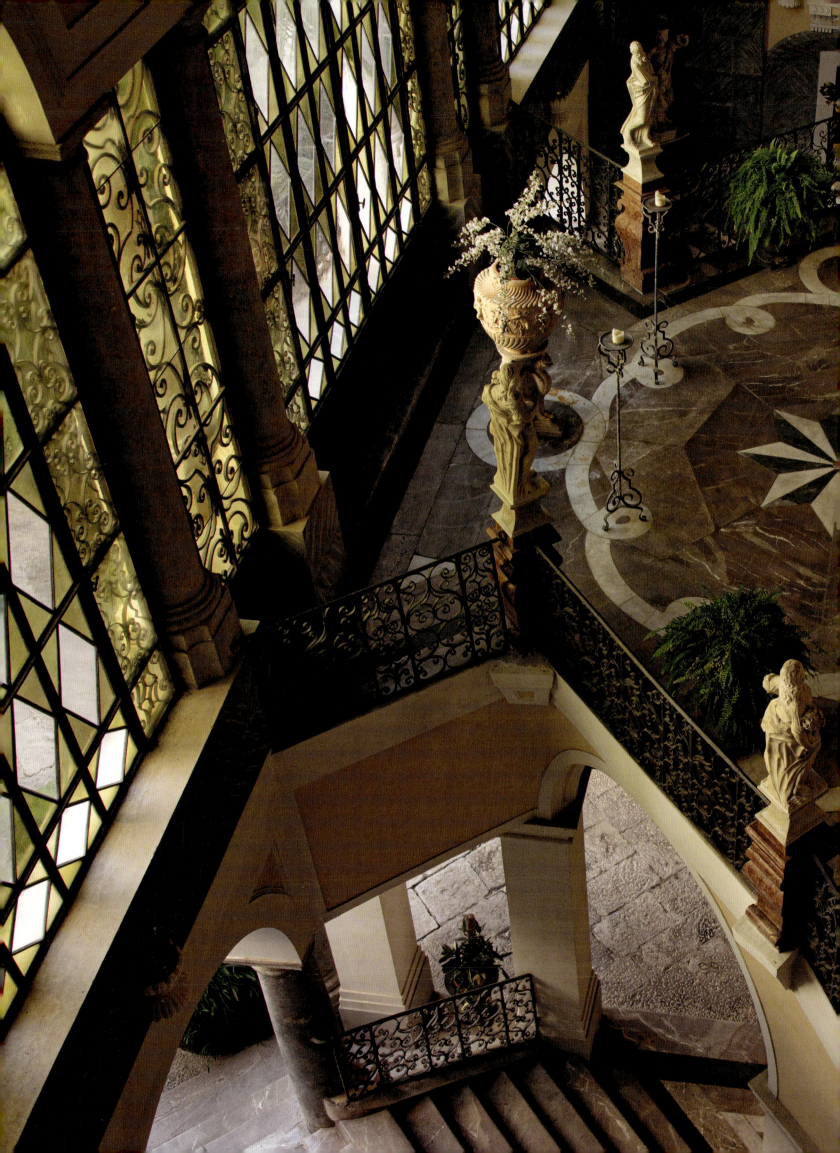

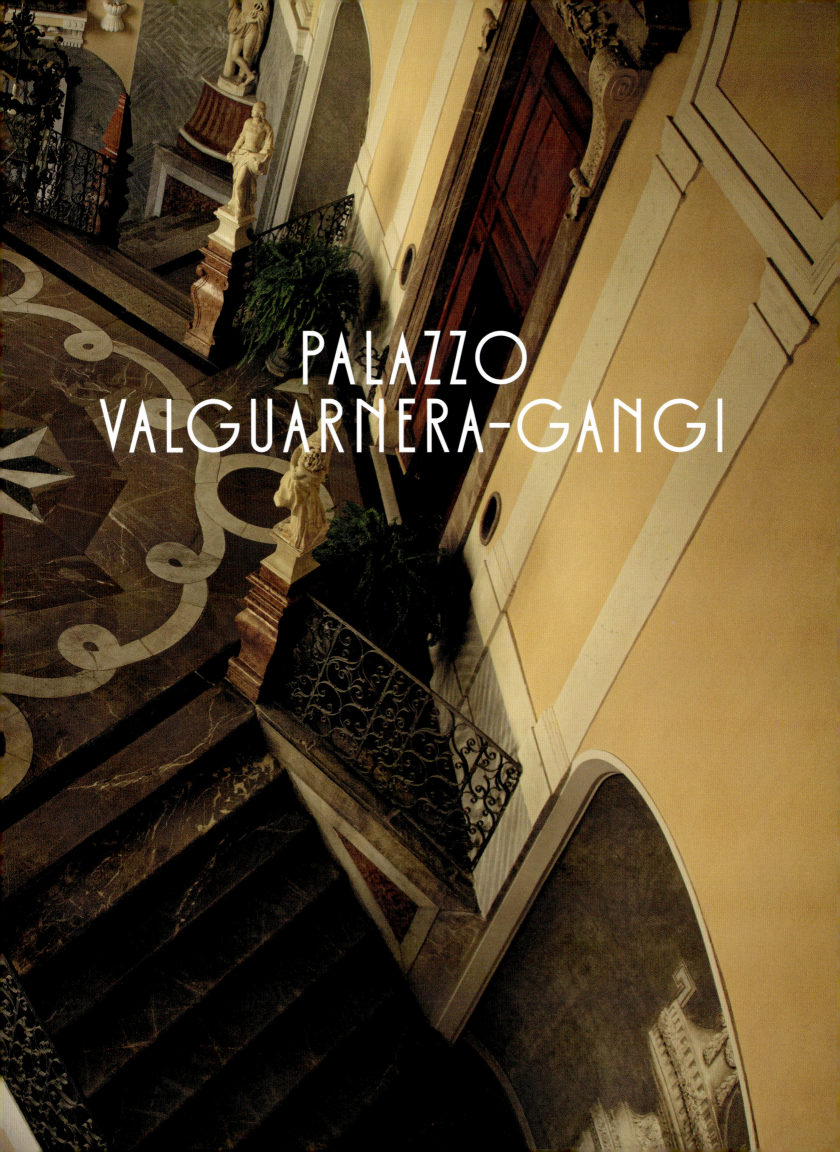

# PALAZZO VALGUARNERA-GANGI

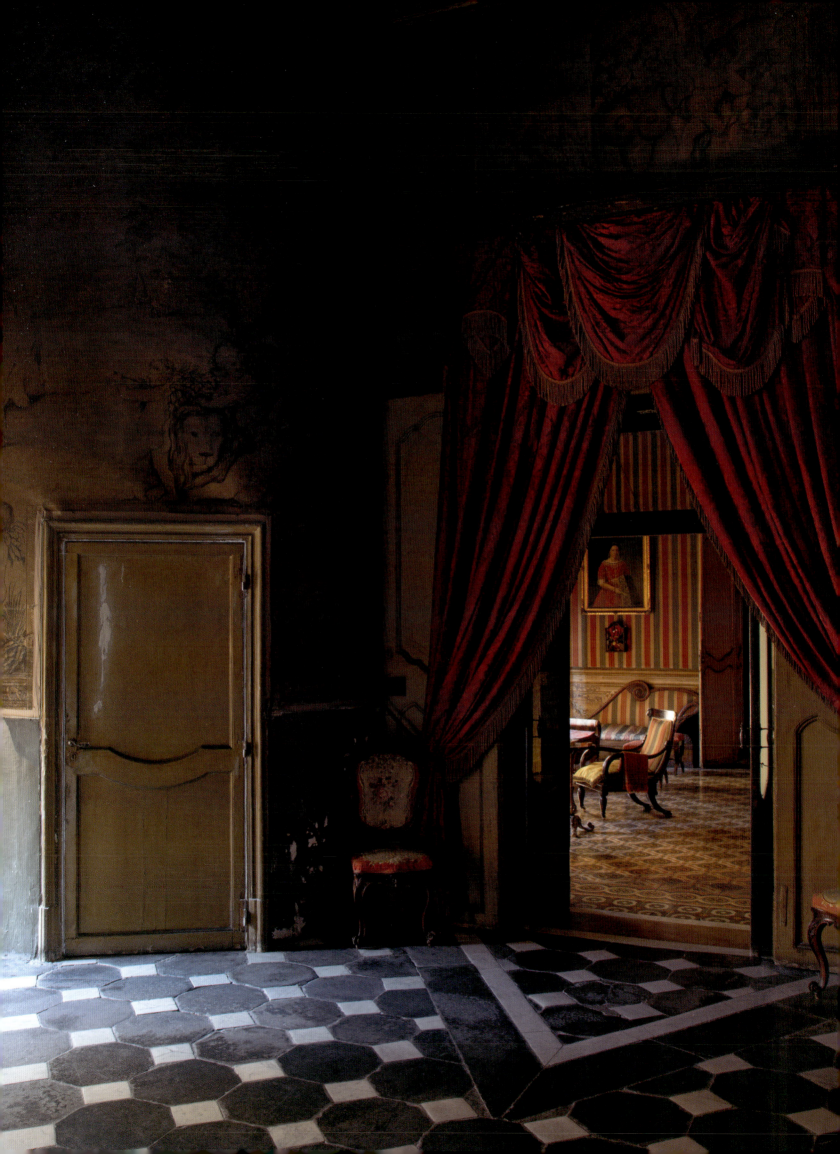

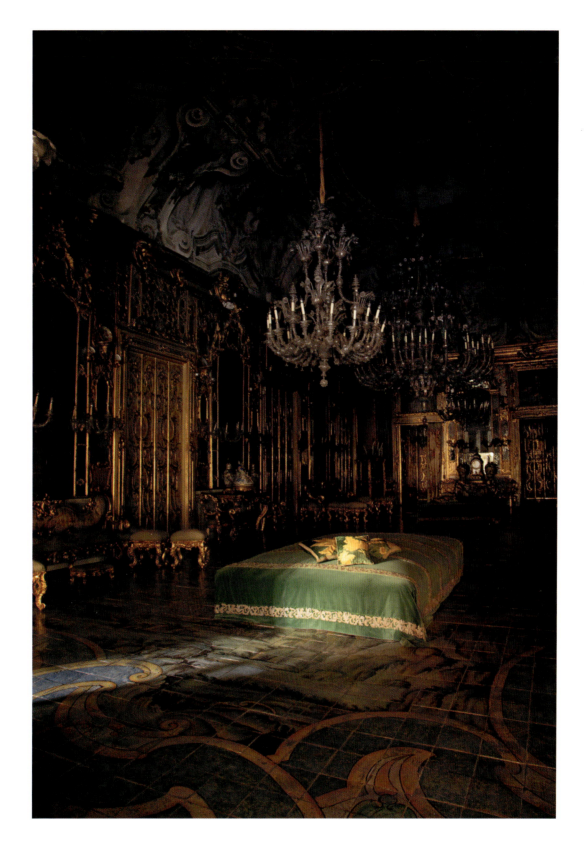

Palazzo Valguarnera-Gangi, an impressive residence of 86,100 square feet (8,000 square meters) in the historic center of Palermo, was built in the eighteenth century by Prince Pietro di Valguarnera and later inherited by the Princes of Gangi. A masterpiece of Sicilian Rococo style, it features the spectacular Hall of Mirrors, a monumental staircase adorned with statues by Ignazio Marabitti (1719–1797), and the Yellow Hall, decorated with luxurious silk damask.

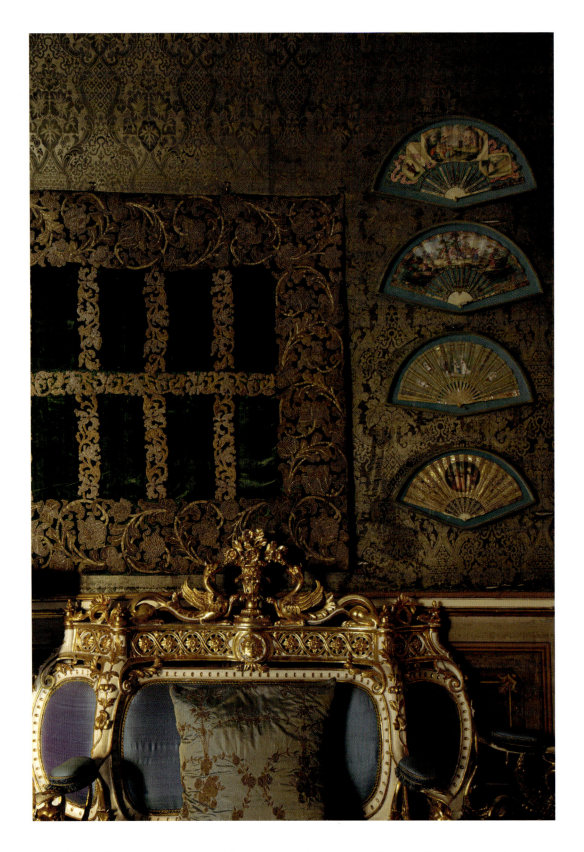

The palace underwent significant renovations in the nineteenth century under Giuseppe Mantegna, who introduced opulent Louis XVI-style elements. Still owned by the family, it was famously used as the setting for the grand ballroom scene in Luchino Visconti's movie *The Leopard* (1963).

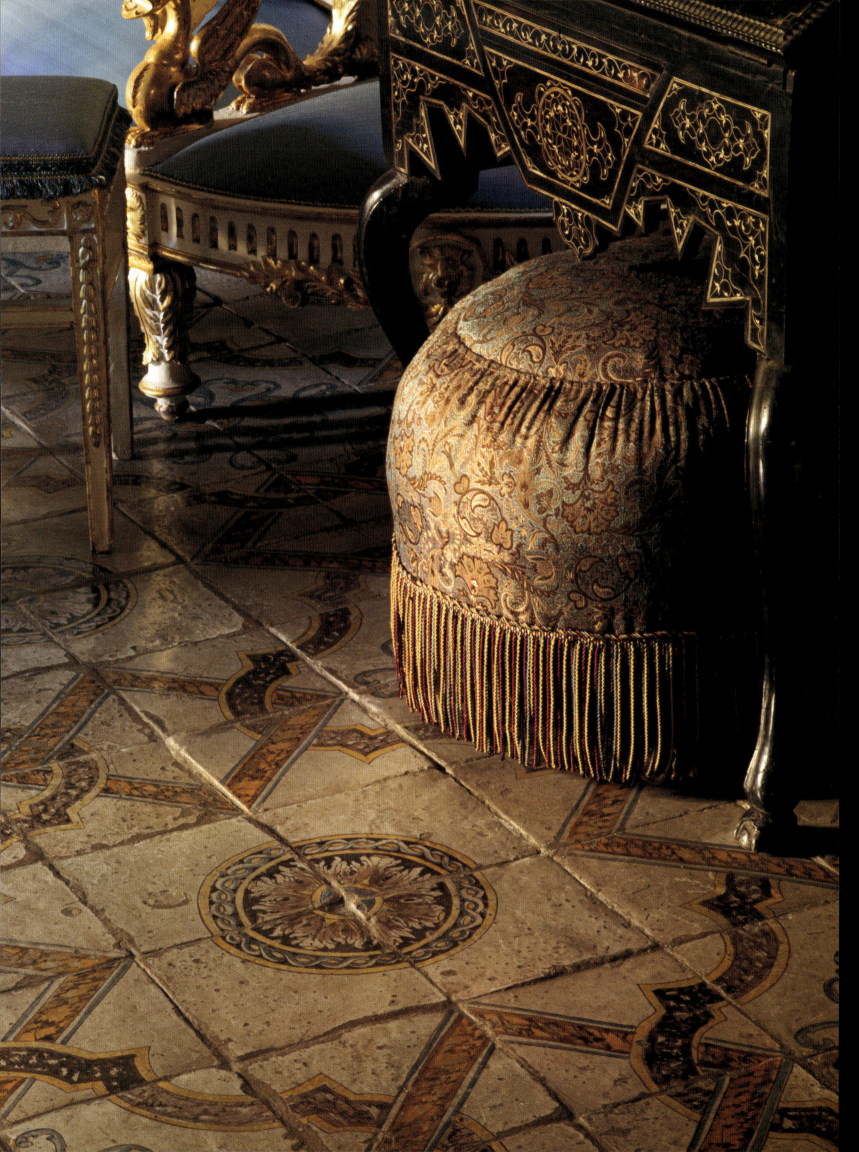

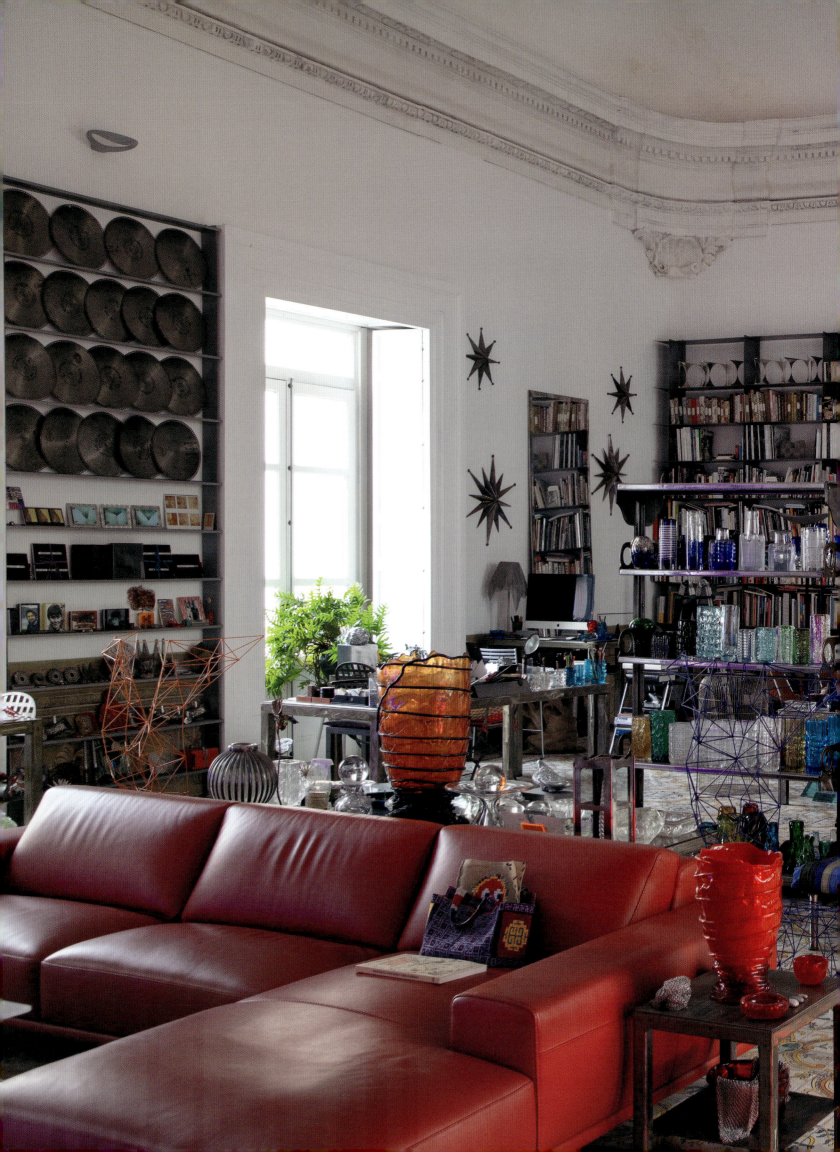

Nathalie Hambro decided to leave London some time before she settled in Sicily. New York or Paris, she felt, would be retreading the past, and Venice was a bit too familiar. But on a visit to Palermo for a curating job, she fell in love with the city, and shortly thereafter fell in love with her apartment. Although finding the property came about quickly, encouraging the intractable lady of the house to finalize the sale was another matter: "It took months of reassuring, but eventually she agreed to move on."

This focused determination is characteristic of Nathalie, an Anglo-French artist, writer, and curator. Her easy smile and gentle approach belie a rare strength that becomes apparent as she describes the work of designing and installing the steel bookcases that fill the wall of her drawing room. The apartment, on the *piano nobile* of Palazzo Resuttano in the city's Kalsa neighborhood, is dominated by the soaring ballroom, in which Nathalie has created a living room that is as much an installation as it is the heart of the house. It is dominated by collections of metal and glass, and punctuated by vivid colors, achieved through the various objects and the violet LED stage lights that edge the room.

Off the living room, smaller spaces provide Nathalie with an office, a kitchen, and bedrooms, while outside is a large plant-filled terrace. Every piece of furniture has been carefully selected or designed by the artist herself, and gives a sharp edge to the eighteenth-century interior, which has gilt plasterwork attributed to the Sicilian master Giacomo Serpotta.

Since 2020, Nathalie has shared her space with a red Shiba Inu named Matcha, and the two can be seen every Sunday exploring the nearby antiques market at the Giardino Garibaldi, or walking on the beach in Mondello. In a few short years, she has become a part of the fabric of Palermo, a city where, as she puts it, "Everything is done in the sun."

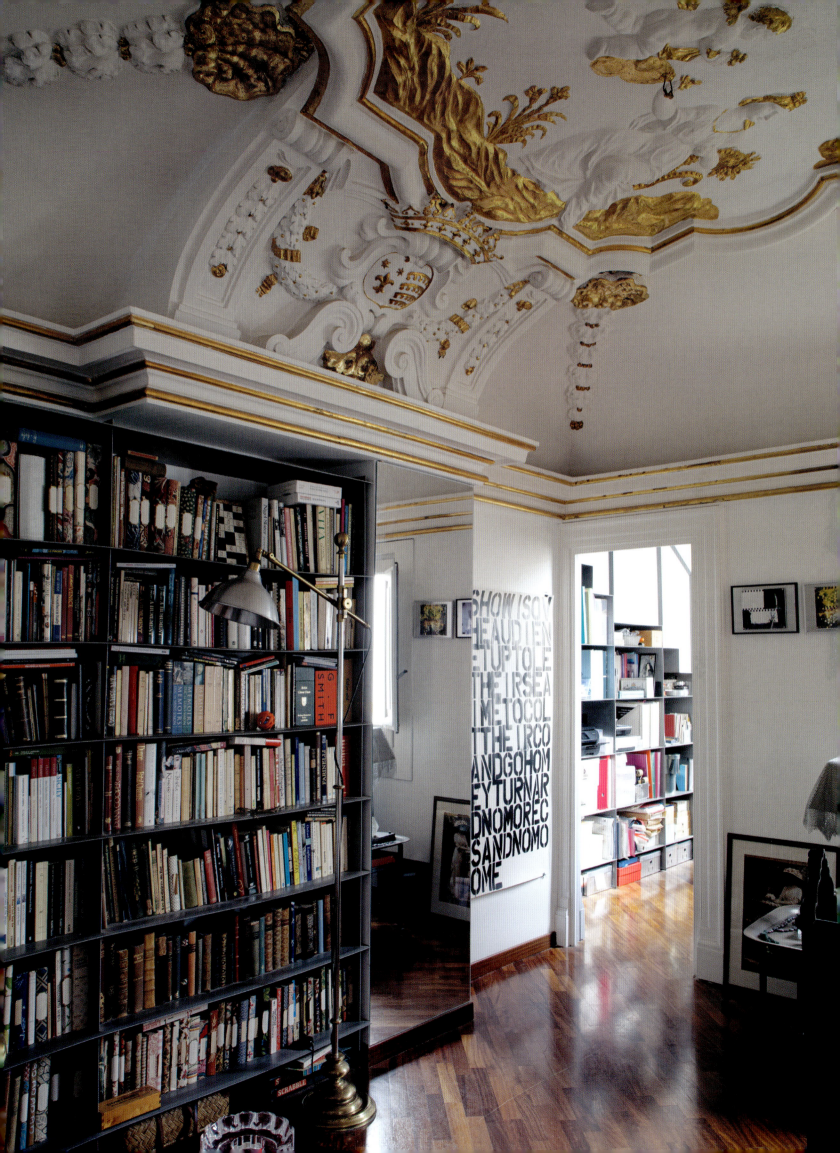

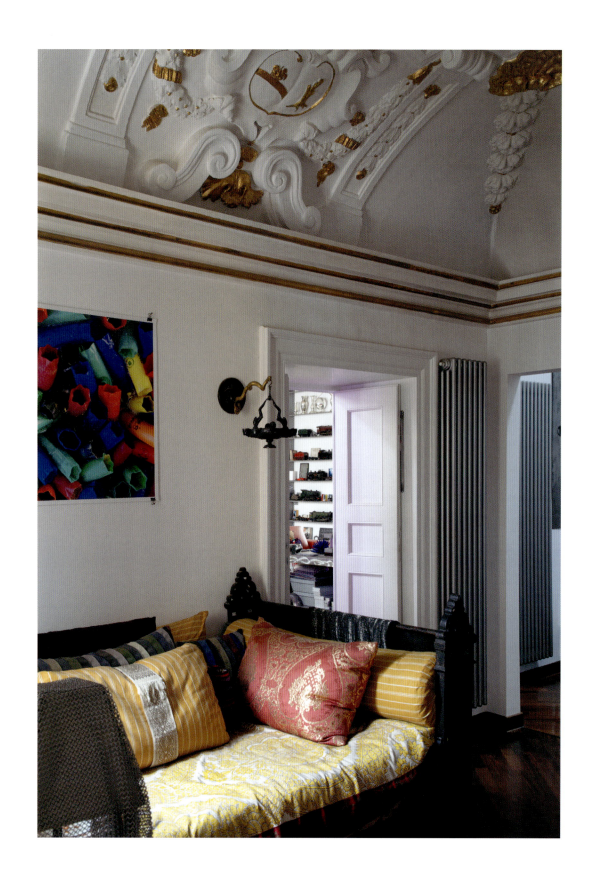

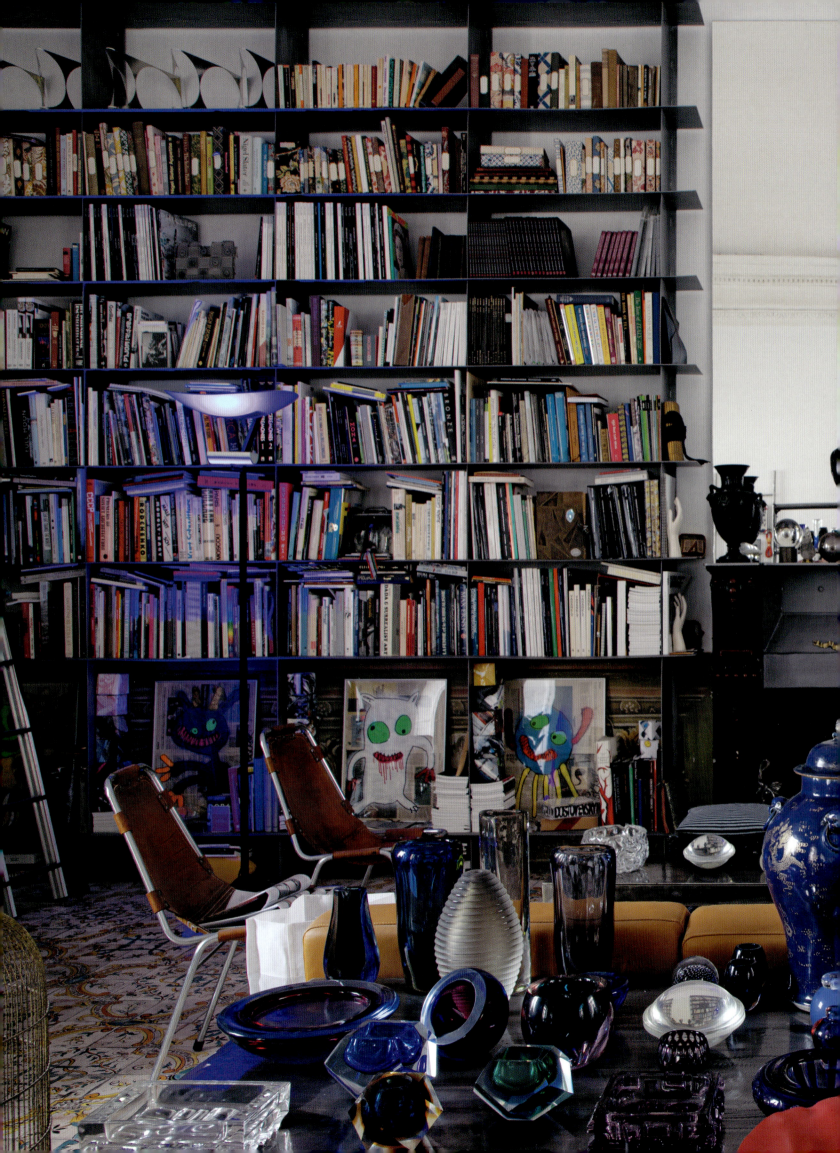

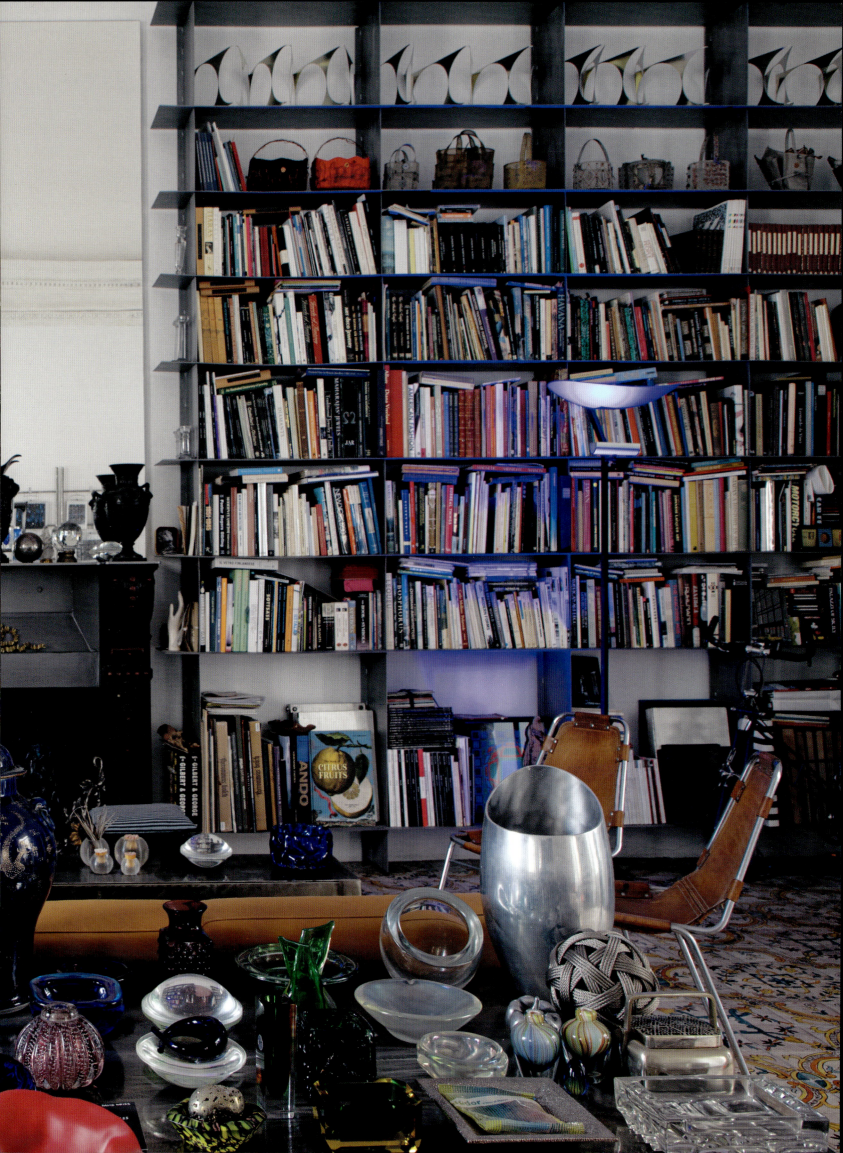

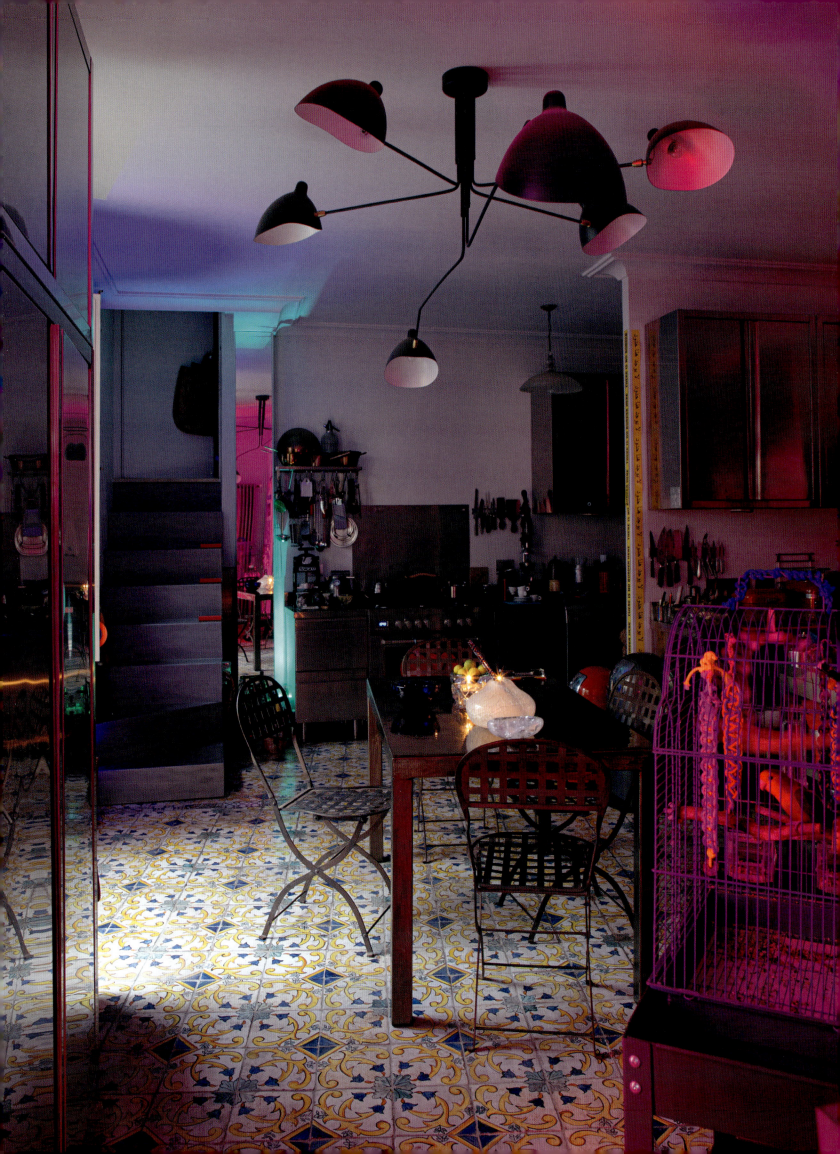

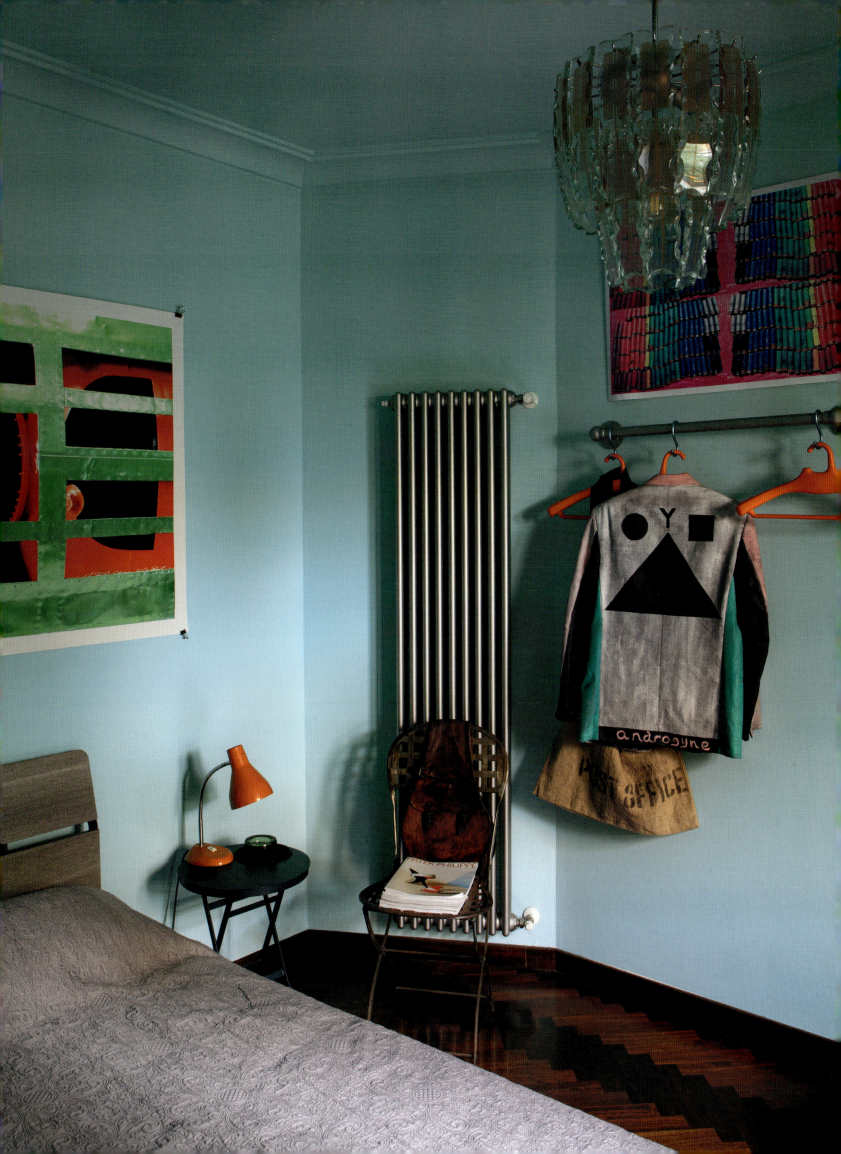

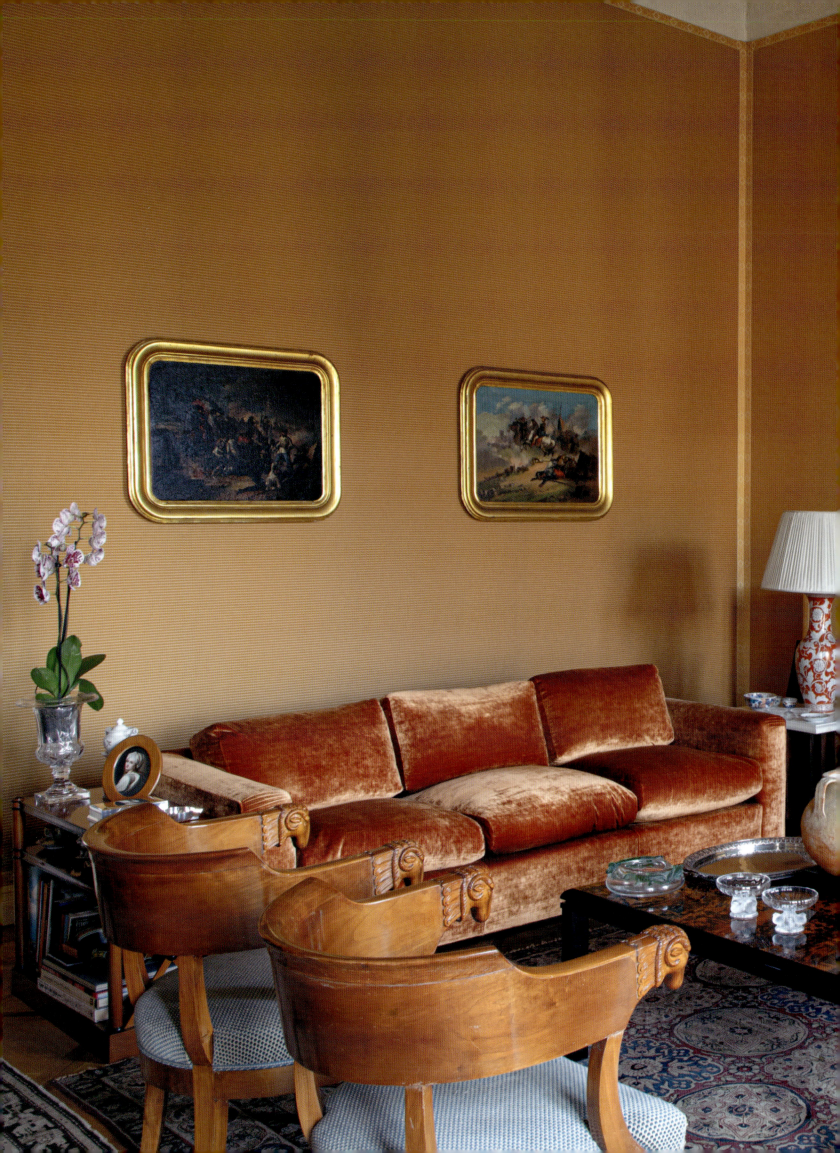

# LIBERTÀ
## ROSELLINA & AGOSTINO RANDAZZO

As ancient Palermo spreads out from its historic center, the Quattro Canti (Four Corners), toward the villas of La Favorita and the beachside borough of Mondello, the neighborhood of Libertà is situated in the city's present-day heart. It was here that, in the late nineteenth century, large Art Nouveau townhouses and well-appointed apartment buildings created a new modern city, and it is here that Rosellina and Agostino Randazzo live in a spacious fourth-floor apartment. Compared to the bustling street outside, this is an oasis, and within it the impeccably dressed Rosellina hosts a mixture of Palermo society.

In the kitchen, Rosellina is cutting a bouquet of hyacinths, getting ready for a dinner party she will host later that evening. "They come from our house in Mondello," she says. "Sometimes, if we have some warm winter days, we get the early spring flowers in the garden." As the blooms go into a vase, their smell wafts through the house, and it is easy to imagine that their fragrance is a harbinger of summer, when the couple will largely close their city apartment and move out to the beach house only twenty minutes away.

An assortment of fabric walls soften the sitting rooms, which are arranged around a generous, light-filled corridor. The Roman-style marble bathtub in the master bathroom is complemented by a pair of rare Gio Ponti cabinets, which add to the room's classical allusions, while elsewhere, a collection of East Asian ceramics brings a worldly charm to the entertaining spaces.

Throughout the house, personal memories are on display, such as a large vitrine in a raffia-clad study showcasing the sailing trophies of Agostino, who is president of the Circolo della Vela Sicilia (Sicilian Sailing Club). Similarly, in the entrance, a prized cabinet contains ancient terra-cotta vessels that were part of a large excavation at the family's historic countryside lands at Buonfornello along the coast to the east, on which the Greek city of Himera once stood. After the excavation (carried out in partnership with the state), this is the portion of finds the family was able to keep. More than merely decorative elements, these flowers, trophies, and artifacts are talismans of the Randazzo family's Palermo, pieces that connect to their Sicilian past, as well as indicating the mark they have made on the city itself.

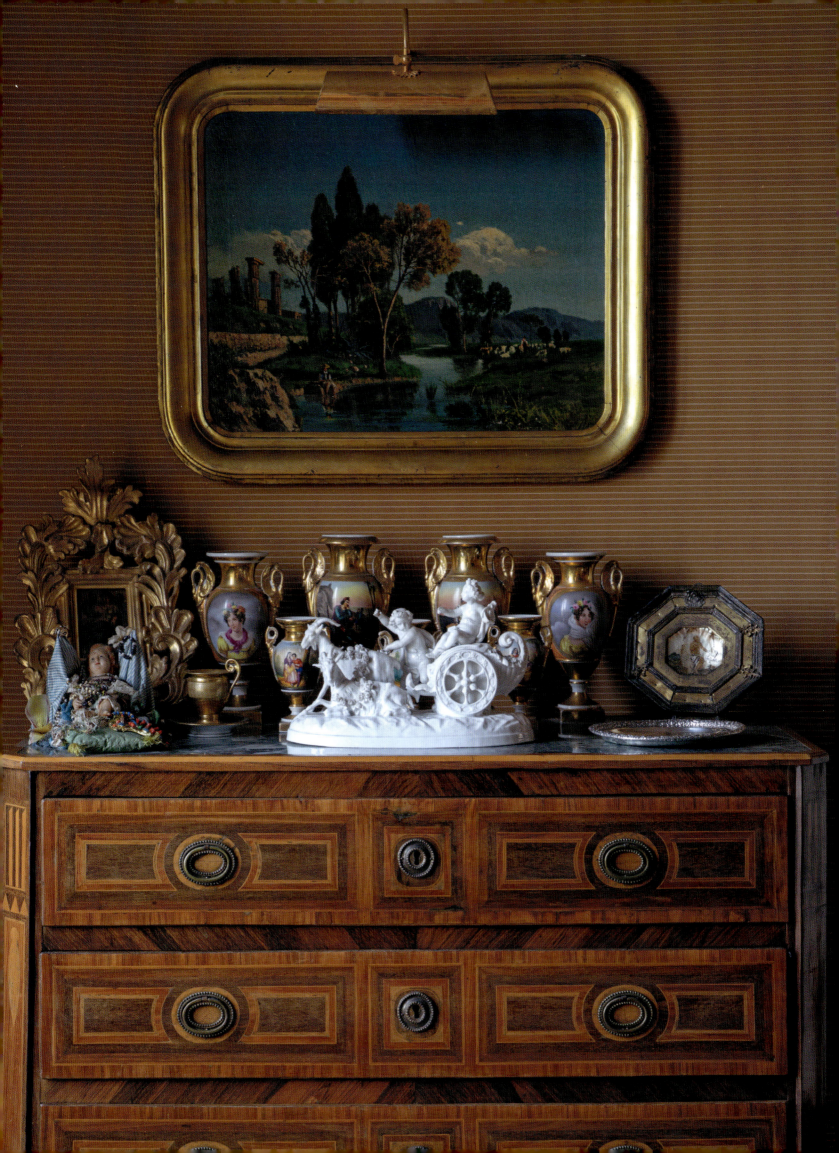

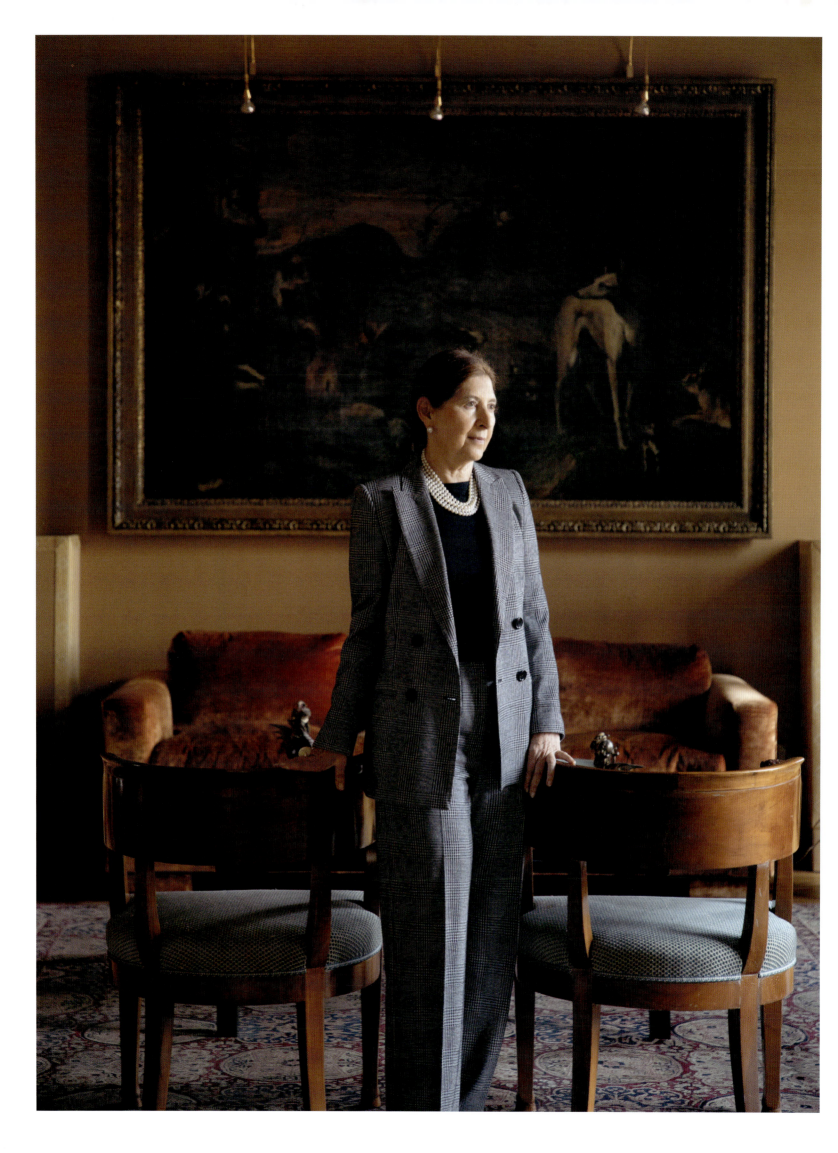

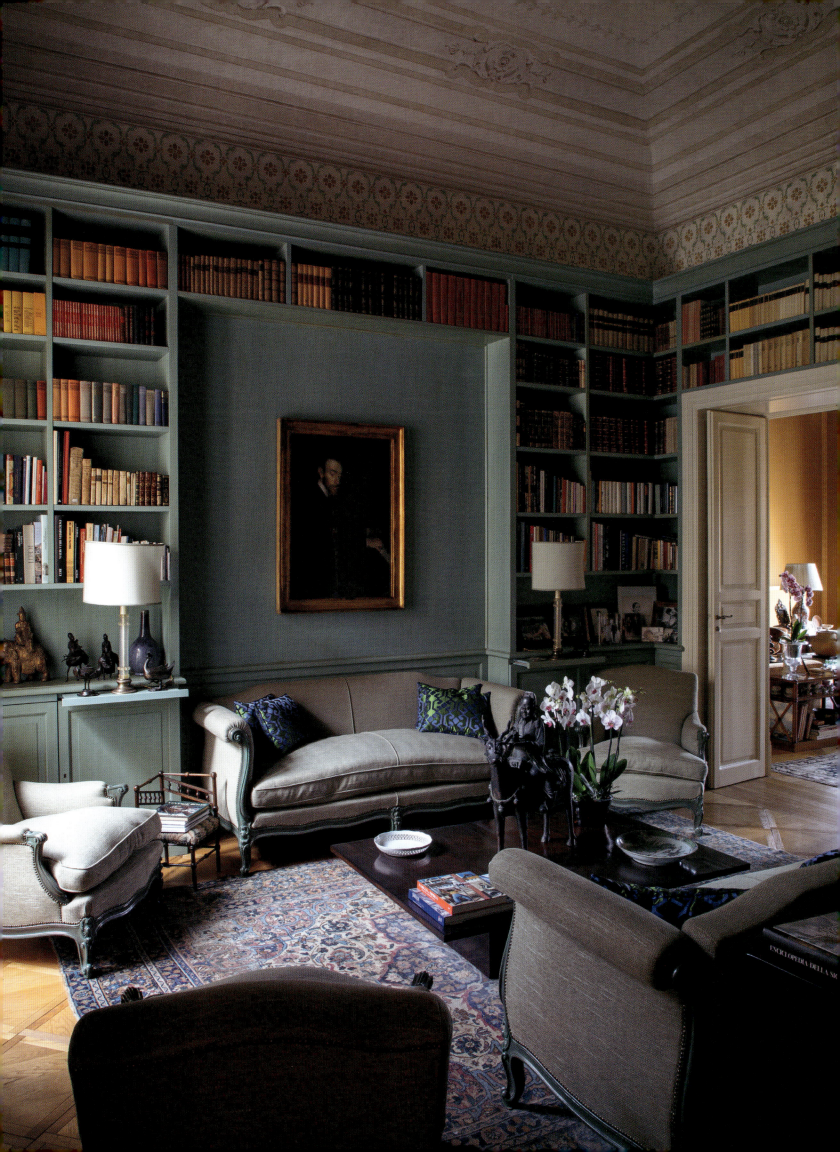

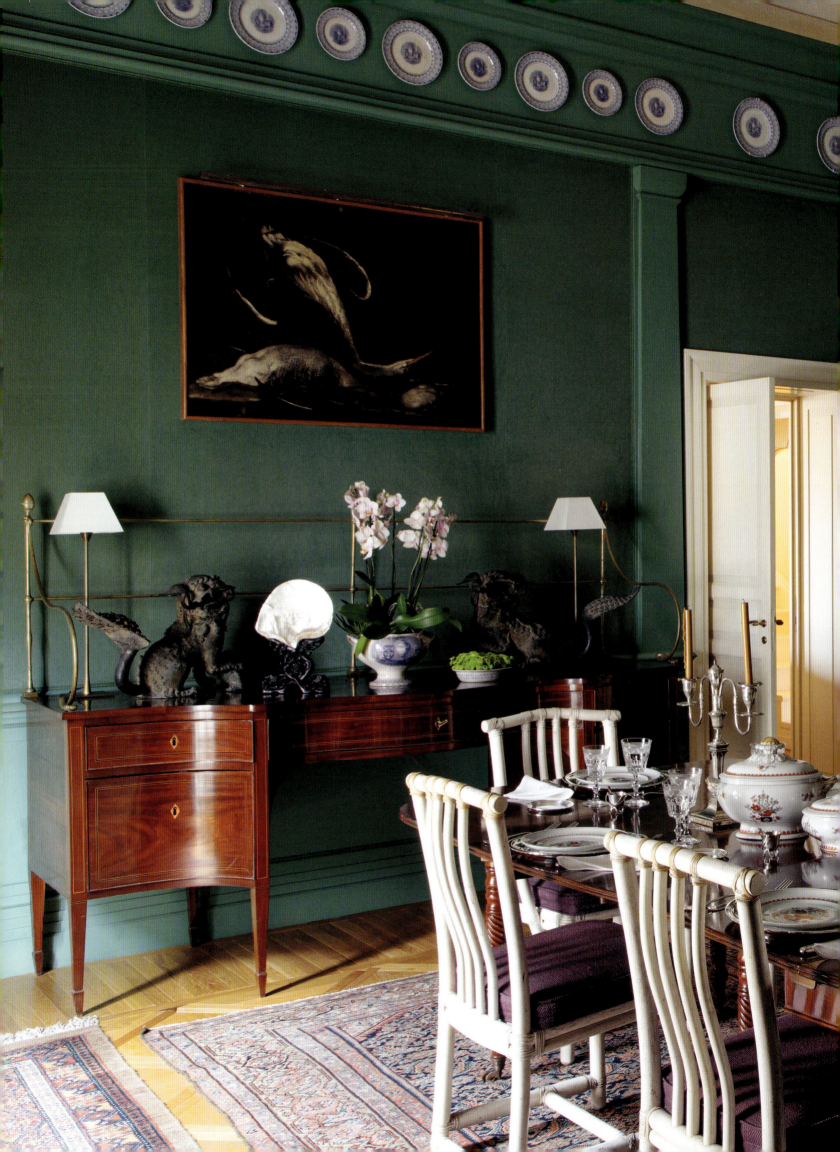

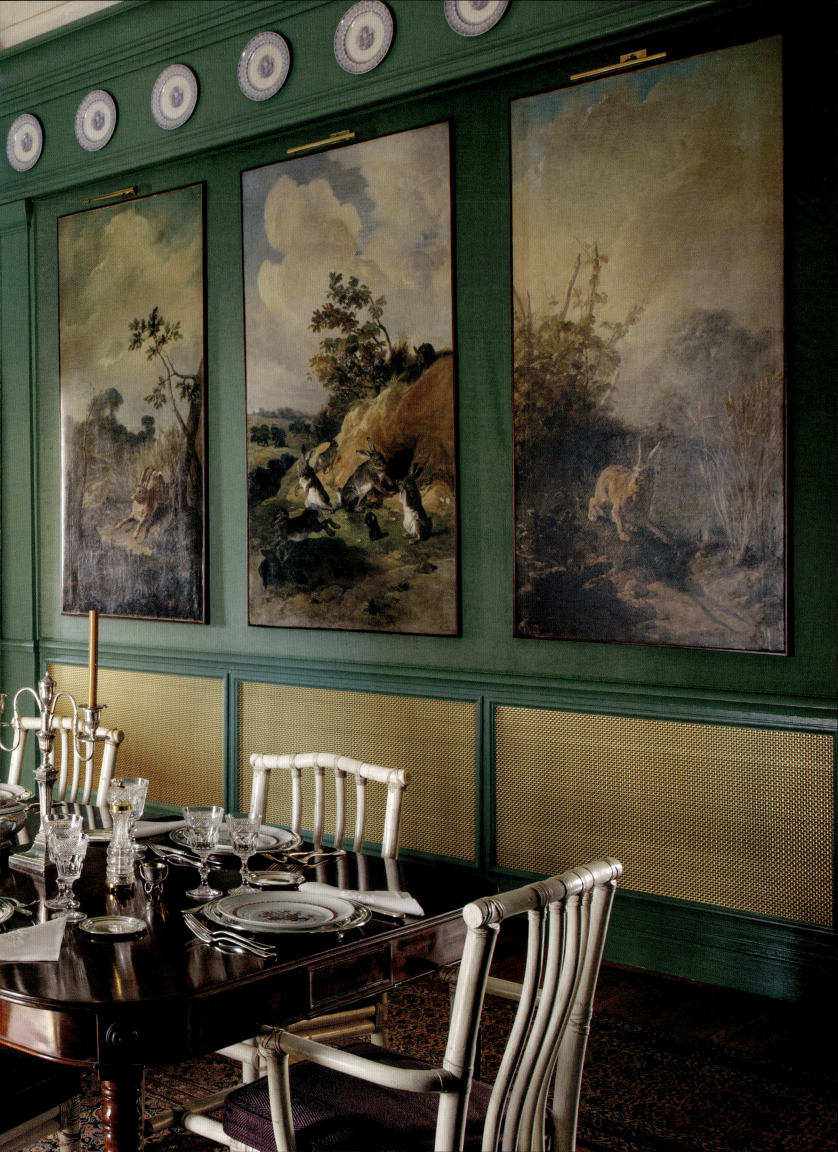

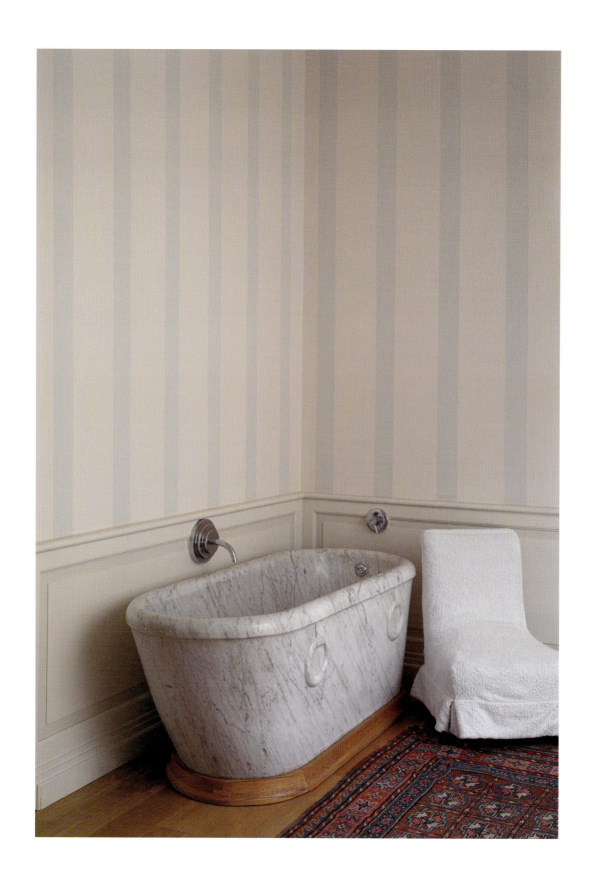

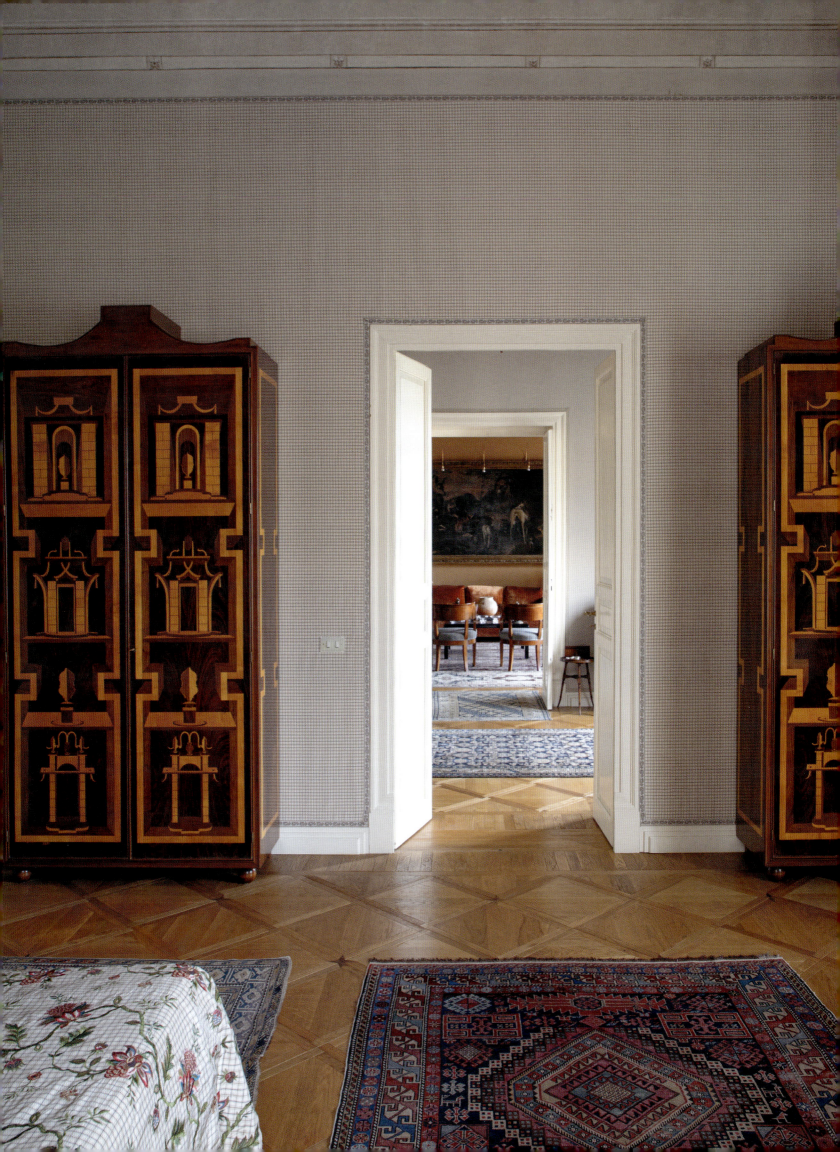

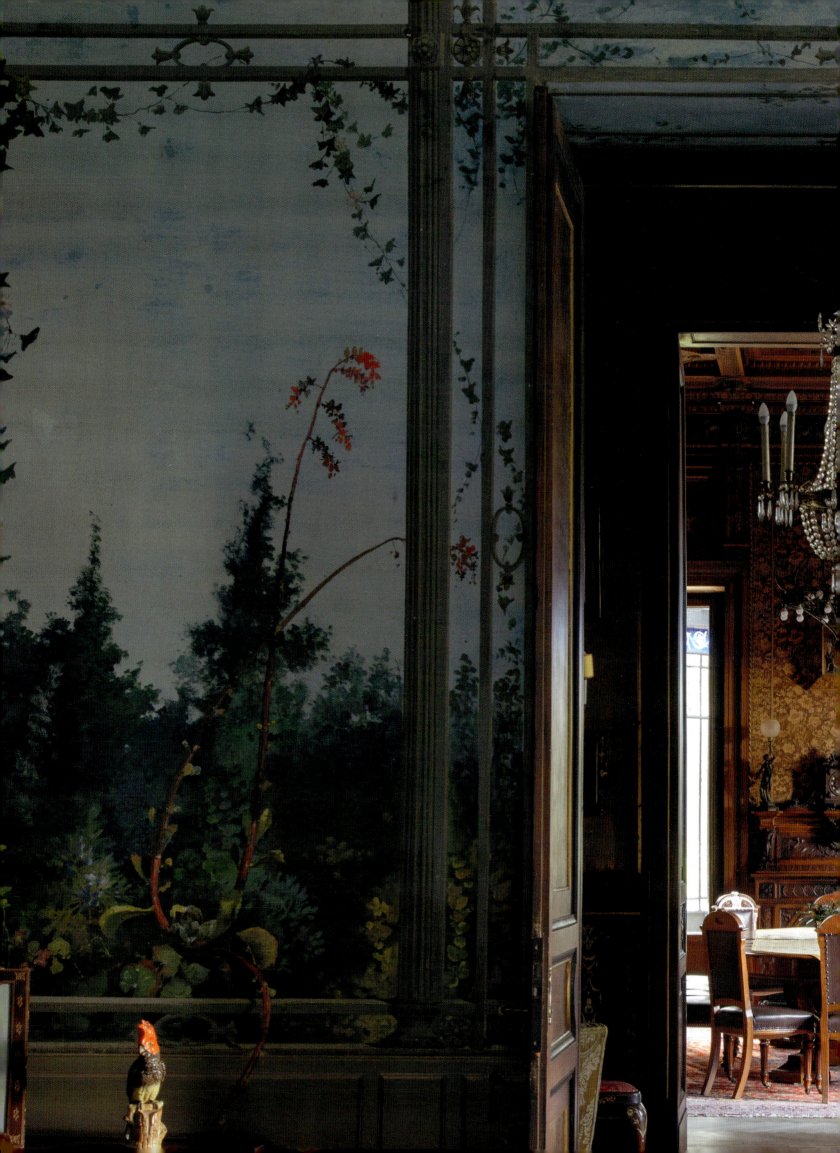

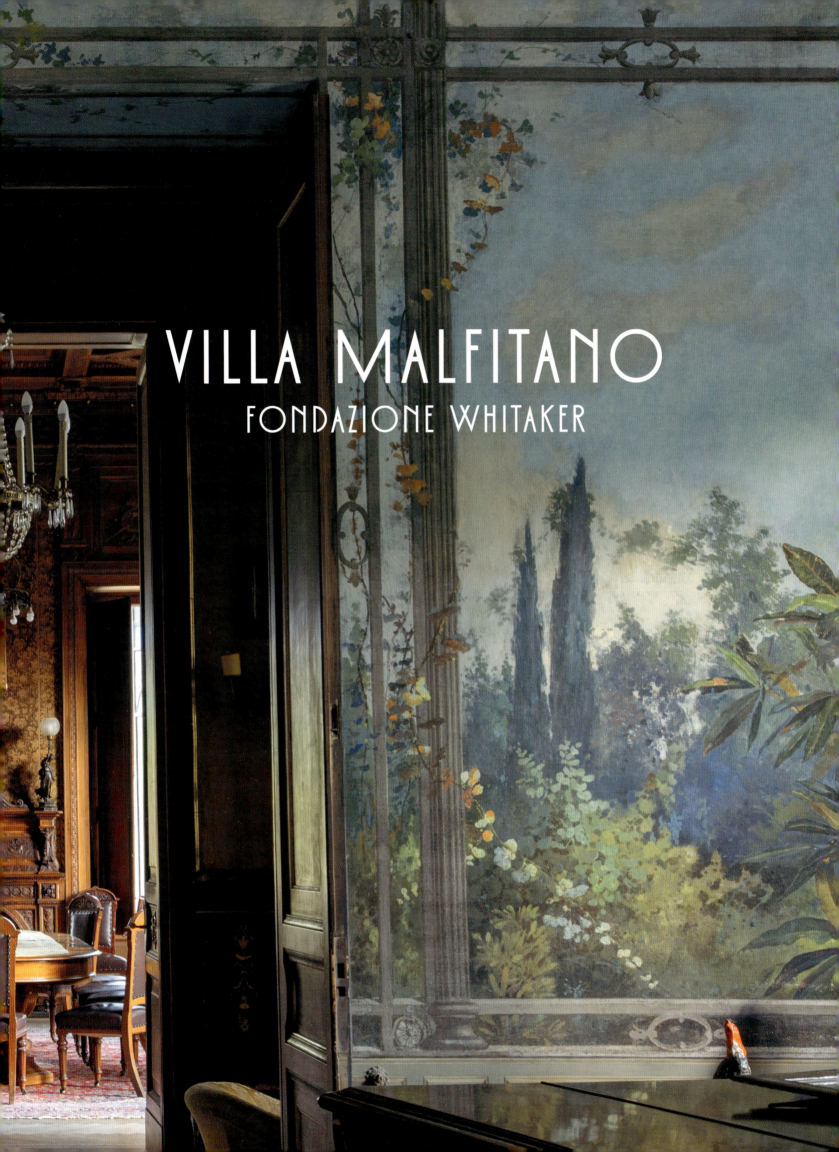

# VILLA MALFITANO
## FONDAZIONE WHITAKER

When Joseph Whitaker set out to make his mark on Palermo, he envisioned a villa that would reflect both his cosmopolitan outlook and his family's stature. The result, designed by the architect Ignazio Greco between 1885 and 1889, was Villa Malfitano, a neoclassical masterpiece that became a cornerstone of Palermo's cultural and social life. At the time, the city was a vibrant hub for European aristocracy, a place where the grandeur of Sicily mingled effortlessly with international sophistication.

The Whitaker family, originally from England, had risen to prominence as pioneers of Sicily's trade in Marsala wine. Their influence soon extended beyond commerce, however, as they became known for their patronage of the arts and sciences. Similar to other grand Belle Époque villas in Palermo, such as Villa Chiaramonte Bordonaro (page 69) and the Florio family's Villa Igiea, Villa Malfitano was as much a stage—a projection of the Whitakers' taste and background—as it was a home.

The villa's design, a blend of neoclassical elegance and Liberty-style (Italian Art Nouveau) innovation, speaks to this cosmopolitan spirit. Greco's vision incorporated grandeur in various ways, from the frescoed Summer Room by Ettore De Maria Bergler (1850–1938) to the opulent Coral Room, adorned with exquisite Trapanesi coral pieces. The ballroom and reception rooms are filled with treasures from Whitaker's travels—such as cloisonné porcelain elephants from Beijing's Imperial Palace, and ancient maiolica ceramics—reflecting his passion for collecting and exploration.

The villa's grandeur extends into its lush gardens, a private botanical haven conceived by the renowned plantsman Emilio Kunzmann. The extensive grounds feature exotic plants from Africa, Sumatra, and the Americas, alongside towering magnolias and a majestic dragon tree (*Dracaena draco*).

More than a residence, Villa Malfitano was a cultural landmark that embodied Palermo's cosmopolitan golden age. The Whitaker family's commitment to blending tradition with innovation helped to position their home as a significant Liberty-style icon, celebrating a world in which art, science, and design intersected. This extraordinary villa remains a testament to that vision, standing as a living museum of elegance and a beacon of Palermo's storied past.

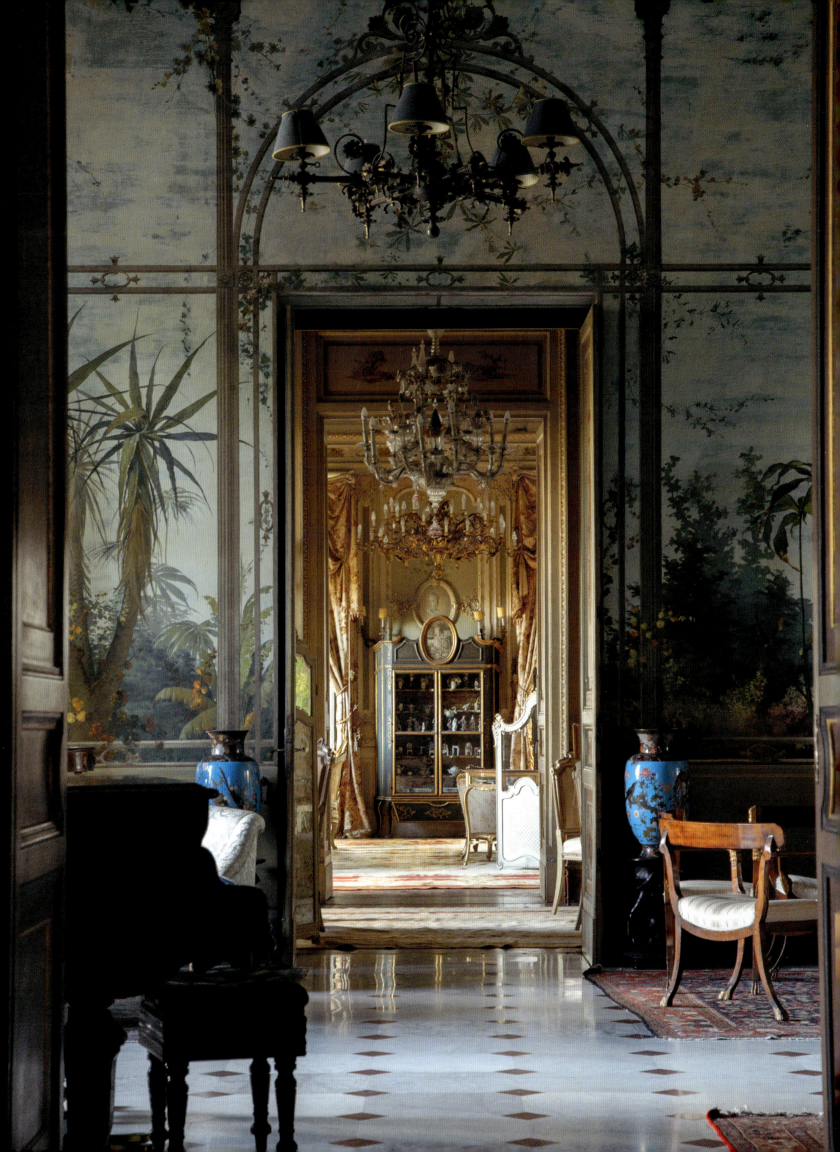

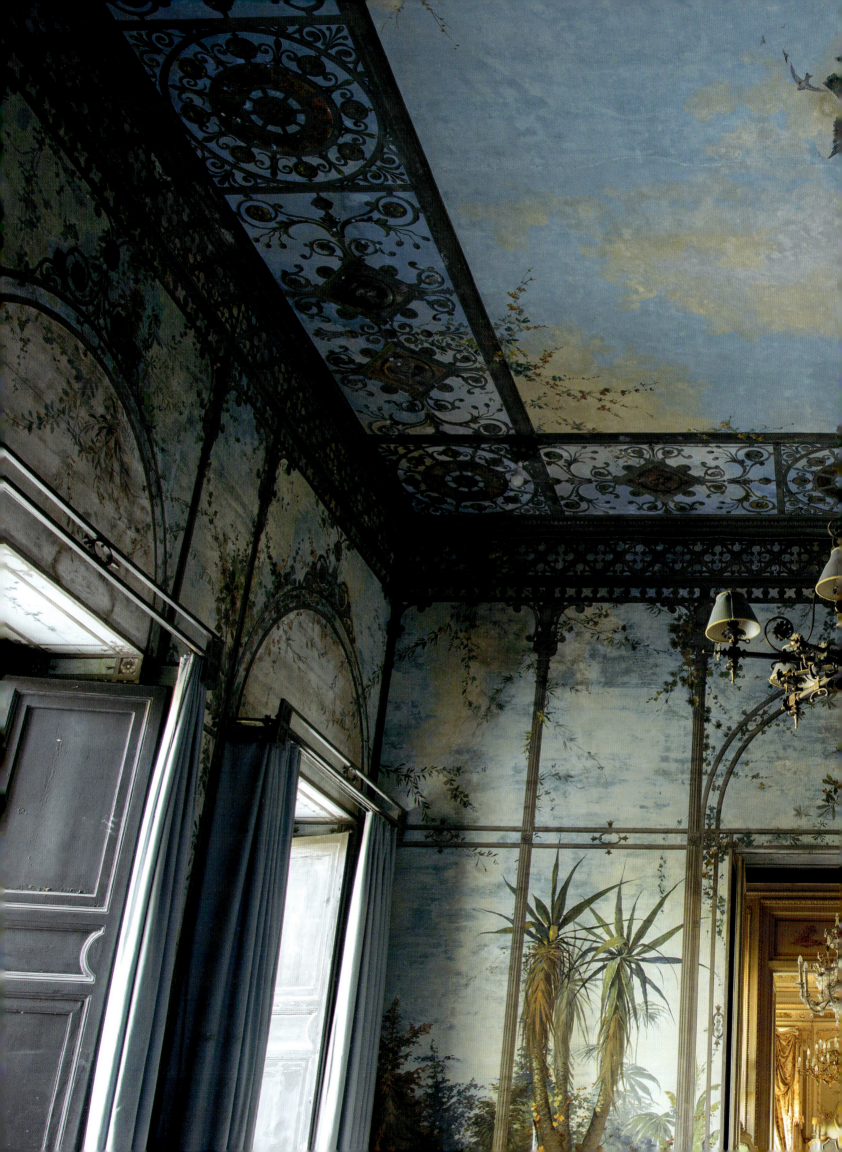

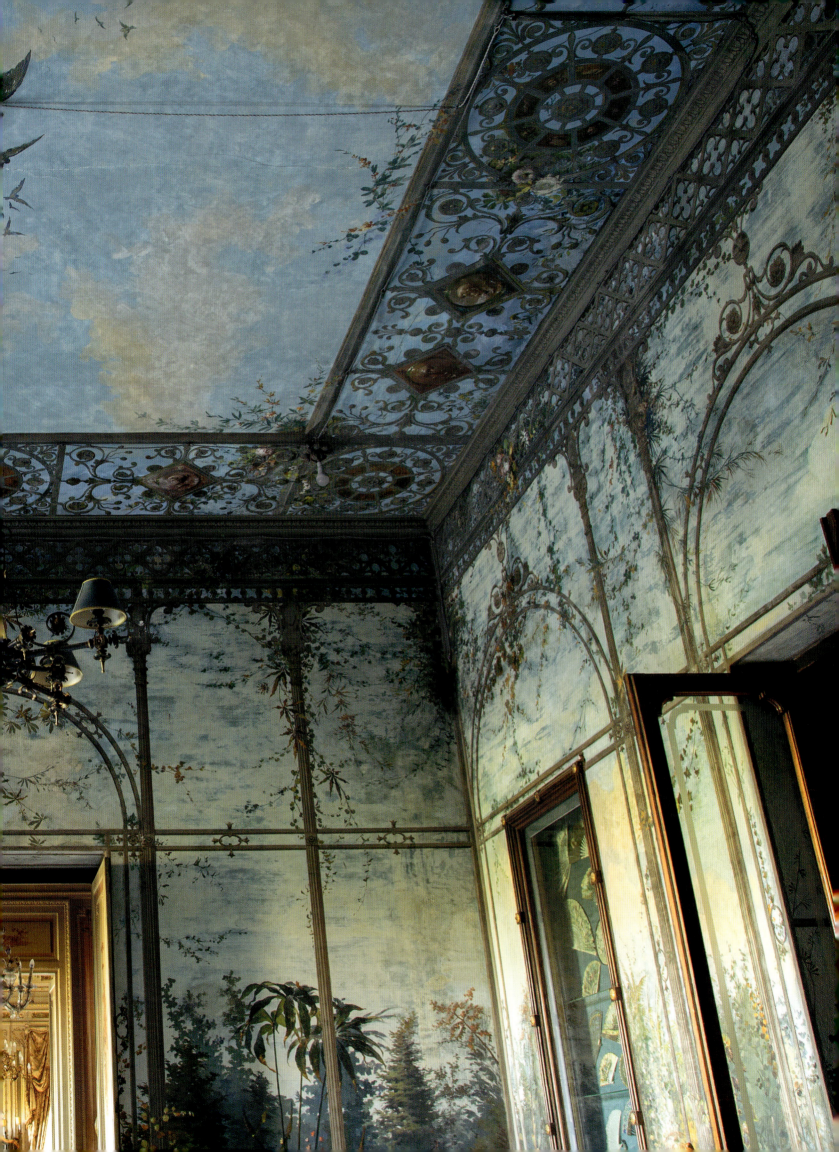

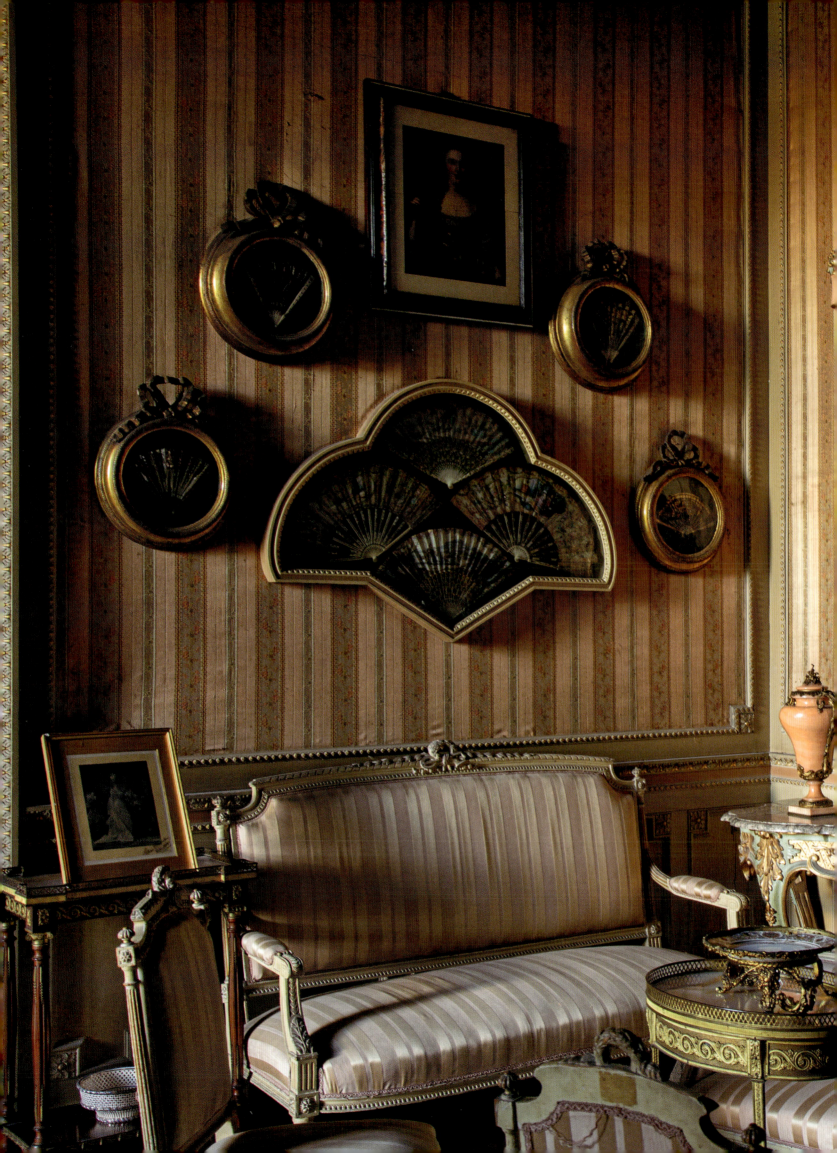

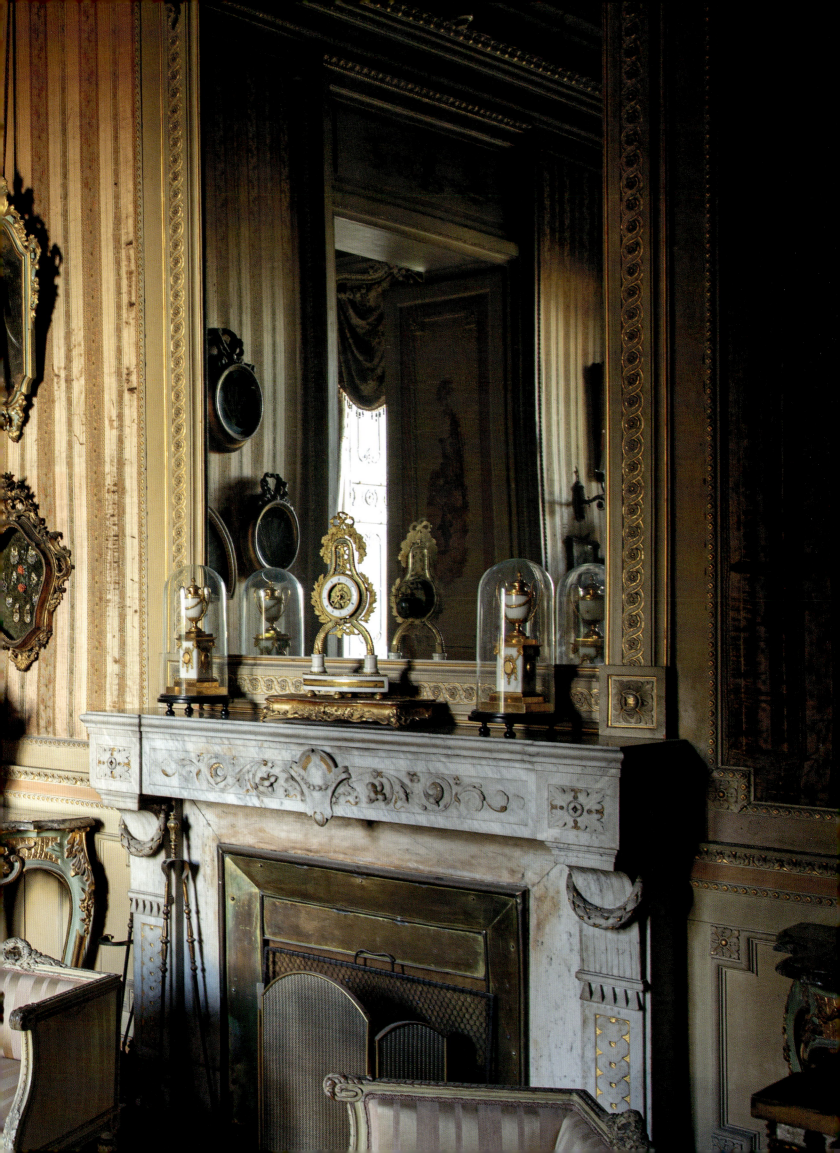

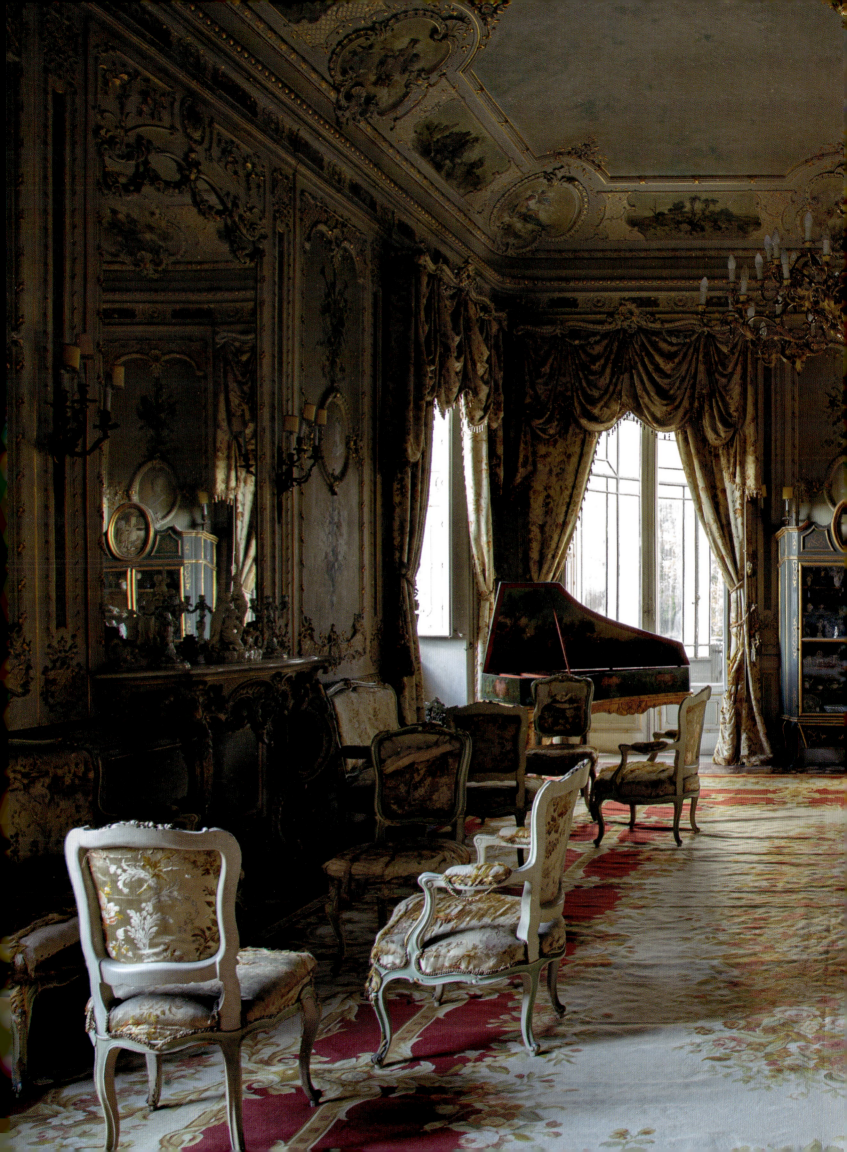

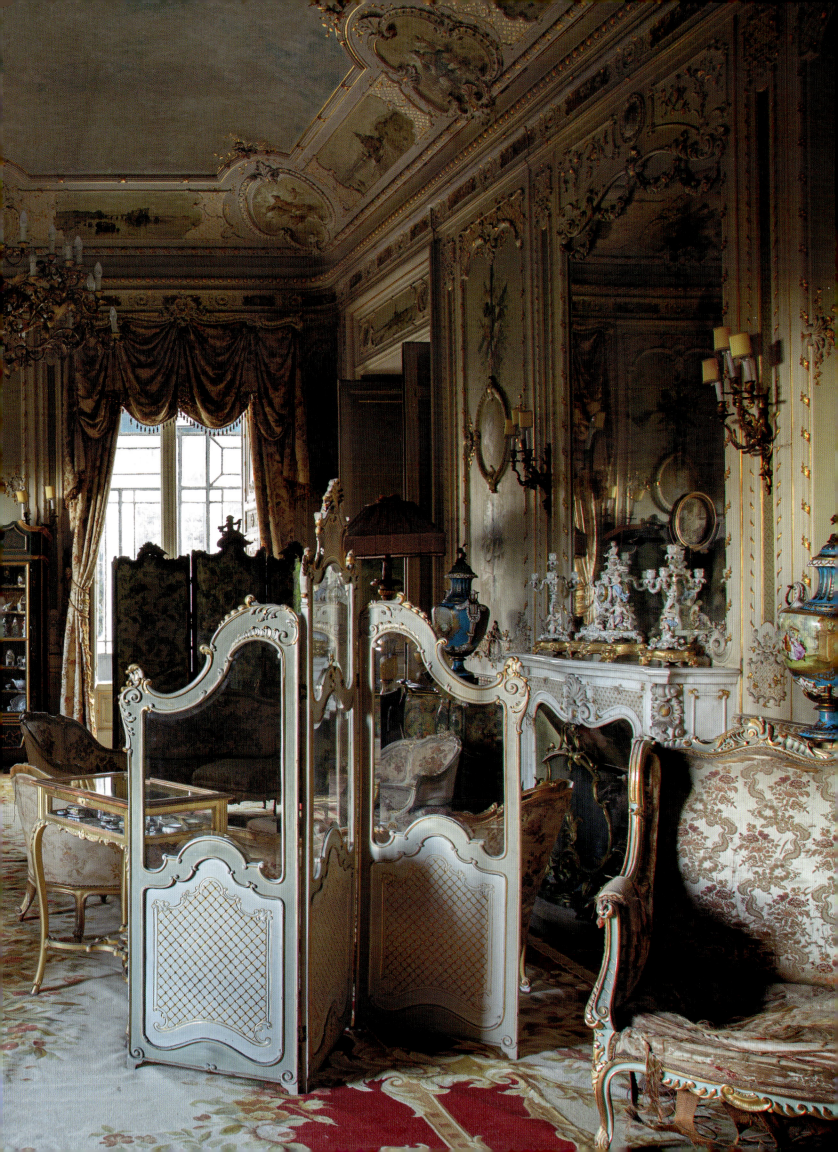

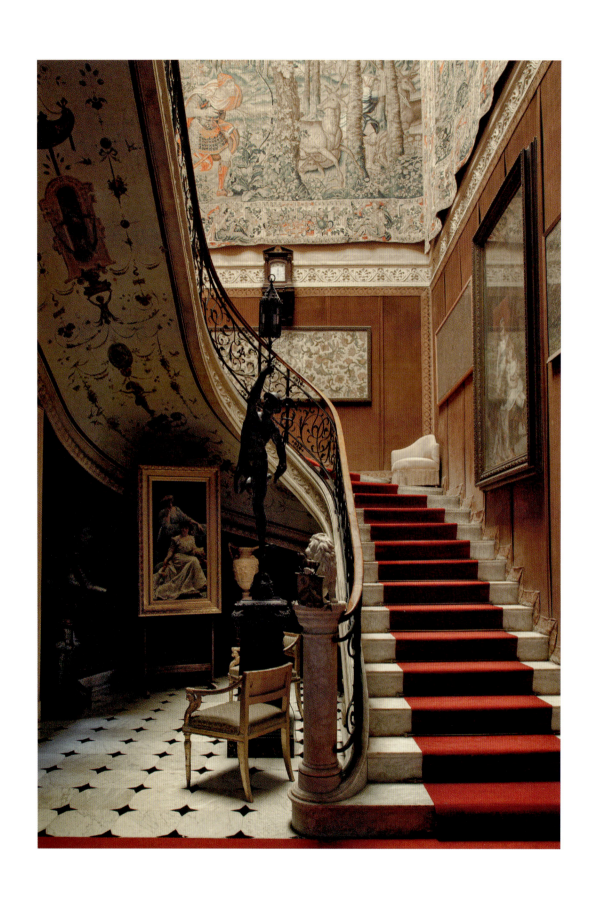

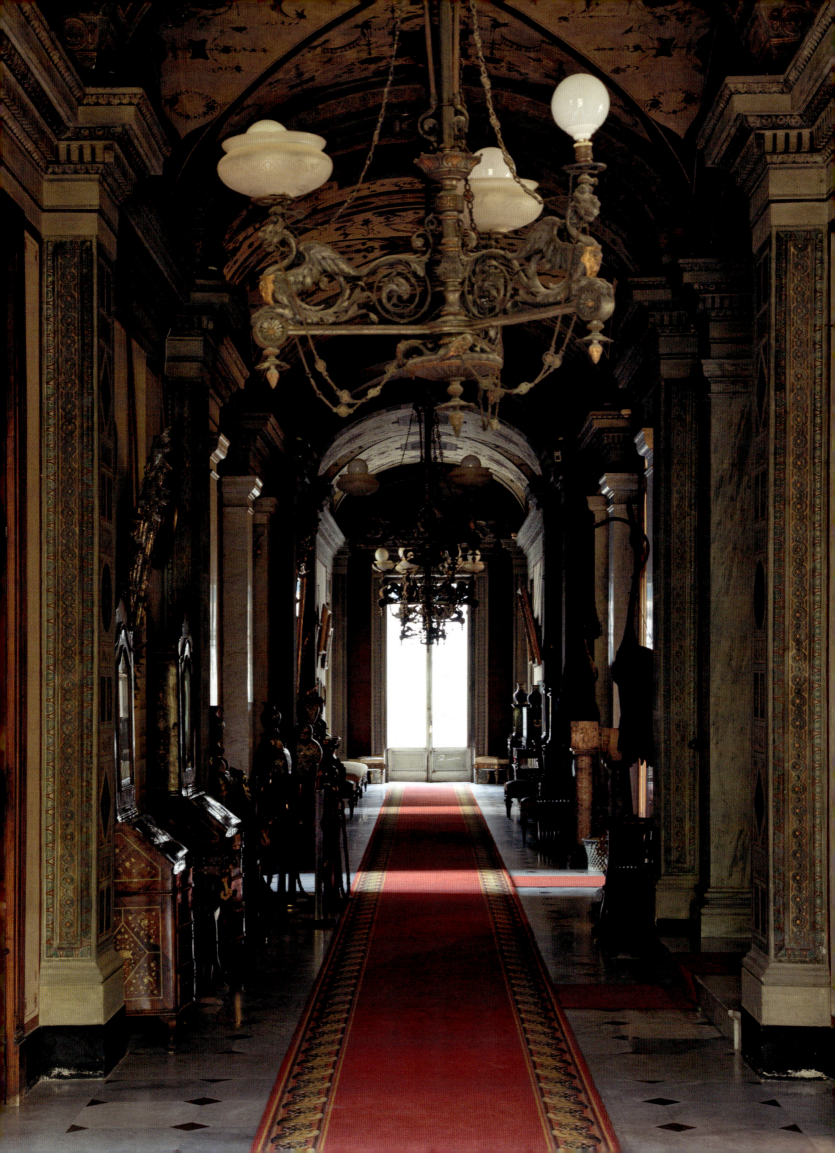

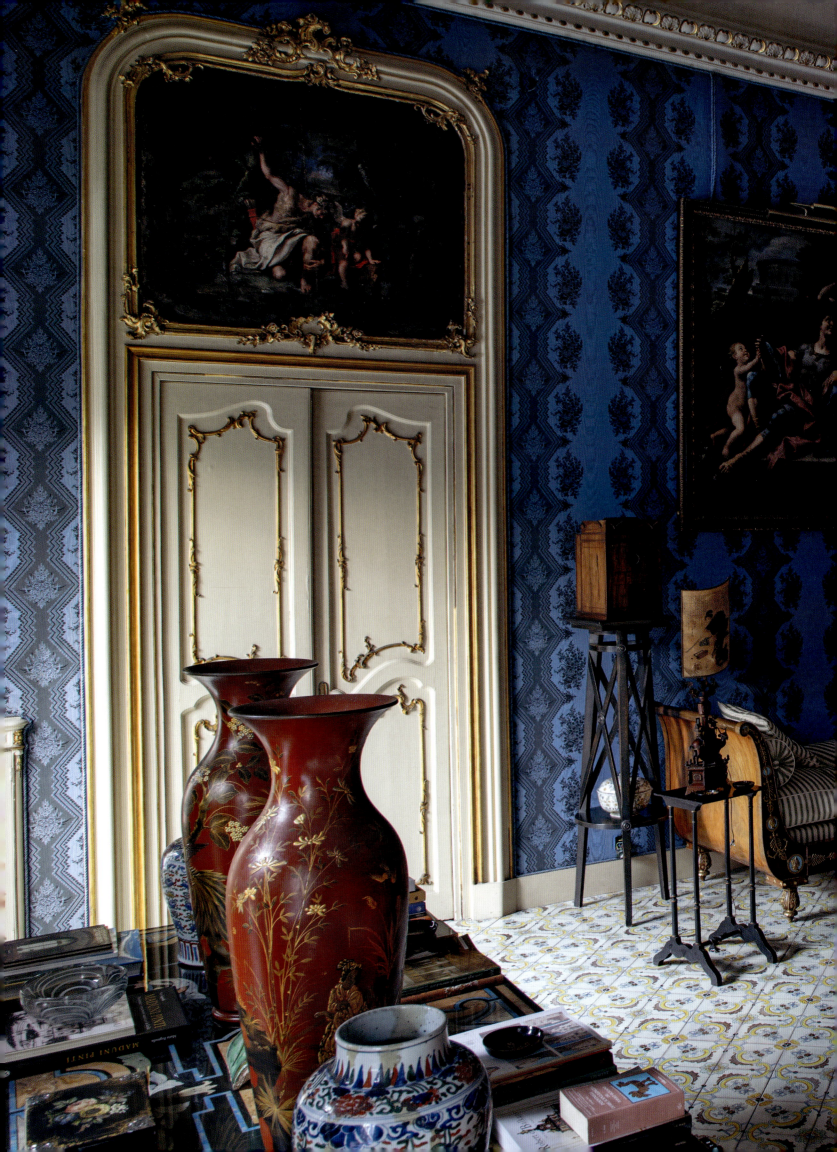

Villa Chiaramonte Bordonaro is nestled in the elegant Libertà district of Palermo. While another branch of its resident family lives in Villa Bordonaro ai Colli in La Favorita (page 83), this home is firmly situated in a later phase of the city's expansion. The Libertà neighborhood developed in the late nineteenth century following the creation of Viale della Libertà, a grand avenue envisioned to connect the historic center with the aristocratic summer residences in the Piana dei Colli (Plain of the Hills). This new district, planned on a rational grid system, quickly became a symbol of Palermo's elite; the composer Richard Wagner (1813–1883) even dubbed it the new Champs-Élysées.

The villa was constructed amid this refined urban fabric between 1893 and 1896, making it one of the earliest significant works of the architect Ernesto Basile (1857–1932). It showcases a synthesis of stylistic influences typical of the era, incorporating Moorish details alongside Rococo elements, foreshadowing Basile's later contributions to the Liberty (Art Nouveau) movement. Commissioned by Baron Gabriele Chiaramonte Bordonaro, a senator of the kingdom, it was conceived as an opulent private retreat.

Although the urban landscape of the neighborhood has transformed over time, and many historic villas have been lost to mid-twentieth-century speculative development, this house is a rare survivor, still owned and lived in by the Bordonaro family. The interiors reflect generations of collecting: rooms filled with antiques, gilded stucco moldings, Murano chandeliers, and damask wall coverings. Every corner of the villa tells a story through furnishings and decorative objects that have been curated over the years.

The responsibility of maintaining this legacy is gradually passing to Andrea Bordonaro, who is preparing to take the helm of the family estate. Beyond this villa, his role extends to overseeing the historic seaside fortress of Castello di Falconara (page 105) and Abbazia Santa Maria del Bosco, a monastic complex on the edge of the Monte Genuardo e Santa Maria del Bosco nature reserve, above Sciacca on Sicily's southern coast. As an architect himself, he is deeply involved in the ongoing maintenance and restoration of these important properties.

While many of Palermo's grand residences have been repurposed or abandoned, Villa Chiaramonte Bordonaro endures as a home. Its continued occupation by the family that commissioned it lends an authenticity that is rare in the modern cityscape. More than a showcase of architectural grandeur, it remains a dynamic part of Palermo's aristocratic history, a bridge between past and present, where tradition is not merely remembered but actively lived.

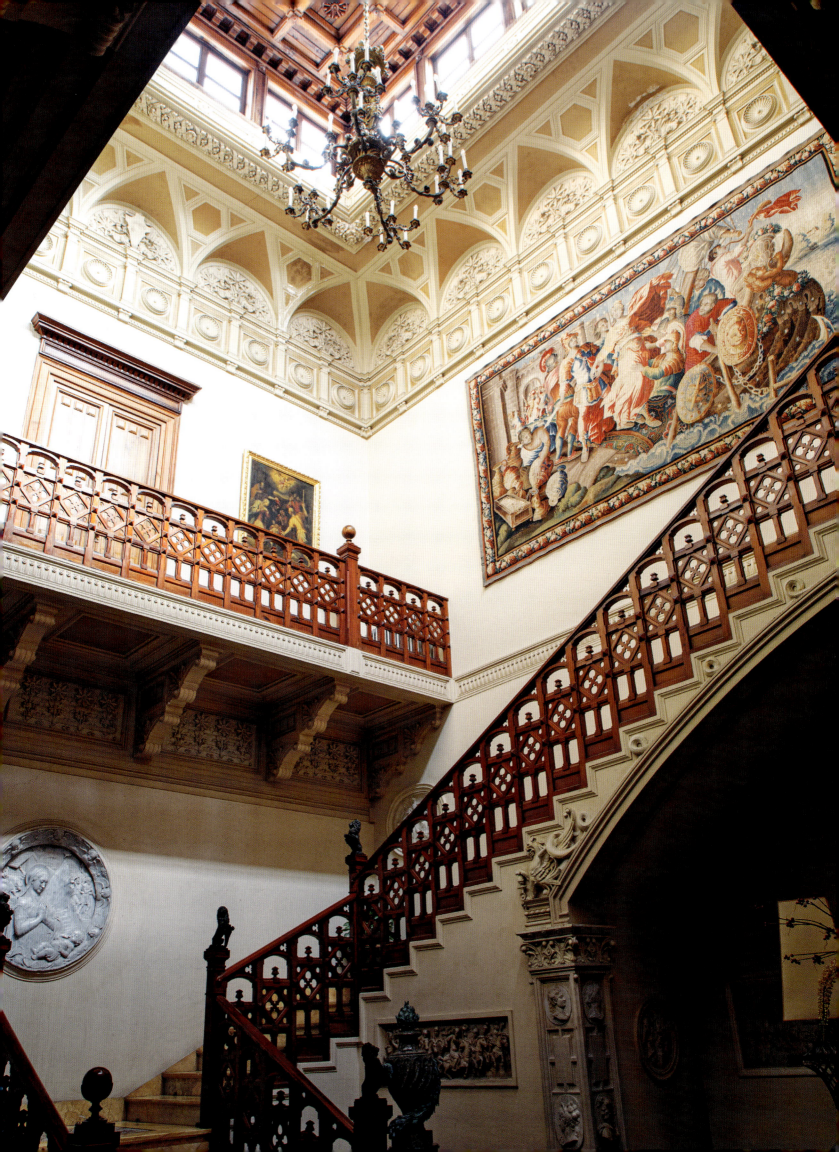

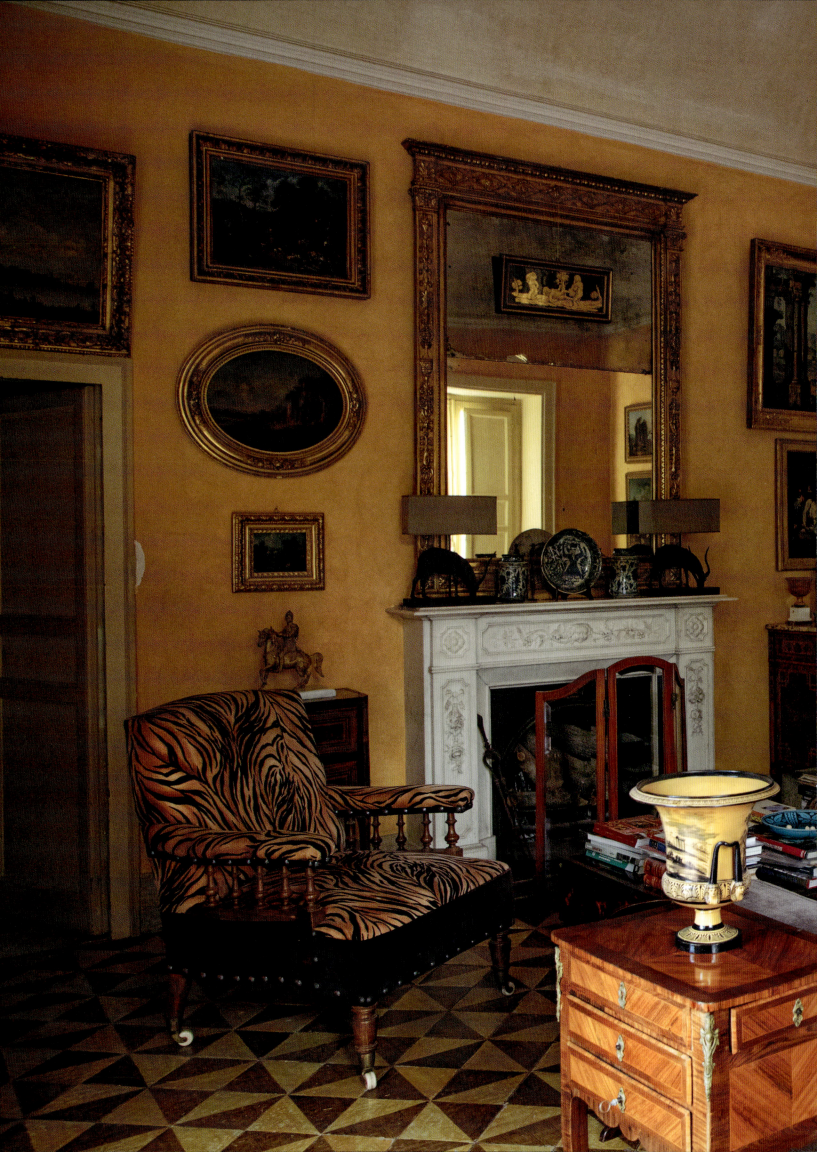

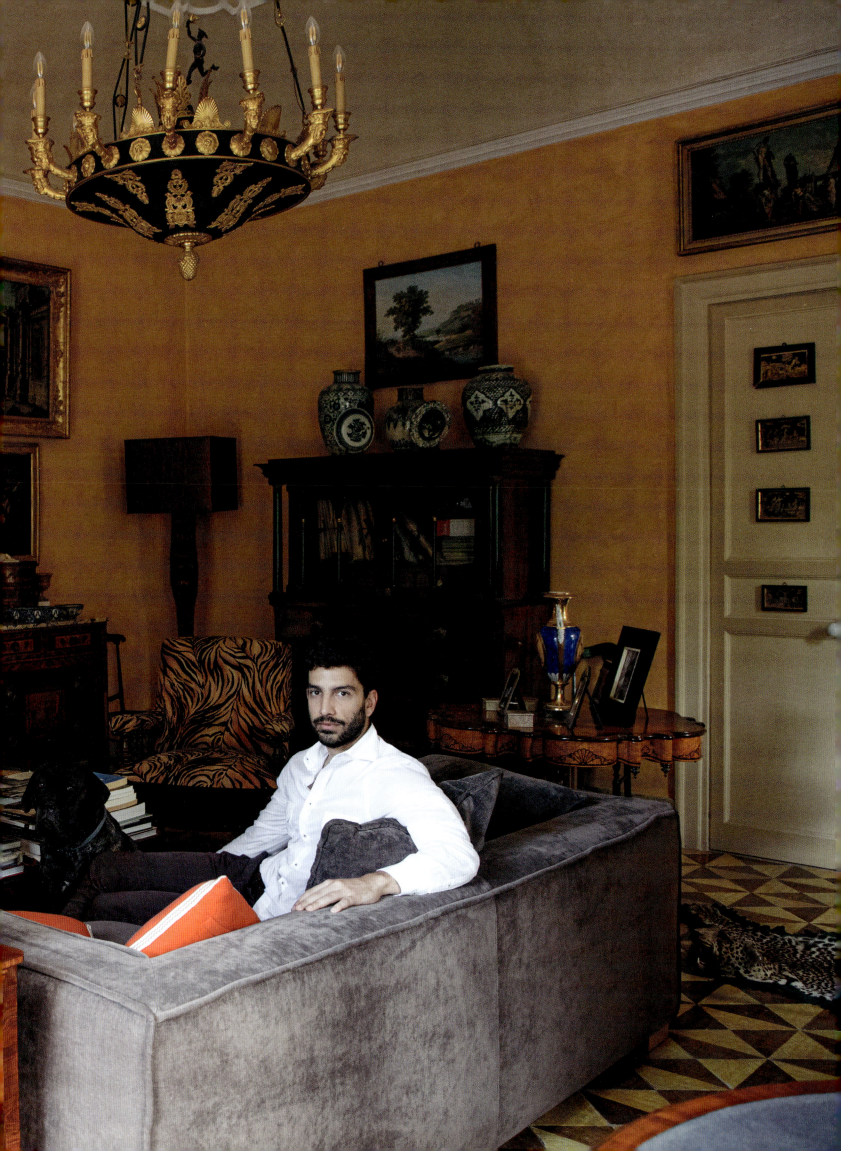

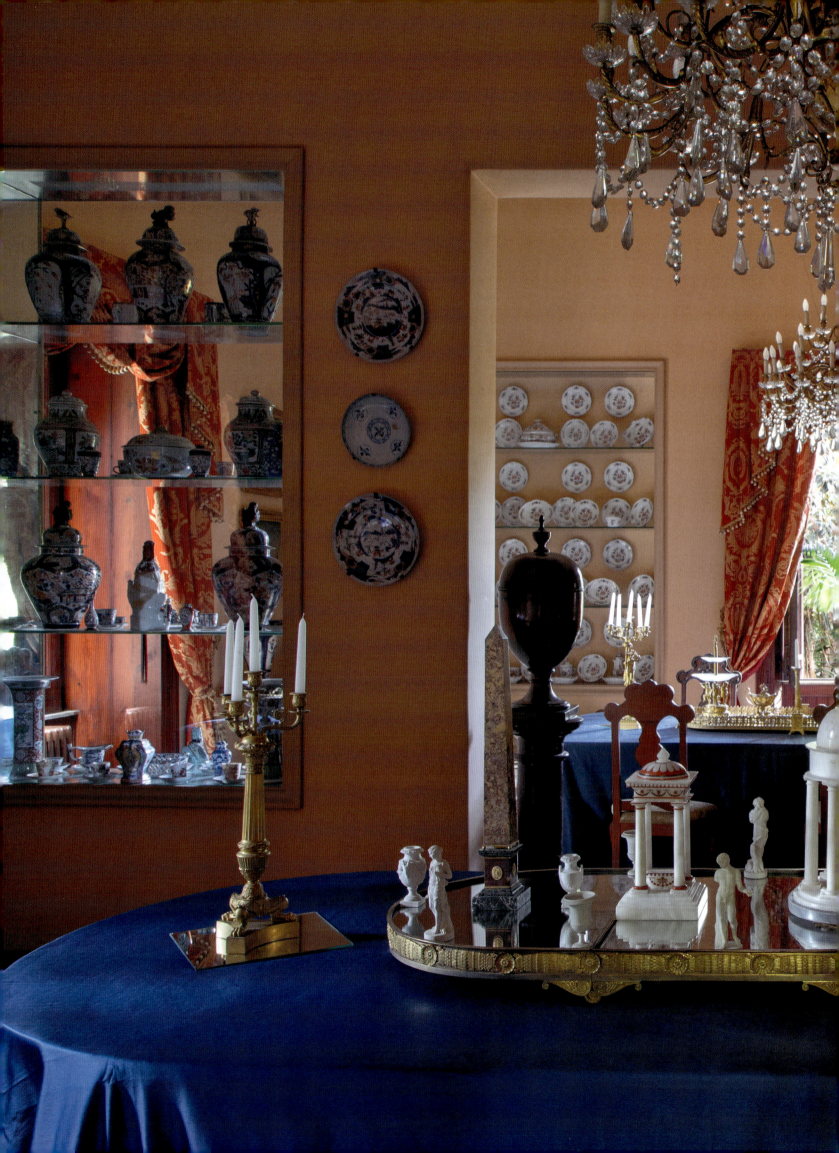

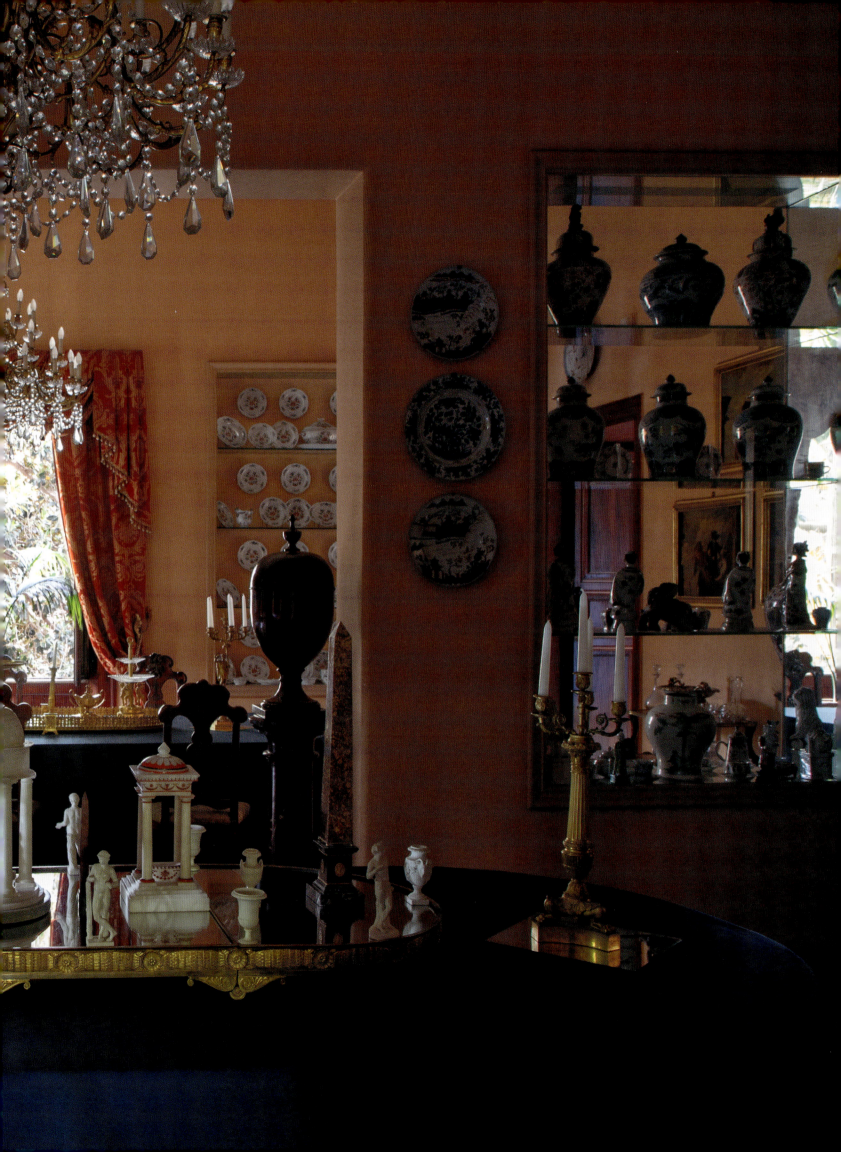

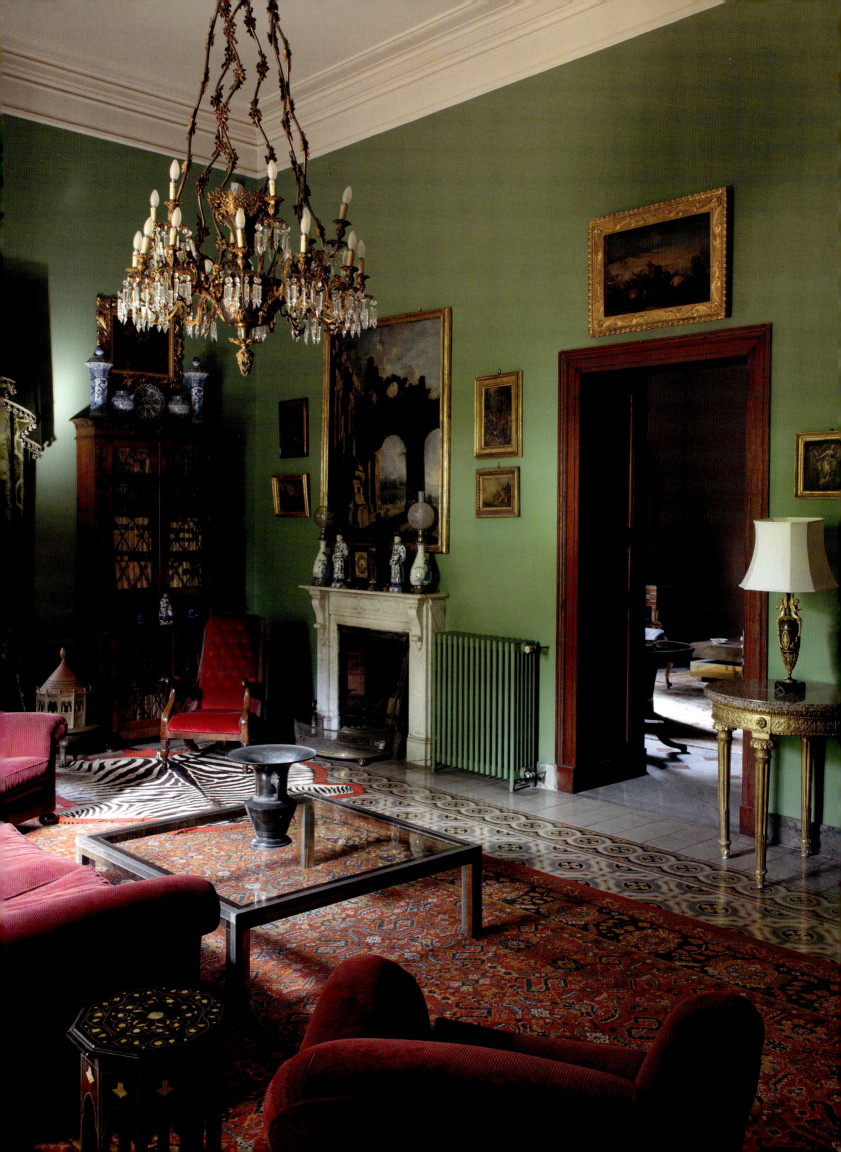

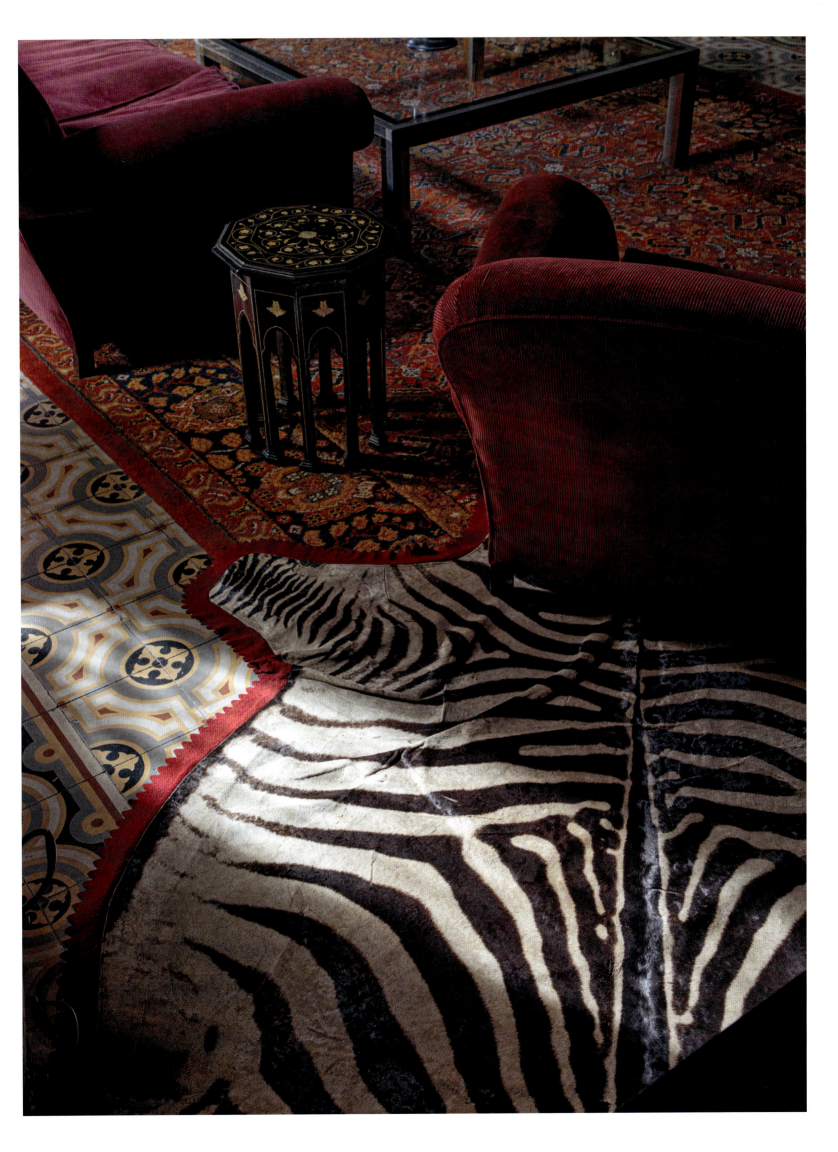

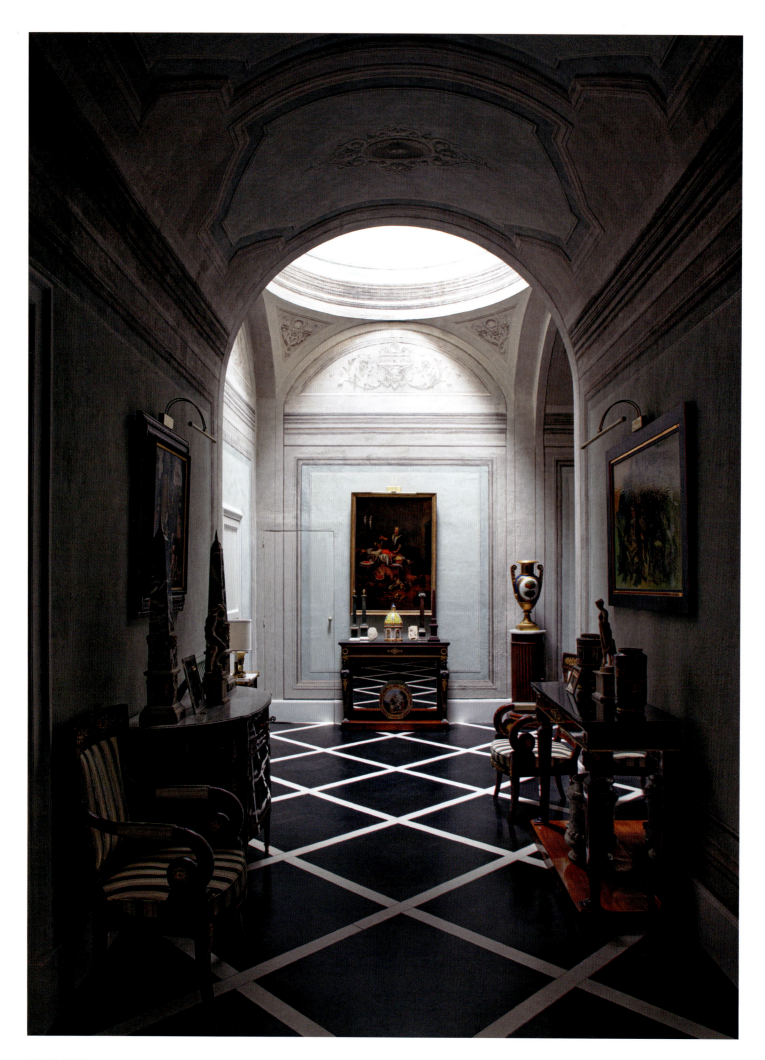

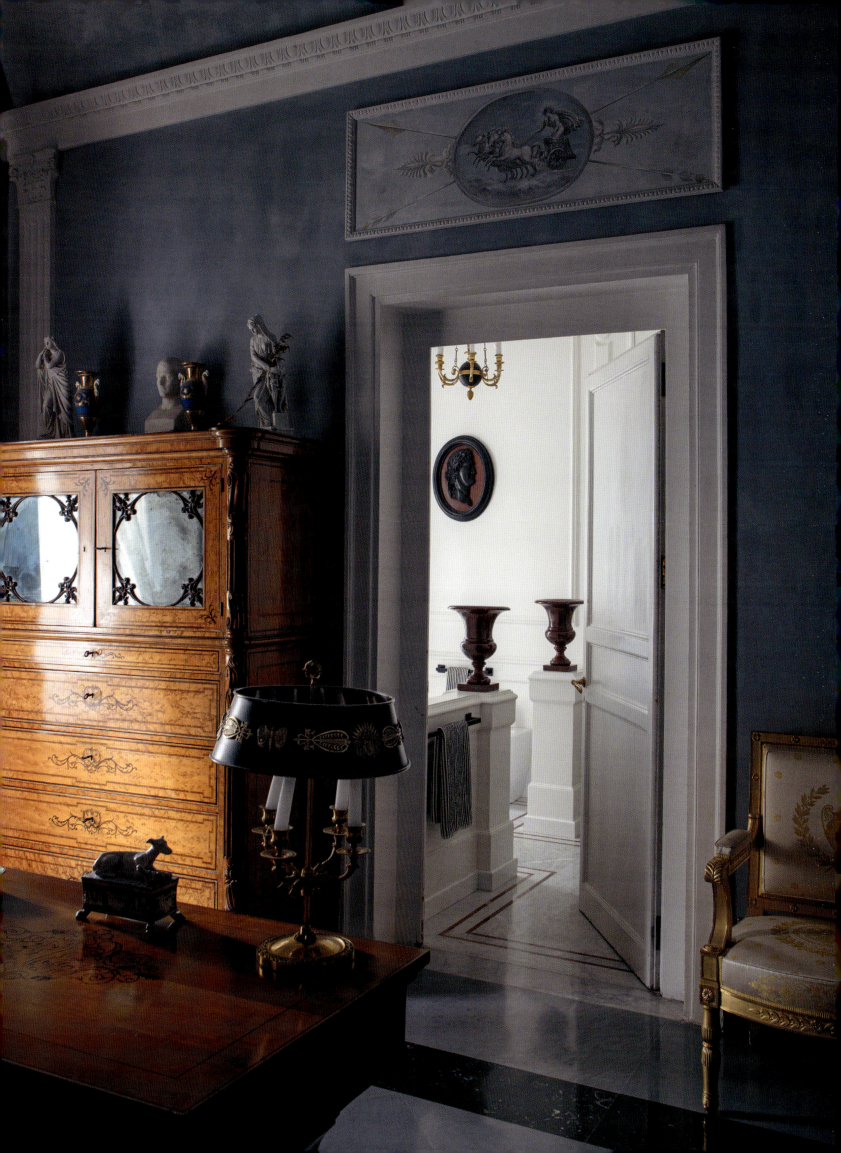

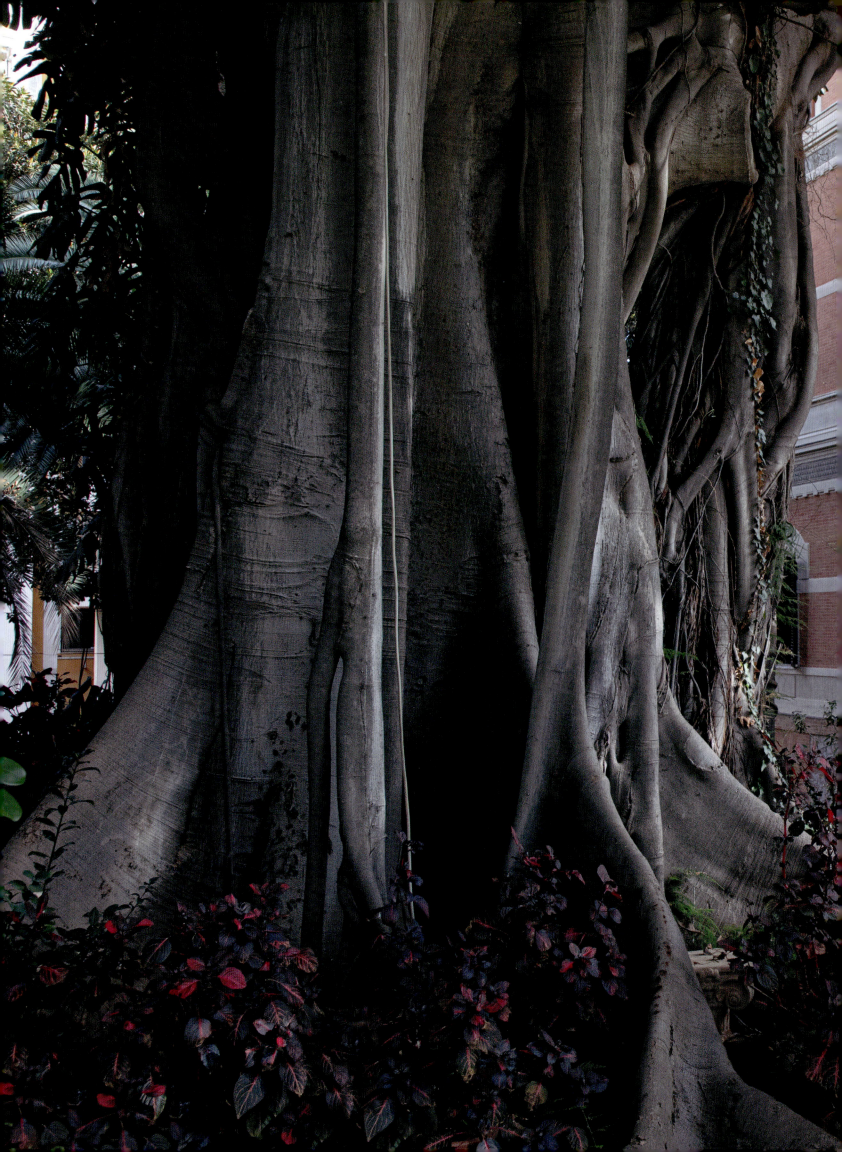

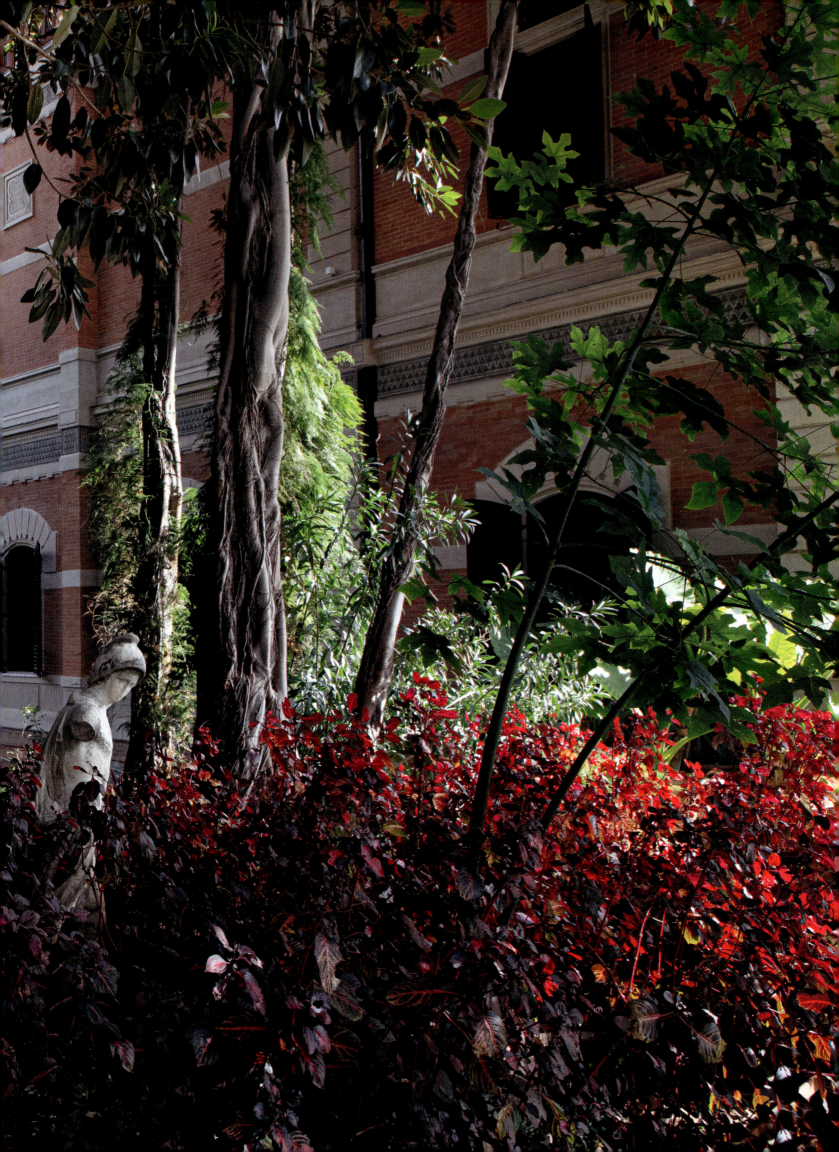

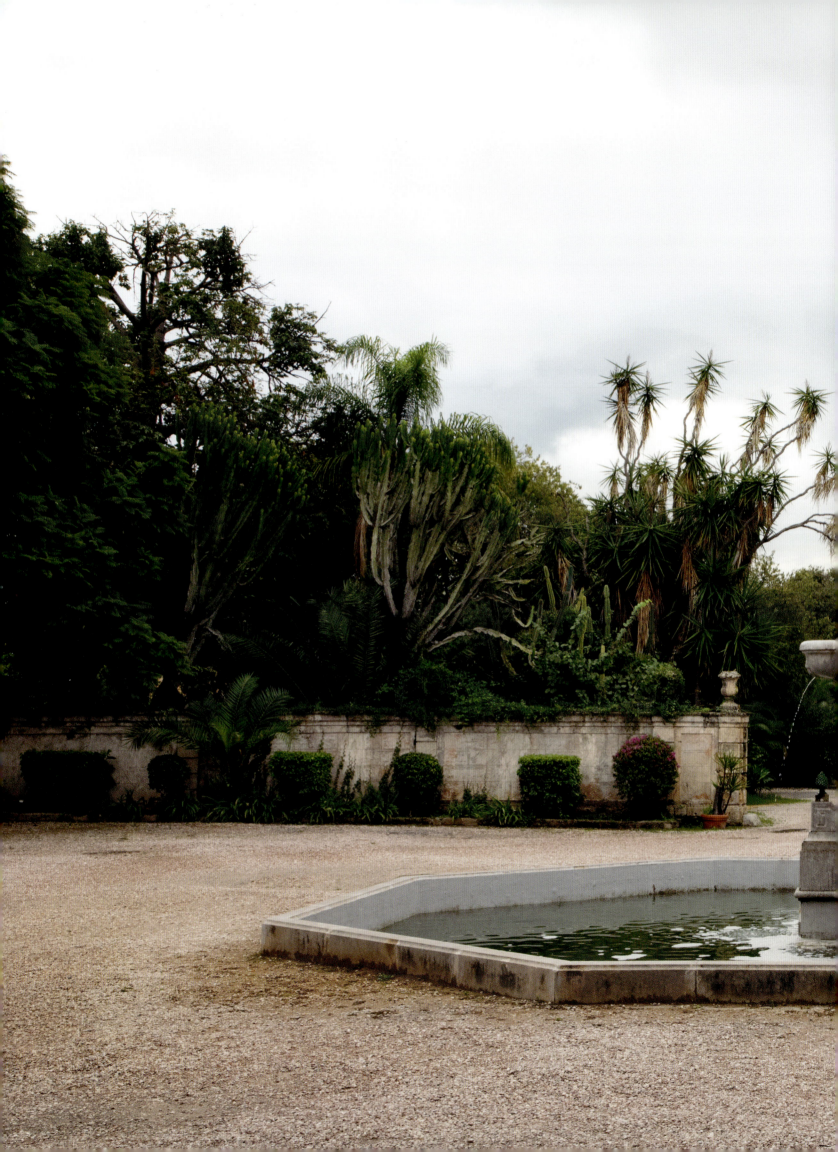

Unlike the Neapolitan or Ligurian coasts, where roads and villages are stitched into cliffsides and teeter above the sea, Palermo is planted in the so-called golden basin, or Conca d'Oro, with its back to the port. Throughout the city, it is the surrounding mountains that dominate the landscape, visible from every angle, while glimpses of the Tyrrhenian Sea are fleeting. Cutting through the circuitous alleys and elongated squares of the old city is Via Maqueda, also known as the Strada Nuova, which bisects Palermo, turns into the Via della Libertà, and empties into La Favorita—Palermo's largest green space and the setting for the city's most romantic villas.

The area, known as *ai Colli* (in the hills), was prized by the city's aristocracy for its cooler air, a welcome retreat from the oppressive summer heat of Palermo. It was here, in the shadow of Monte Pellegrino and just an hour's walk from the center, that the Spanish kings had their game reserve. Built in the eighteenth century as a hunting lodge, Villa Bordonaro ai Colli is one of the few remaining villas in La Favorita that is still occupied by the family that commissioned it. In 1799, when King Ferdinand III of Bourbon and his wife, Queen Carolina, were exiled from Naples, the family hosted them at the villa, along with Admiral Nelson. Subsequently, the royal family took up residence at the nearby Palazzina Cinese, the park of which is thought to be named after the king's mistress—*la sua favorita* (his favorite).

The villa's original structure consists of a central building flanked by two lower wings that enclose a grand courtyard with an octagonal fountain in the middle. The *piano nobile* is reached by an internal staircase adorned with marble statues, leading to the grand salons with frescoed ceilings and polychrome ceramic floors. The rooms are lined with fourteenth- and fifteenth-century Italian paintings, Flemish works from the seventeenth century, and a remarkable collection of maiolica, Greek amphorae, and taxidermic birds. Many of these pieces were acquired by the family directly from museums in the nineteenth century, and today this is one of the most significant private collections in southern Italy.

Having fallen into disuse, the villa was restored in the 1940s by the senator, racing driver, and playboy Baron Luigi Chiaramonte Bordonaro and used as a country estate. (The family's Palermo residence, Villa Chiaramonte Bordonaro, is on page 69.) The charismatic baron, known as "the last *Gattopardo*" (leopard), decorated the enfilade of spaces beautifully with rich damasks and strong, jewel-toned colors.

Today, the baron's granddaughter Gaia Palma Chiaramonte Bordonaro lives in the main section of the house with her husband and daughter, while her brother Luigi lives in the adjacent wing with his wife. In their downstairs living room, the parties spill out into the garden, where meals are still prepared in the original kitchen using the massive stove and bread oven. More than simply preserving the family's extraordinary collection of art and design, Gaia continues the warm tradition of entertaining and opening the villa's doors in the same generous spirit in which it was intended.

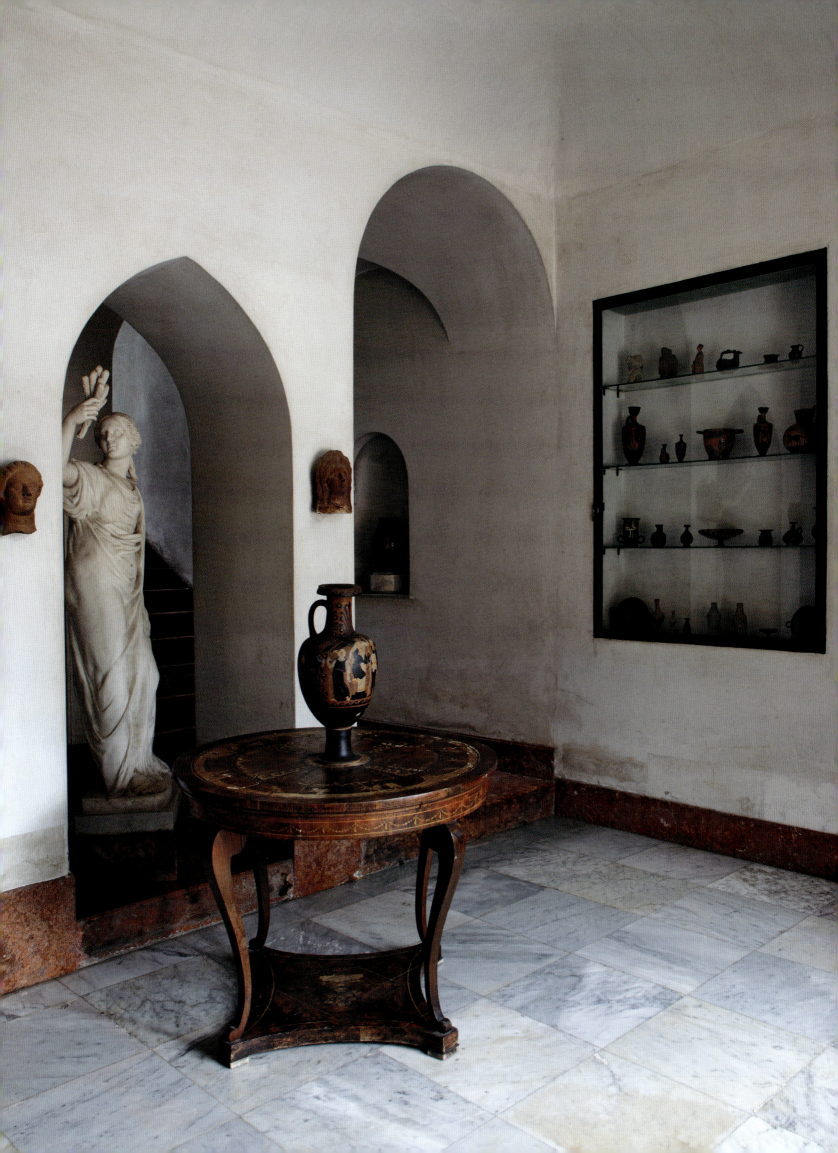

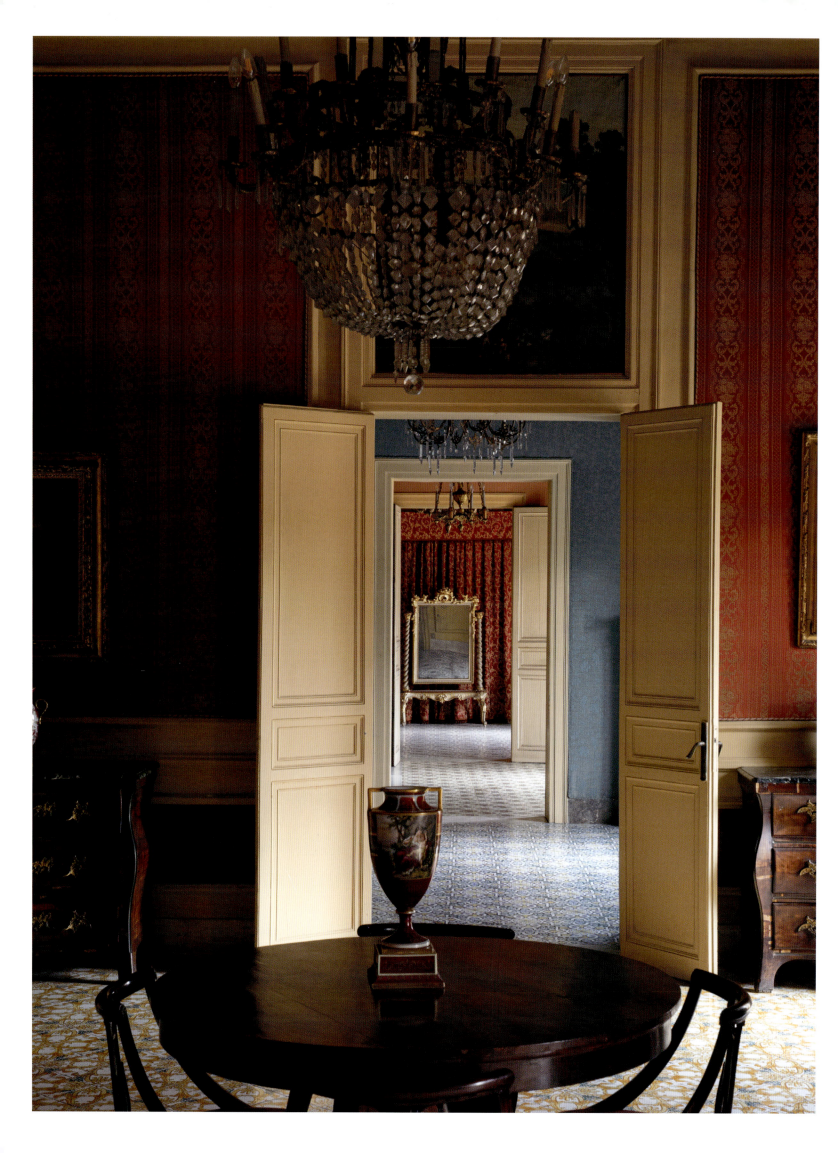

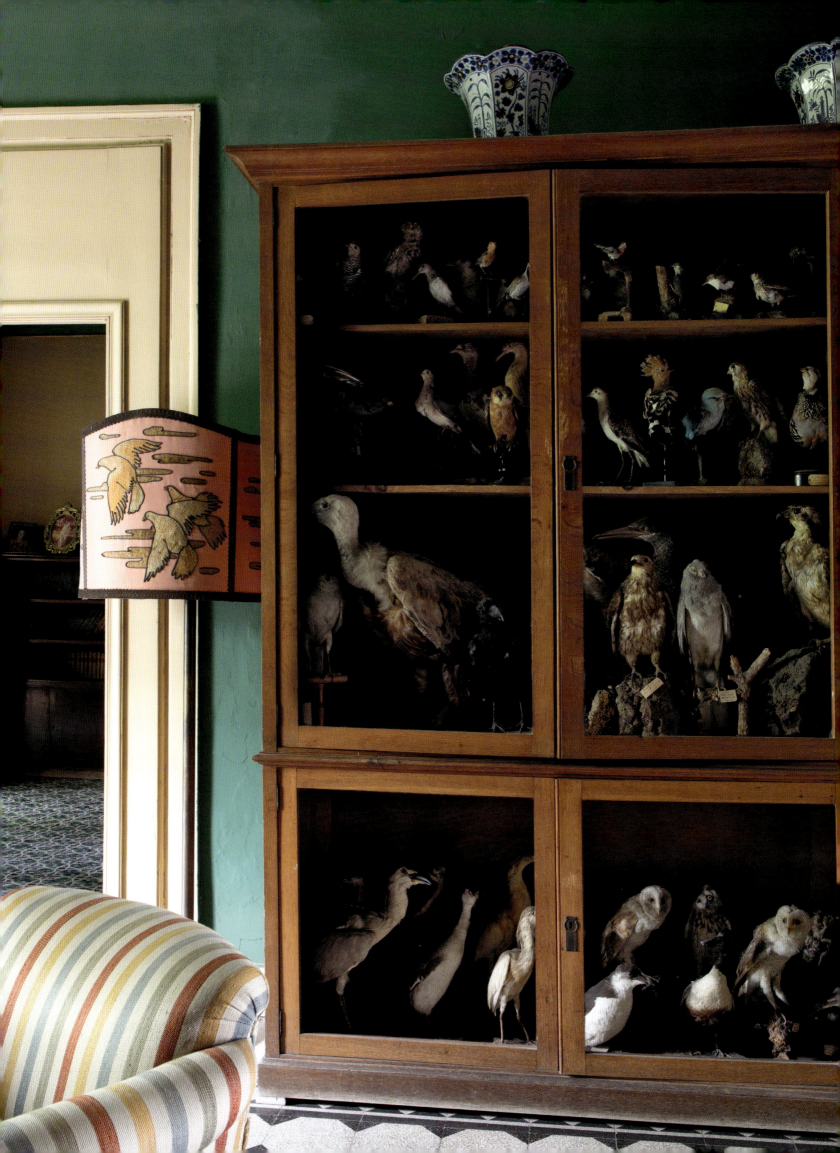

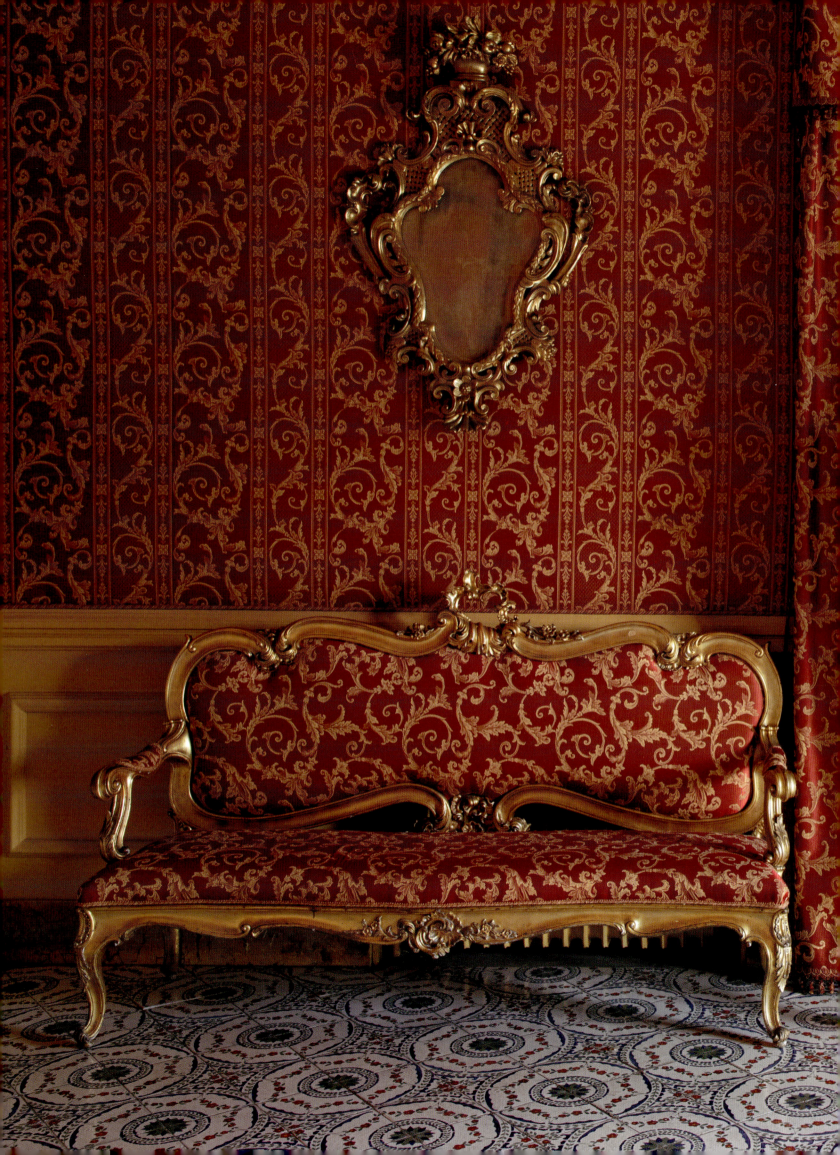

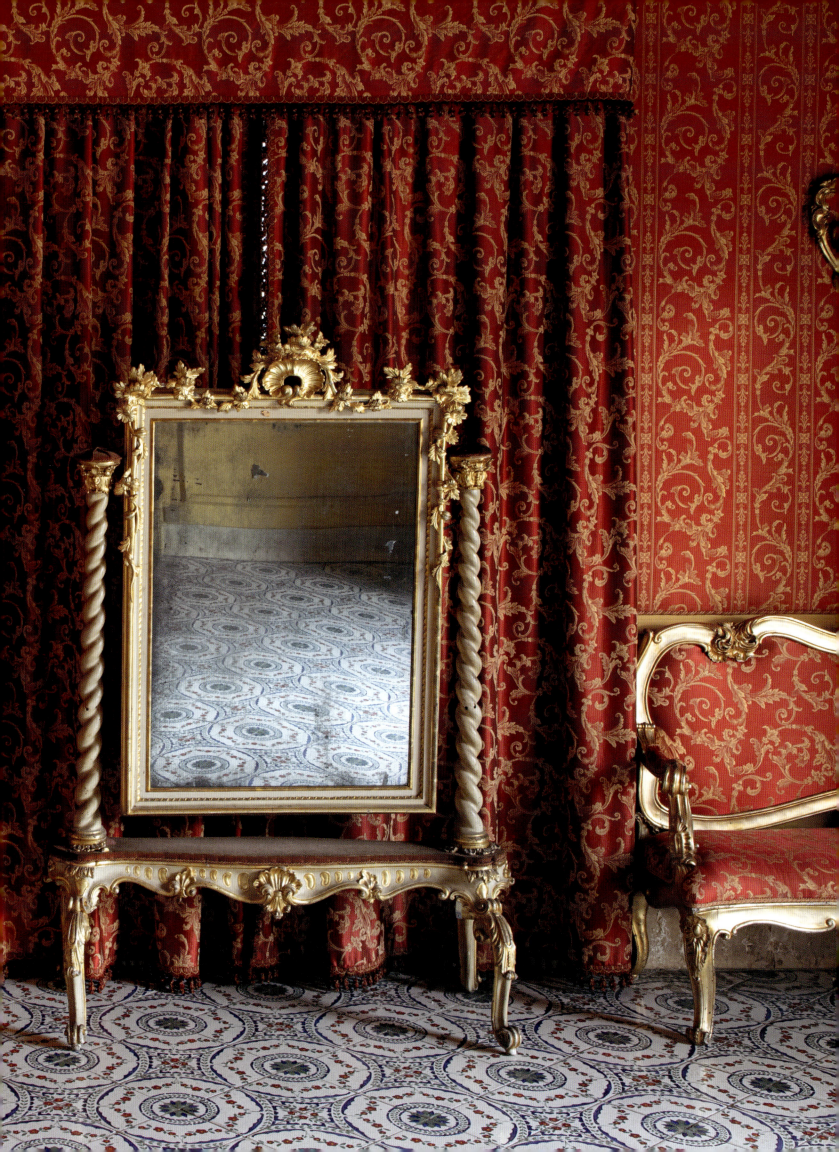

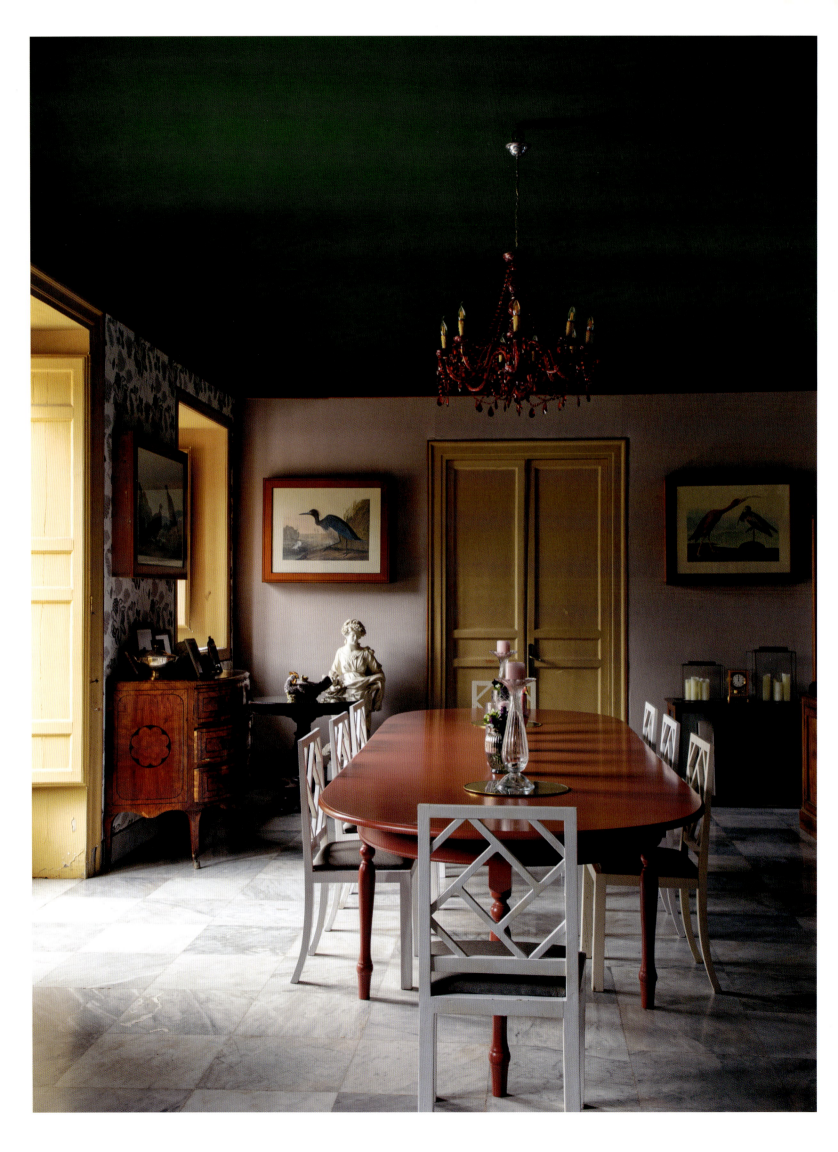

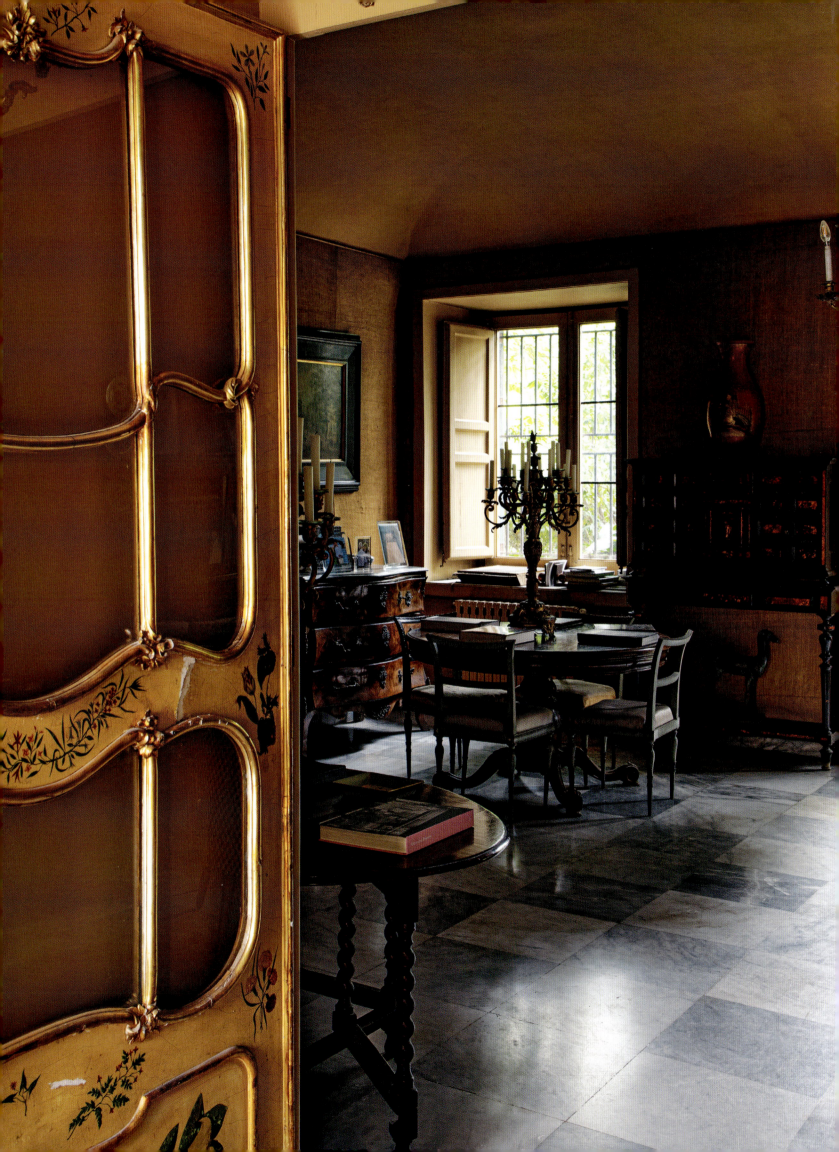

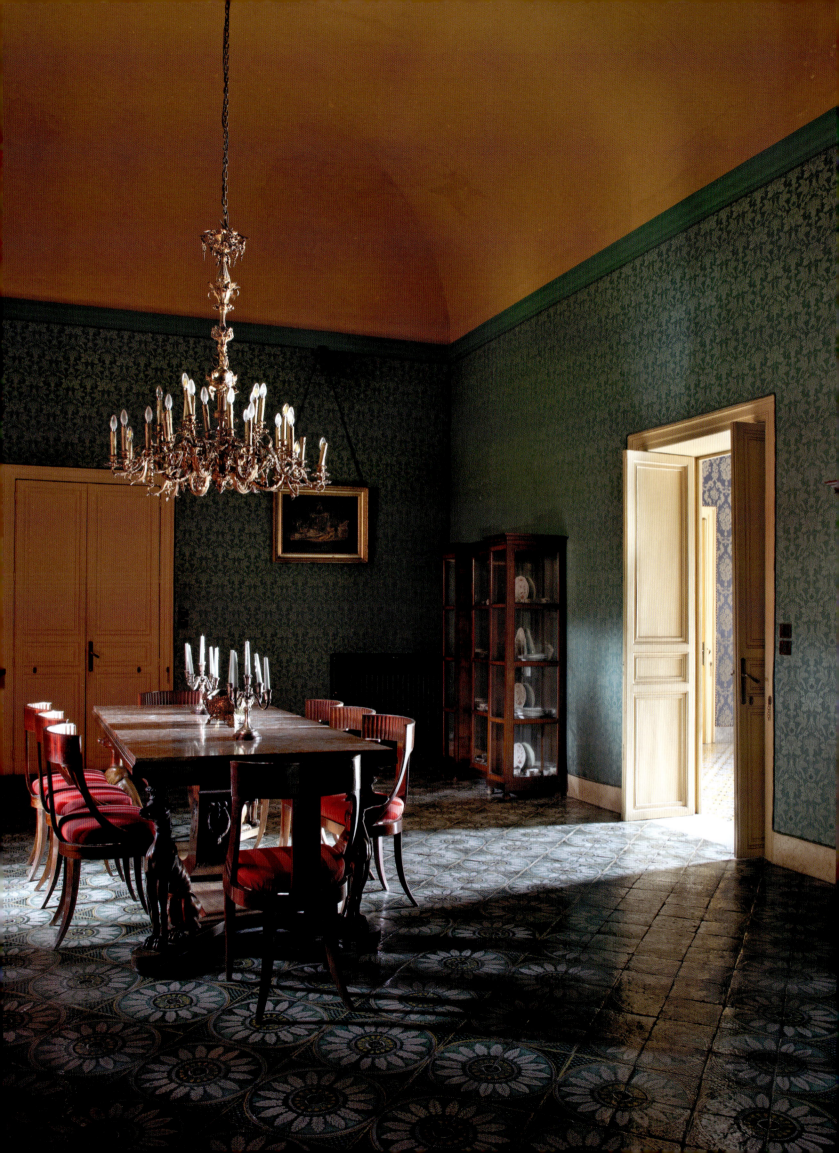

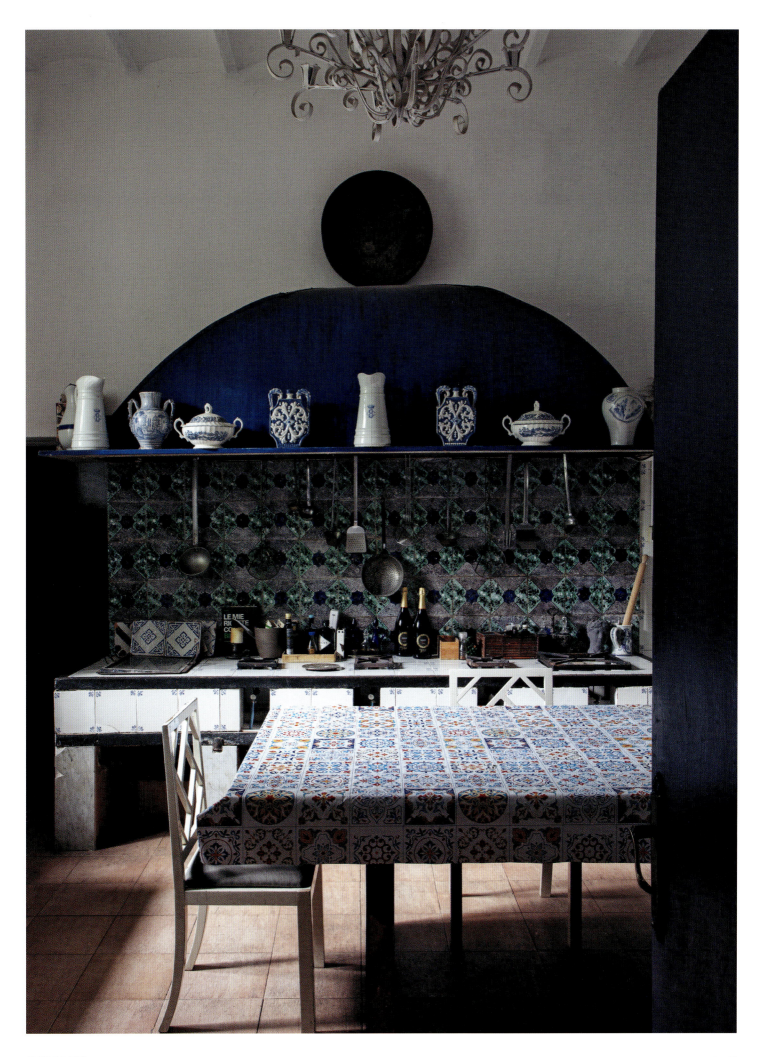

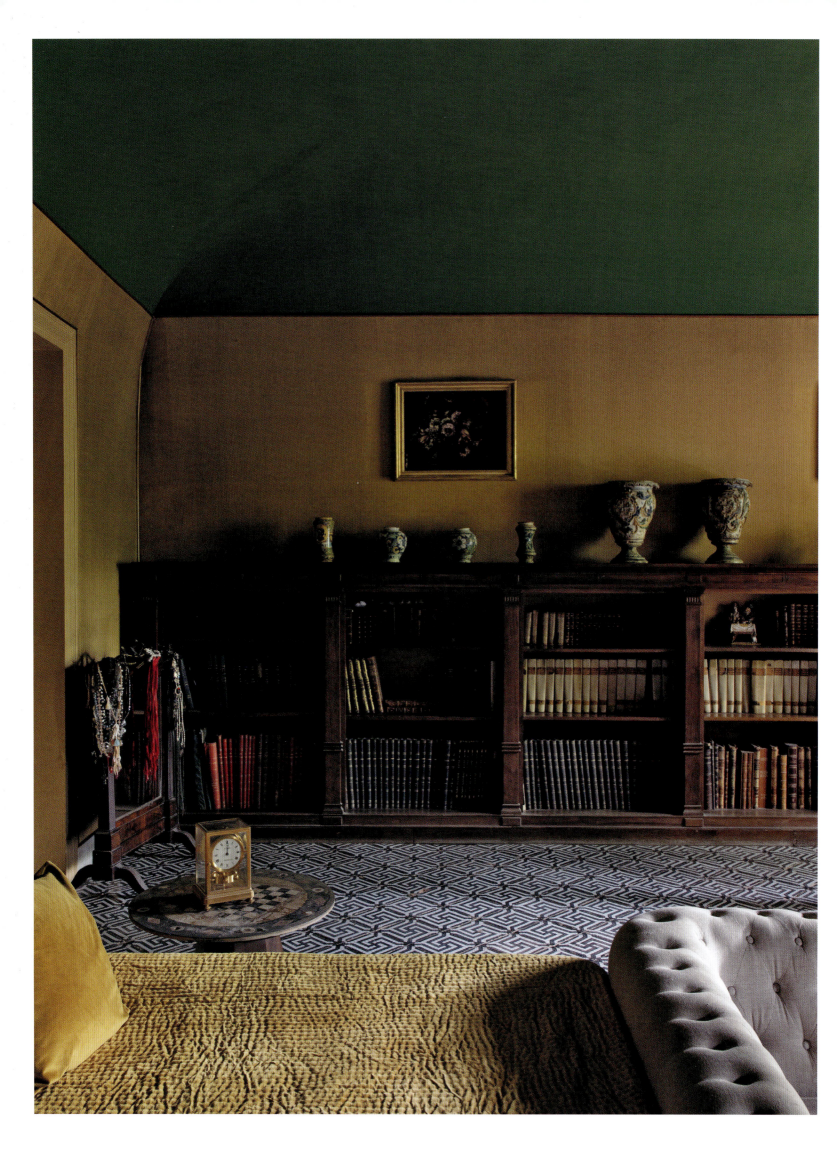

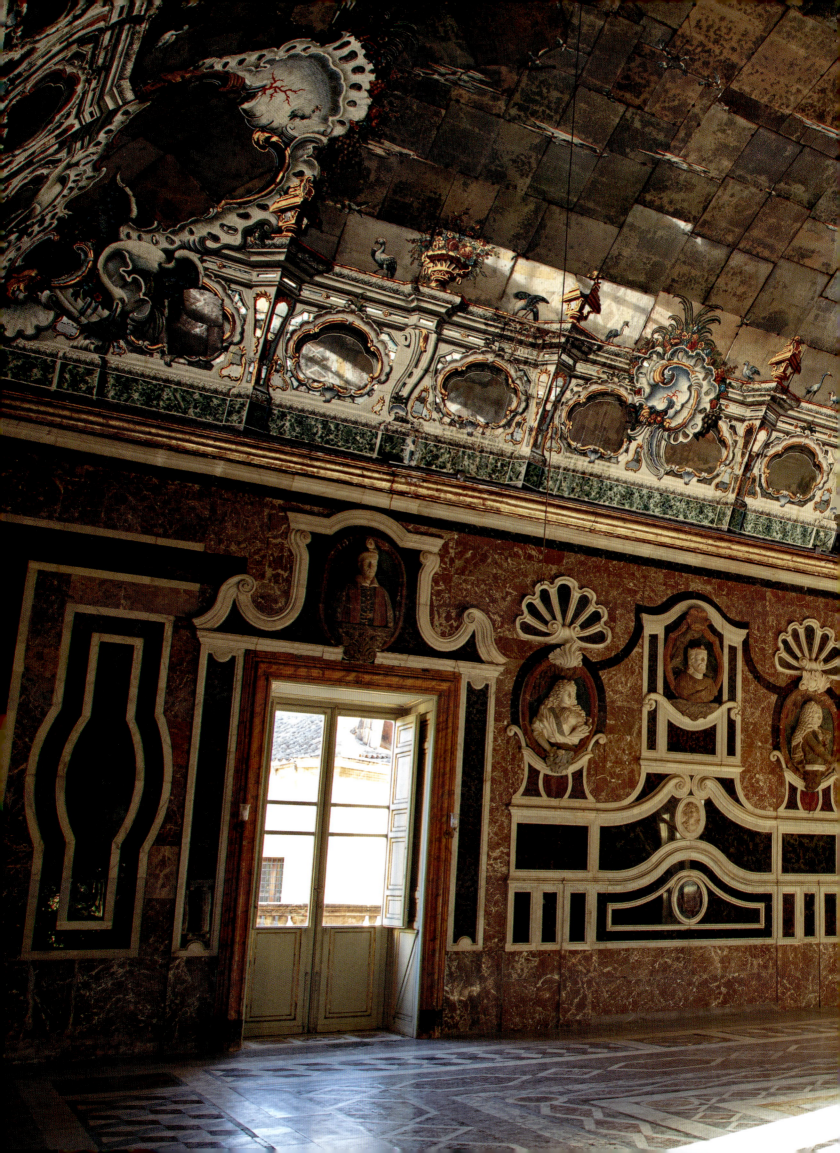

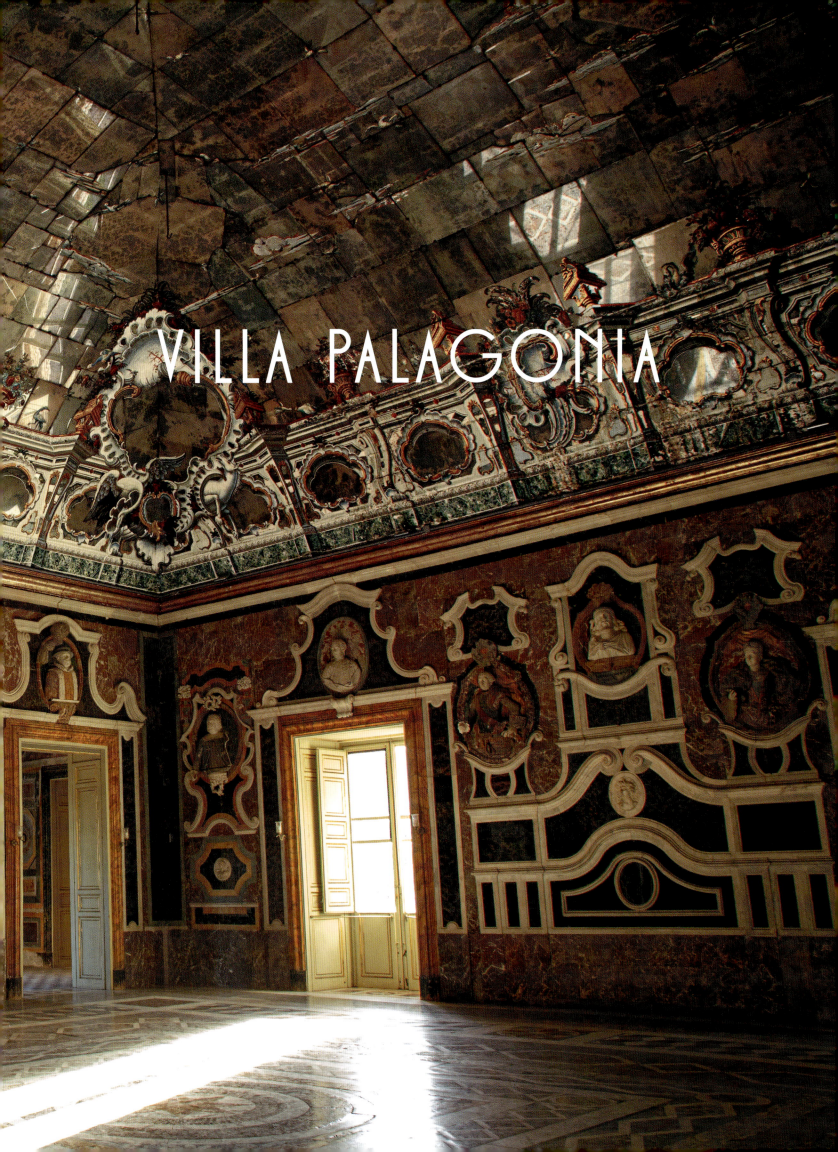

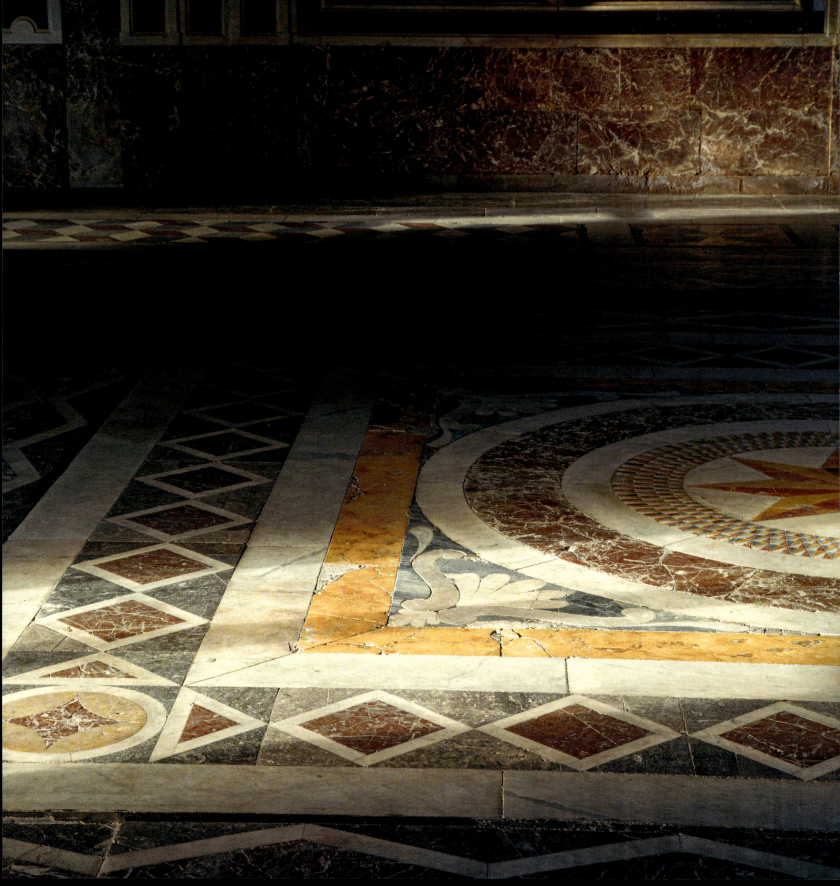

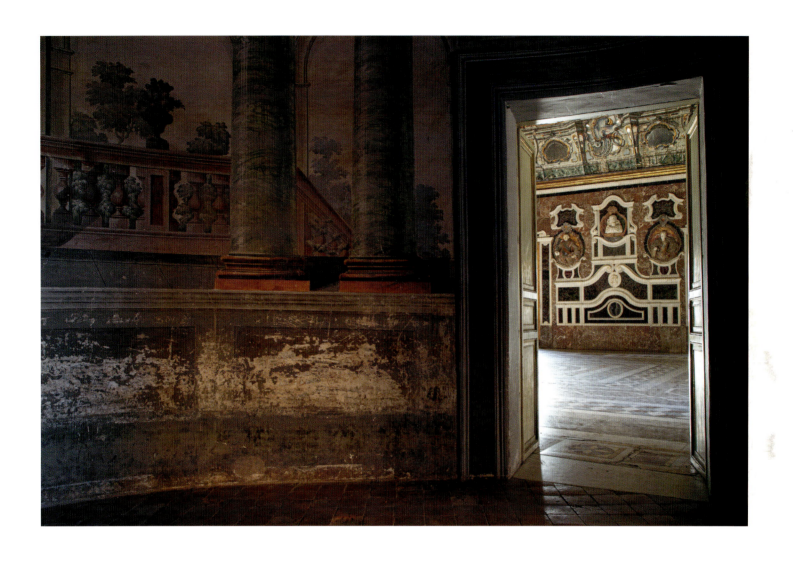

Villa Palagonia is in Bagheria, a small city east of Palermo known for its many aristocratic villas. Built in 1715 for Don Ferdinando Gravina, Prince of Palagonia, it became famous for its surreal atmosphere. Perched atop an exterior wall is a series of grotesque stone statues—from the monstrous to mythical and bizarre caricatures—earning it the nickname "Villa dei Mostri" (Villa of Monsters).

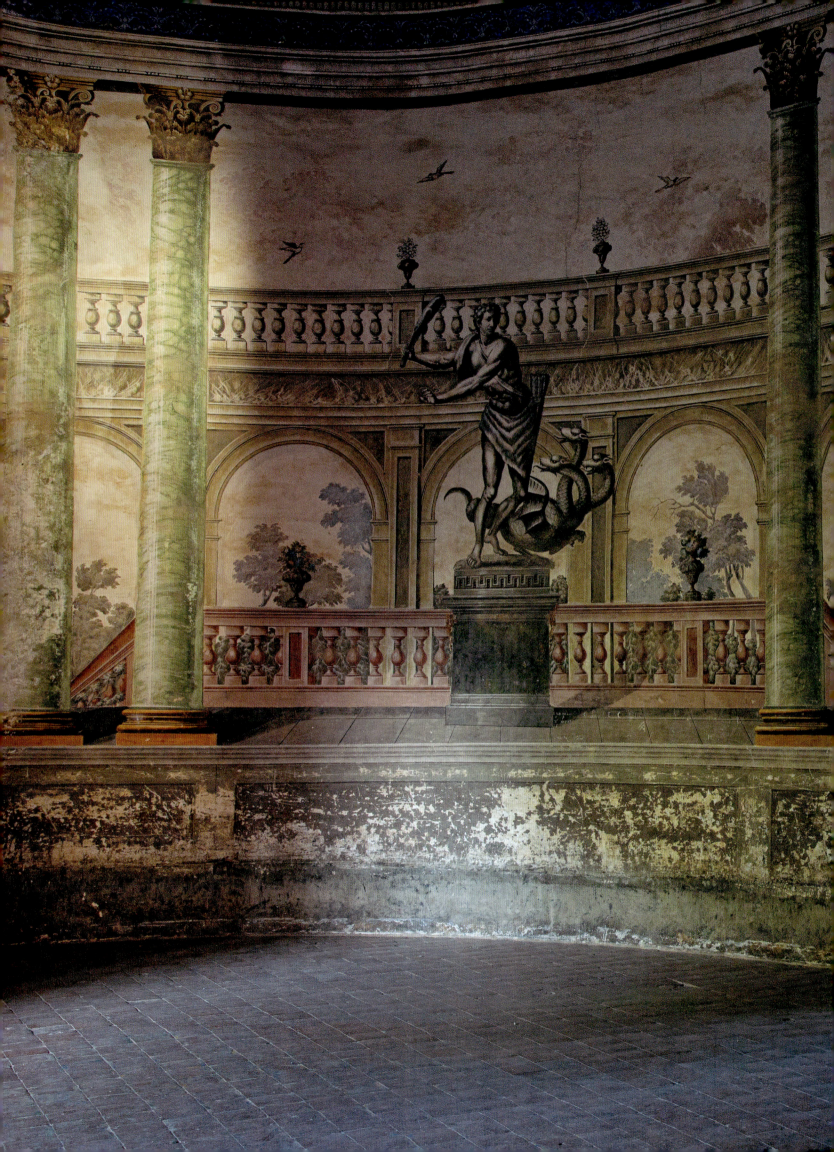

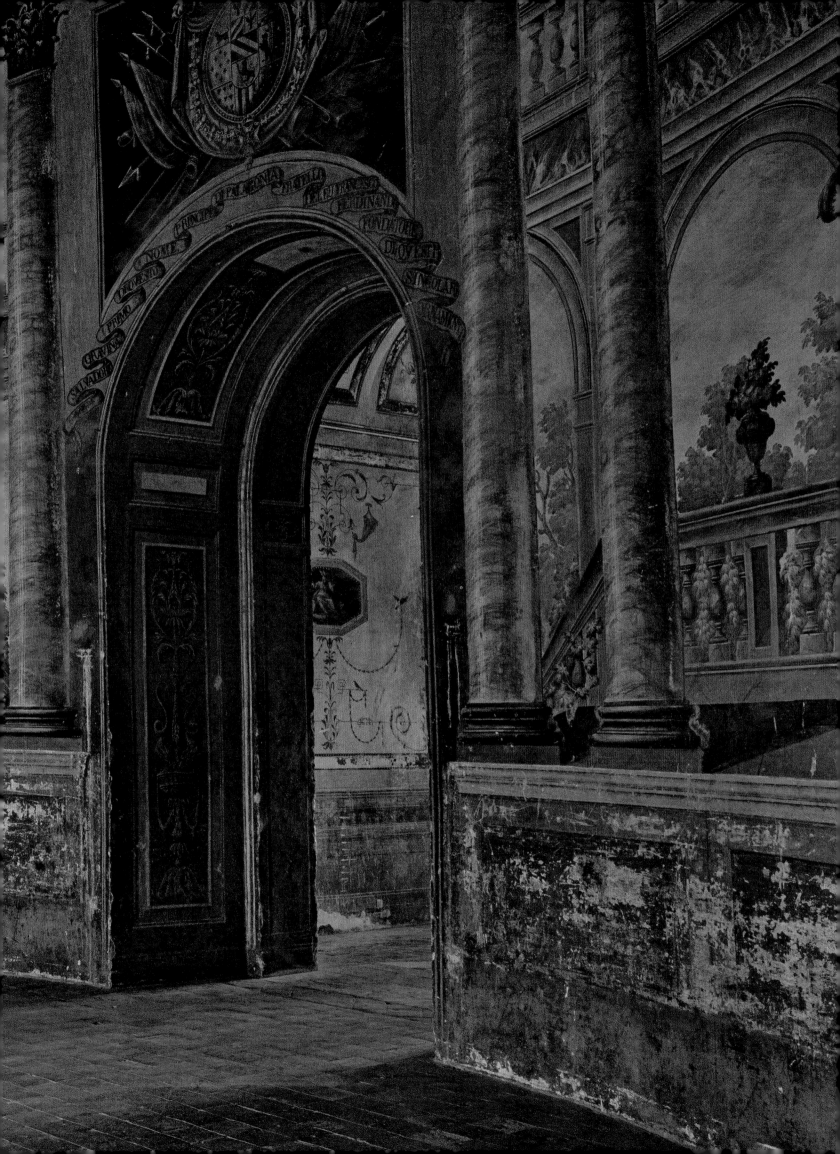

Inside, the spectacular Hall of Mirrors creates endless visual illusions enhanced by *verre eglomisé* (reverse-gilded glass), which creates a lustrous, reflective marble-like interior. The writer Johann Wolfgang von Goethe (1749–1832), who visited in 1787, found it both unsettling and fascinating. He wrote: "Never have I seen anything so whimsical, so out of all rule and measure, as this villa."

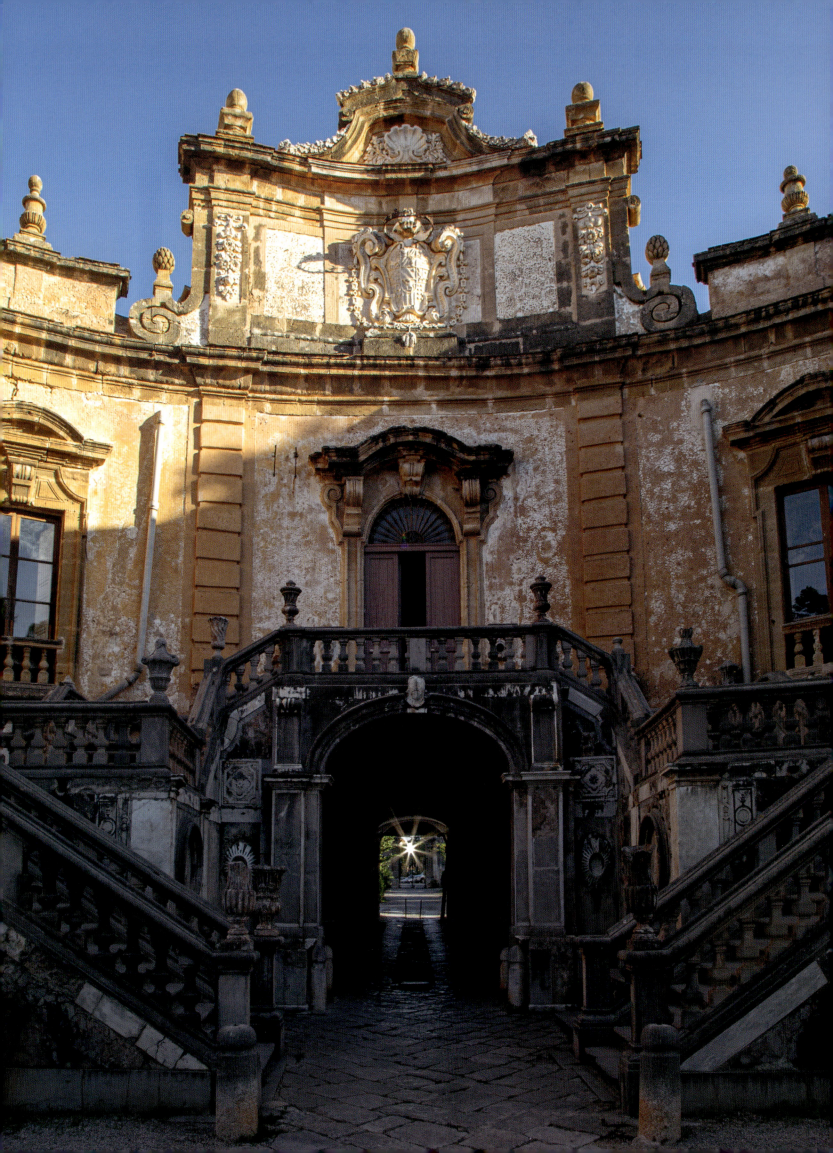

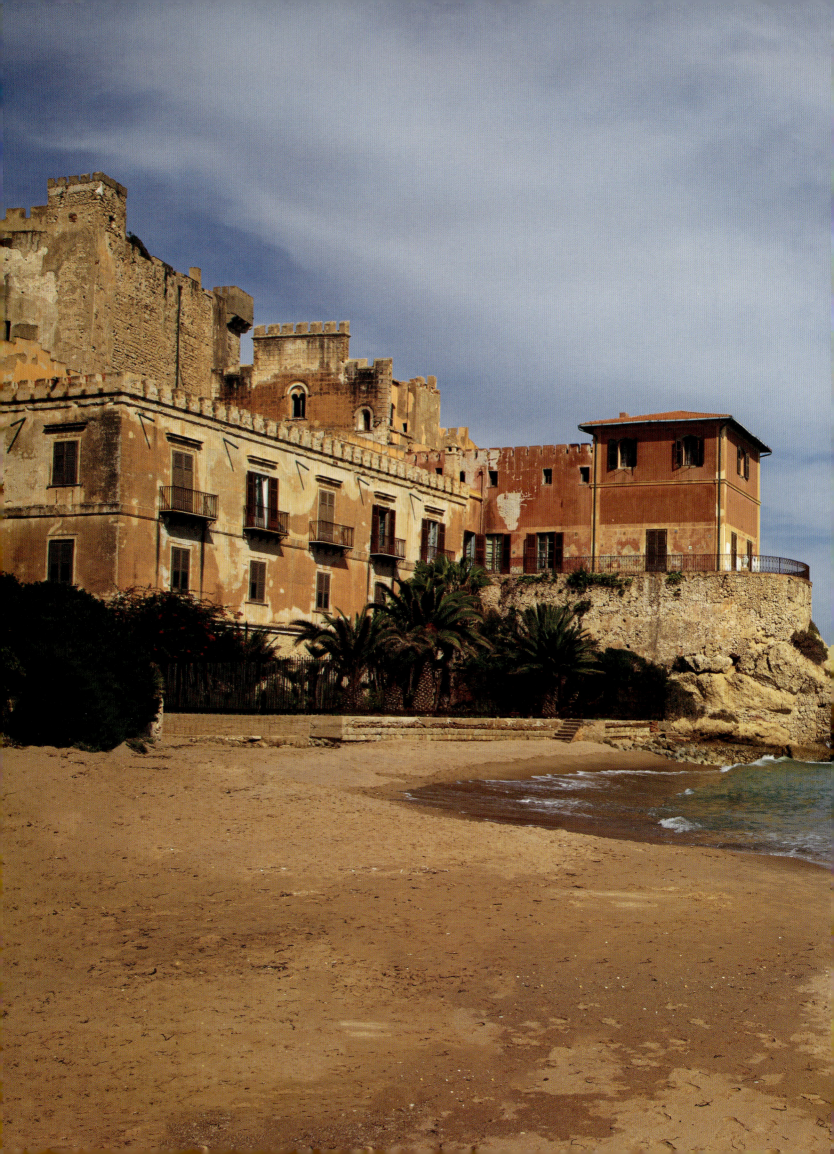

The Sicilian Vespers rebellion of the thirteenth century is rarely studied these days, but it represents the moment in Sicily's long and complicated history when the island's national identity coalesced. What began as a small riot in Palermo spread across the island and resulted in a twenty-year war that changed power dynamics all over Europe, from England to Constantinople and the Levant. After centuries of outside rule, the resulting melange of Greek, Arab, Latin, and Norman peoples unified for the first time as Sicilian, with the goal of rejecting French governance.

In the shadow of this war, the Castello di Falconara was built to defend the craggy southern coast of Sicily, with its promontories of coral-studded sedimentary rock jutting out between sandy coves. Not far from the Greek temples of Agrigento, it is the only castle in the province of Caltanissetta to overlook the sea. Originating in a central tower—a falconry dating from 1313, after which the villa is named—built into one of the promontories, it was added to and modified in layers over the next six hundred years, creating a layered artifact with its own geology that pushes out into the sea like the prow of a ship.

In the eighteenth and nineteenth centuries, when Falconara was no longer of defensive importance, it was converted into a neoclassical villa, with an enfilade of rooms encircling the original castle. It is now owned by the family of Andrea Bordonaro (see page 69). A palm-lined driveway meanders through the gardens, where subtropical plants—some cultivated from rare specimens in the Palermo Botanic Garden—lead up to the ancient castle. Medieval crenelated walls conceal the ancient keep, and, unusually, the castle is entered from the roof, so that the inner rooms give the impression of being "below deck" on an ocean liner.

At the end of the sunbaked inner courtyard, an iron gate leads to a whitewashed, domed hall, where a staircase hung with taxidermy caked in lime powder (to reduce odor) descends to the neoclassical villa. The sitting rooms, which are decorated with French Empire and English Regency pieces, are linked via an exterior walkway of turquoise tiles that surrounds the castle and appears to hover over the sea below. Behind the dining room, further stairs lead down to a cave chiseled out of the rock. Niches in a narrow passage hold torches to light the way toward the sound of waves crashing against the shore below, until the cave opens up to a small landing on the Ionian Sea.

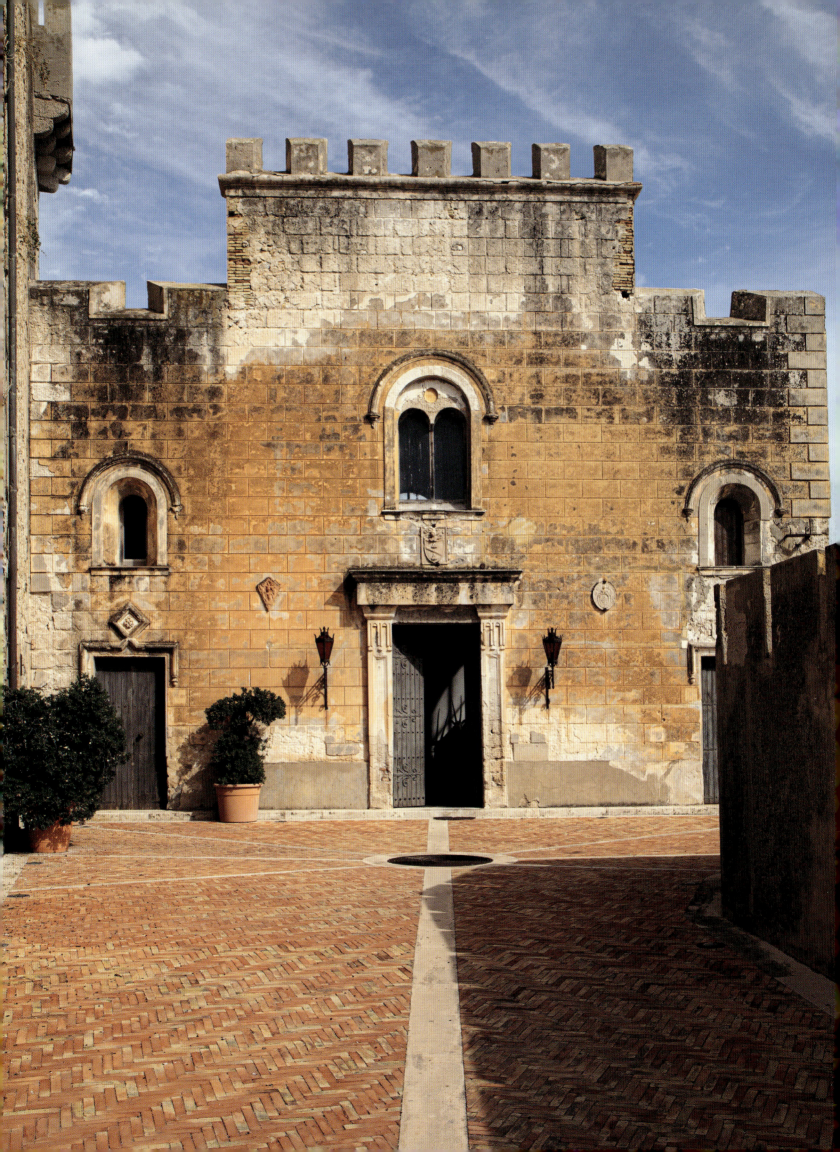

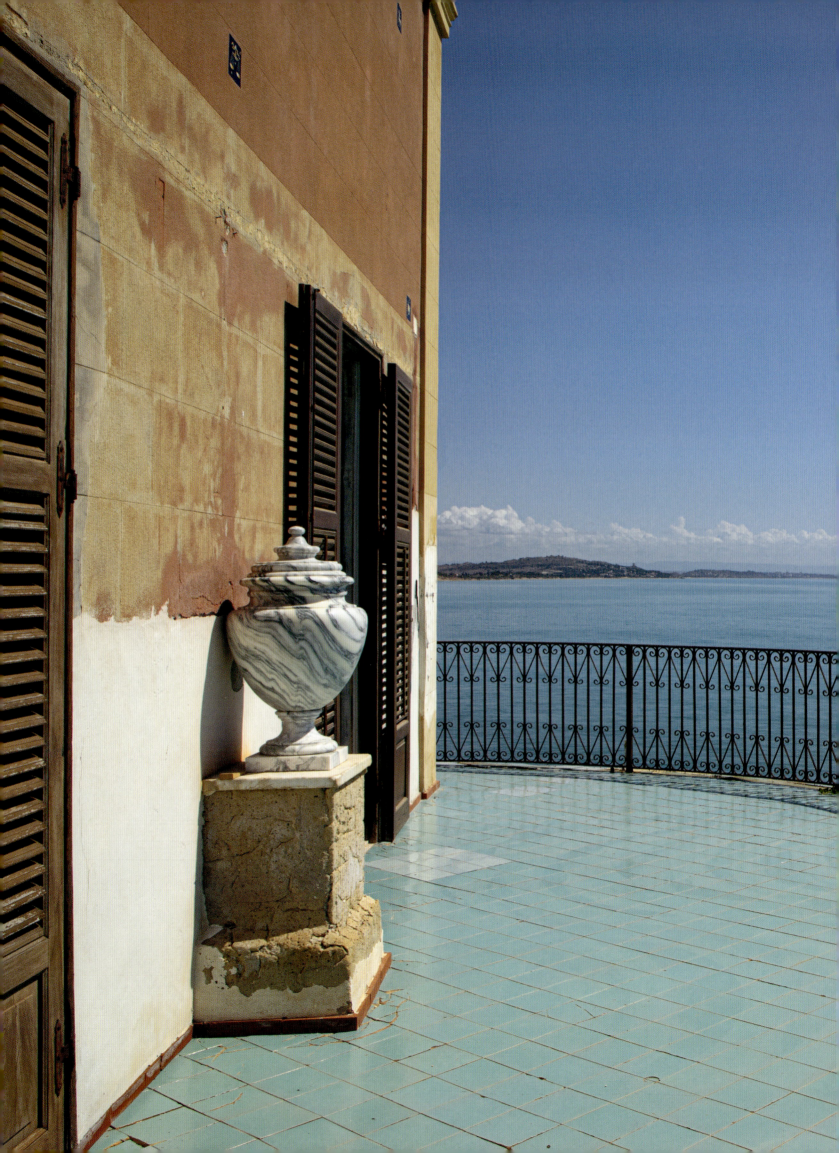

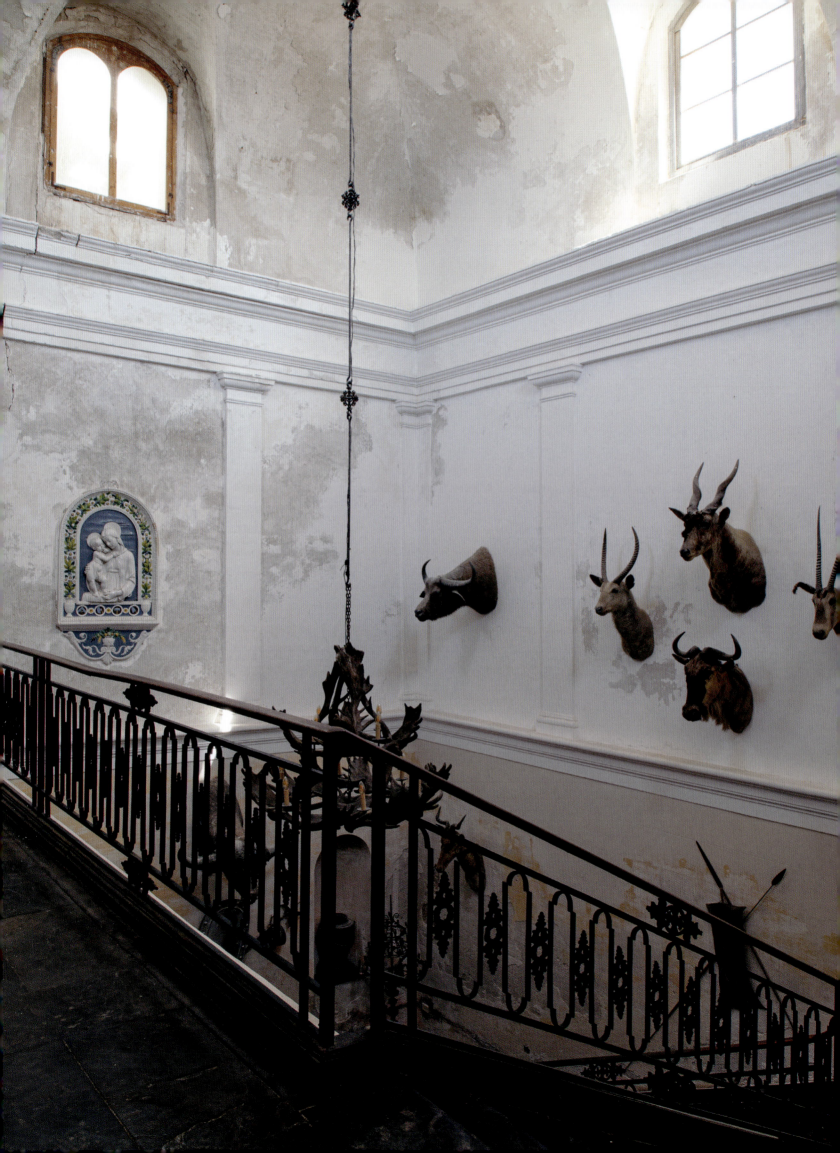

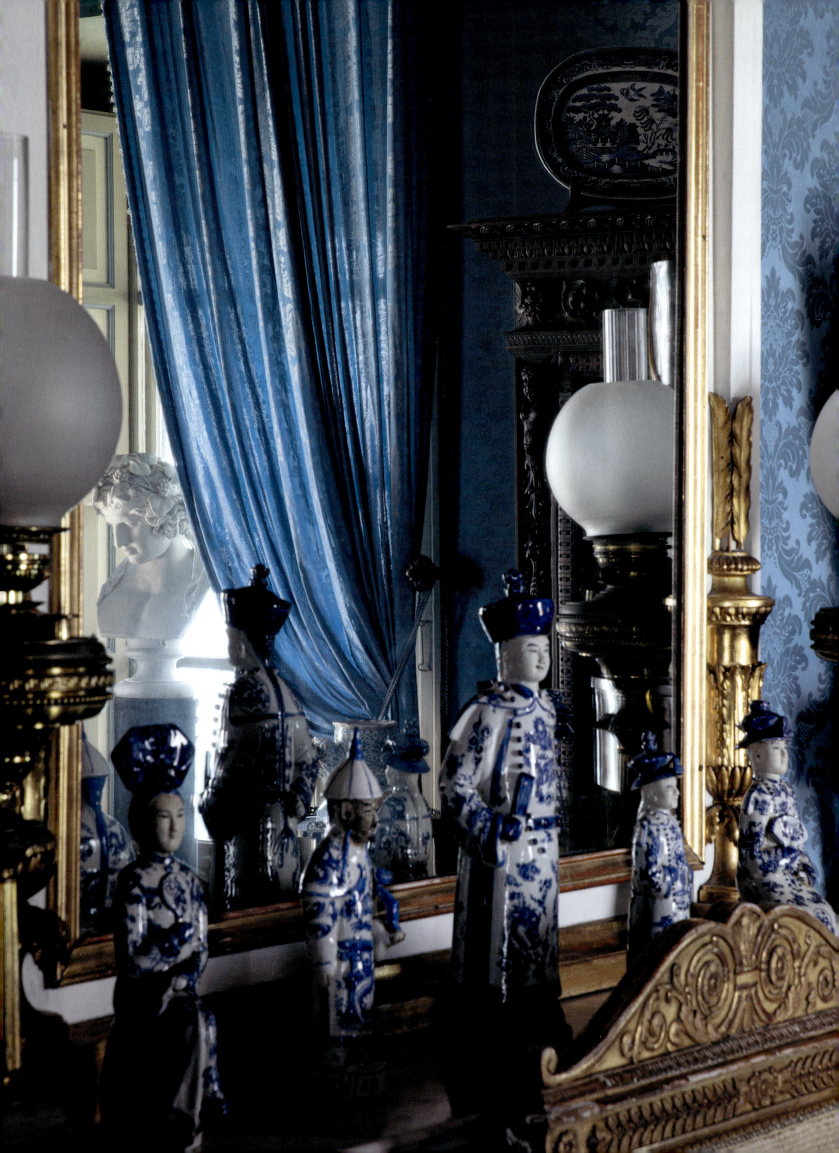

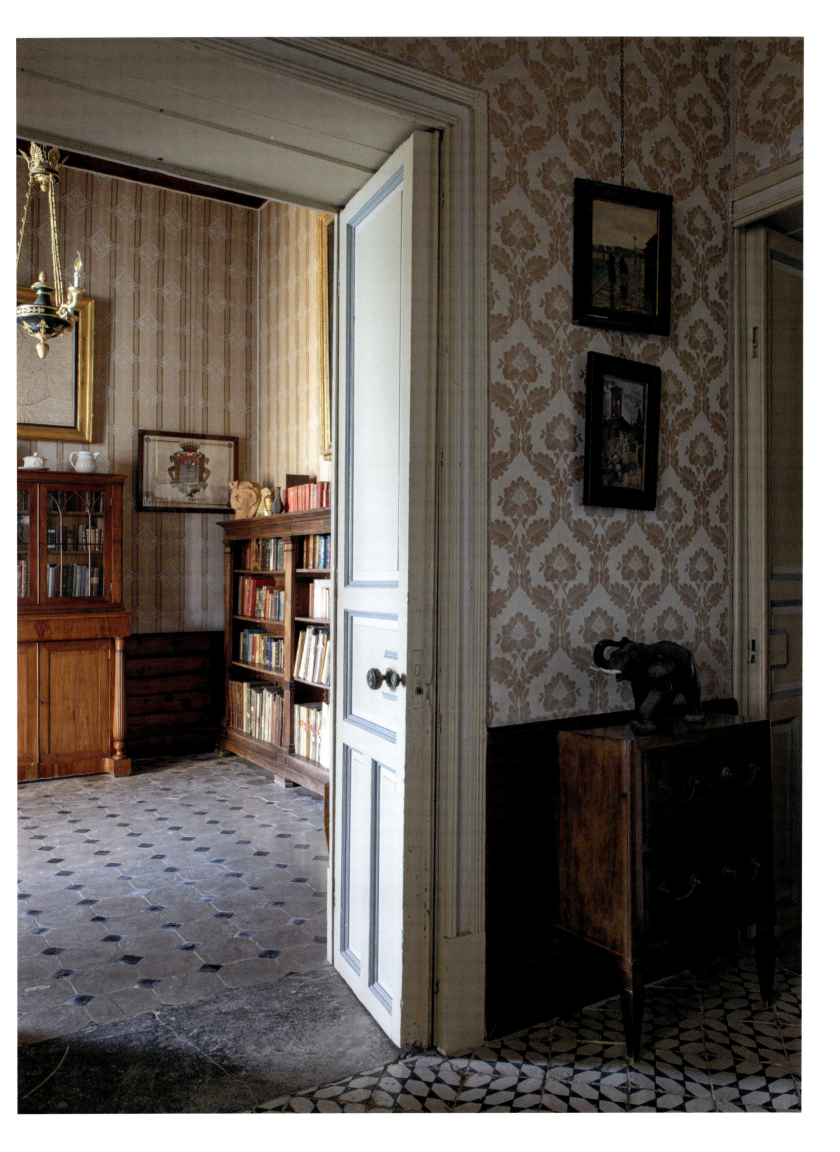

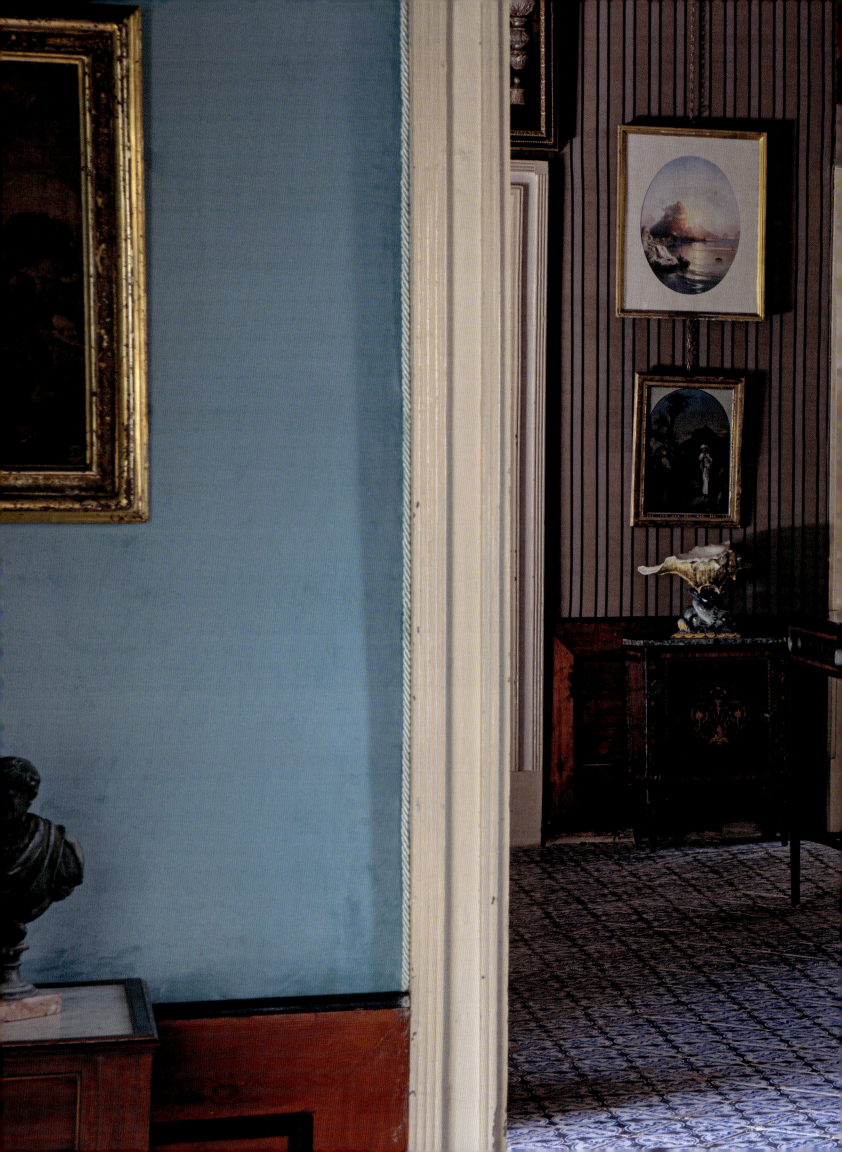

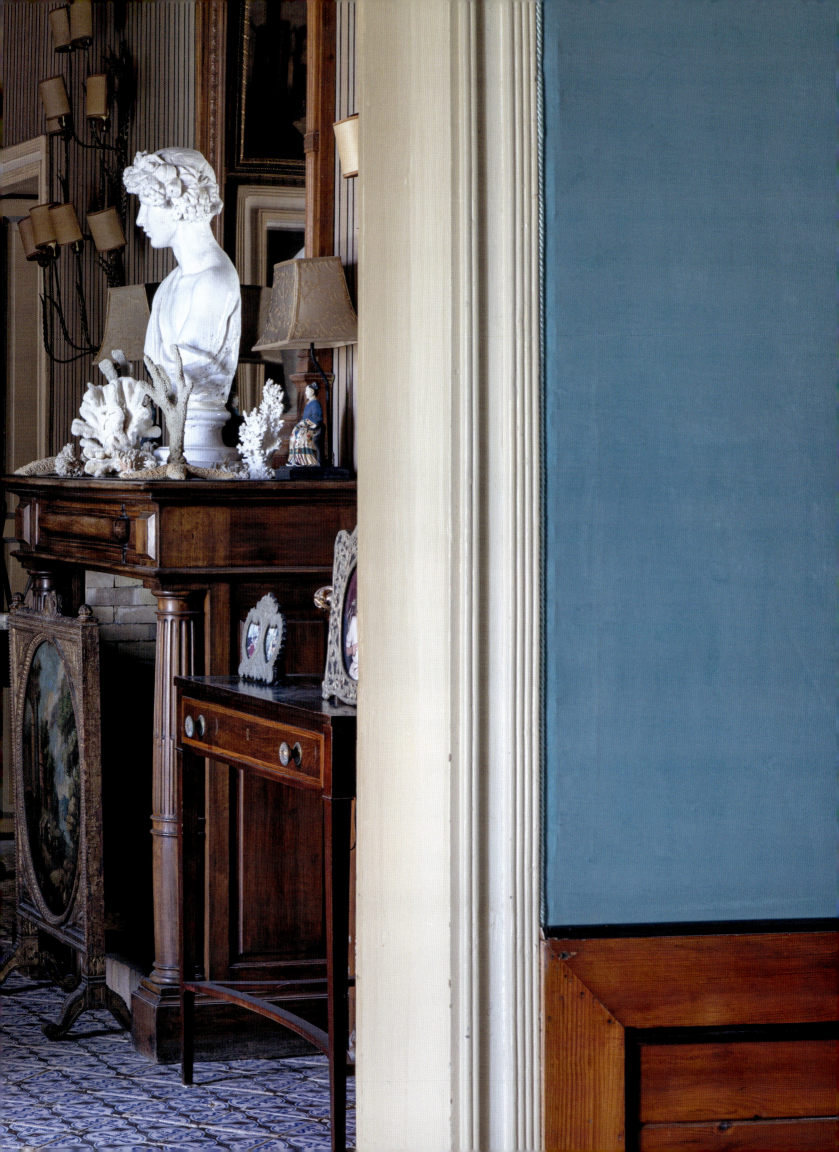

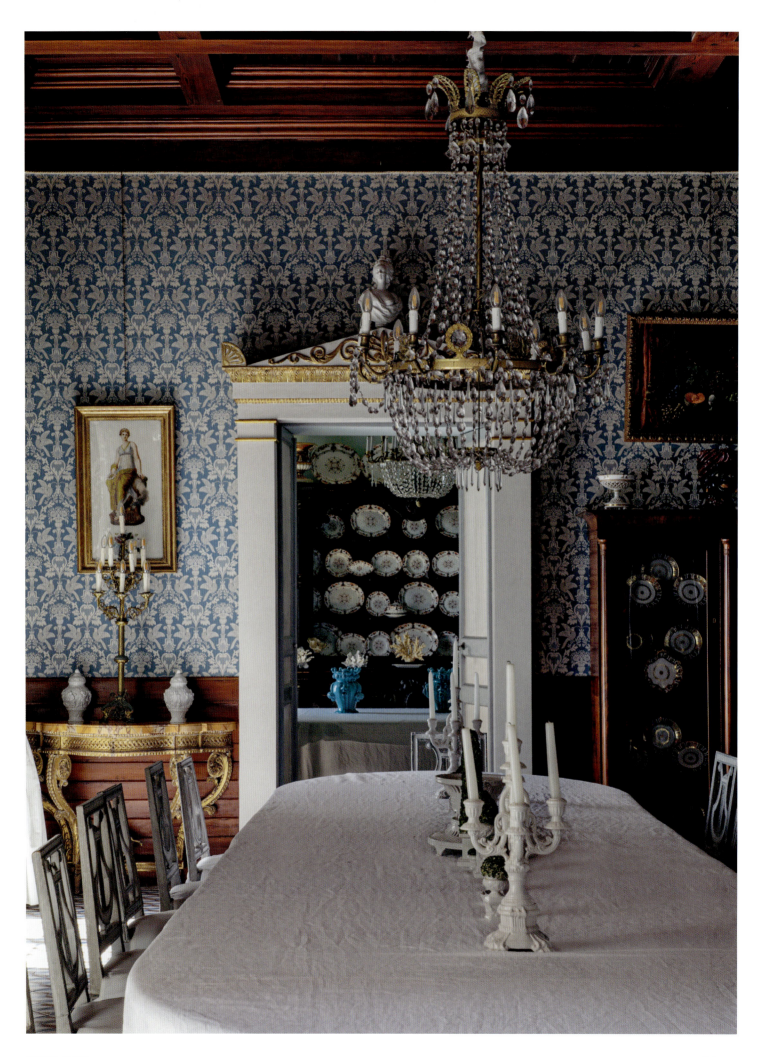

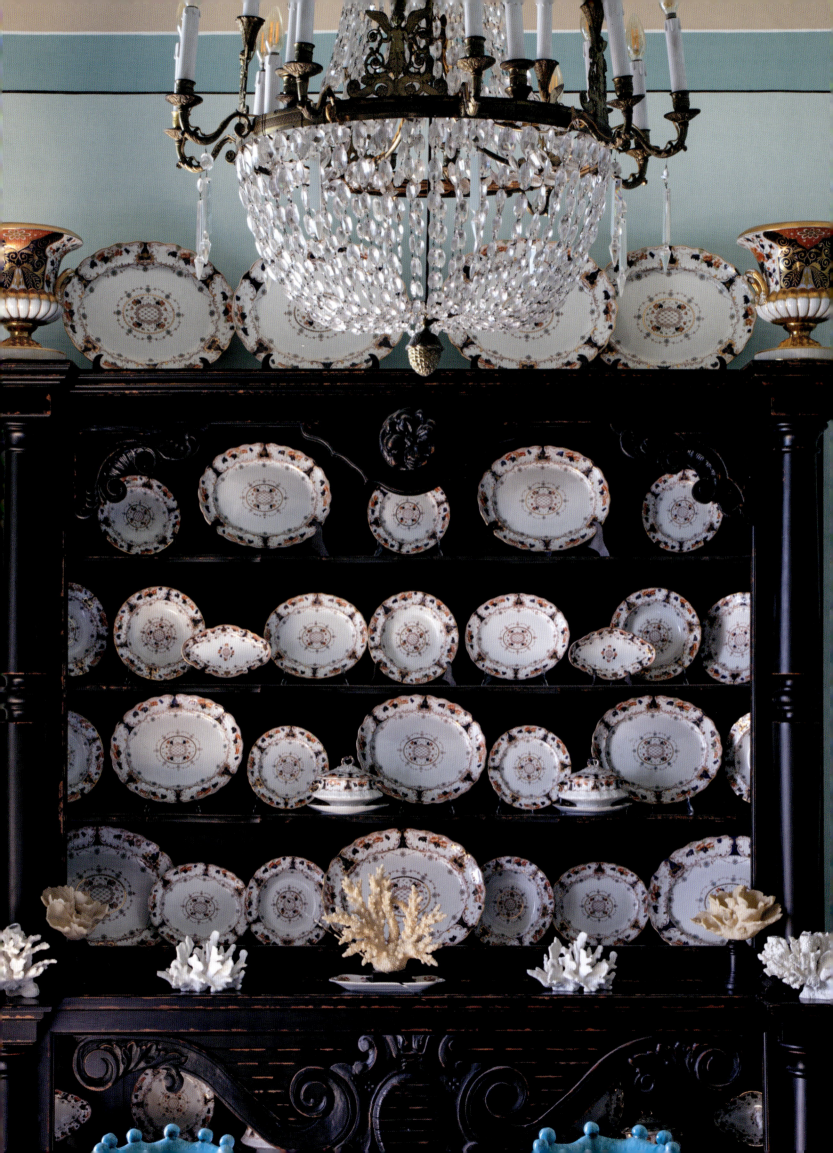

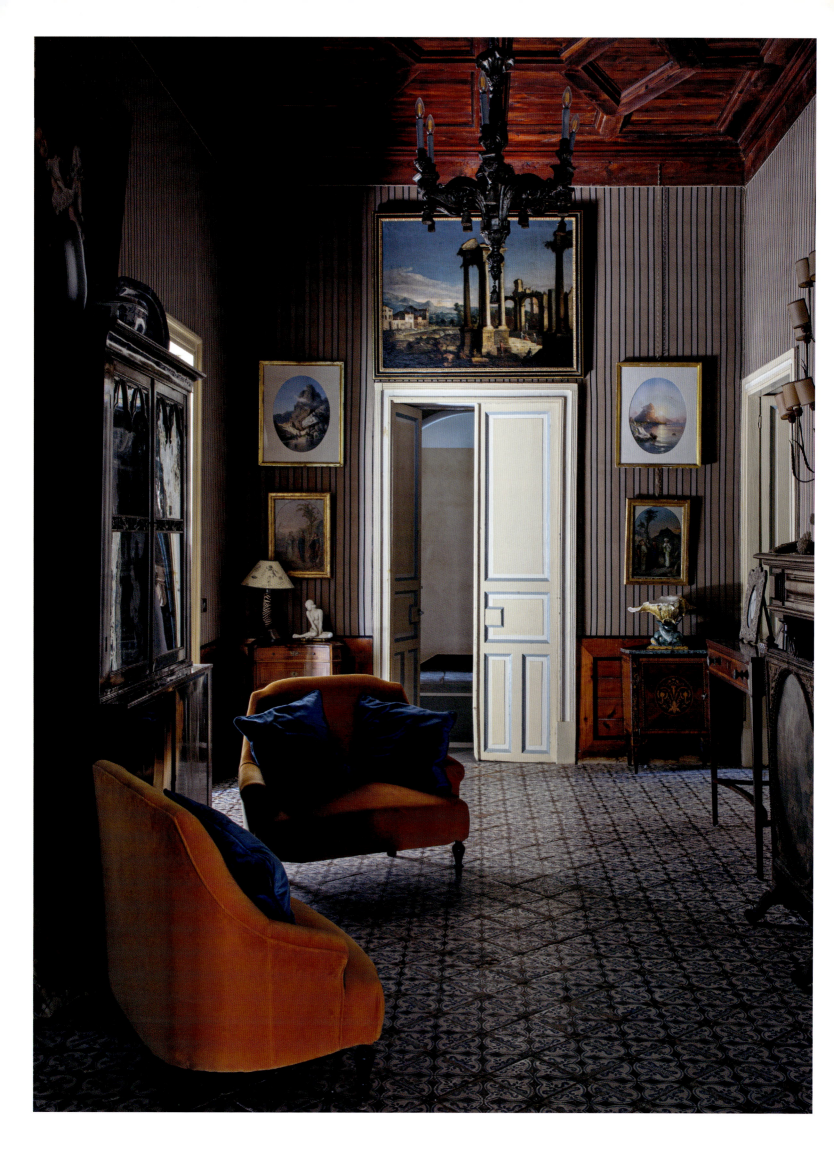

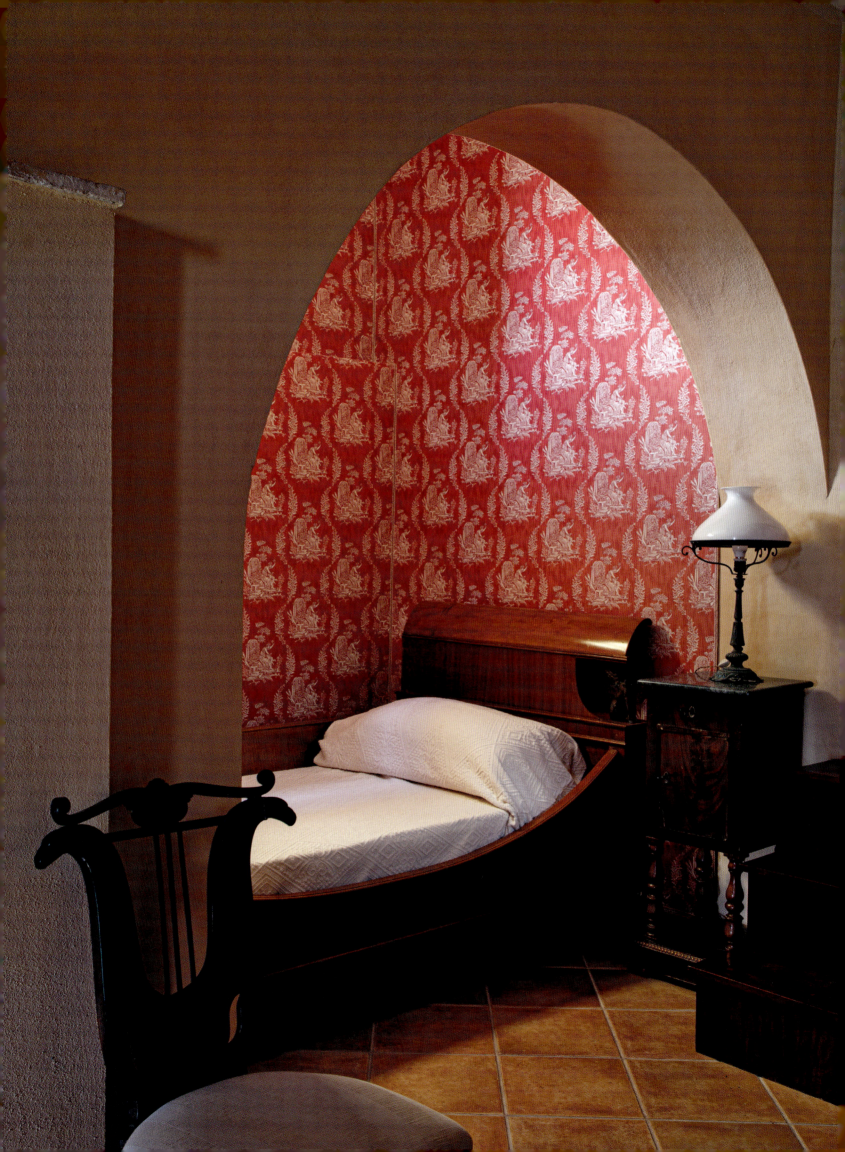

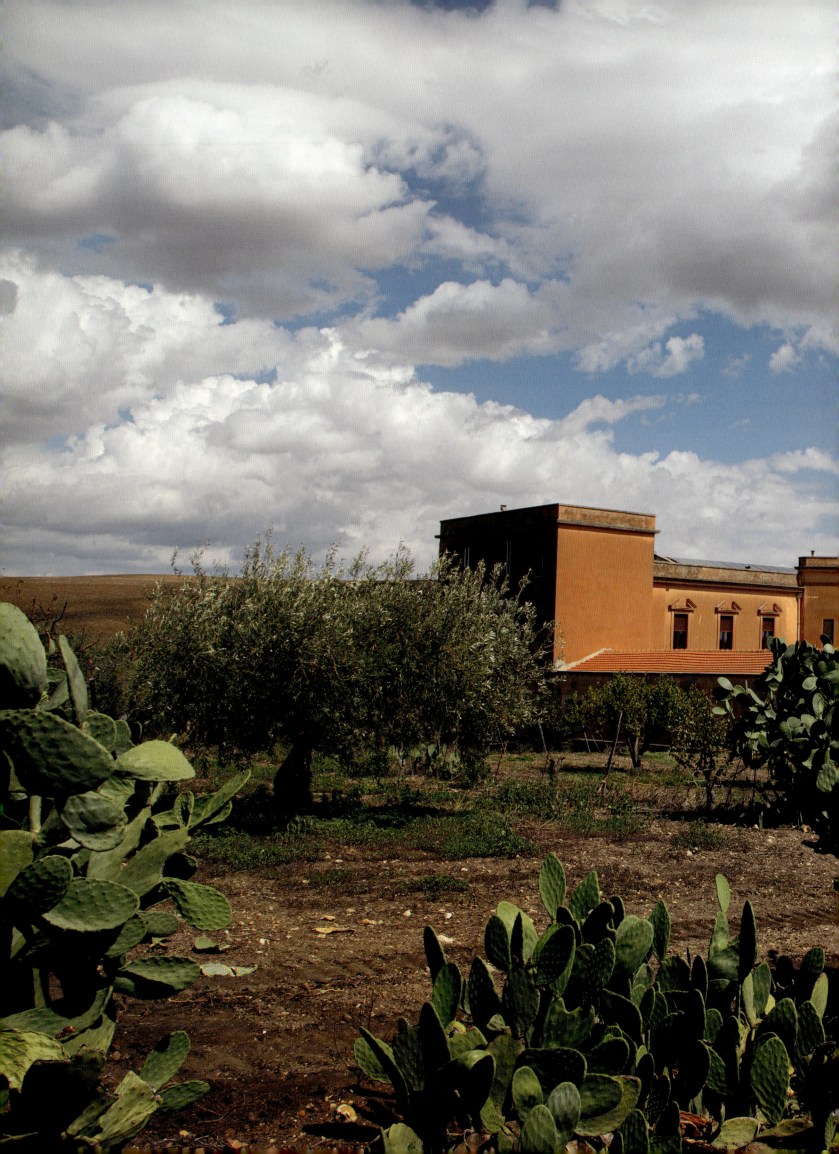

Sara Prato remembers the day her family moved into this striking *masseria* (farmhouse). "The house was new," she says. "We must have been the first people for miles with running water and electricity." She now owns the 740-acre (300-hectare) agricultural estate near Valguarnera Caropepe, a small town in the Sicilian hinterland north of the city of Piazza Armerina.

Built in 1943, the house was the vision of the chief municipal engineer of Palermo, who combined rationalist elements with neo-Roman flourishes to create a modern interpretation of the traditional Sicilian *masseria*. It is, in essence, a fortress—a necessary feature during the uncertainties of the 1940s. A gatehouse is adorned with medieval fishtail merlons that contrast with the otherwise Modernist estate. The central structure leads to the private areas, which are flanked by the stables and the *dopolavoro*, where workers would gather after long days spent in the fields.

The two-story central structure has a municipal quality yet is executed with a luxurious attention to detail, an approach that recalls Piero Portaluppi's work on Casa Corbellini-Wassermann in Milan. The façade juxtaposes fake travertine with real travertine, playing with perceptions of material authenticity. The five-sided semicircular archway that frames the entrance gives the house an inviting yet monumental presence, and the courtyard's pavement conceals a massive underground cistern, bringing a further sense of self-sufficiency.

The interiors are a striking Gesamtkunstwerk. All the original furniture was crafted specifically for the house to designs that pushed function over form, including low-hanging chandeliers and sconces with exposed bulbs, and a dining set that combines oak seats and surfaces with aluminum legs. Many of the decorative elements were entrusted to the young Carmelo Comes (1905–1988), who was beginning to make a name for himself in Sicily at the time. He painted frescoes of allegorical figures and agricultural scenes, of laborers busily tilling the land, depicting an idealized yet deeply rooted vision of rural Sicily. Comes also designed the elaborate ceiling stuccos, including the zodiac in the sitting room, which blends classical with Modernist sensibilities.

Exploring the house today has an archaeological quality. Family heirlooms and remnants of a once-thriving estate speak to a past where industrialization was just beginning to touch rural life. At the time of its construction, there was a luxury to "factory-made," as can be seen in the stylized terrazzo tiles in the bathrooms and the chrome kitchen appliances. Additionally, the house's service spaces were designed with a generosity that reflects the rationalist idea that hygiene, sunlight, and functionality must be equally applied to the whole.

The estate has suffered in recent years from the shifting earth below, resulting in cracks here and there that the family works to patch as they appear. Sara's late brother the architect Antonio Prato was particularly dedicated to keeping on top of the maintenance. While the land is still managed as an active farm, the halls of this once great property no longer have the constant hum of activity they once did. But the house seems poised in anticipation, filled with the ghosts of its past and redolent with the promise of renewal.

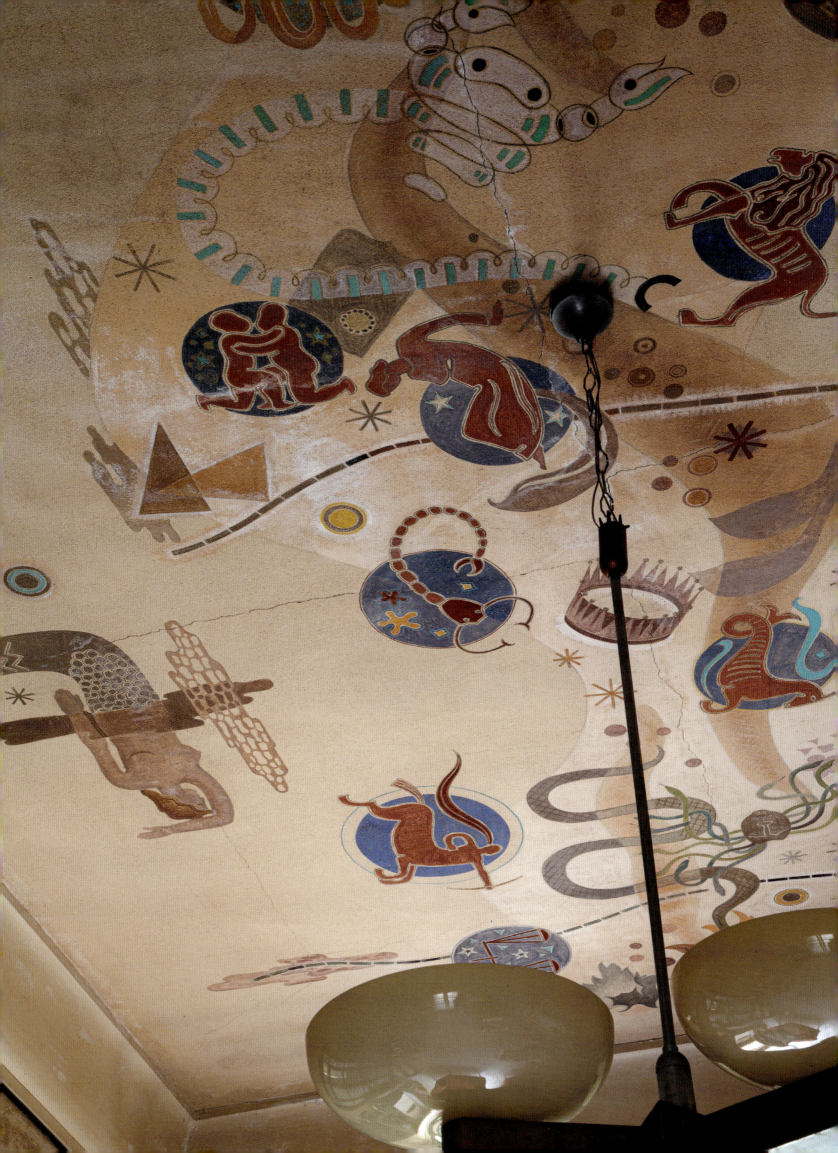

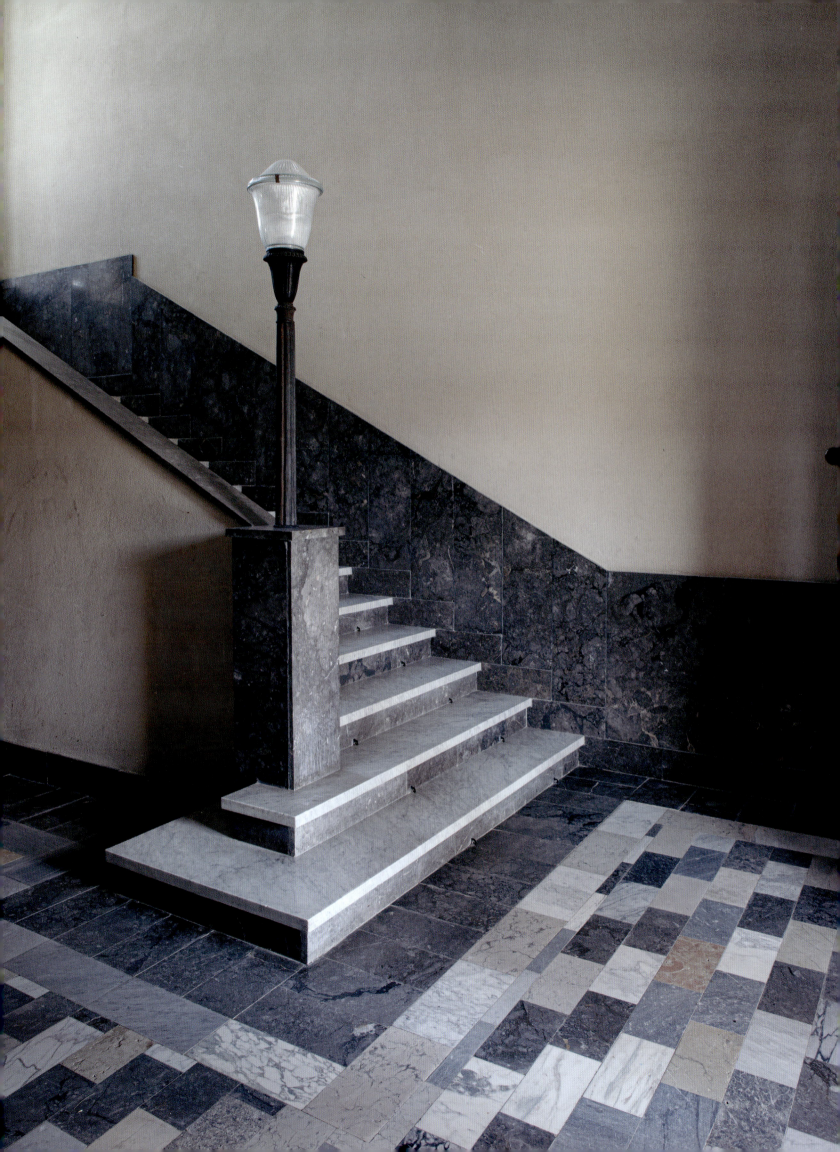

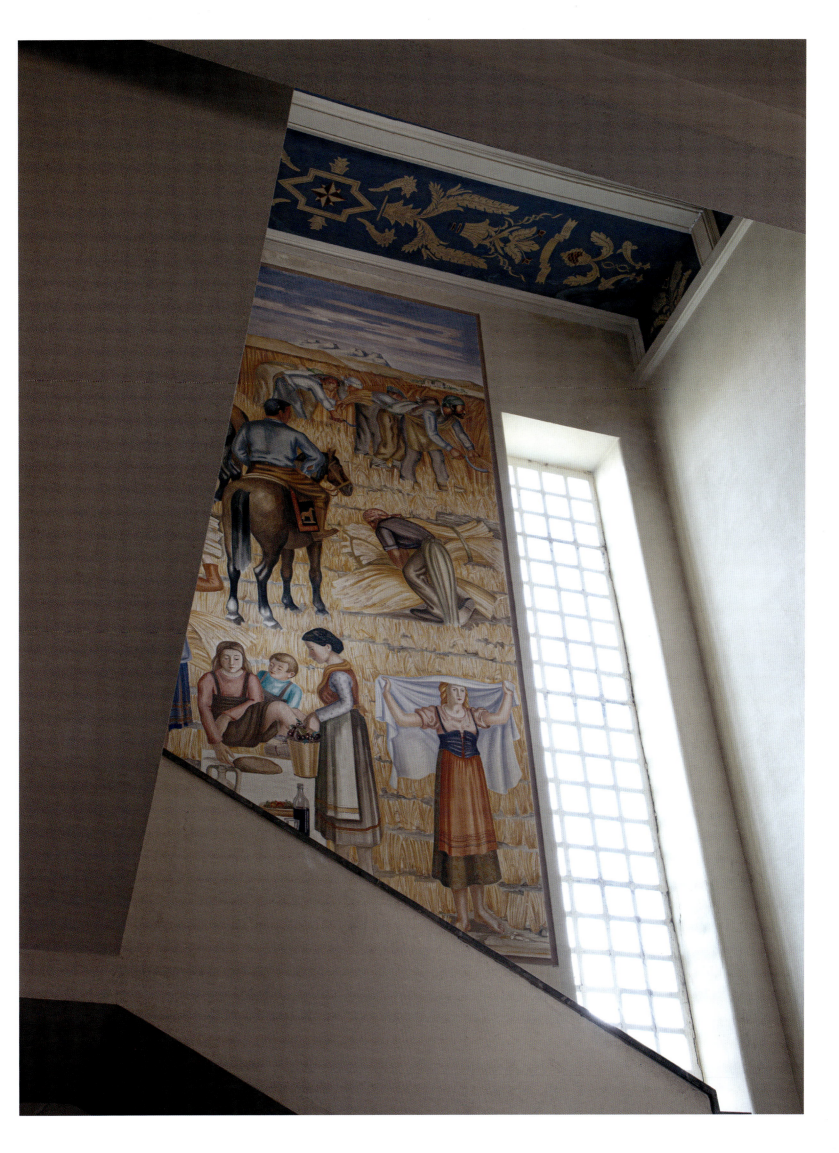

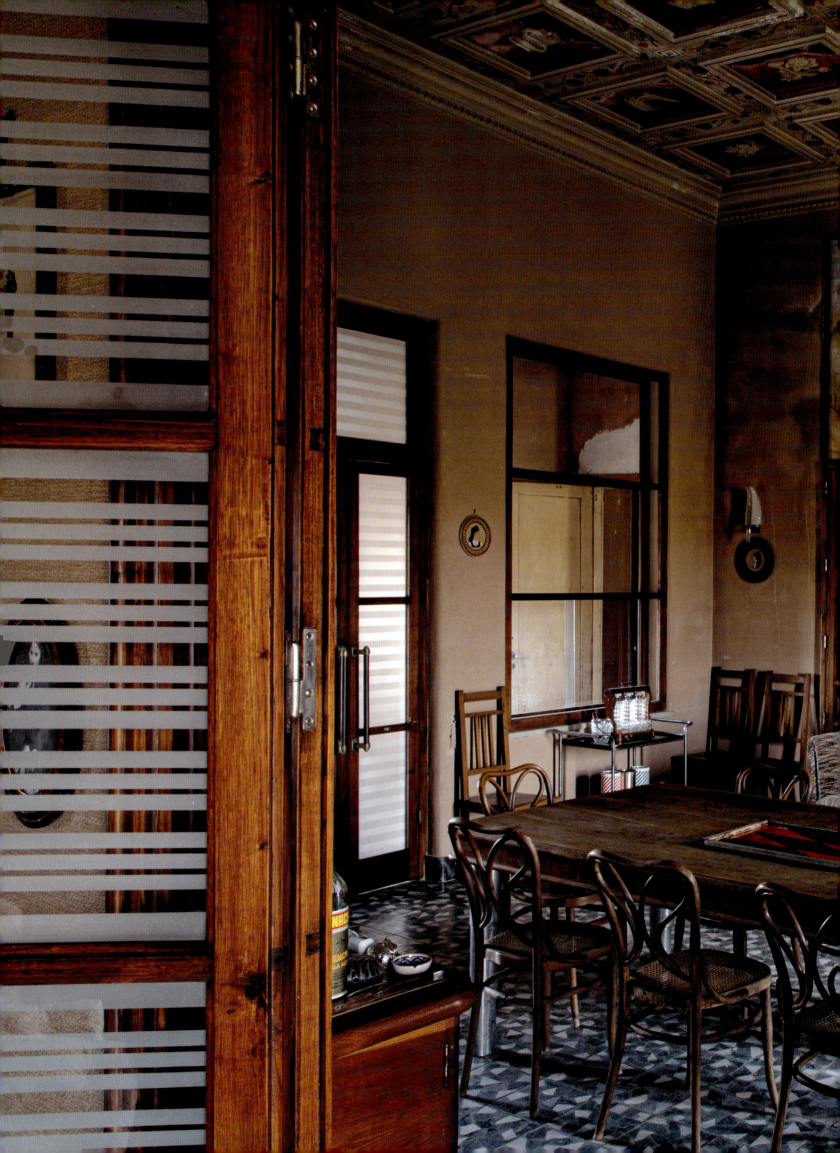

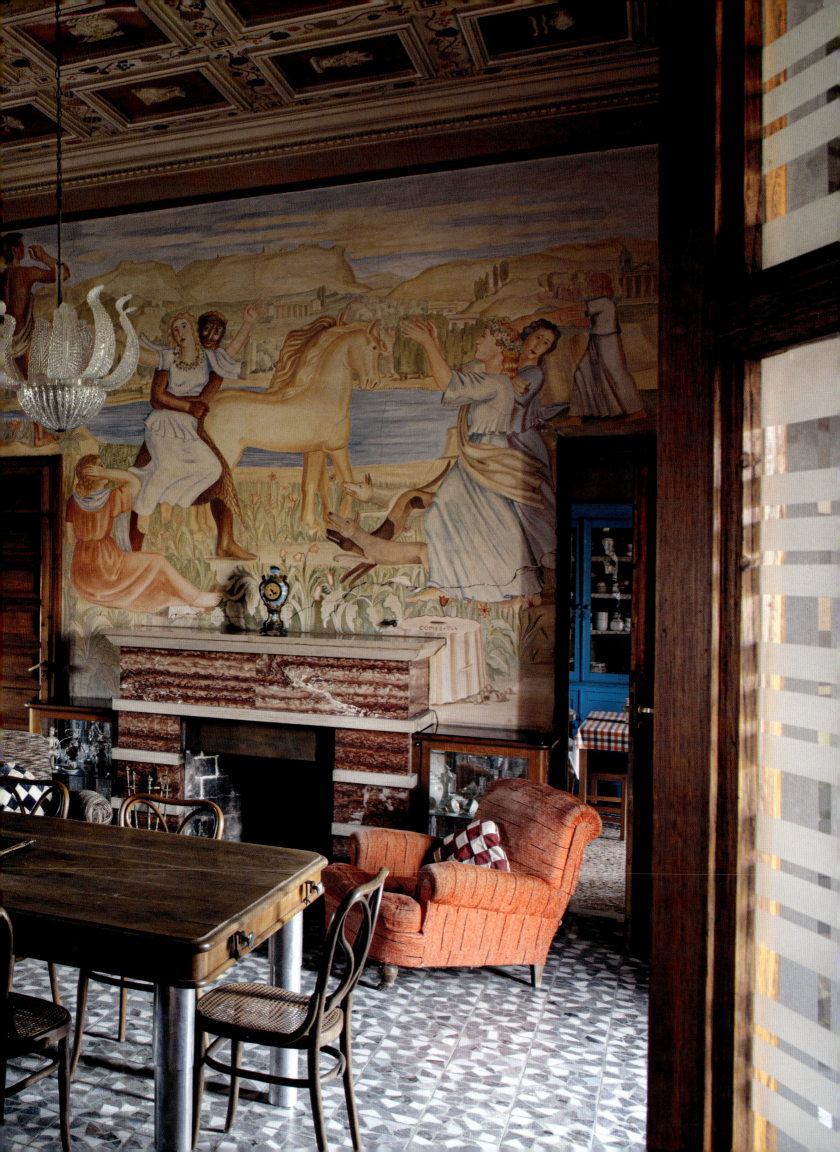

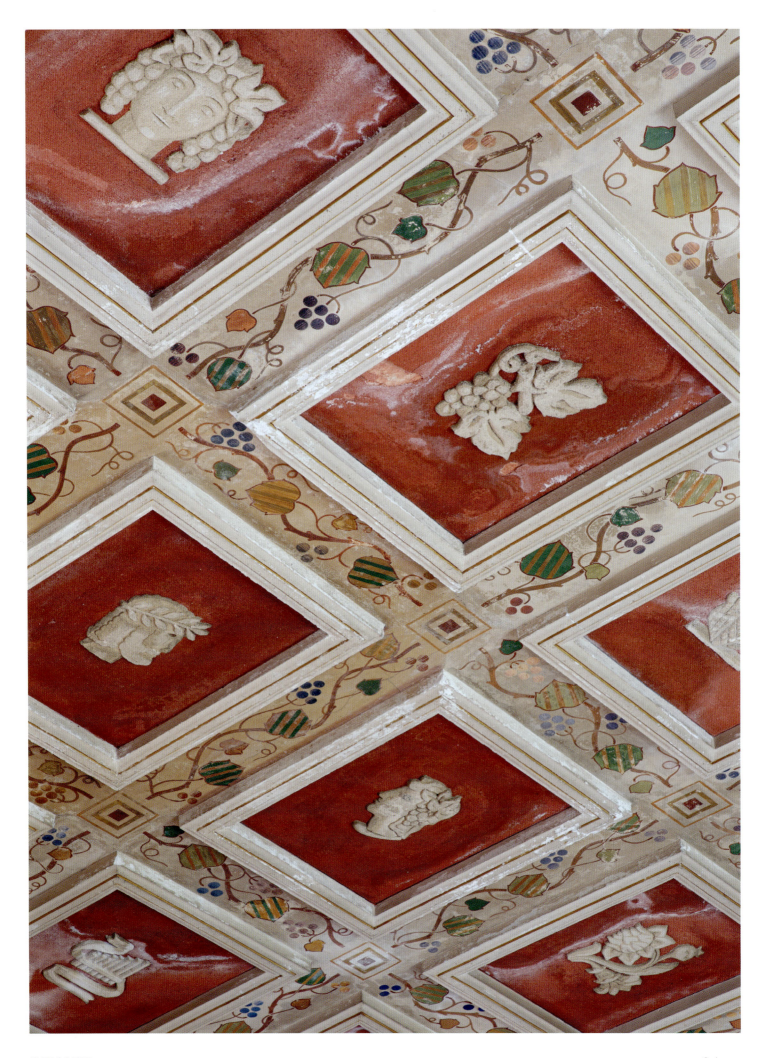

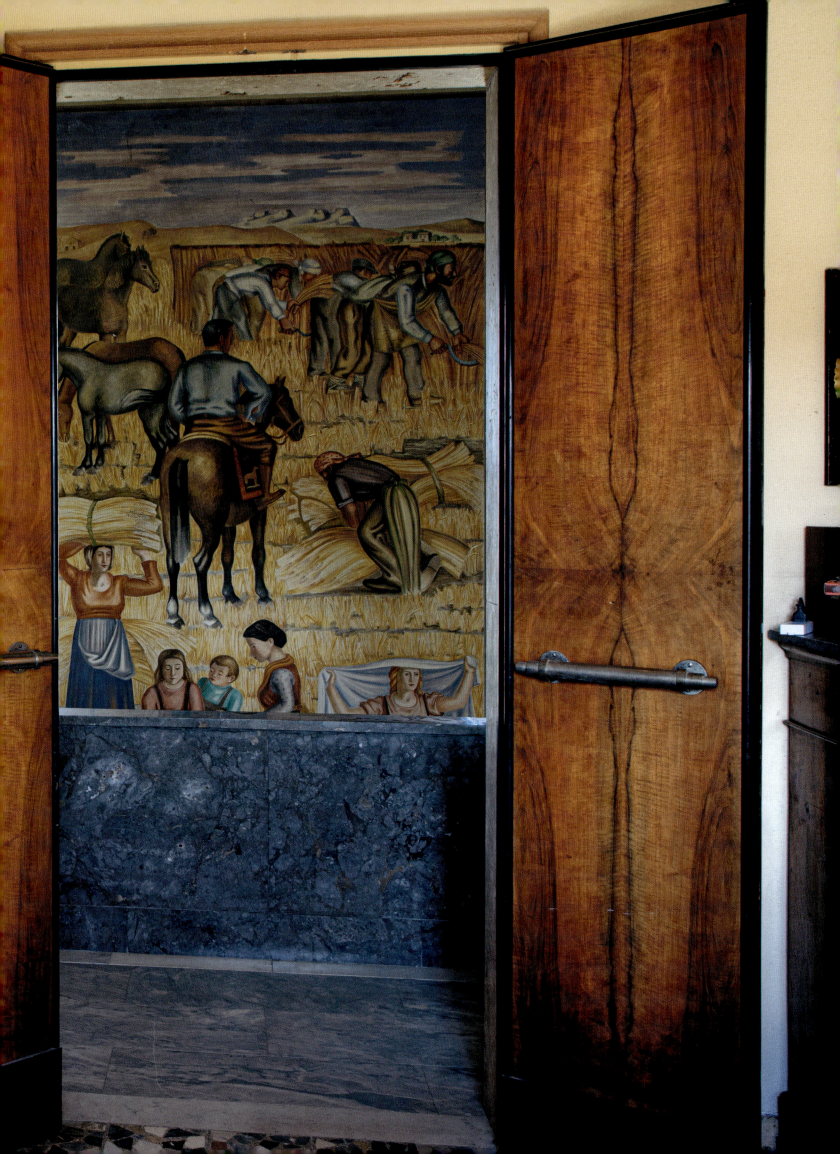

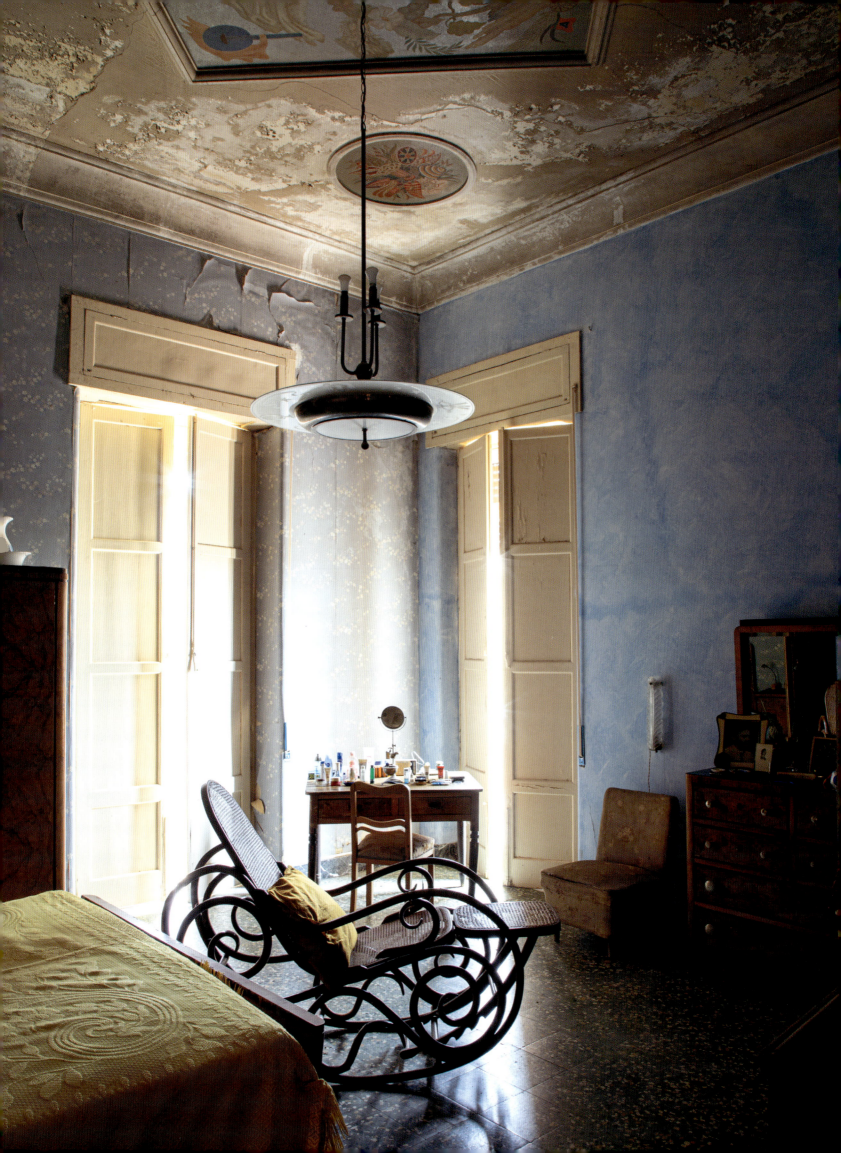

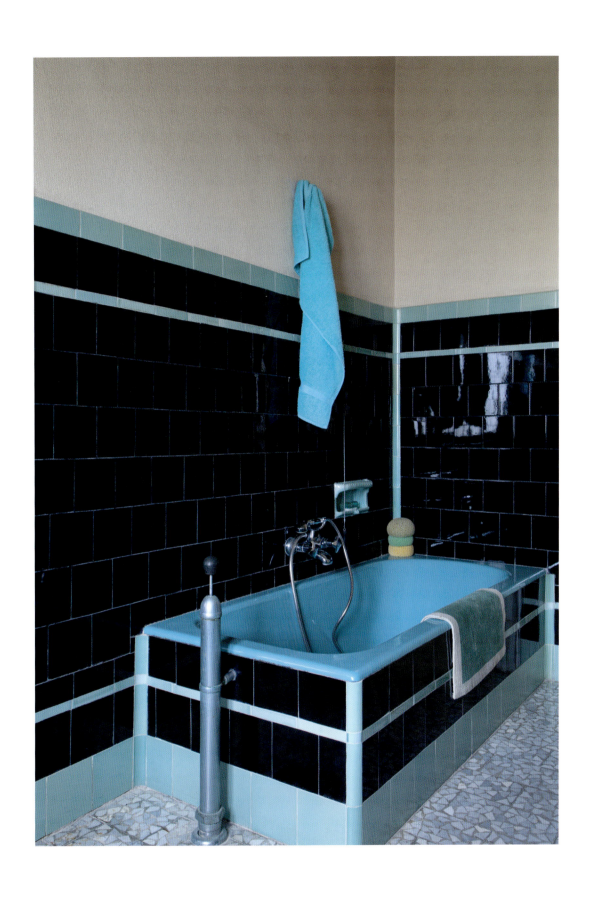

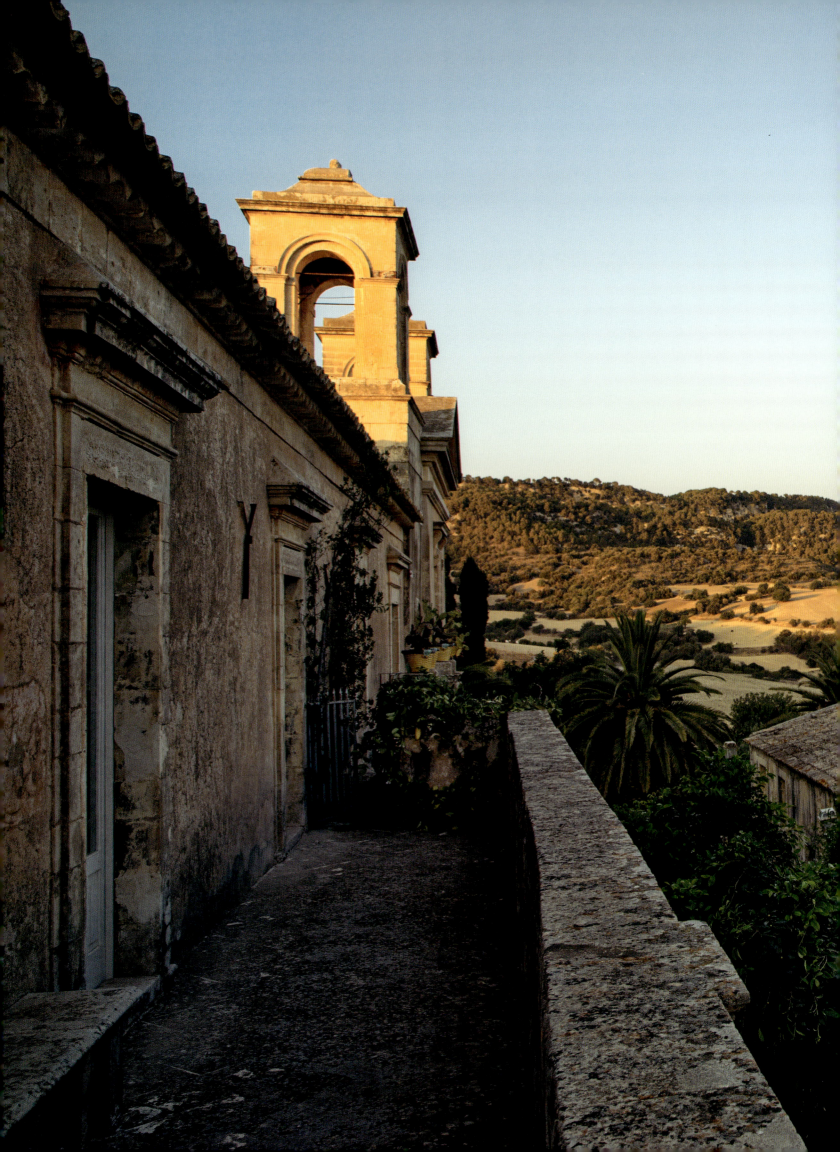

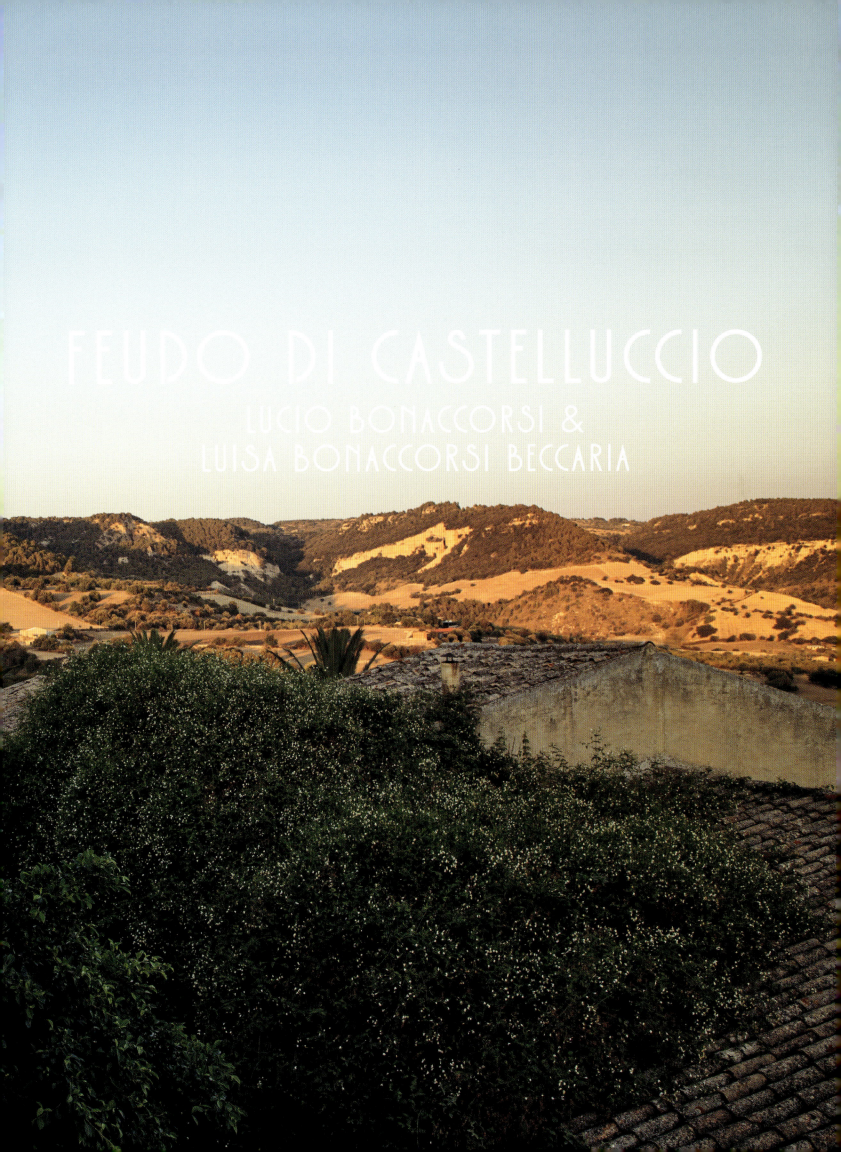

Shortly after her marriage, Luisa Beccaria, the indefatigable Milanese couturier, fell in love with Sicily. It was perhaps inevitable, because for her husband, Lucio Bonaccorsi dei Principi di Reburdone, these sunbaked plains above the city of Noto are an extension of who he is. Together, over the past twenty-five years, this remarkable, visionary couple have reinvigorated the land and rebuilt the walls of their eighteenth-century Feudo di Castelluccio.

On a typical morning, Don Lucio receives the workers who oversee more than 1,100 acres (450 hectares) of almond and olive trees, discussing farm management in the local dialect, while Luisa sees after the construction of various outbuildings and the supervision of the house. In the kitchen, bread and fresh ricotta are produced throughout the week, while vegetables are restocked from the garden, and the flower room overflows with fresh and dried cuttings from the grounds. There is such a peaceful ease to life on the plantation that one might easily be deceived into imagining that Castelluccio has existed perpetually as a working, landed estate. In fact, when Luisa first toured the property as a newlywed only thirty or so years ago, it was a ruin of almost prohibitive remoteness. In those years, before the introduction of paved roads and highways, they were pioneers.

The *feudo*—literally "fief"—is one of three typical estate styles in Sicily: larger than the fortified *masseria* from the east of the island and the courtyard-focused *baglio* (bailey) found in the west. It was a village under the control of a baron or marquis, and its inhabitants would have been tithed to the land, part of a state within a state. As the feudal system in Sicily eroded, so too did the need for these villages, and while the commercial activity has continued, it wasn't until Luisa brought in a new perspective from the north that the value of maintaining and restoring Castelluccio became clear once more.

She began with the roads. In order to establish a unified *paysage* (landscape), grass lawns replaced the crumbling asphalt and cracked cement that filled the spaces between buildings. Slowly—and to the amazement of her curious in-laws—the property became what it is today: a thirty-two-bedroom working estate with new outbuildings being restored all the time. Luisa feels that bringing the *feudo* back to life by creating its gardens and designing the interiors was a way for her to express and define her aesthetic universe, which has blossomed into her own eponymous lifestyle brand. There is an open-door quality to the way the family runs the house; people are always visiting, and there is always some excuse to throw a party.

In 1999, almost the same day as Luisa's youngest was born, they found an important well, the *sorgente* Luccino, on the estate. The two share a name. For the family, it was a true omen and a celebration of their work. Today, as the stretch of land from Noto down to Scicli blossoms with renovated villas, many of the new residents ascribe their investments to the inspiration of Castelluccio.

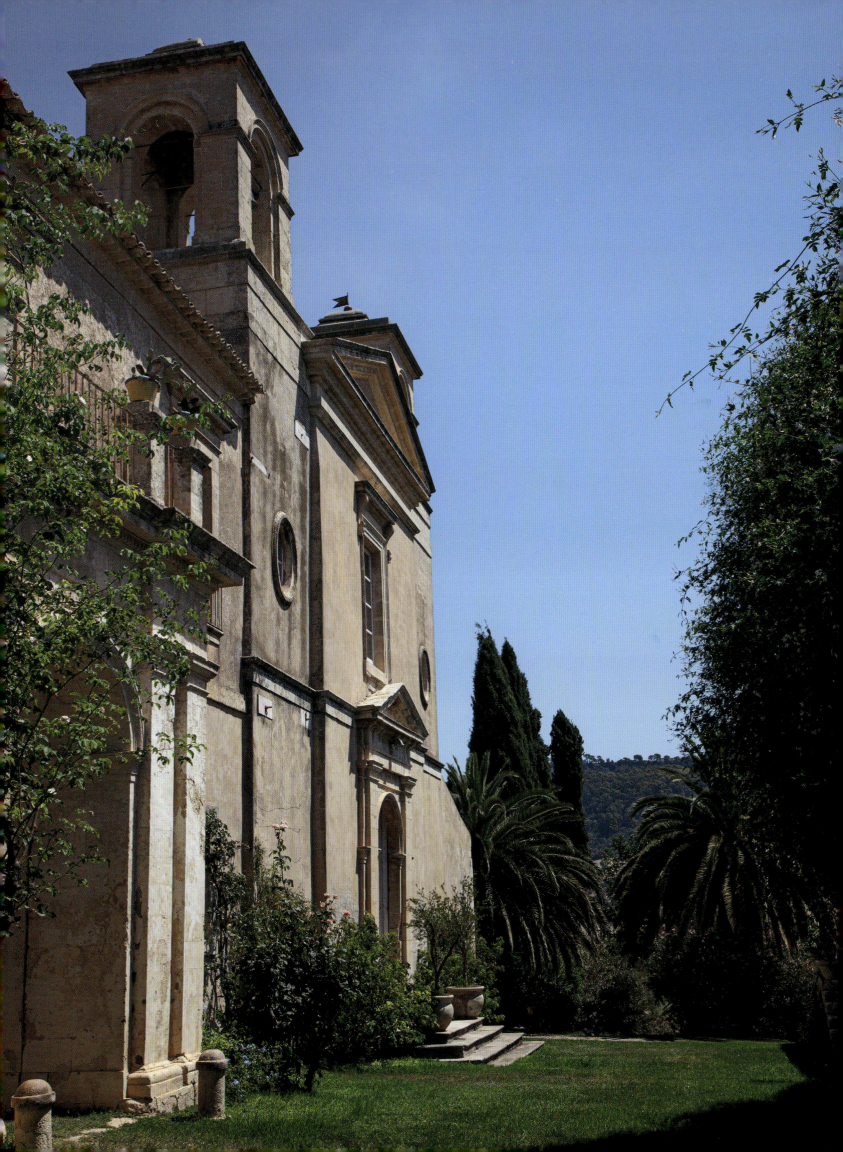

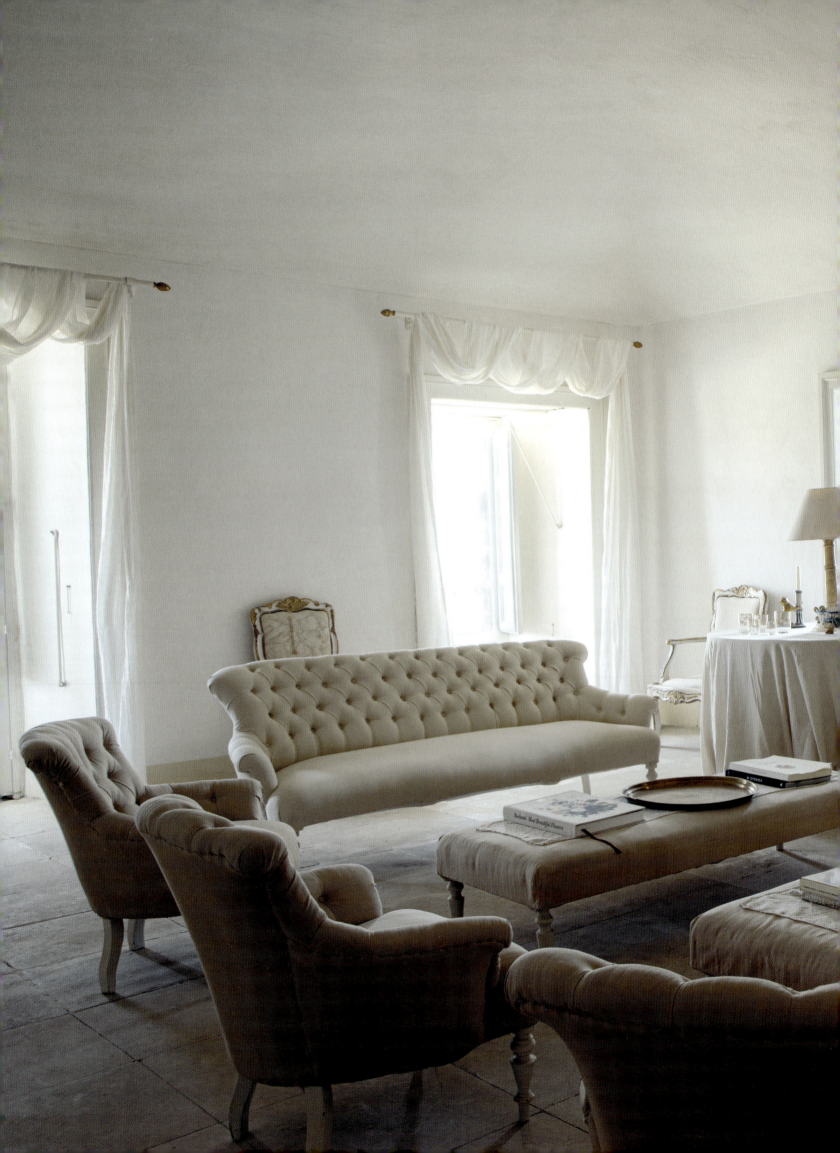

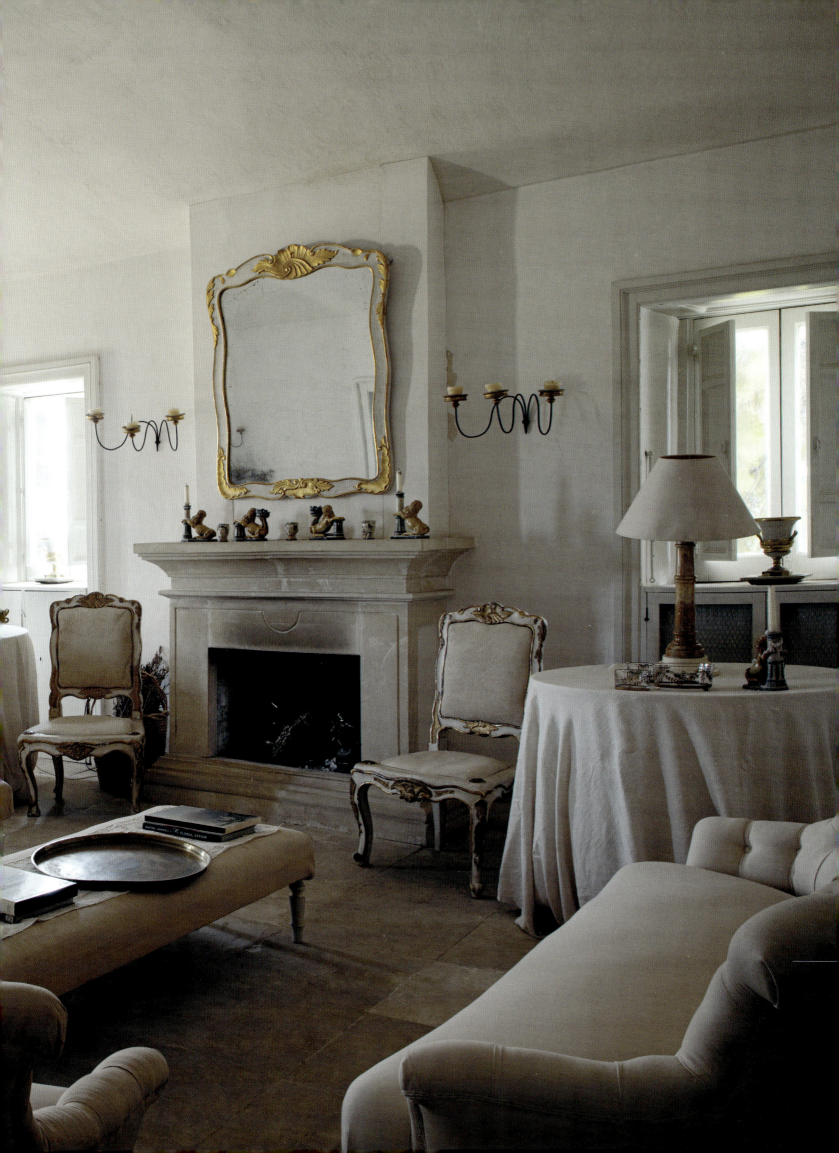

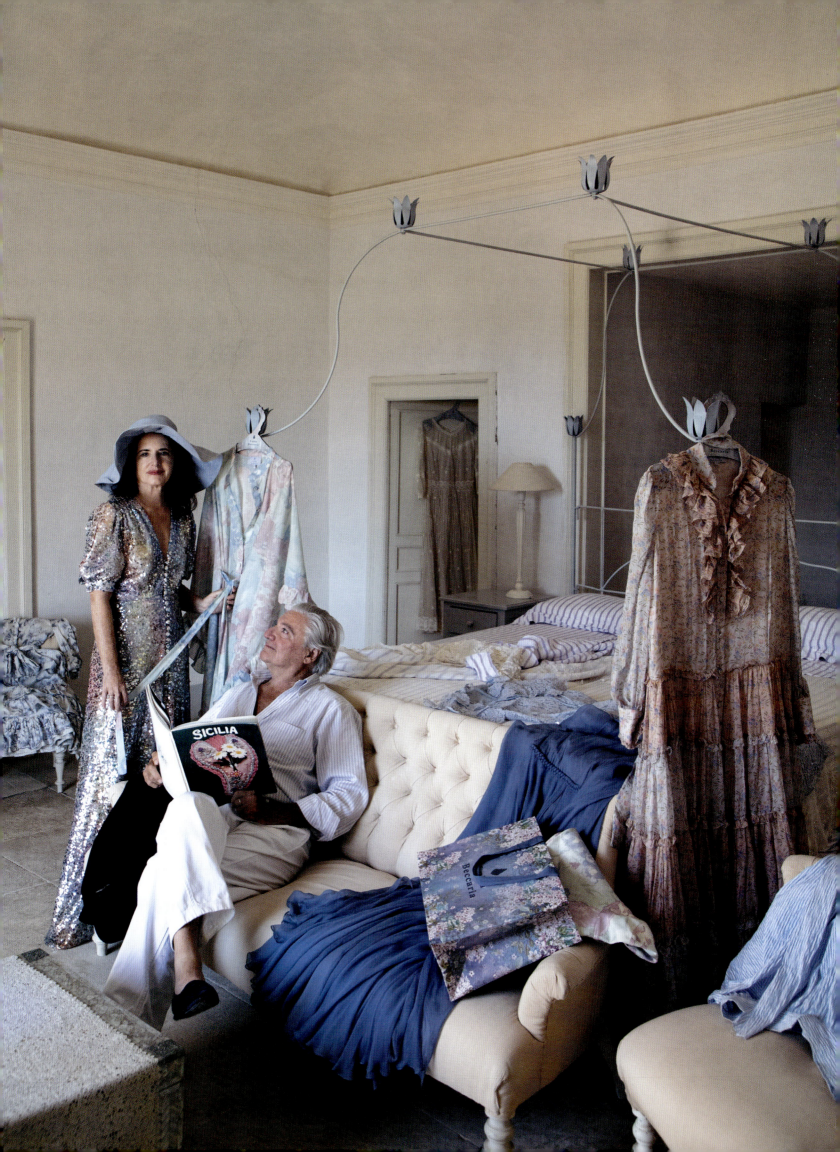

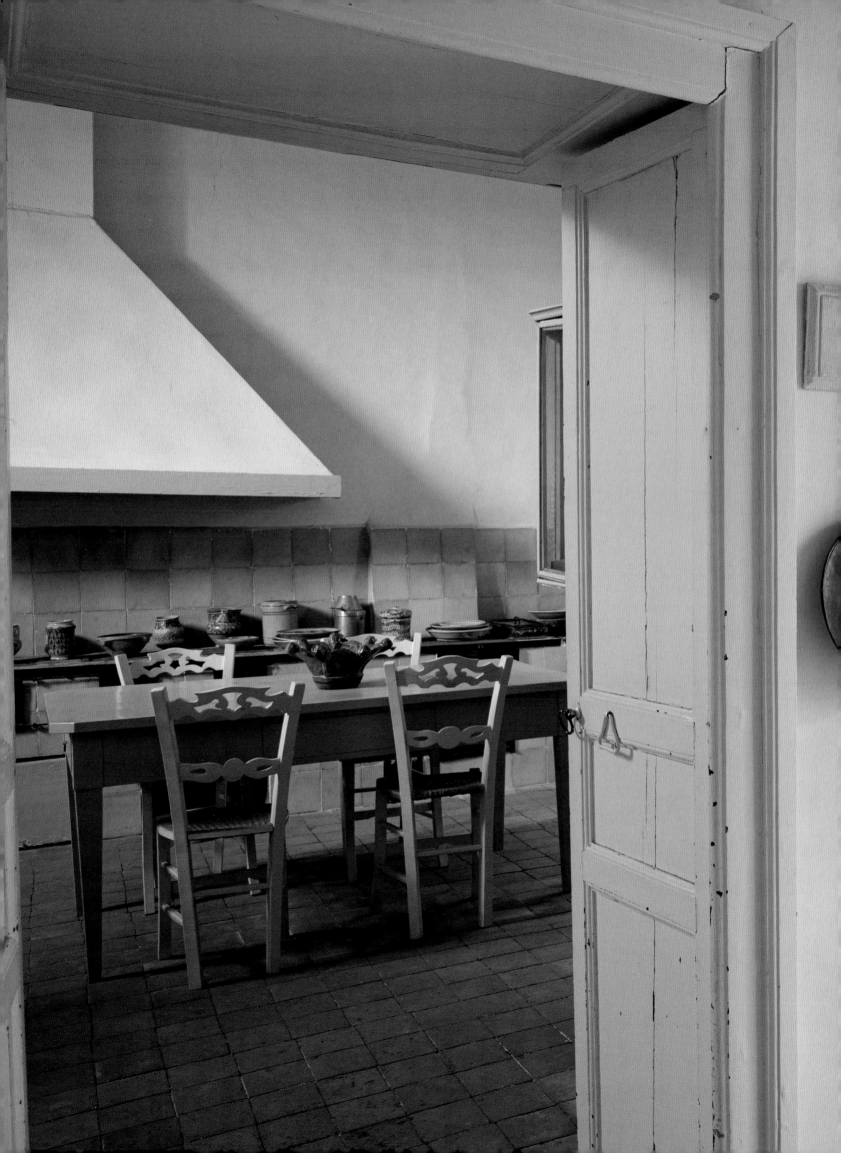

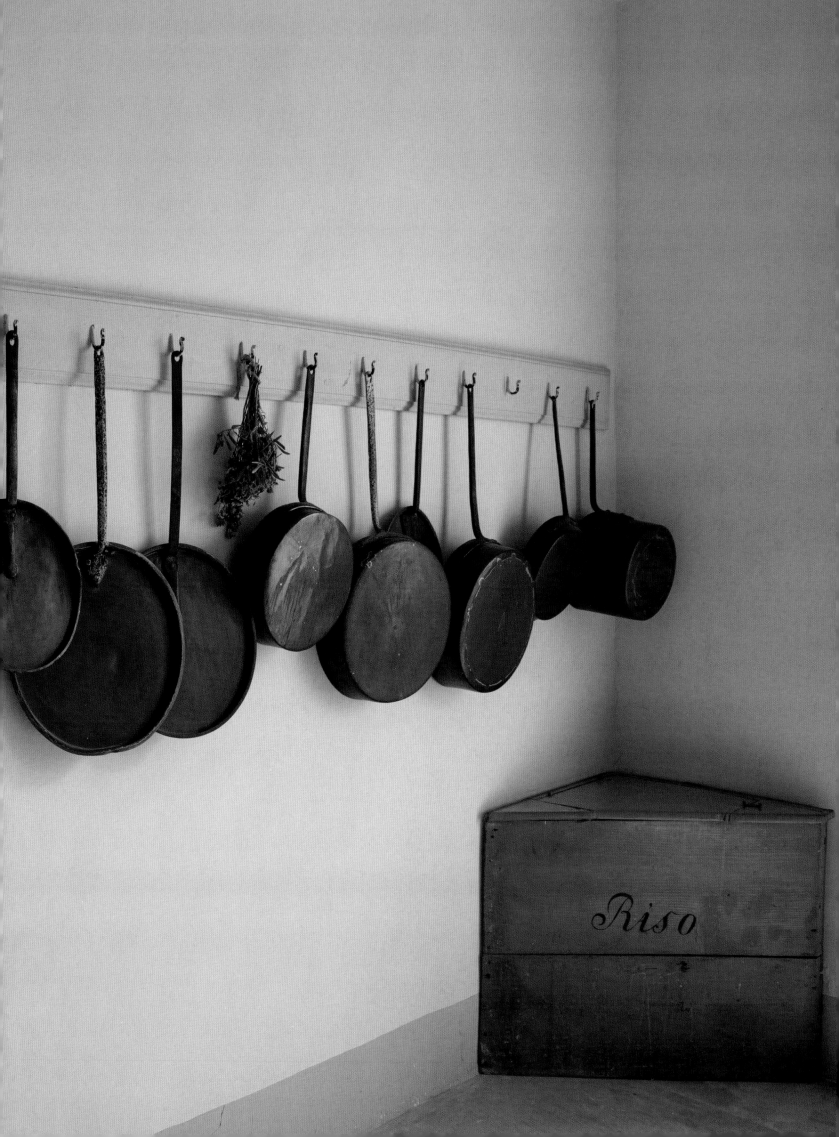

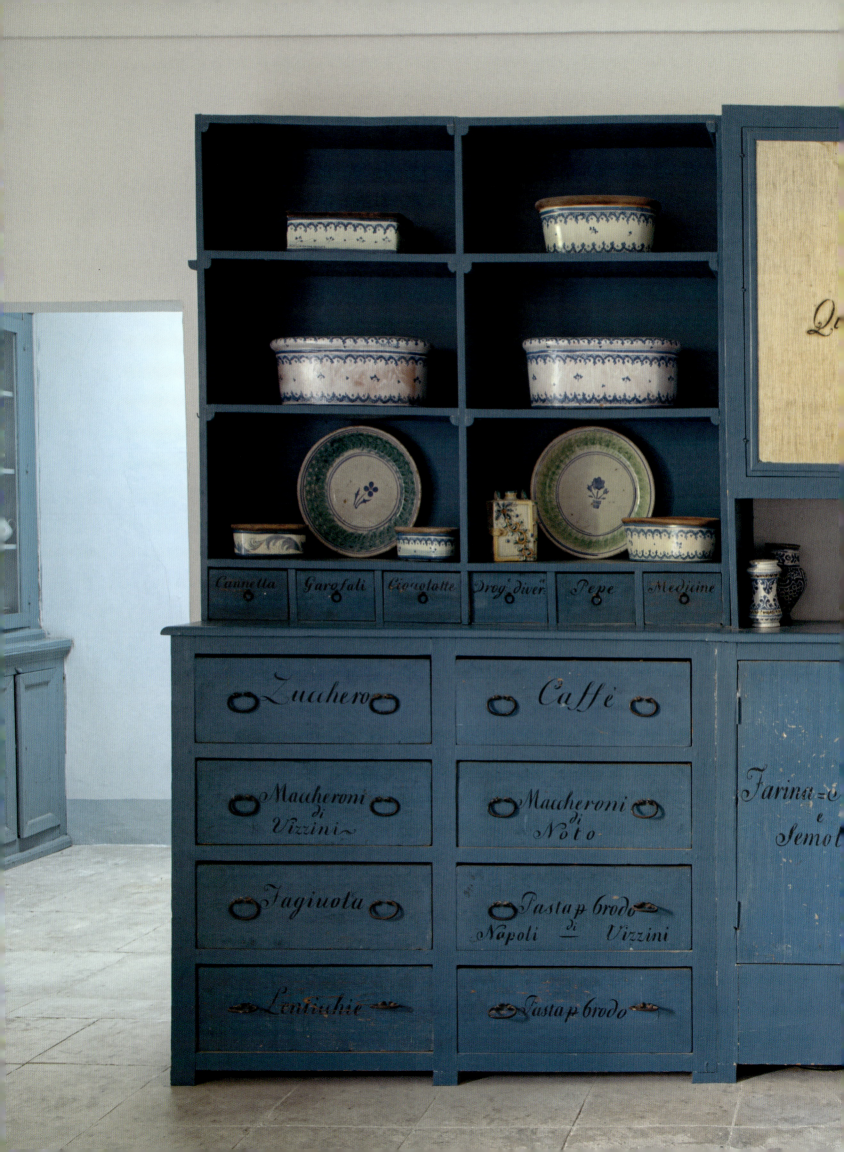

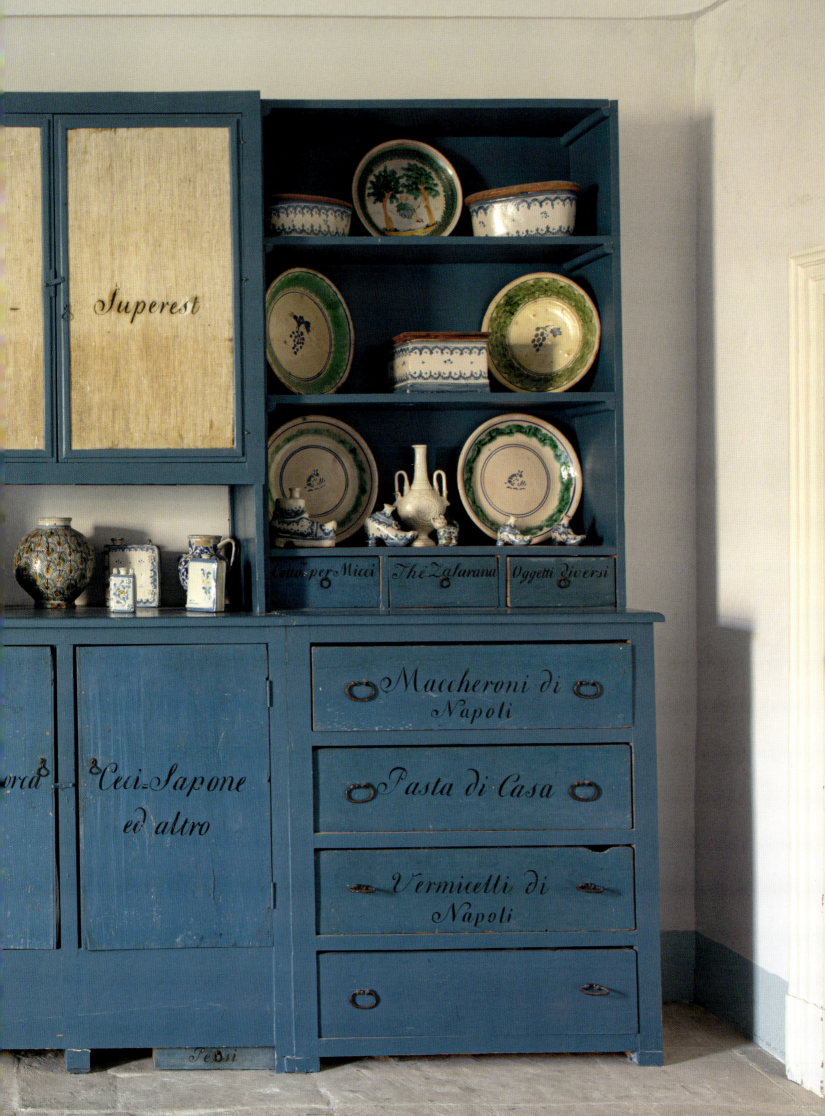

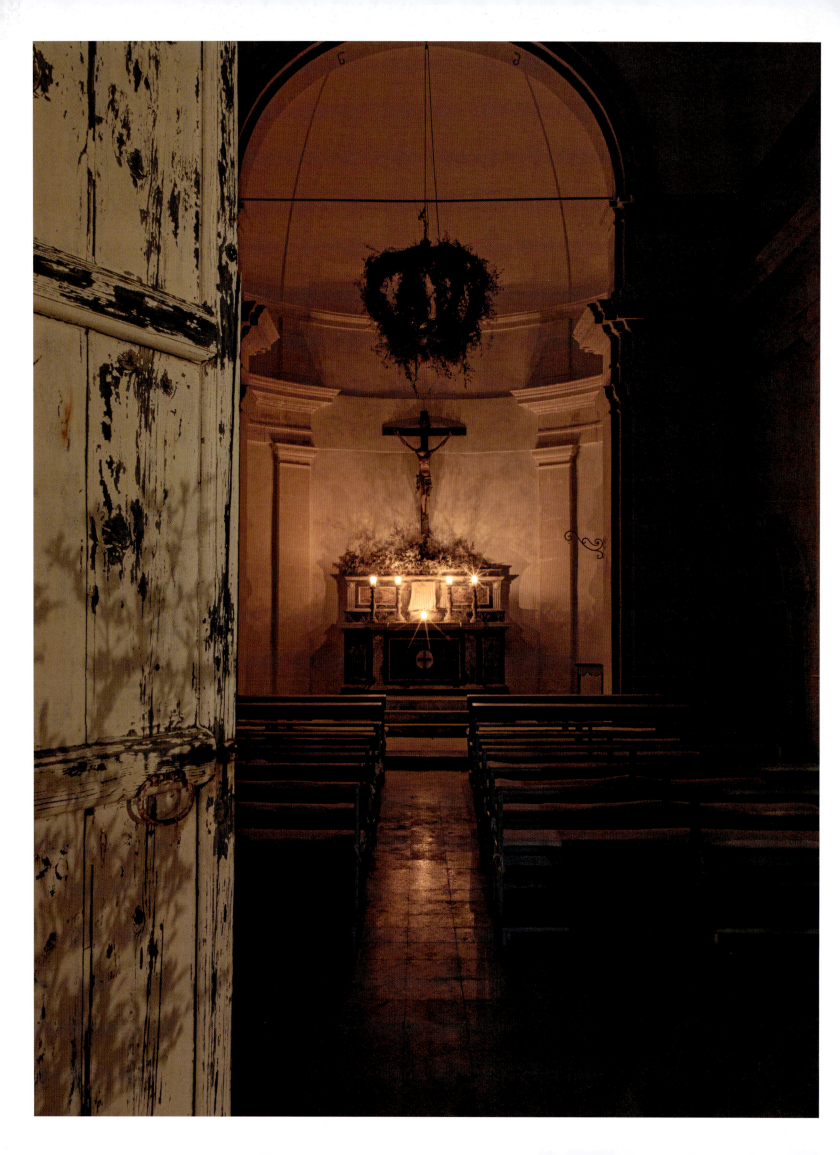

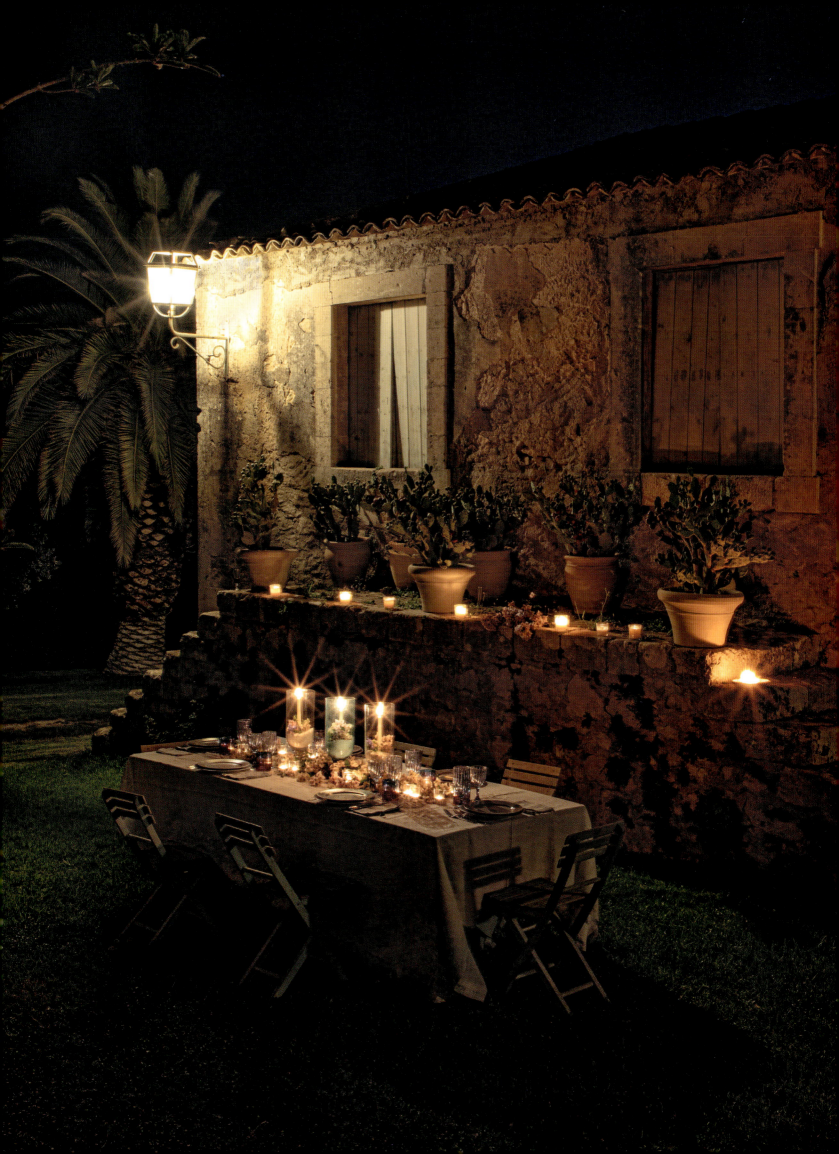

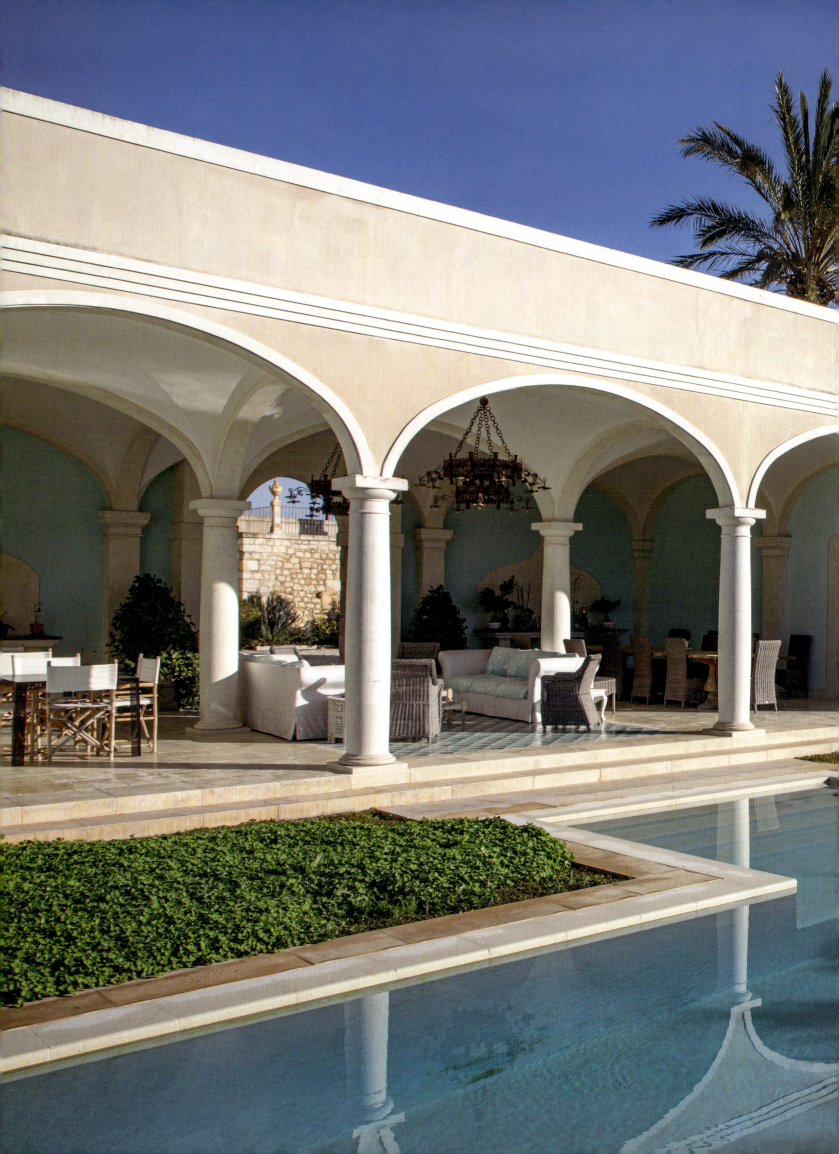

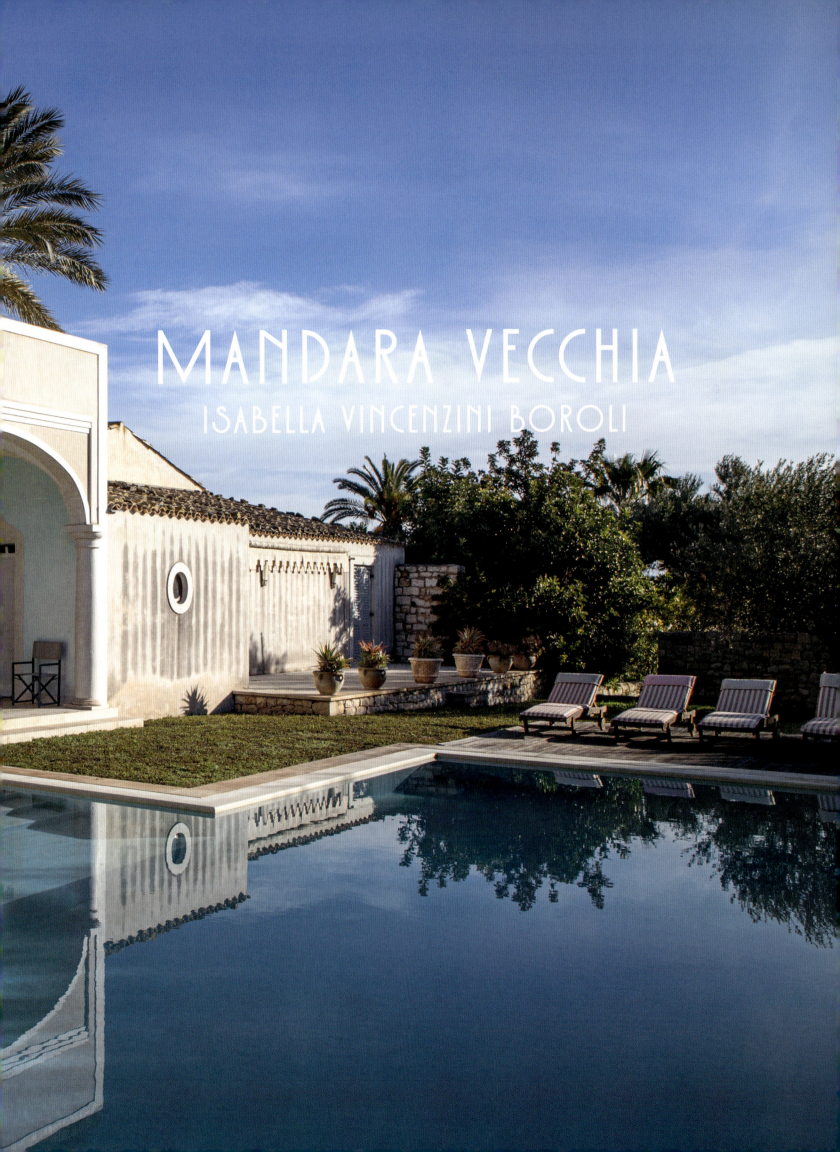

On one of the dusty dirt roads linking Noto to Ragusa, where fields of almond trees and small agricultural enterprises seem untouched by time, a narrow driveway leads to Mandara Vecchia. The journey is marked by ancient drystone walls, cut and stacked with precision, guiding visitors to the *masseria*. Even before reaching the entrance, the landscape reveals its layered richness as spires of giant agave the color of oxidized copper pierce the silver-flecked foliage of centuries-old olive trees. Just beyond, an emerald expanse of manicured lawn unfurls like a moat around the *masseria*, an unexpected oasis in the parched Sicilian terrain.

Mandara Vecchia is the project of Isabella Boroli, of the DeAgostini media empire, and her husband, Giorgio Vincenzini, formerly a leading international maritime lawyer. The couple, who primarily reside in the hills above Lucca on the Italian mainland, escape southward as often as possible to chase the Sicilian sun. Although both have a deep affection for the home, Isabella's imprint on it is unmistakable. She poured her heart into its design and the lush garden that envelops it, crafting a retreat that feels both ancient and intimate.

The *masseria*'s central courtyard, which contains both rebuilt and new structures, is enclosed by honey-hued limestone walls that have been engulfed by masses of thistle-tinted bougainvillea. Isabella greets us with secateurs in hand, fresh roses spilling from her basket. "We don't lack for water," she laughs, briefly recalling the challenges of construction and well-building. But generally, she speaks of the house's rebirth with fondness, and any frustrations with the process seem to have softened with time. "I loved the construction process," she insists, her enthusiasm palpable.

The architecture blends tradition with subtle idiosyncrasies. From the pavilion overlooking the main pool, Isabella gestures toward the columns, each swelling slightly at the center. This technique, known as *entasis*, was first perfected by the Greeks to counteract an optical illusion: if the middle of the columns were made a little bulkier, the light would slim them back down so that they would look straight. Here, Isabella has exaggerated the effect—not an easy feat, but one that lends a sculptural quality to the space.

Moving between the pavilions, there is a seamless integration between interior and exterior. A guest pavilion, framed by an intricately carved entryway of Balinese wood, opens to a lotus-filled reflecting pool. Inside the main house, smoothly plastered arched passages transition into creamy stone floors that match the materials in the courtyard. Each room adheres to its own subtle color scheme, reinforcing the home's sense of deliberate cohesion, with surfaces that glow under the warm Sicilian light. Every detail, from the arcaded loggias to the shaded terraces, suggests a home designed with intention and love, a place where nature and architecture exist in quiet harmony.

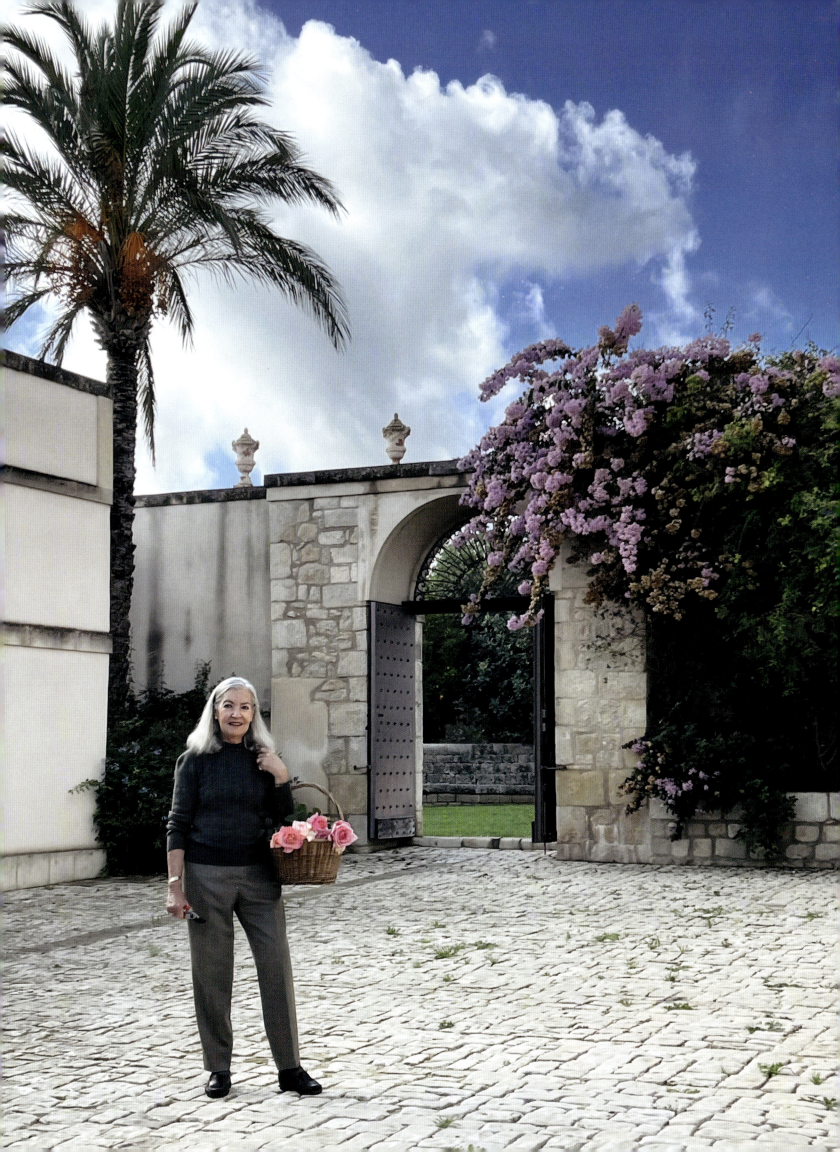

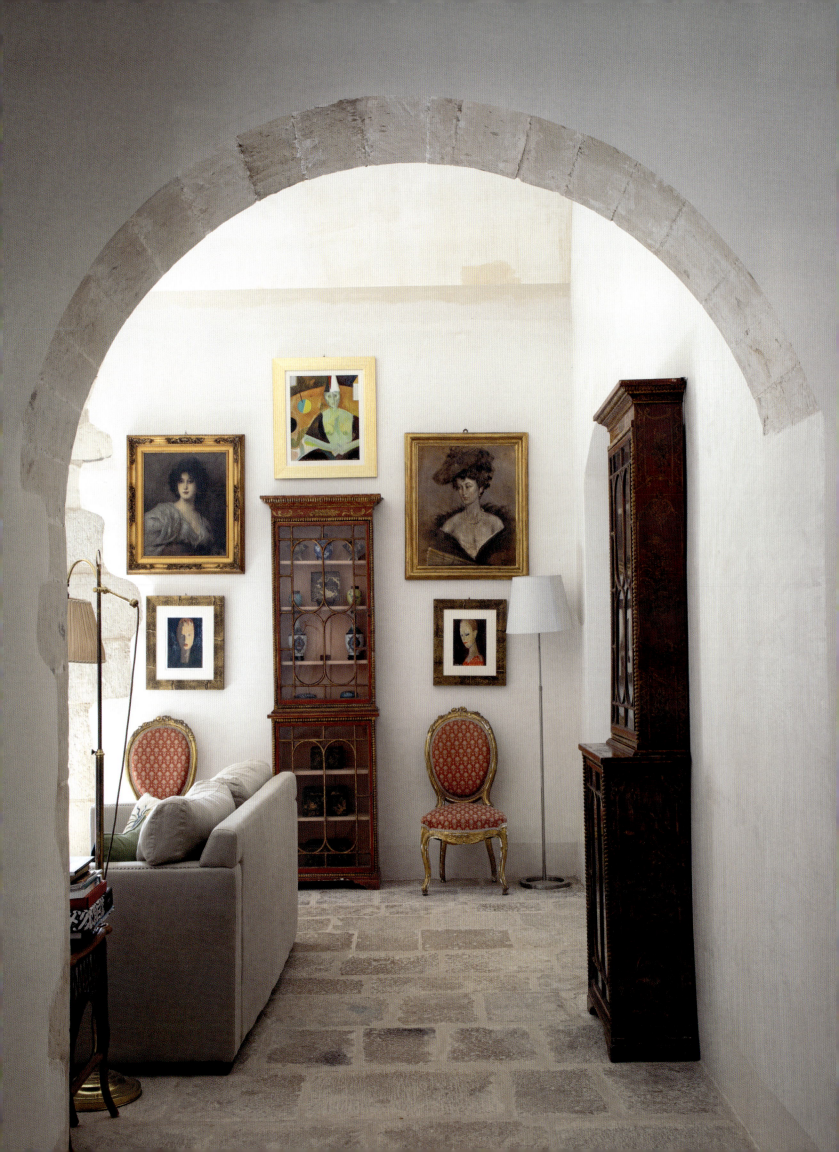

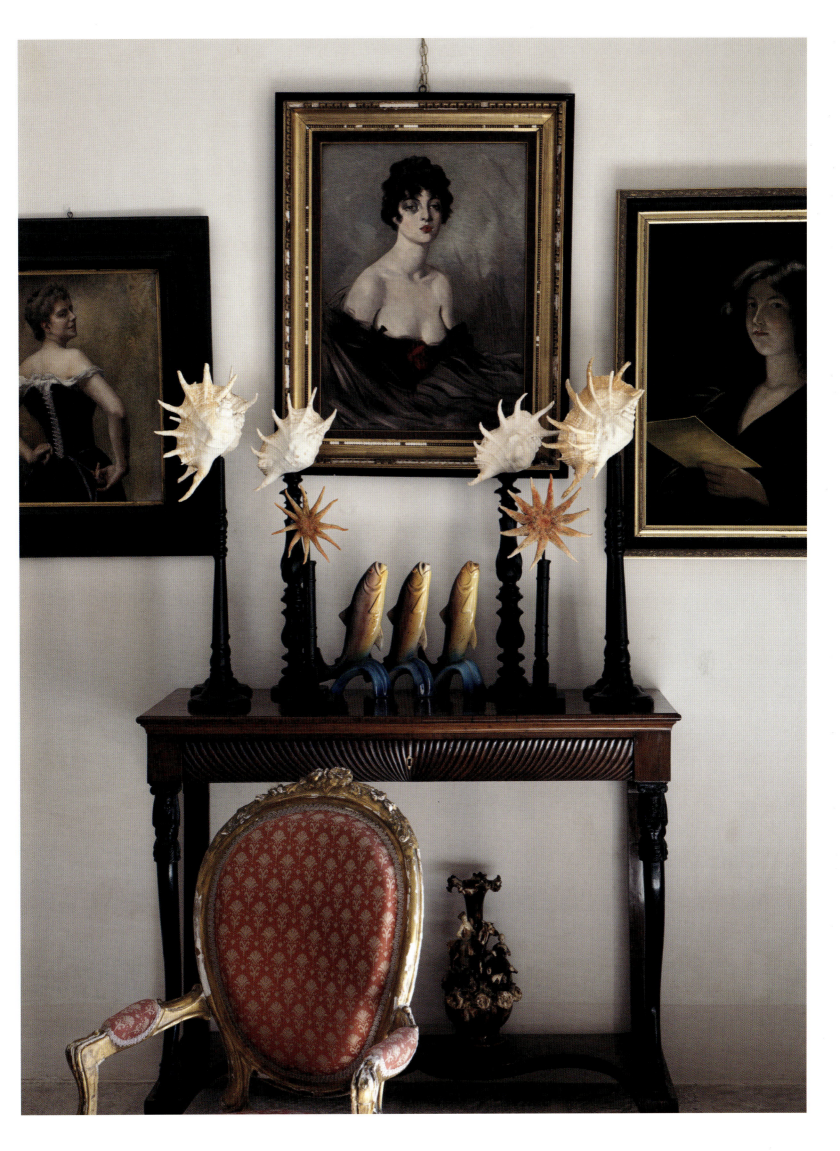

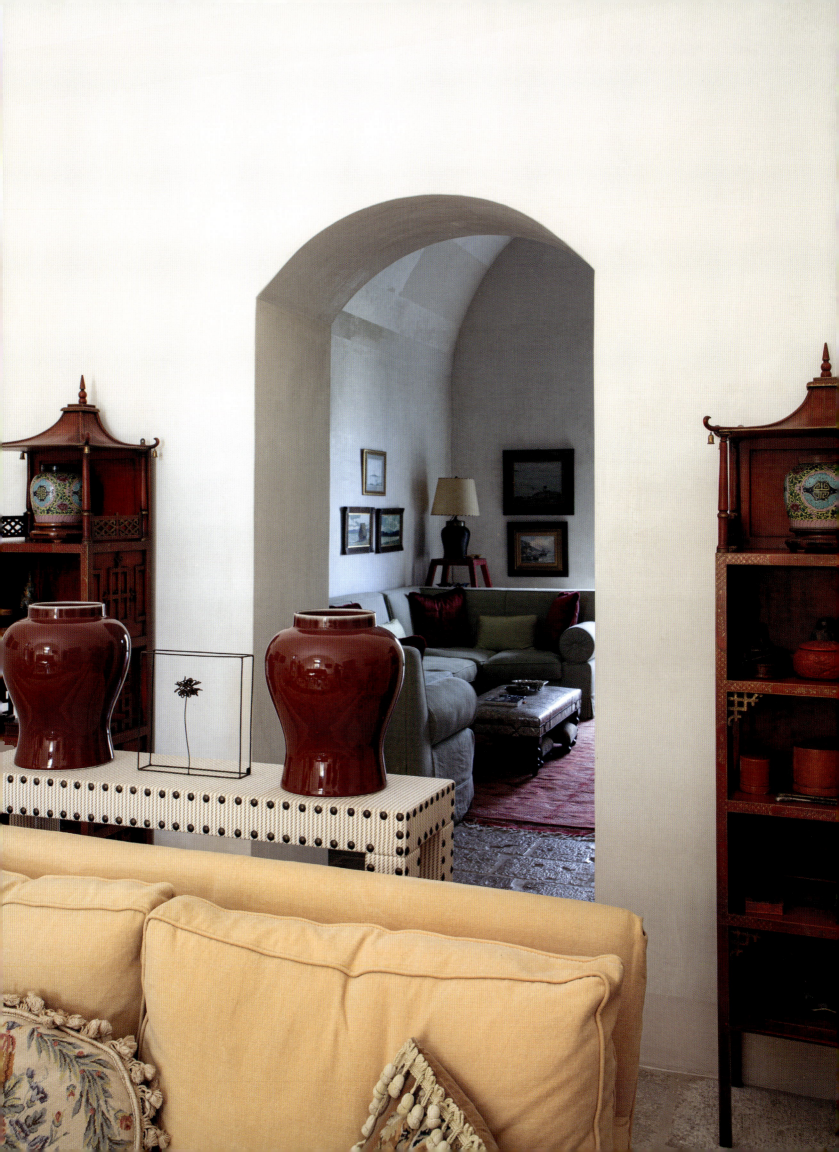

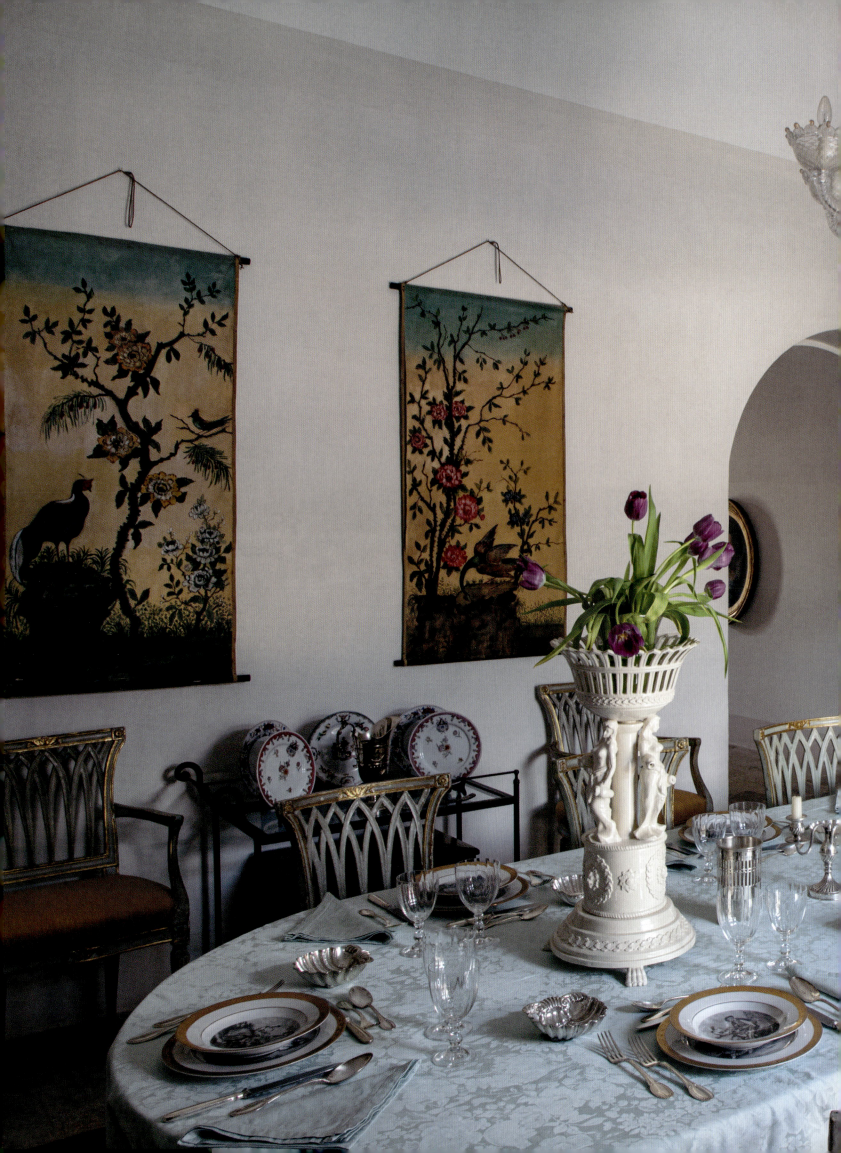

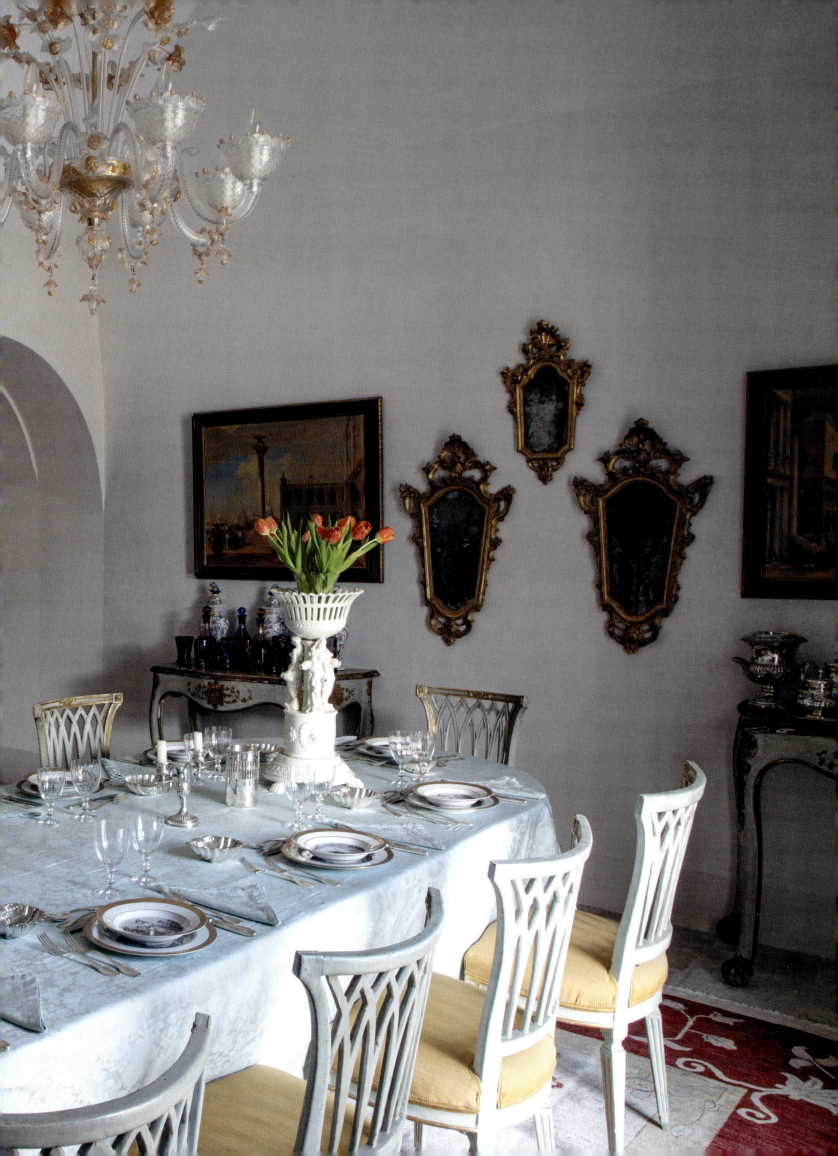

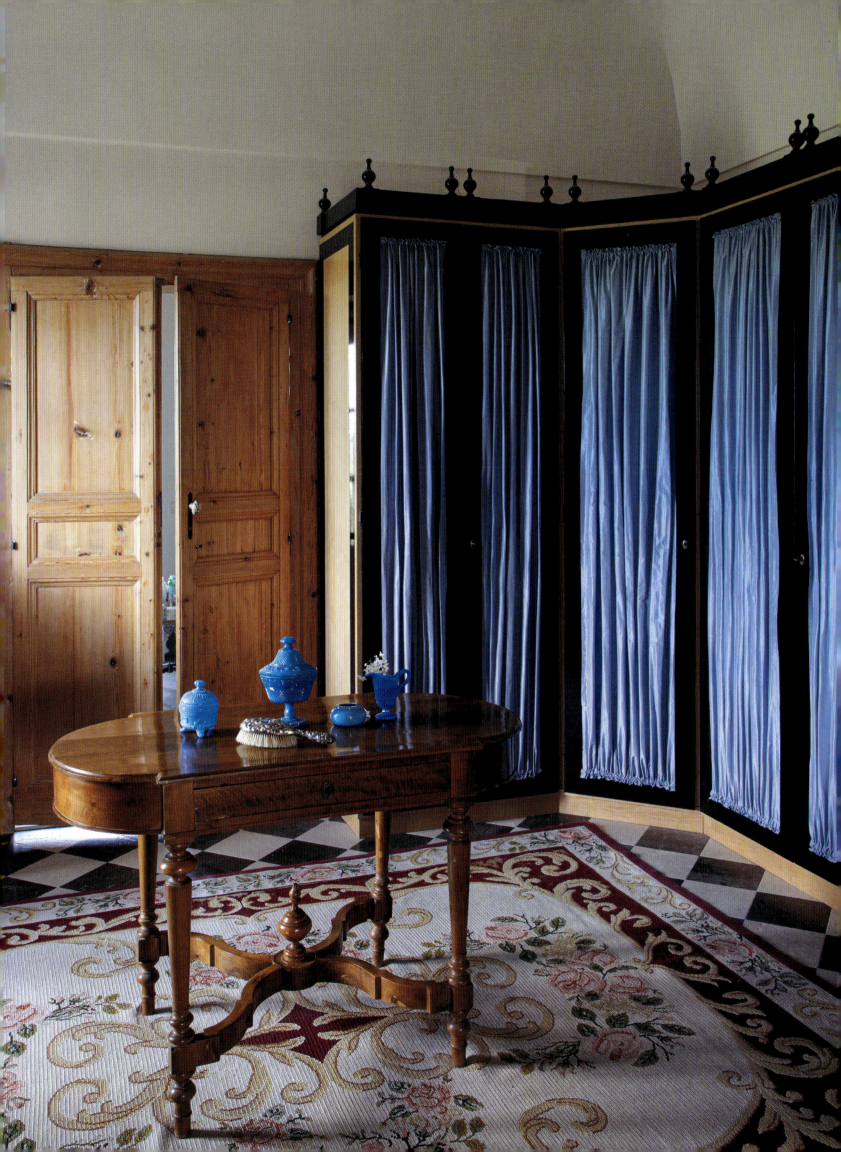

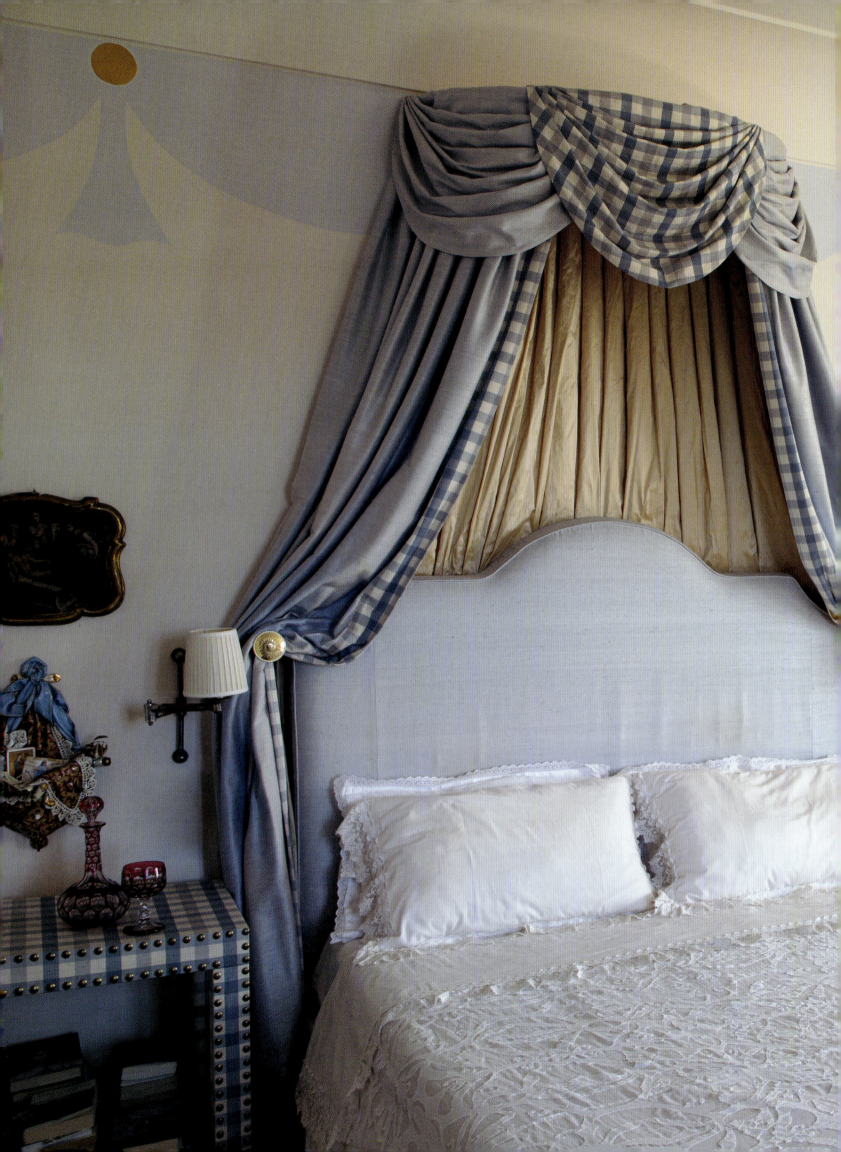

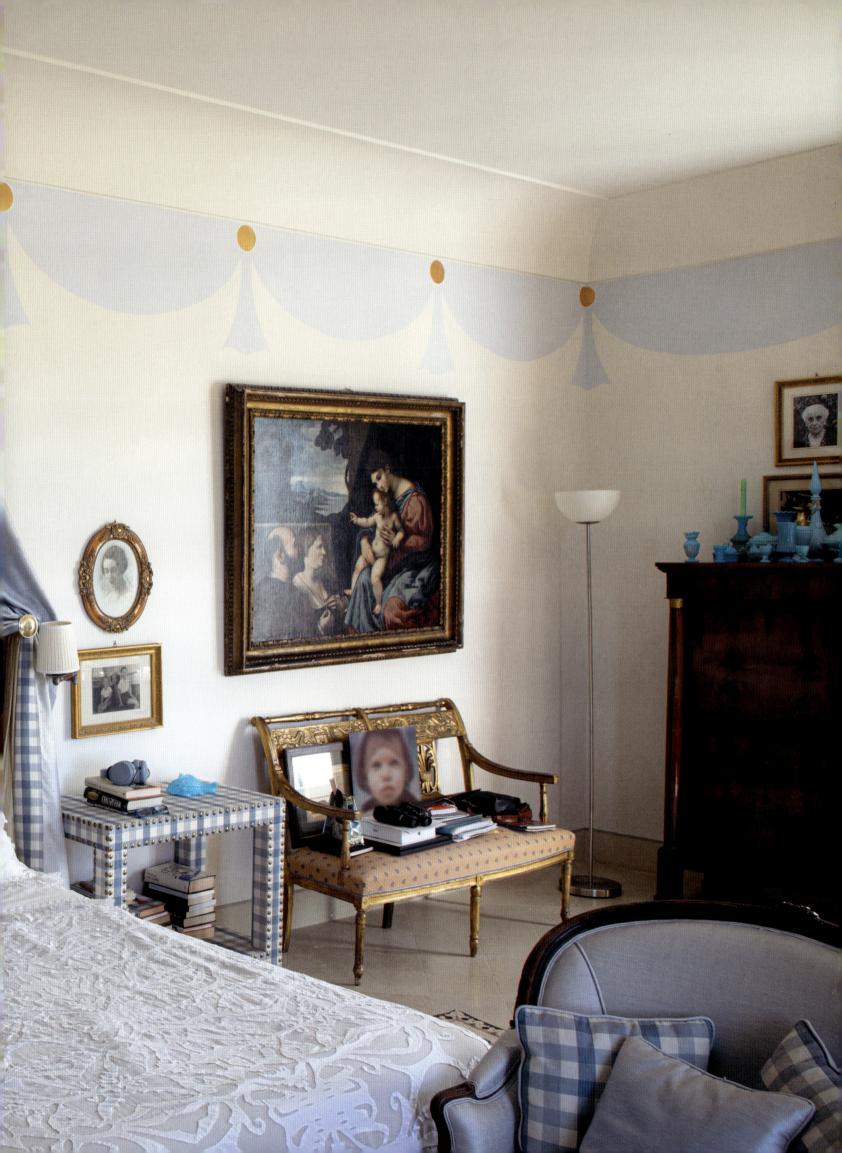

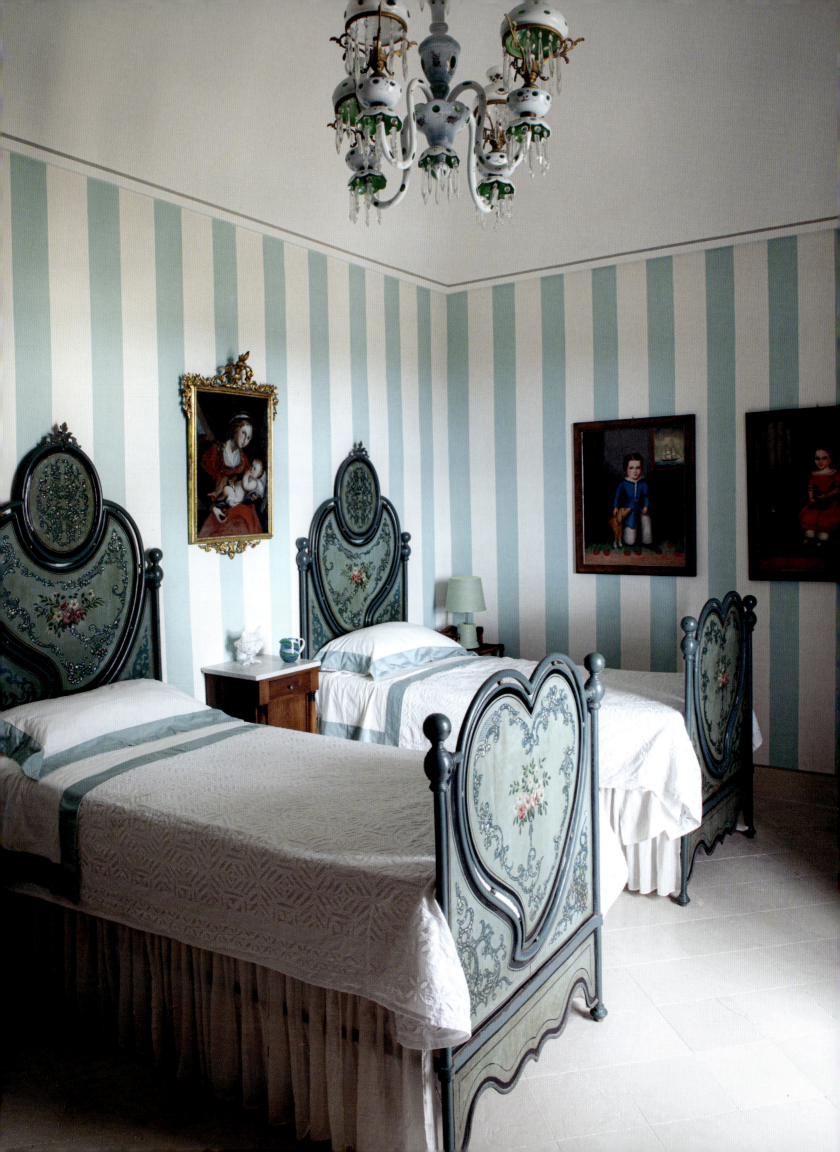

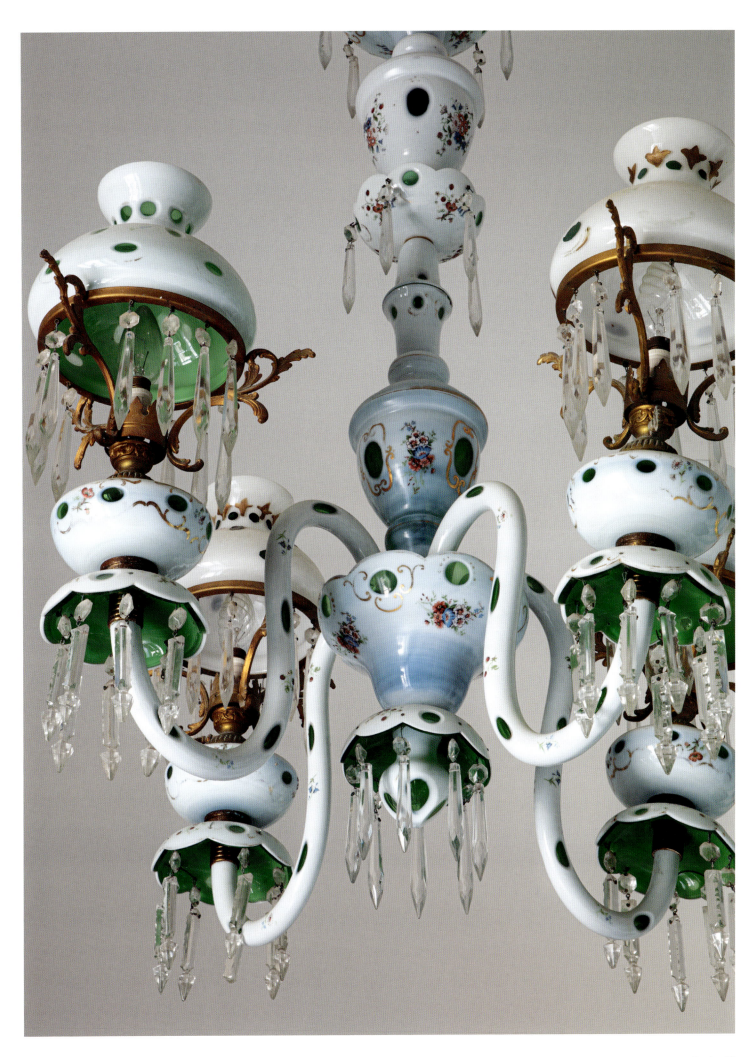

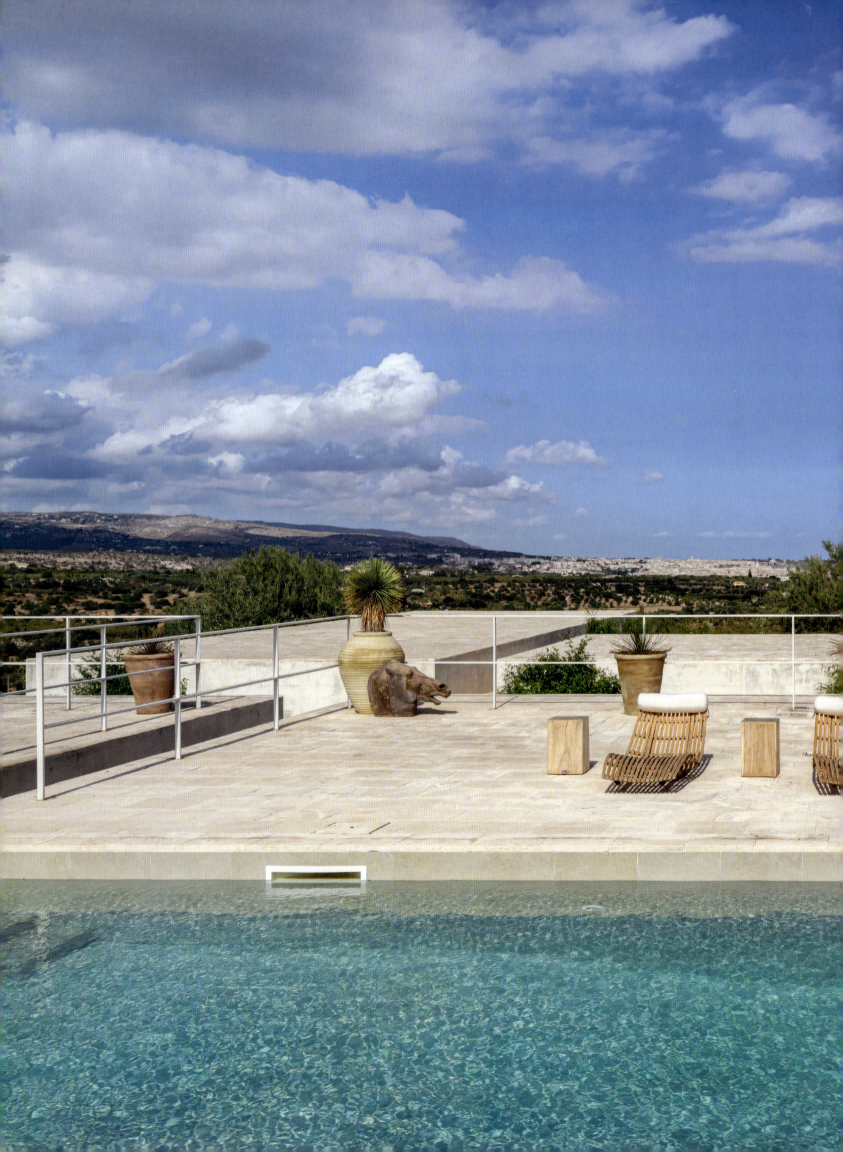

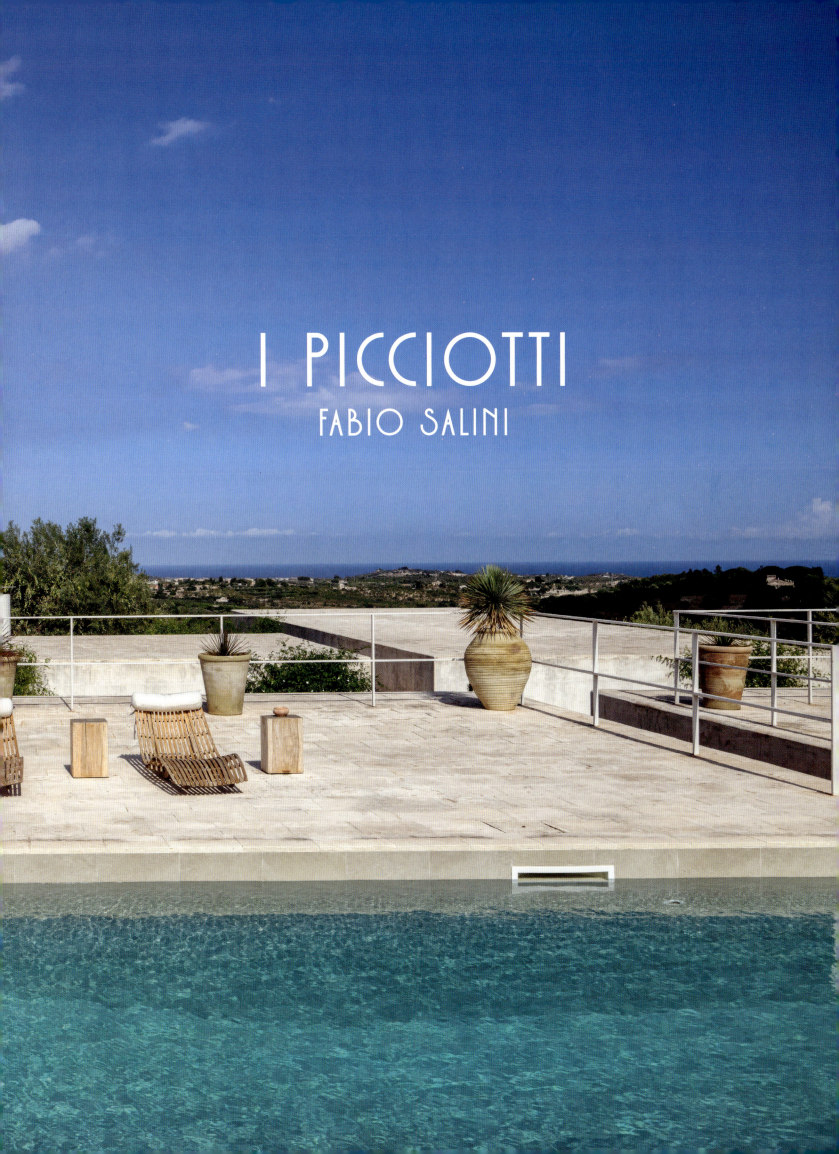

Perched high in the hills overlooking the limestone city of Noto and the shimmering Mediterranean beyond, this strikingly modern house—the Sicilian retreat of jeweler Fabio Salini—is in the Baroque triangle between Noto, Modica, and Scicli that is sometimes affectionately called the Sicilian Riviera. It is designed by Rome-based firm Bevilacqua Architects, and constitutes a unique interpretation of the island's vernacular architecture. Two minimalist volumes—one housing guest rooms, a gym, and a rooftop pool, and the other containing the main living and dining areas, as well as two master bedrooms—are set in a lush garden. Although contemporary in form, the house remains deeply connected to its surroundings, with carefully designed openings that keep the scorching sun at bay while allowing the cooling sea breezes to flow freely.

Fabio is a designer whose jewelry challenges traditional notions of luxury, so it is fitting that his home does the same for architecture. "I didn't want it to be a new house imitating an old one," he explains. Instead, he sought to capture the essence of Sicily through materiality, craft, and a seamless relationship with the land. I Picciotti is very much a product of his design approach: an appreciation for tradition without nostalgia; a reverence for craft; and an unshakable belief that true luxury lies not in extravagance, but in authenticity.

The structure is inspired by the *baglio siciliano*, a traditional courtyard house like a bailey, with a centuries-old olive tree at its heart. The walls, thick and textured, are rendered in sand-colored plaster, echoing the island's limestone terrain, while floors of hand-worked Noto stone create continuity between the interiors and the terraces. The furnishings, too, are an homage to Sicilian heritage, with antique pieces sourced from local *palazzi* sitting alongside custom-made contemporary designs in natural materials, such as leather, wood, and linen.

Fabio's reverence for craft is evident throughout the house. He spent years seeking out the island's most extraordinary artisans, commissioning works that imbue his home with a profound sense of place. One of his most notable collaborators is the ceramicist Gaspare Patti, whose Sciacca workshop Fabio describes as "a world unto itself, filled with poetry and boundless creativity." Patti's sculptural ceramics—which range from tableware to large-scale pieces—lend a tactile, artistic dimension to the interiors of I Picciotti. In Noto, Fabio turned to Antonino Sciortino, an iron artist known for his fluid metalwork. "He works iron the way others might sketch with a pencil," Fabio observes, admiring the lightness Sciortino's handcrafted designs bring to the space.

For Fabio, whose life in Rome and London is defined by precision and refinement, this house represents a return to elemental beauty. "It's a place where I can truly disconnect," he says. "Every season is magical because of the changing landscape." Here, he embraces the quiet rhythms of Sicilian life, dining on the terrace with fresh fish and local wine, surrounded by a creative community of artists and designers who, like him, have chosen to make this corner of the island their refuge.

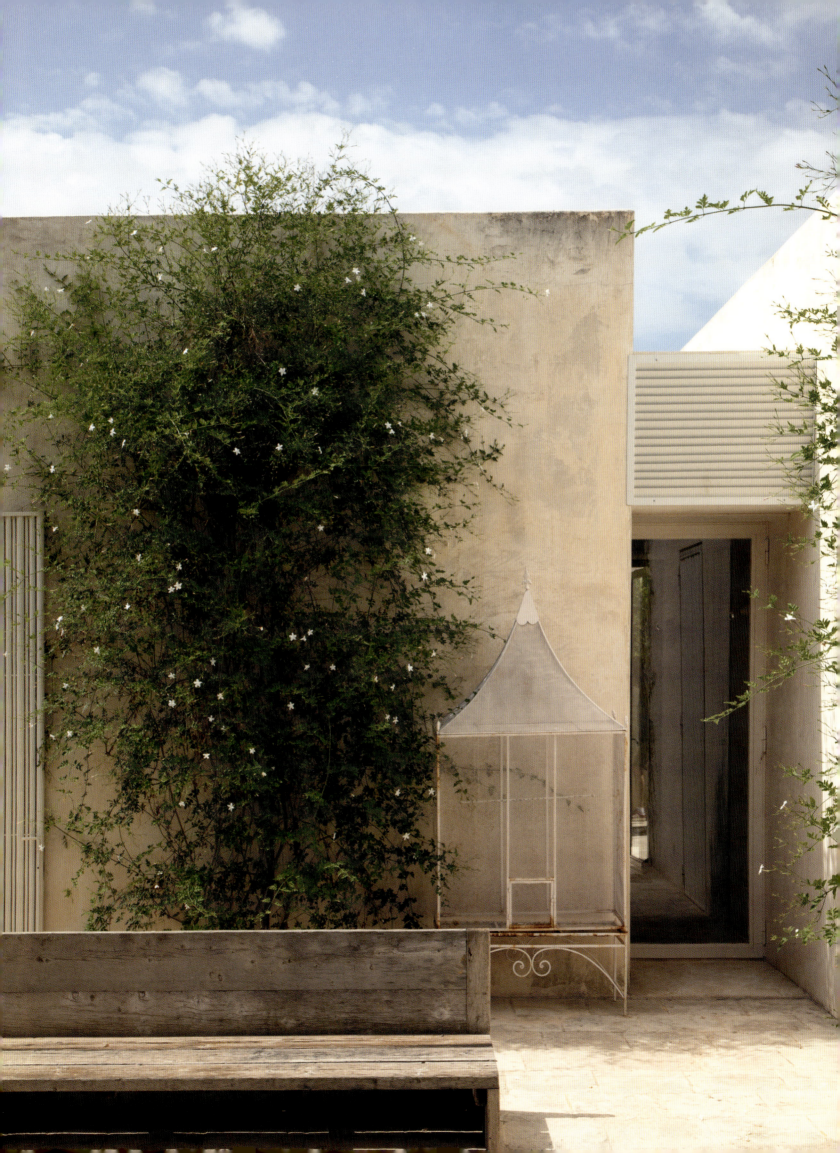

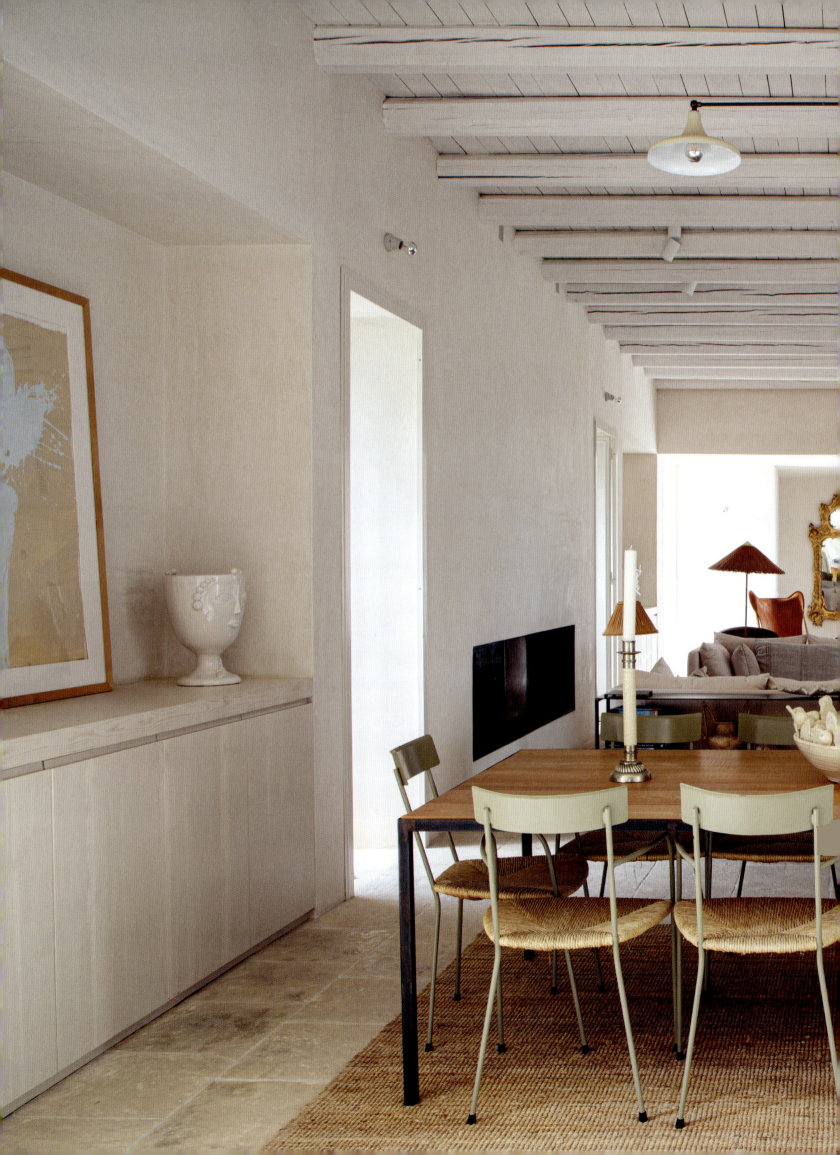

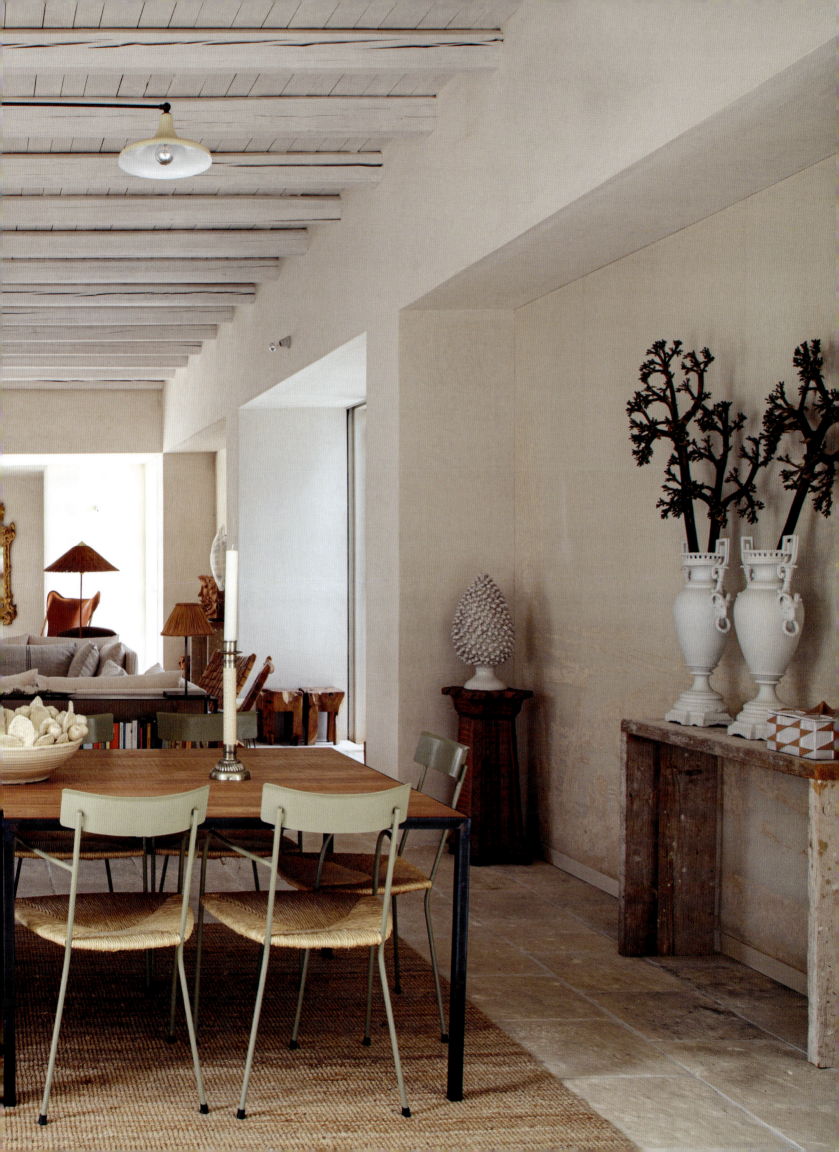

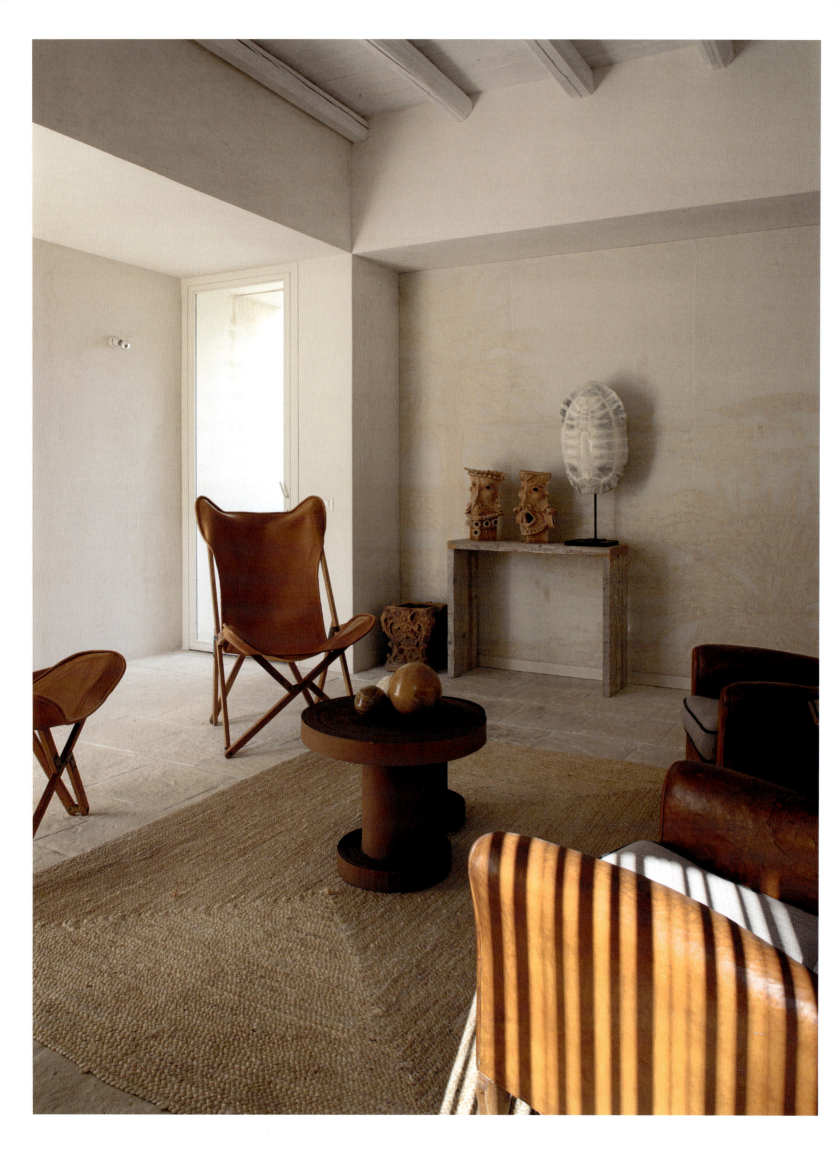

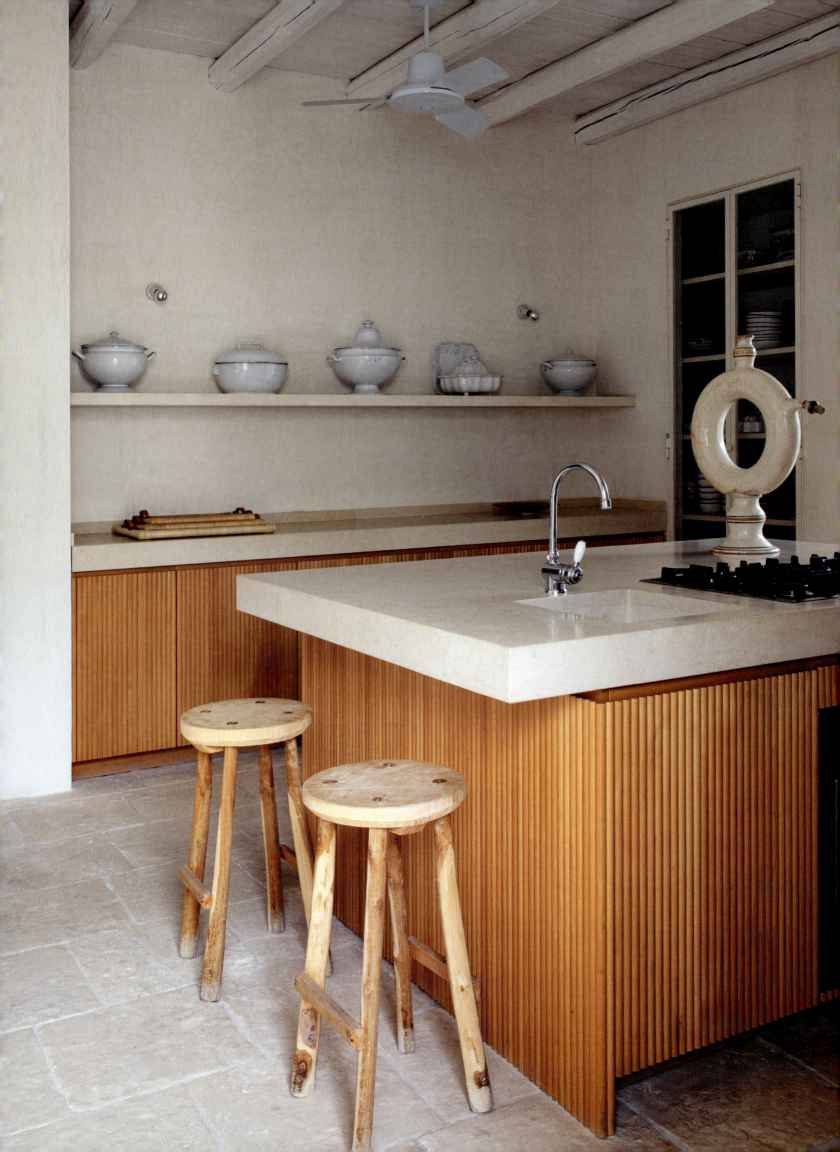

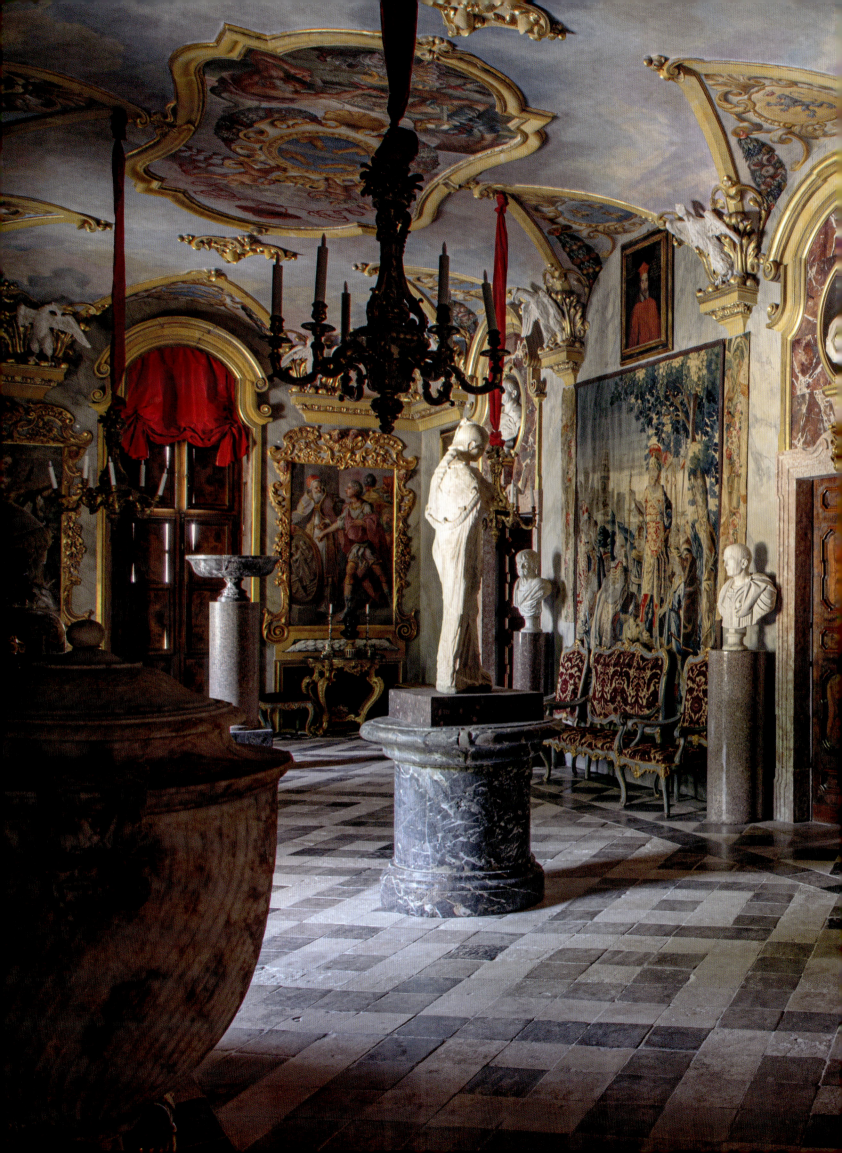

Nestled in the rolling hills near Noto, Villa Elena feels like a dream brought to life—a neoclassical jewel shimmering in the Sicilian sun. The property, lovingly restored by the architect and interior designer Jacques Garcia, is more than a home; it's a tribute to the island of Sicily's layered history, with particular attention to its Baroque grandeur.

For Jacques, the allure of Sicily is irresistible. "I spent ten years of my life recomposing the earth," he says, referencing the earthquake of 1693 that reshaped the island and gave rise to its exuberant architectural style. The building of Villa Elena began in 2015 on the remains of a Jesuit monastery, and has never really concluded; for Jacques, this is the project of a lifetime. His desk is filled with sketches of new ideas for the compound, which includes a number of outbuildings and pavilions. Its design nods to the opulence of eighteenth-century Sicilian Baroque—bold, dramatic, and unapologetically ornate—while incorporating Jacques's flair for storytelling through interiors.

The villa's Grande Galerie, once a barn in the monastery's heyday, now is embellished with floors of Sicilian stone, and seventeenth- and eighteenth-century antiques. French and Italian influences intermingle in the reception rooms, creating spaces that feel both majestic and intimate. The Green Room is particularly enchanting: a symphony of light green brocade walls, delicate plasterwork, and a show-stopping fireplace crafted from Caltagirone ceramics, among the oldest and most refined in Sicily.

Evidence of Jacques's eye for detail is everywhere: Period four-poster beds are upholstered in rich emerald and ruby silks, mahogany chairs that once belonged to the King of Naples, Marshal Murat (1767–1815), quietly grace a room, while tapestries and marble treasures round out a collection that encompasses centuries of Sicilian craft. Even the chapel is a treasure trove, with low Sicilian paneling sourced in London and a gilded bronze tabernacle that seems to glow in the light.

Step outside and the storytelling continues. Jacques's love of outdoor spaces led him to reimagine the surrounding landscape as an extension of the villa itself. Terraces cascade down the hillsides, revealing olive groves, citrus orchards, and fields of almond trees, the bare branches of which are suddenly awash with fragrant white flowers in the winter.

Villa Elena is a testament to Jacques's boundless creativity and his deep connection with Sicily. "It's not just a villa," he says. "It's the meeting of monasteries and the sea, a supernatural monument." Indeed, Villa Elena feels like a place out of time, a vision of Sicily both romantic and enduring.

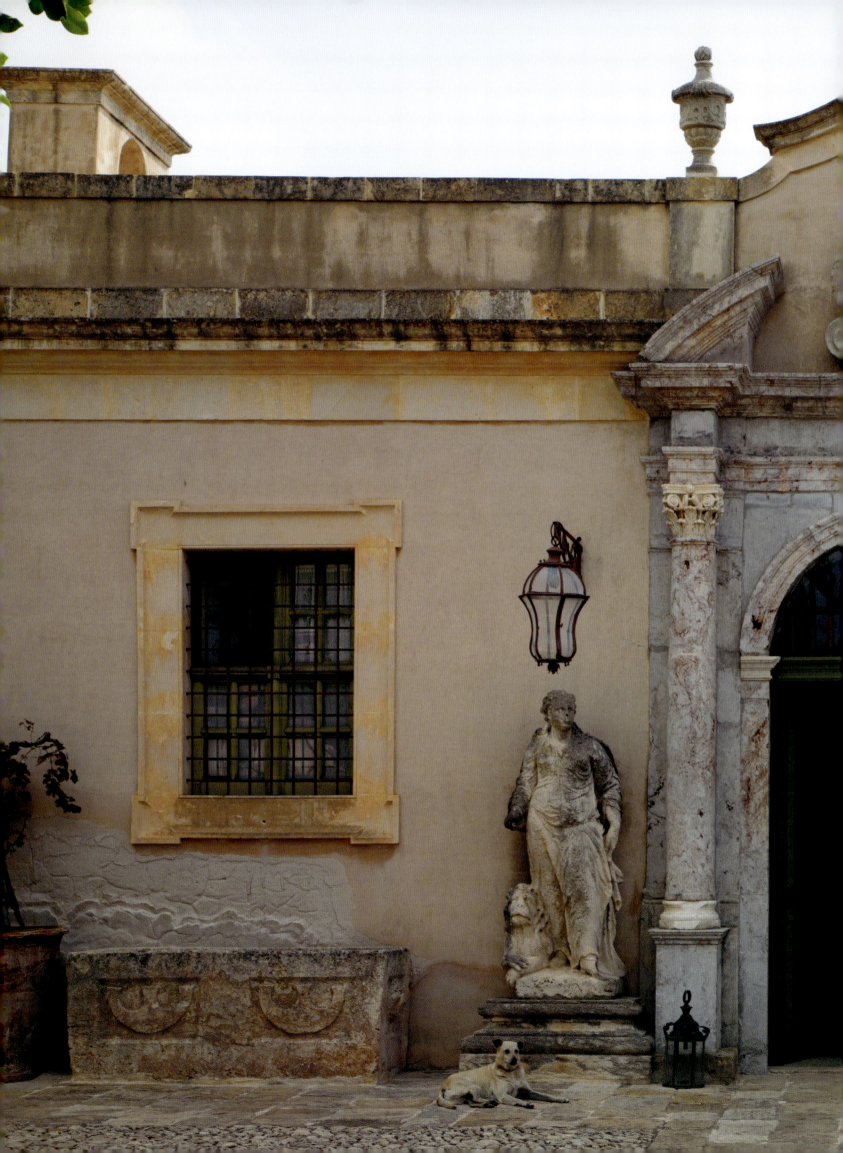

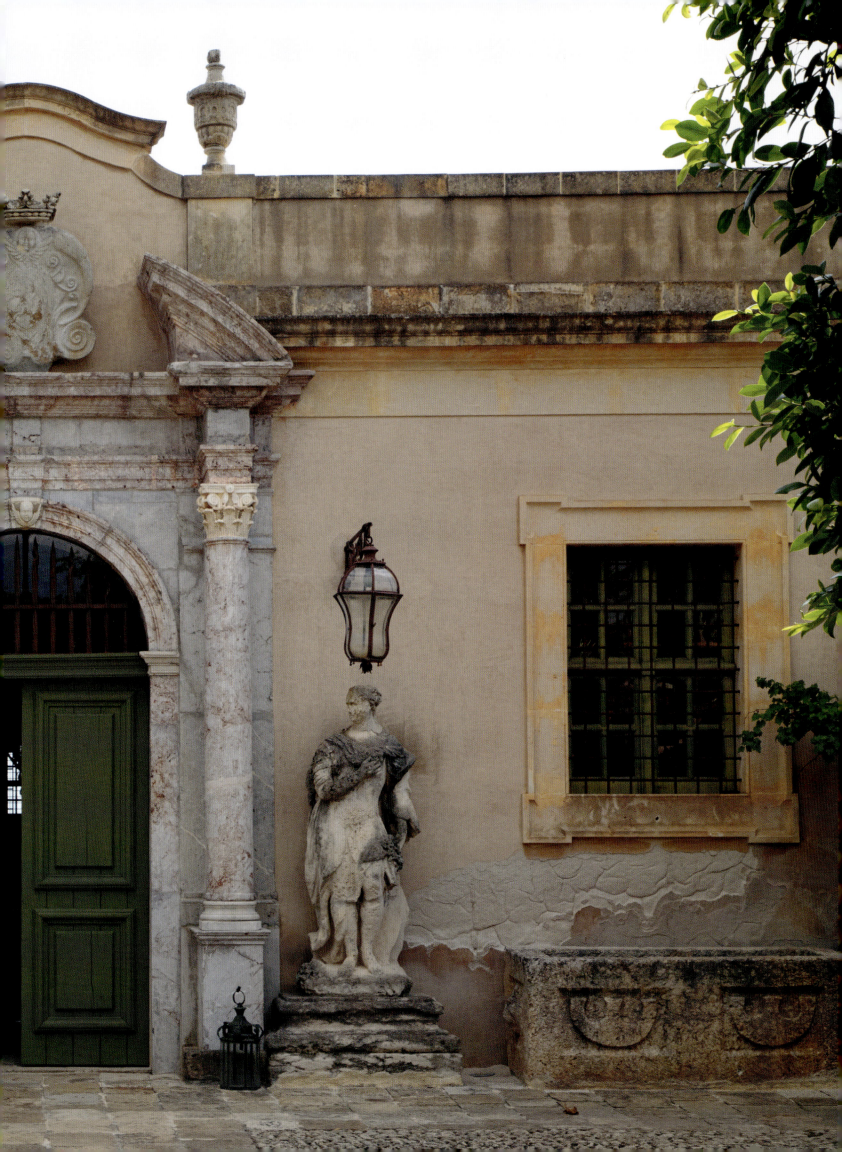

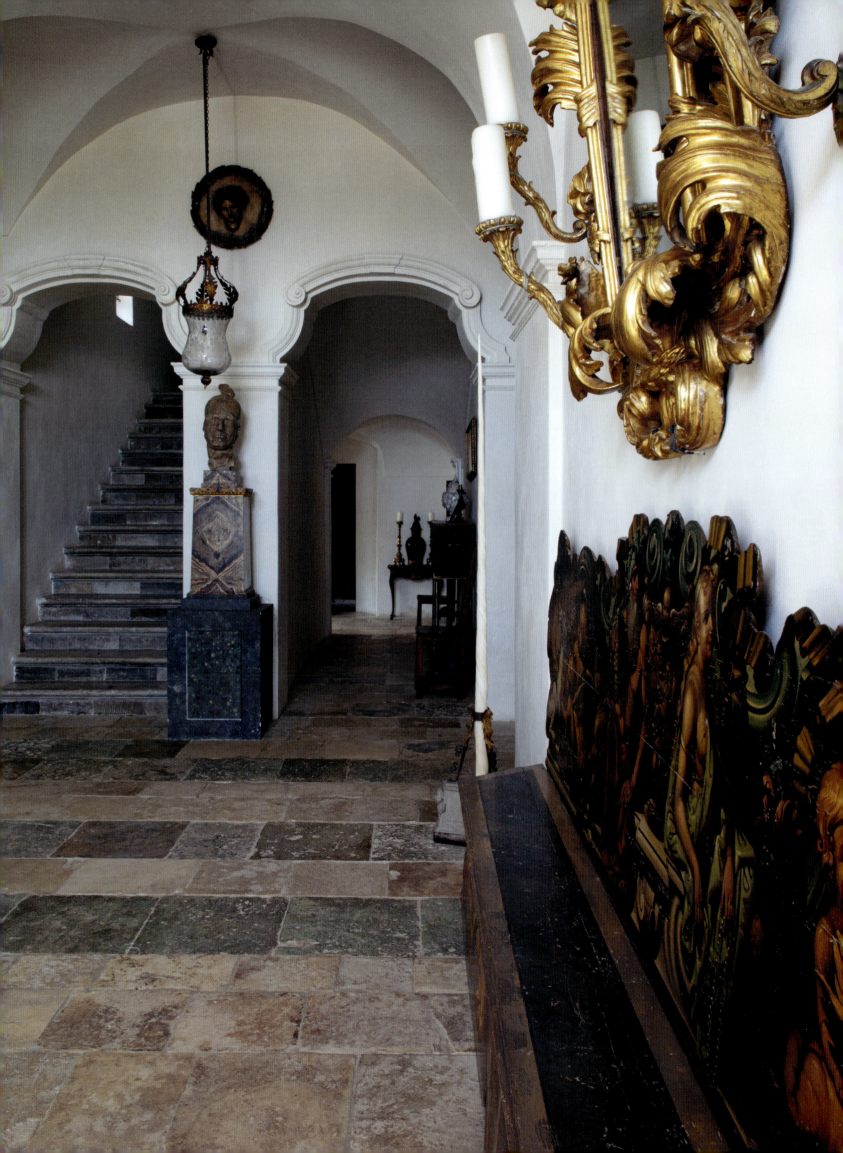

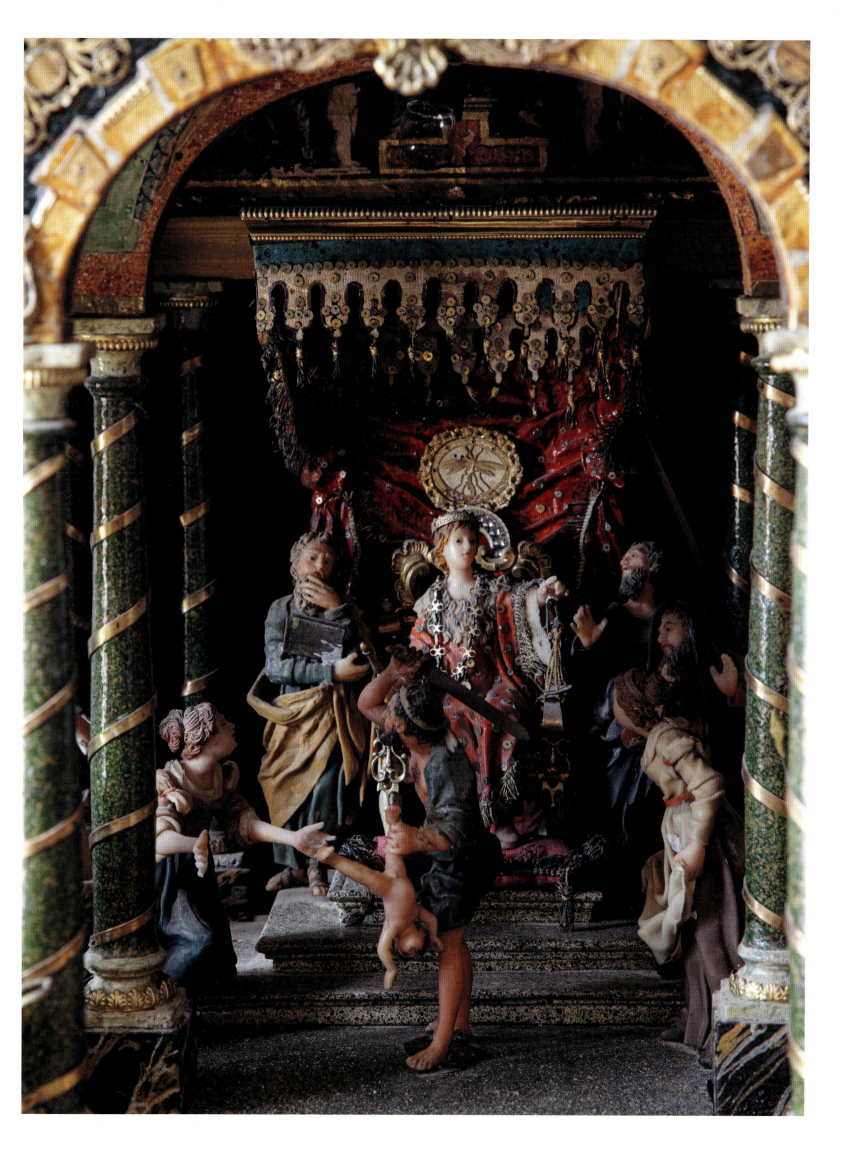

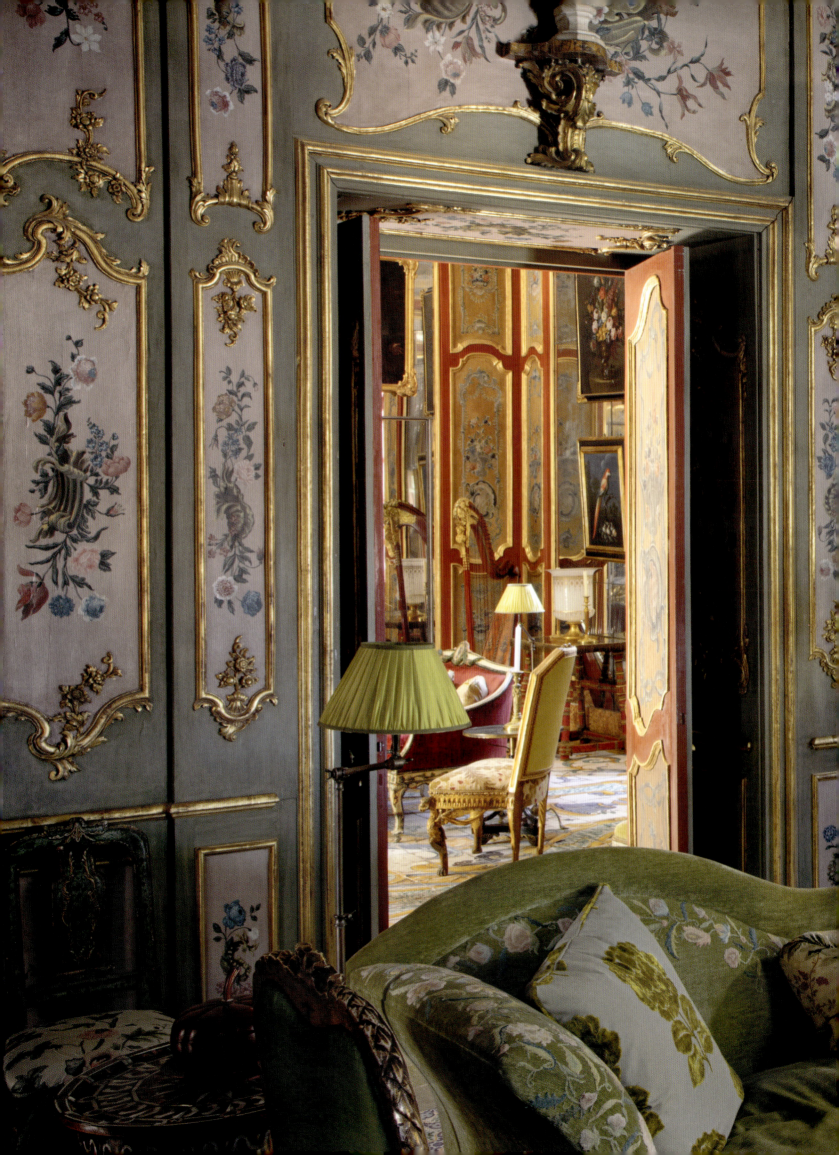

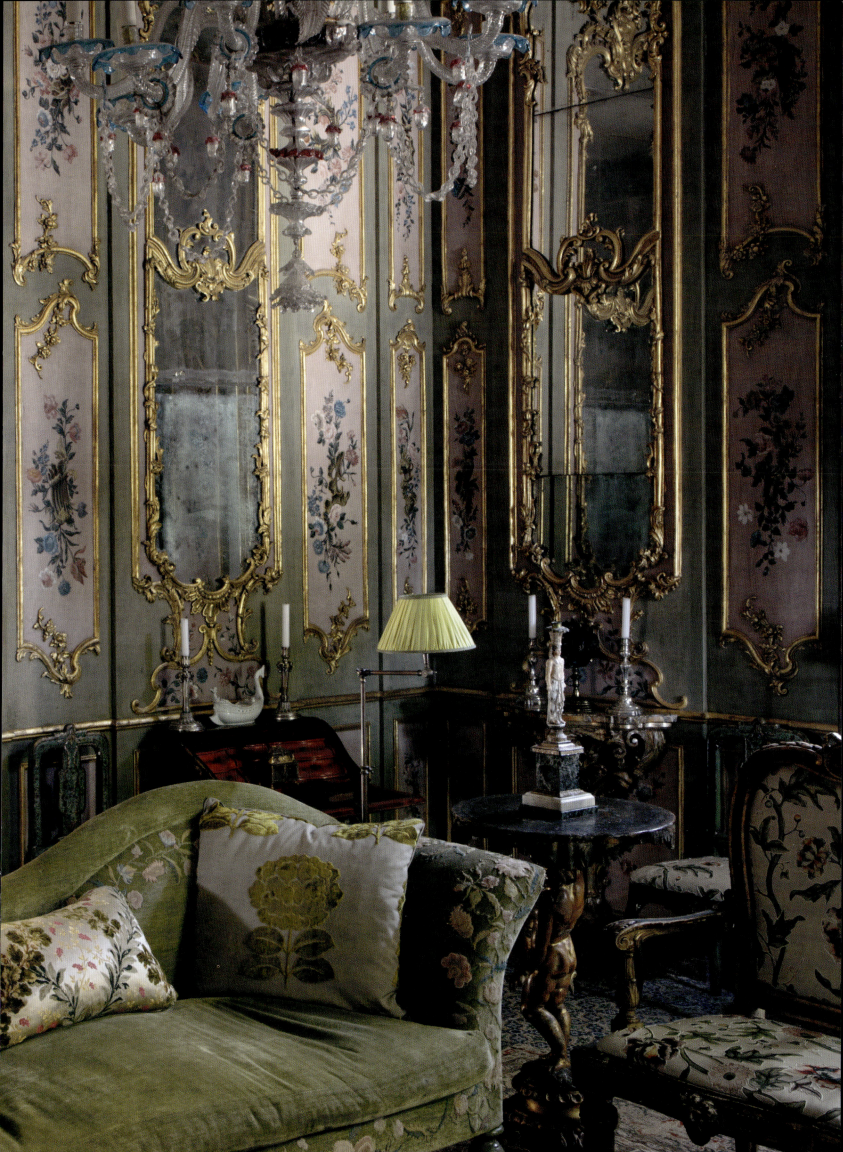

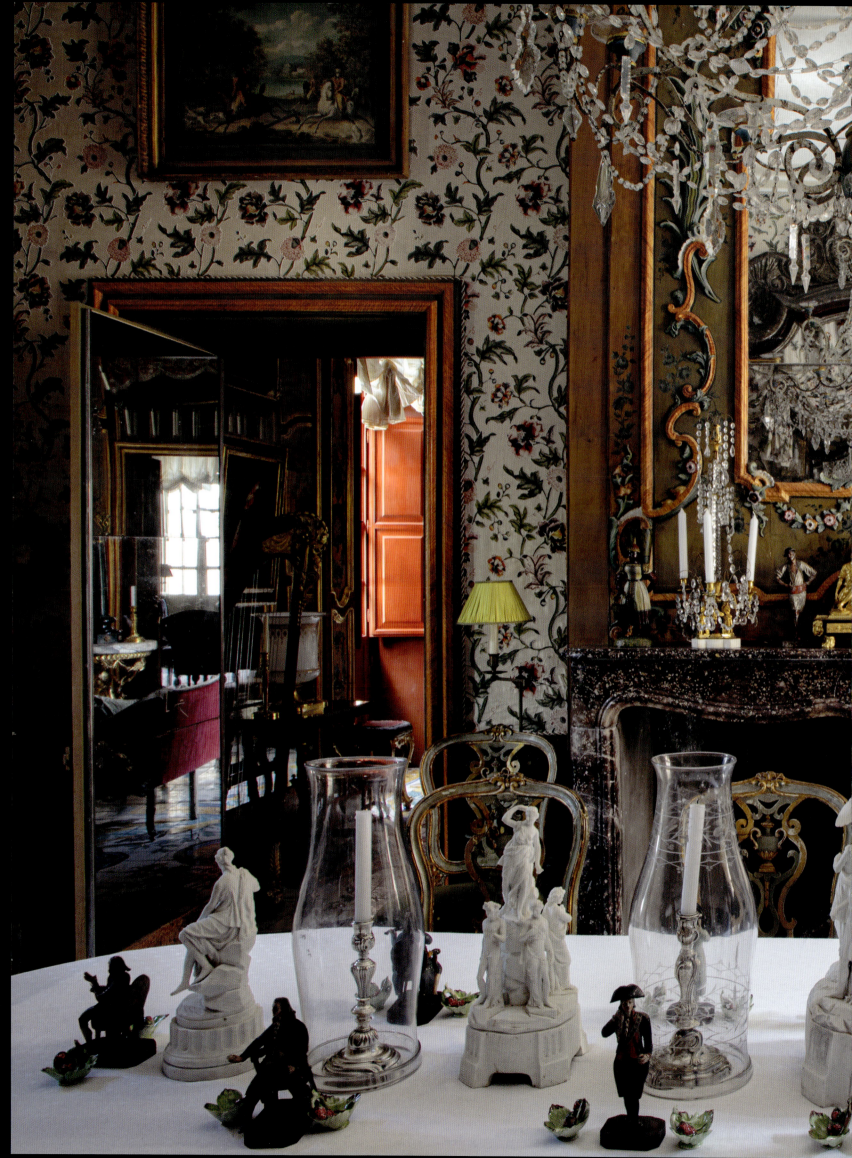

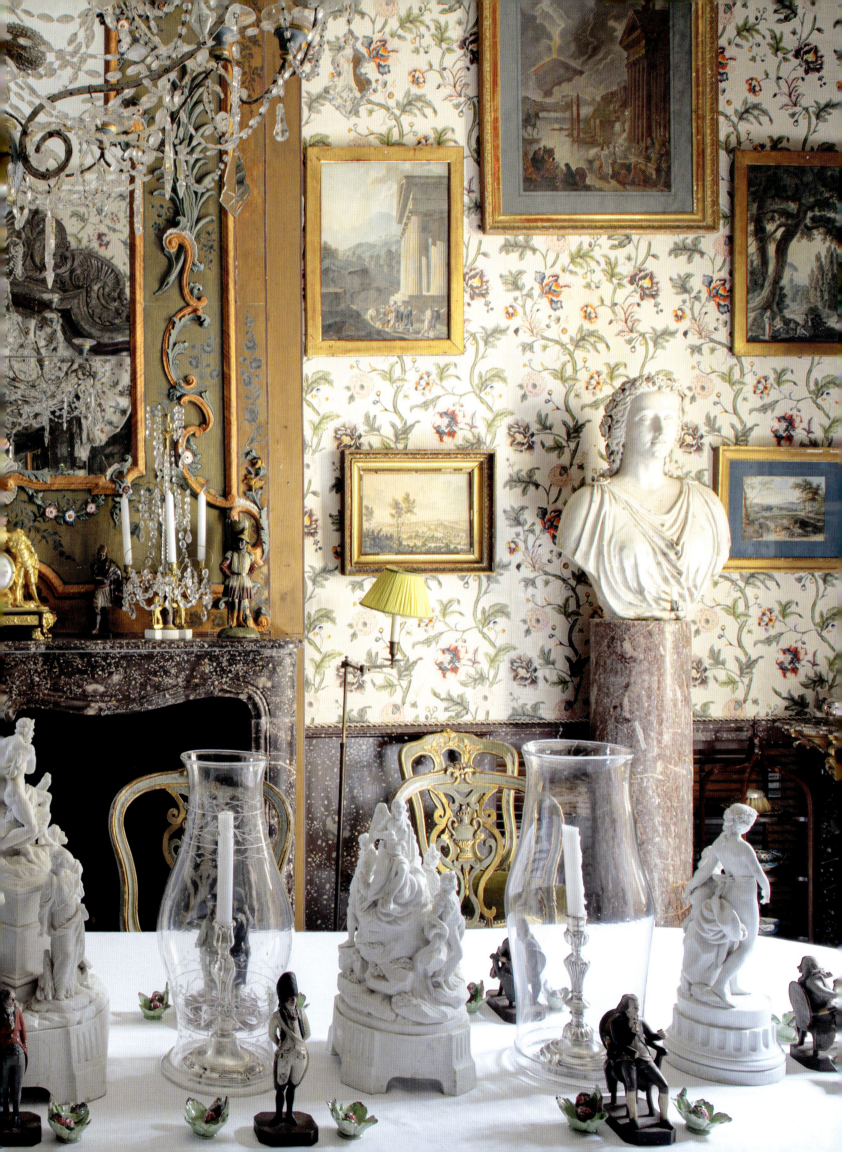

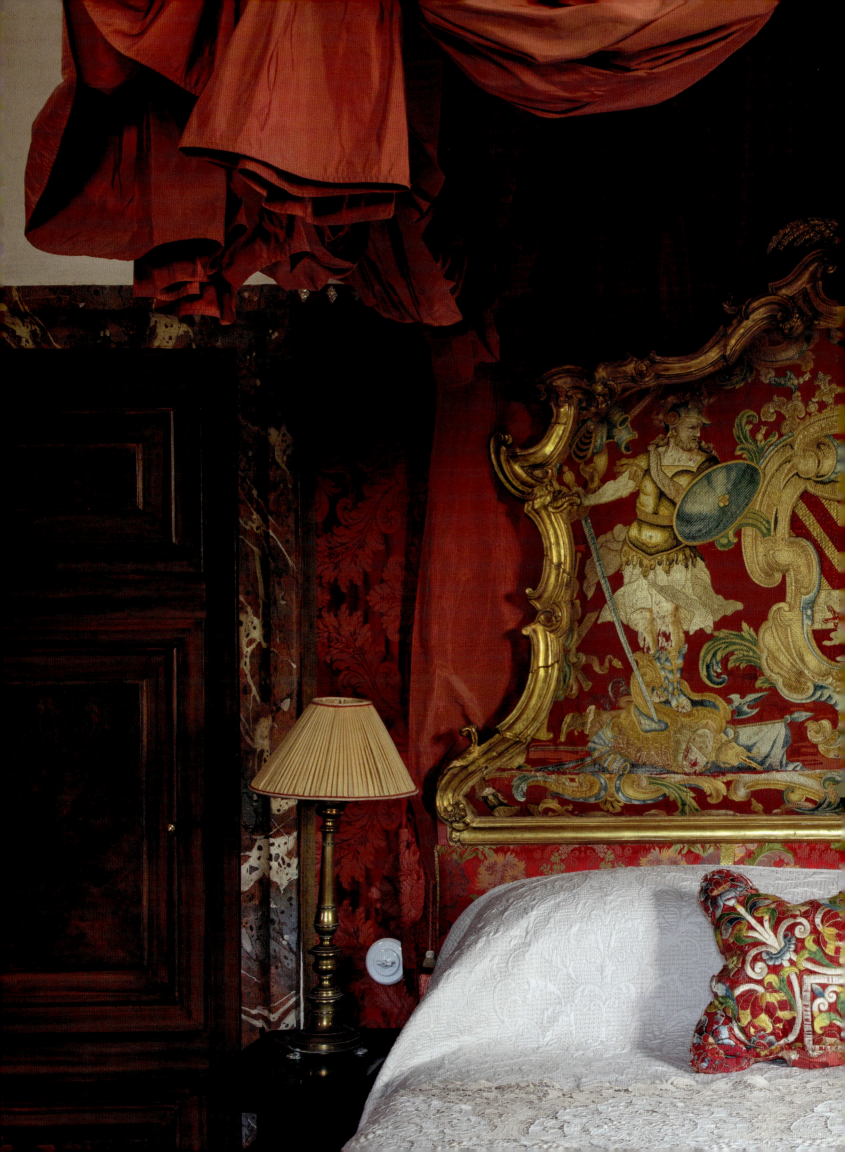

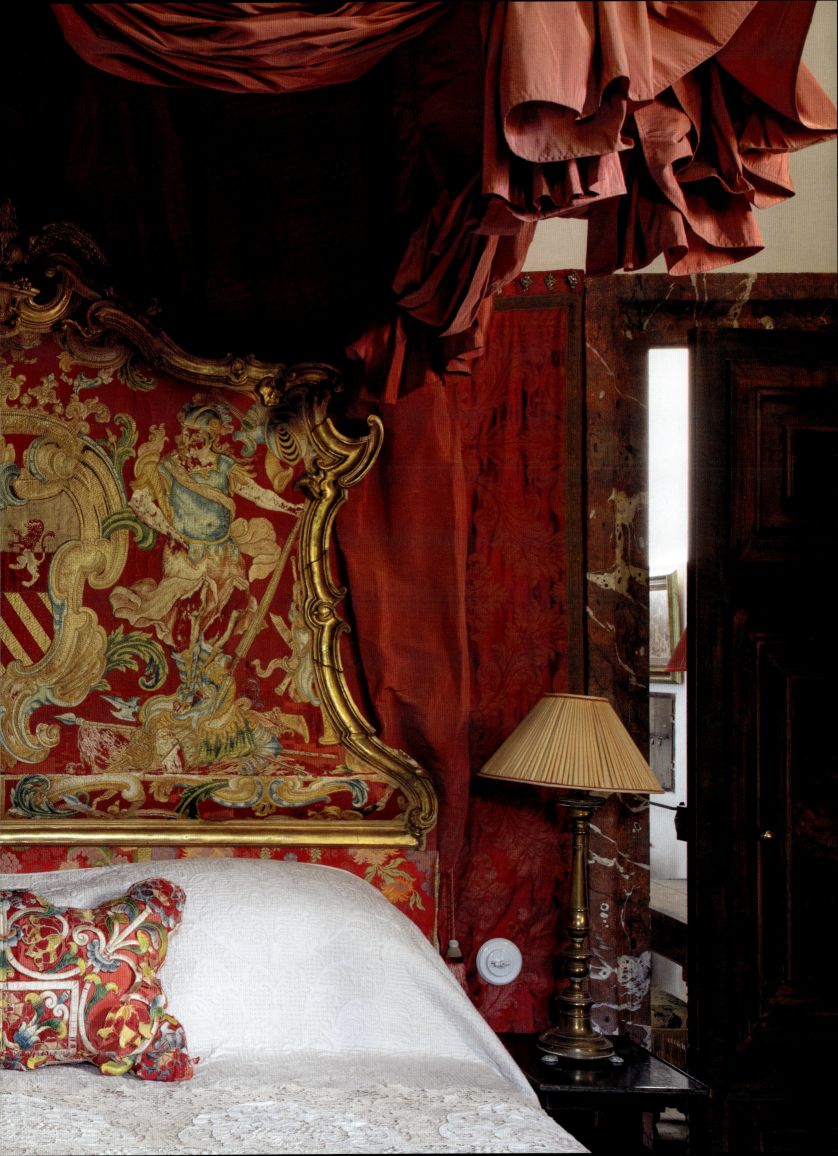

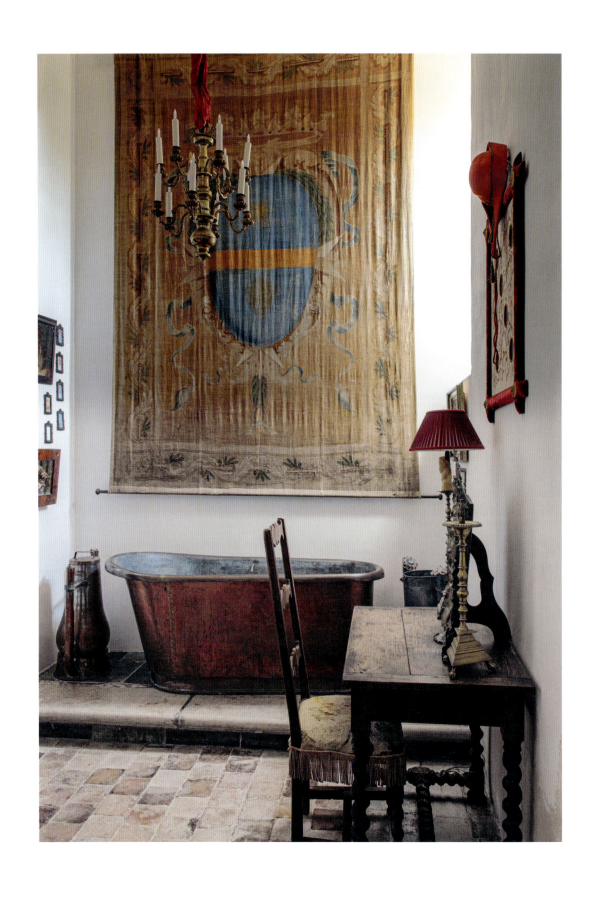

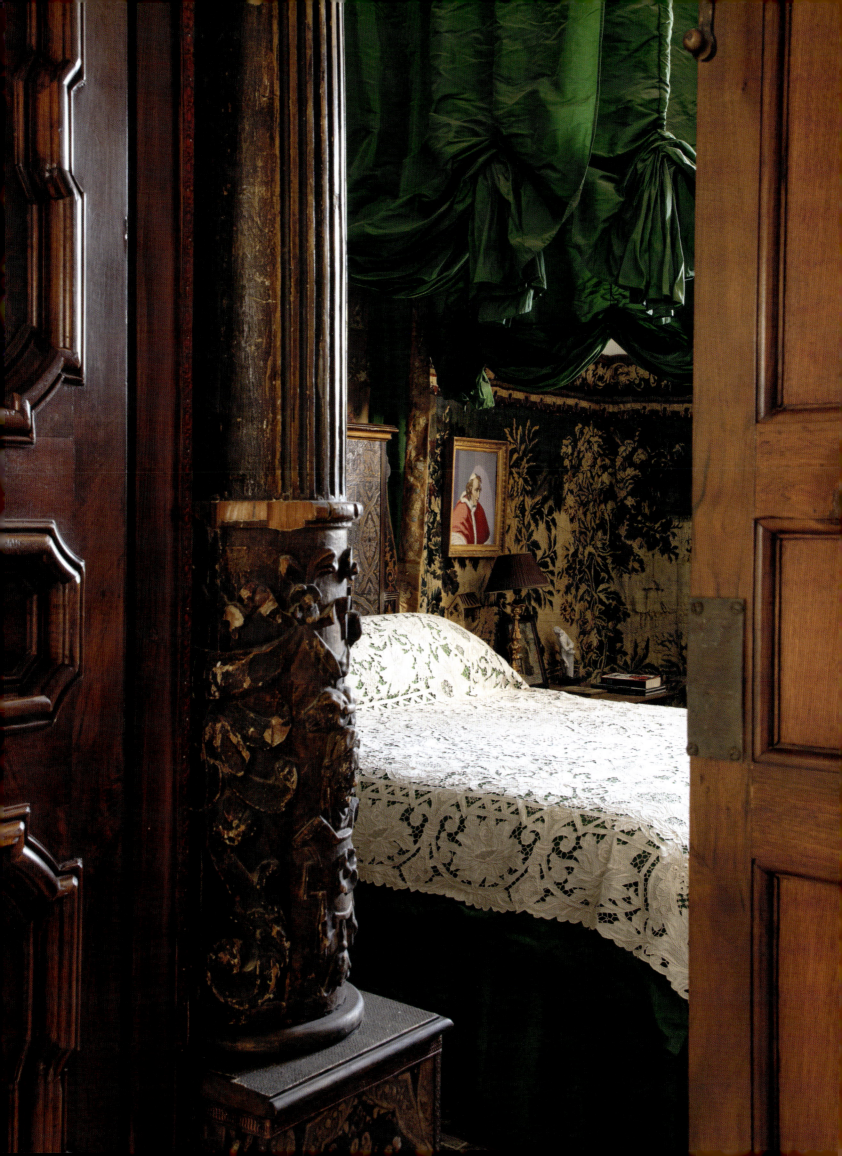

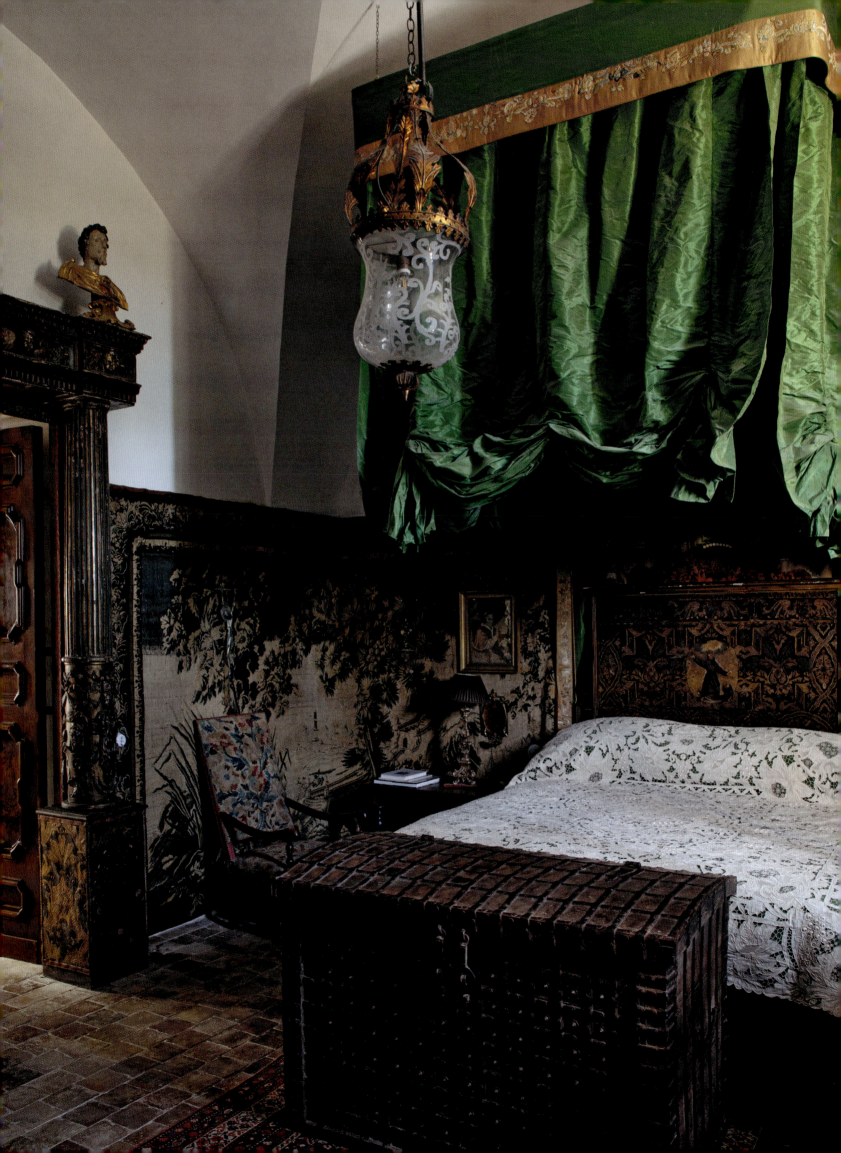

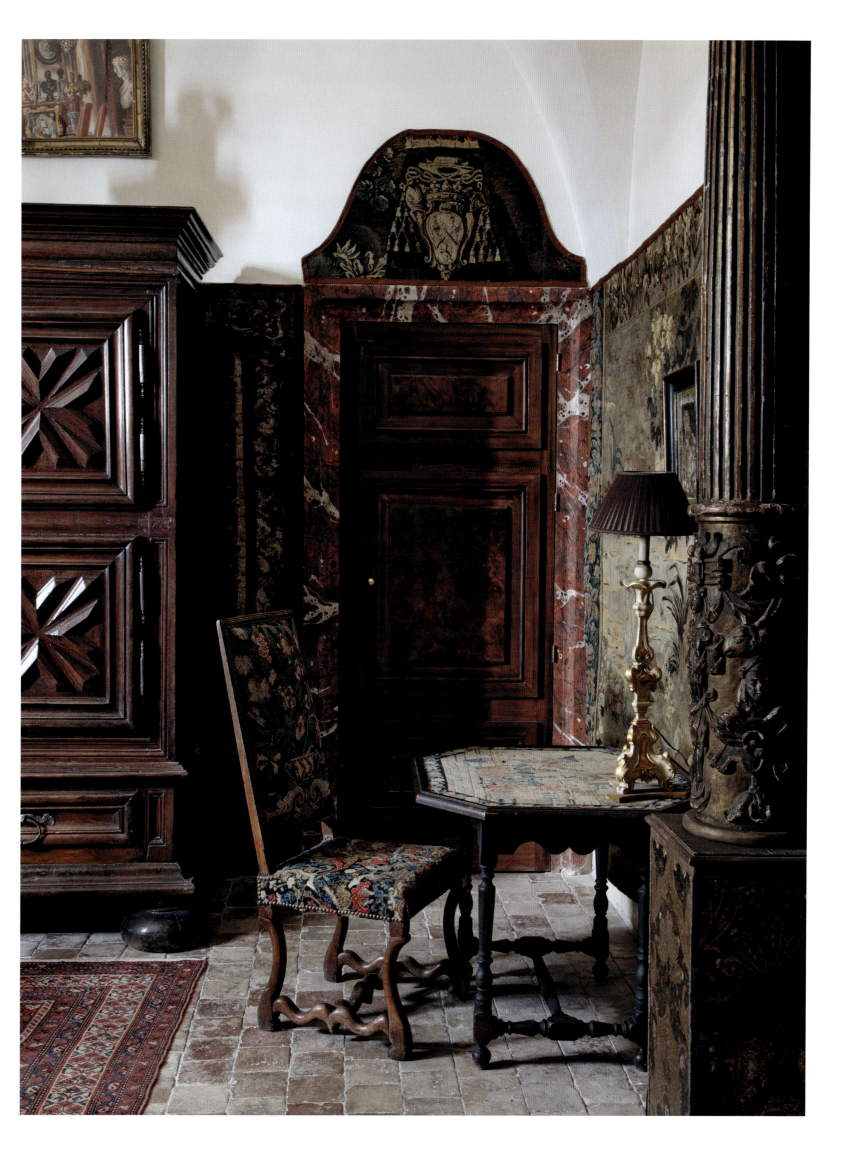

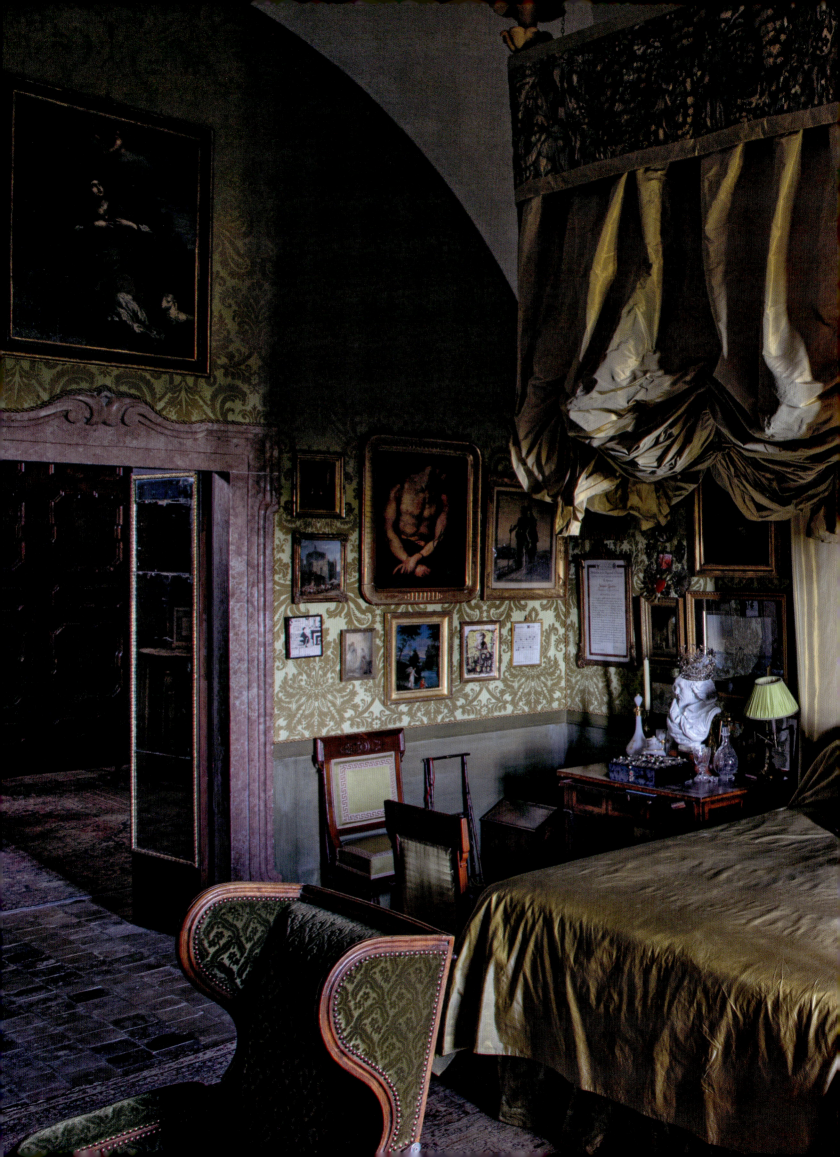

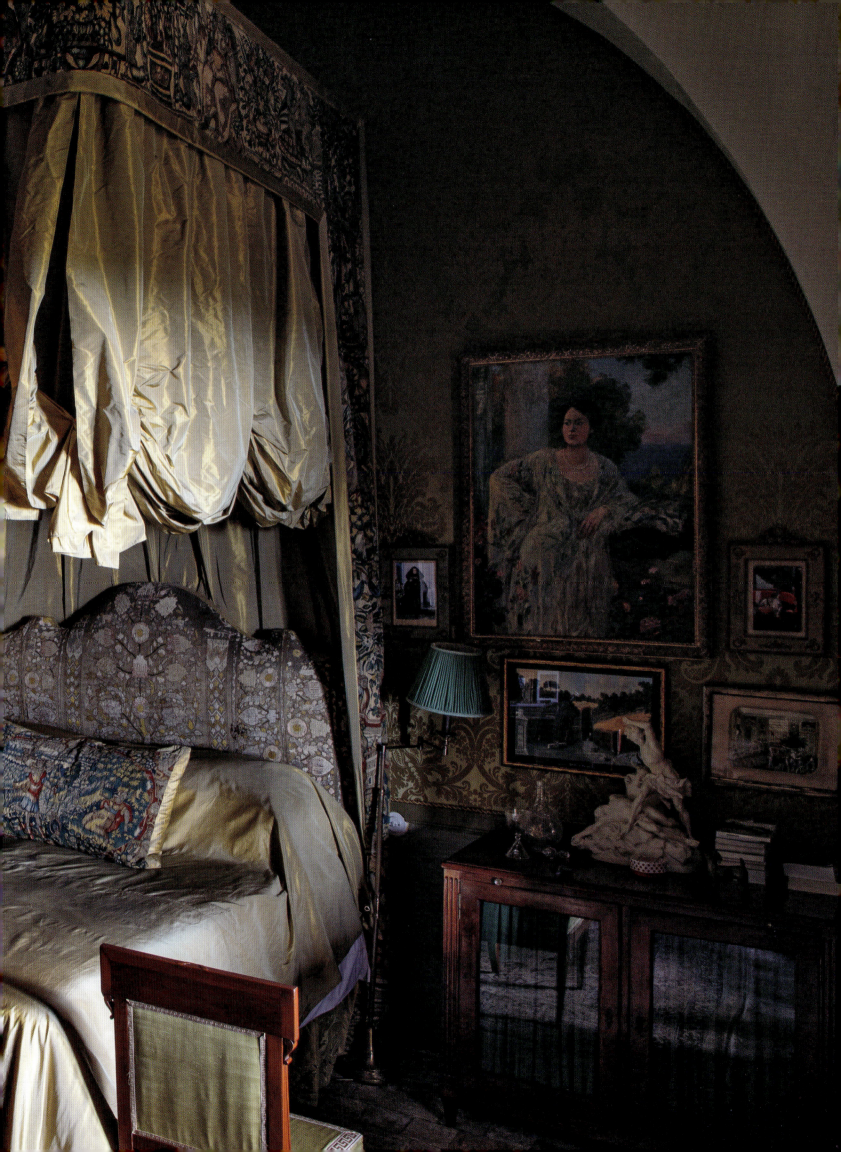

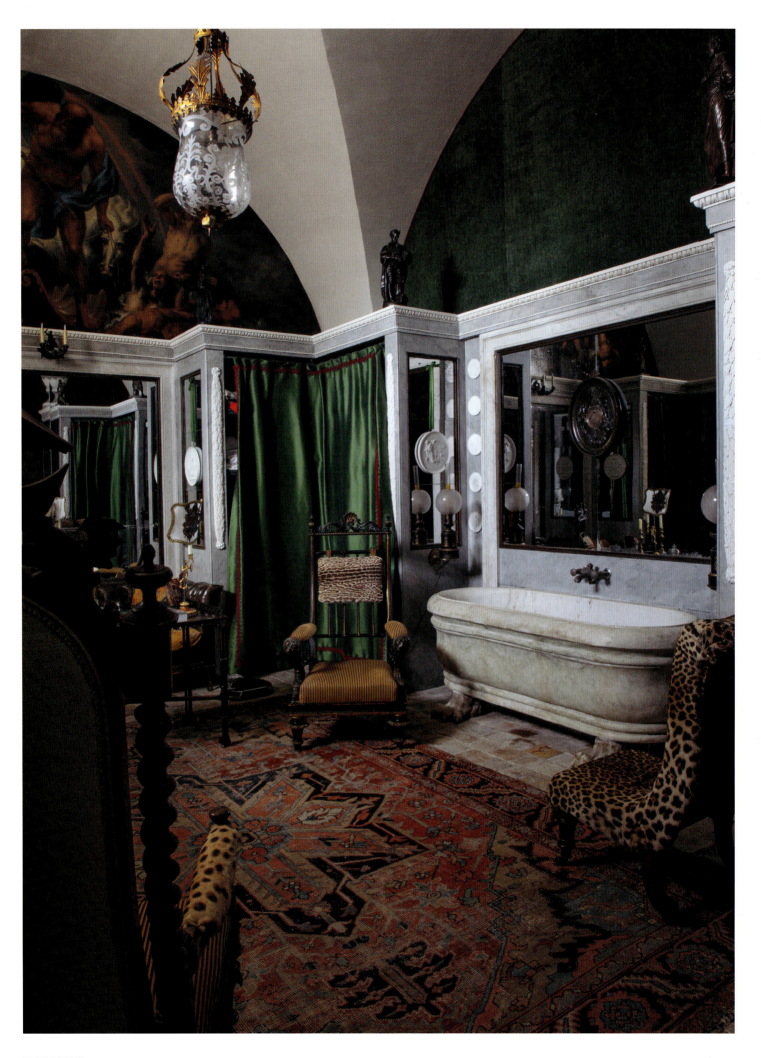

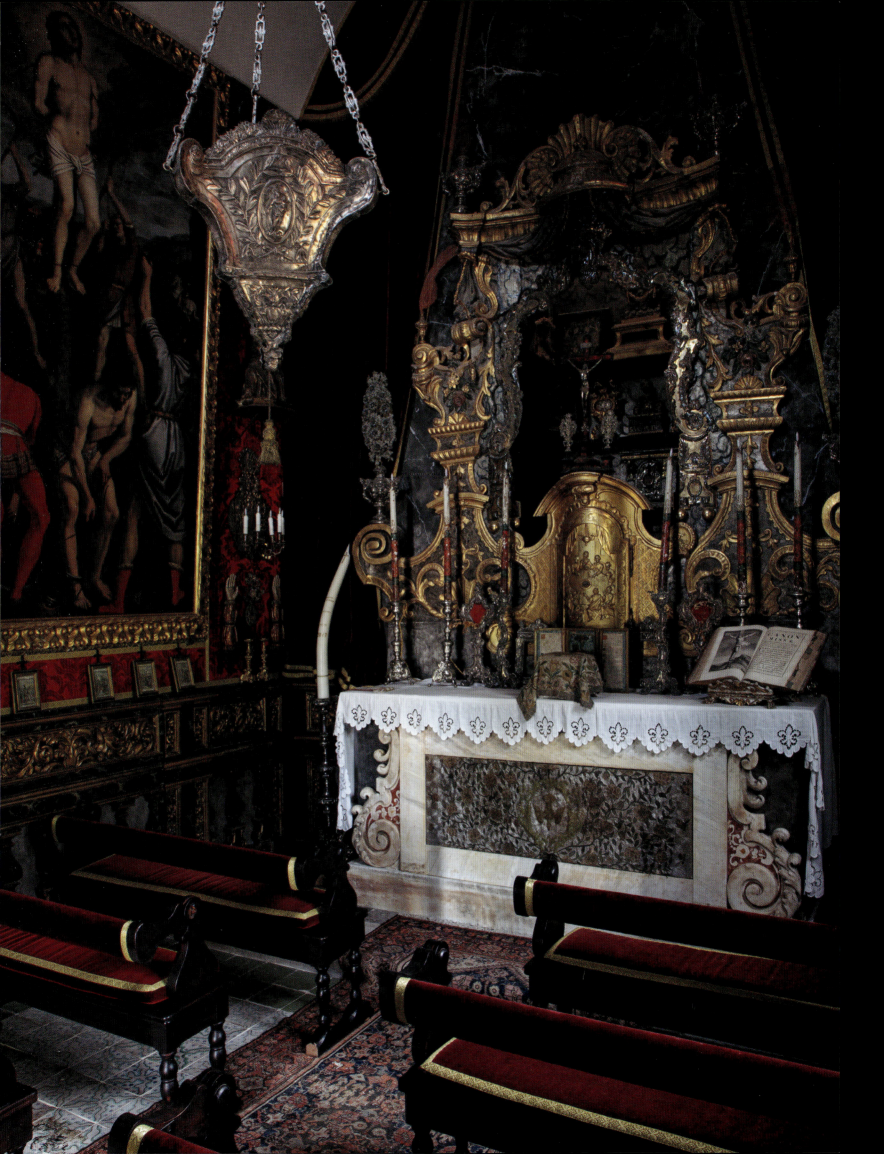

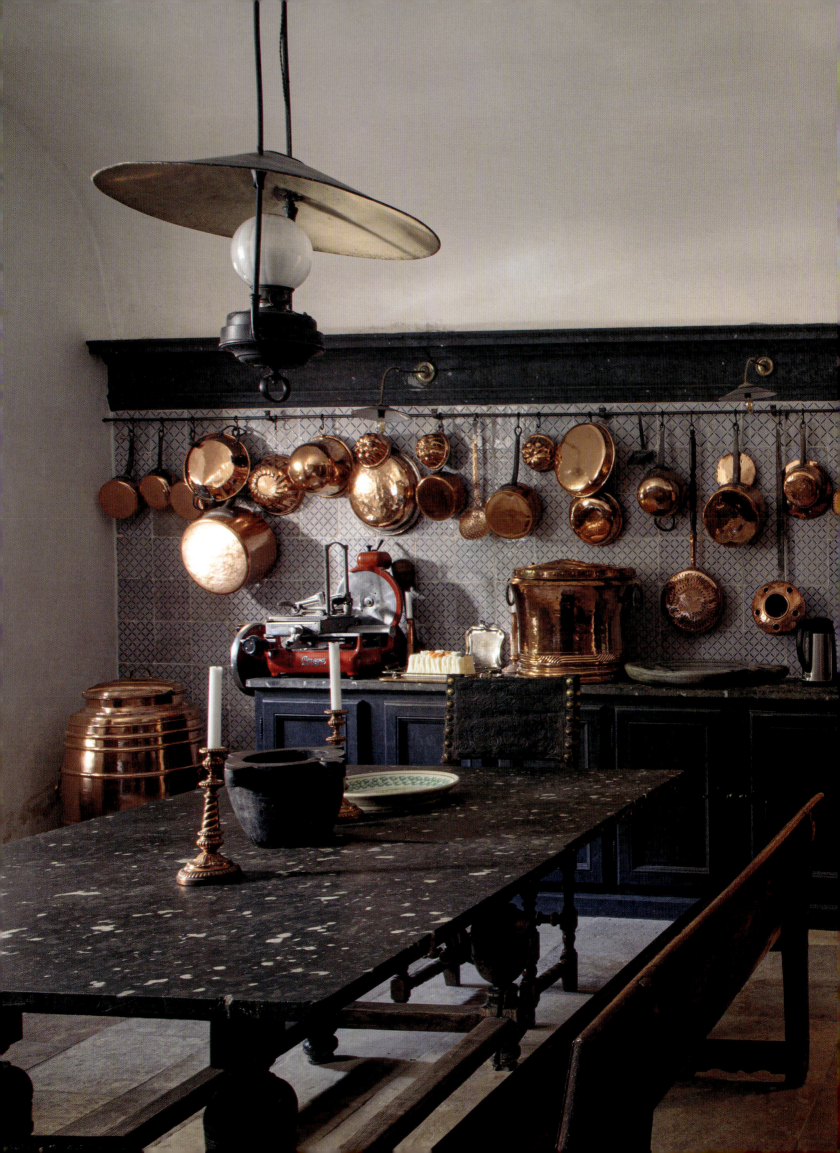

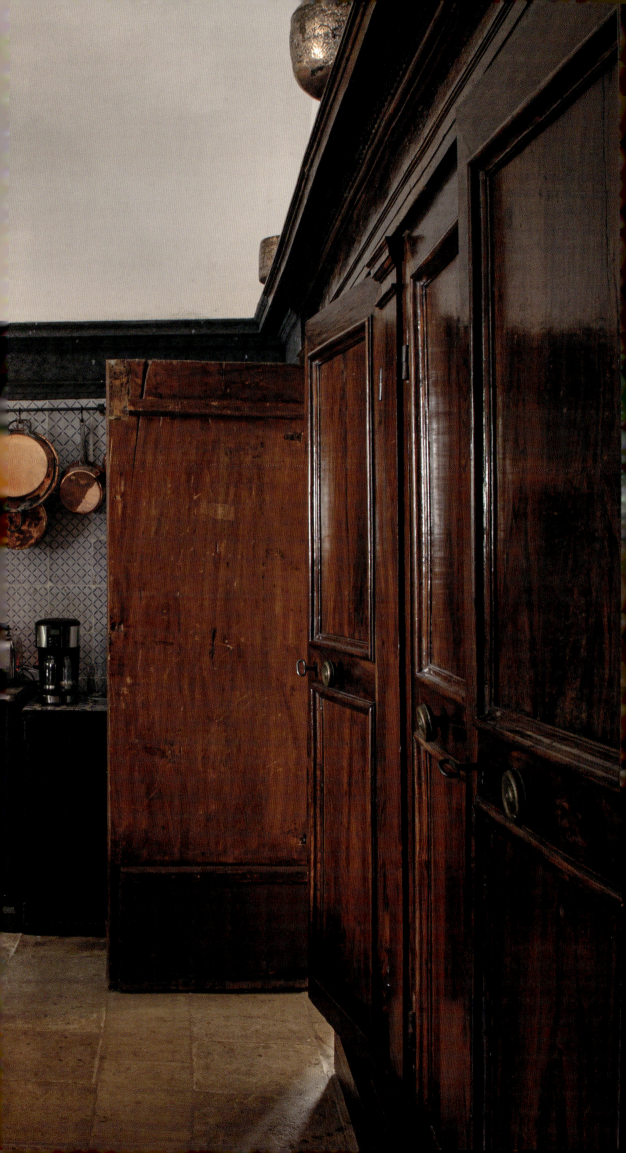

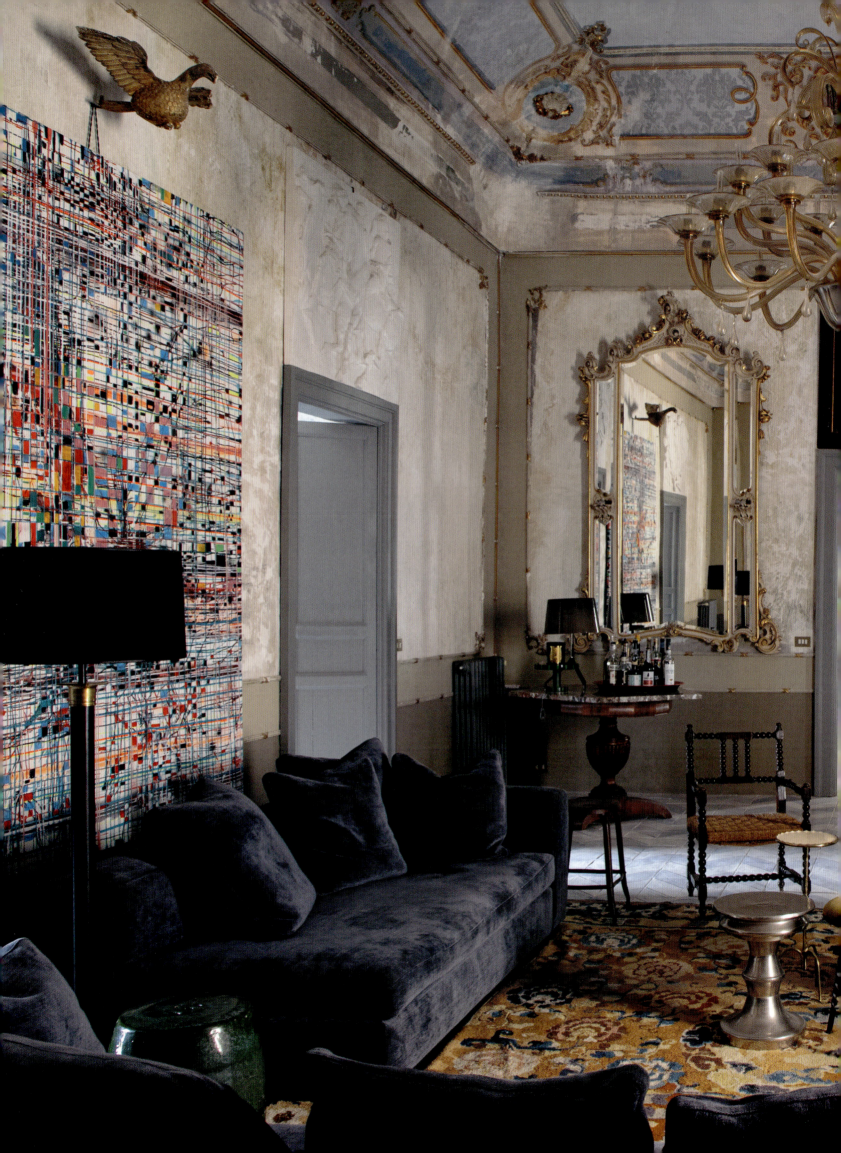

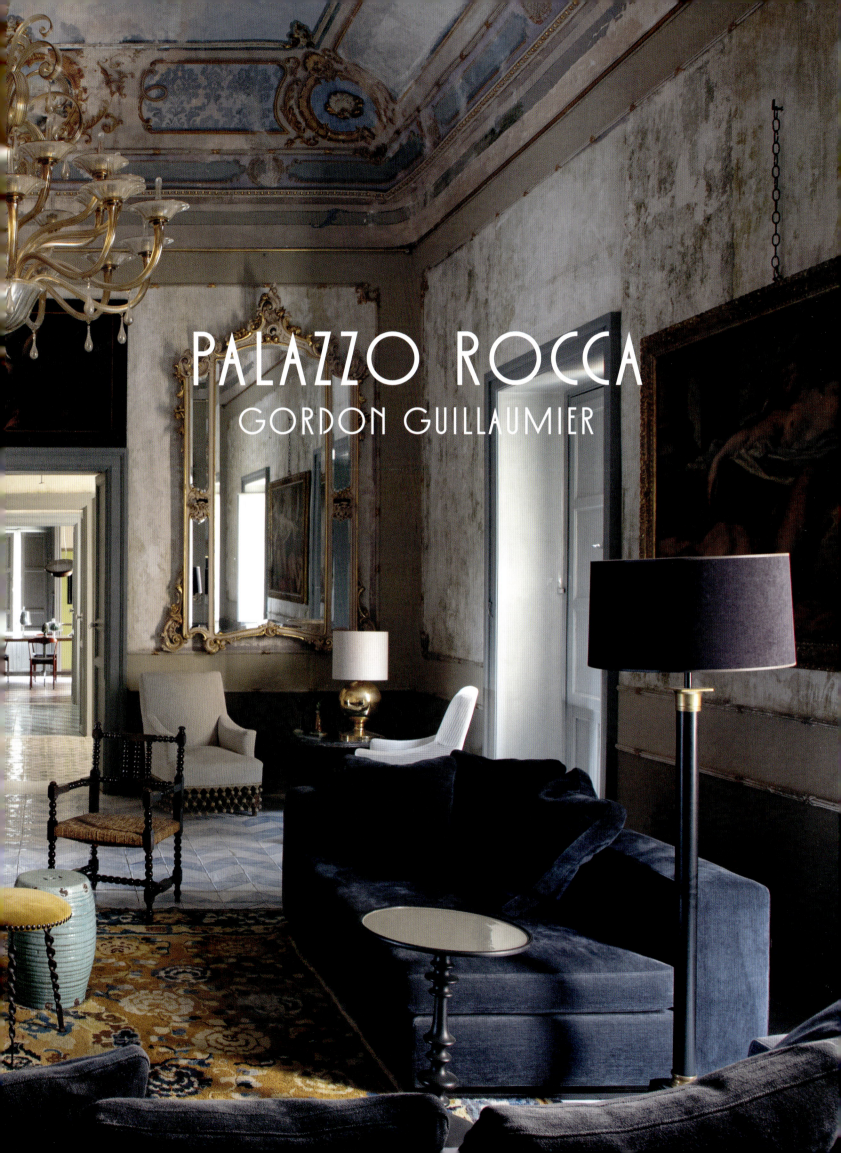
# PALAZZO ROCCA
## GORDON GUILLAUMIER

"This wasn't our first place in Sicily," says Gordon Guillaumier, the Milan-based Maltese architect and designer who spent years visiting and working in this part of Sicily with his partner, the late Rodolfo Dordoni (also an architect and designer). "But it was our most collaborative Sicilian project."

The careers of both men were steeped in Italian postmodern design. Rodolfo was creative director of Artemide, Cappellini, and the furnishings division of FontanaArte. The pair's previous home in the Sicilian countryside reflected this influence; dominated by clean lines and polished concrete, it cut through the undulating landscape so as to preserve privacy while creating views of the hills. But a palazzo in Noto provided a completely new background for their collaboration.

The eighteenth-century Palazzo Rocca was topped with a nineteenth-century *piano nobile* when it became Aquila d'Oro, a hotel used by visitors on the Grand Tour. It later became the residence of a Sicilian magistrate, but it fell into disuse in the 1990s after an earthquake. Ragged damasks clung to the sitting-room walls, while garish *trompe-l'œil* vignettes decorated the ceilings. The structure was solid, however, and Gordon and Rodolfo were excited to restore a piece of historic Noto. "Once we removed the fabric walls, Rodolfo suggested we keep the worn plaster panels while cleaning up the trim and frames, and toning down the vignettes; I remember the former caretaker, puzzled, asking when we were going to finish painting," says Gordon with a laugh. The distressed finish complements the objects, sculptures, and paintings that dominate each room, enveloping them in their environment.

Similar decisions were made elsewhere, such as in the kitchen, where the old woodstove was left untouched, even though it can no longer be used. It serves as a beautiful support for a tabletop gas range so that its three chimneys retain their symbolic function. Gordon and Rodolfo slowly acquired pieces of the original structure, which had been sold off bit by bit. It was a way of reconstructing the past, of putting back what was lost. The mezzanine, originally intended as a design studio, sits at the ready should the need to work from Sicily arise, while the *piano nobile* brims with life. Here, art and design converse across grand rooms in which objects are arranged with precision, each responding to the space around it, maintaining a balance between the intimate and the imposing. Golden light filters in through oversized windows, illuminating a world of contrasts: antique ceramic tiles meeting polished stainless steel, sculptural forms resting against richly worn walls.

This dialogue between past and present, the personal and the monumental, reflects the aesthetic sensibilities that Gordon and Rodolfo honed over decades working together. The house displays their shared vision, the culmination of a long conversation between two architects who understood that design is as much about history as it is about innovation.

After Rodolfo's passing, the house remains imbued with his touch, yet his legacy extends far beyond its walls. It lives in the countless projects he shaped, the influence he had on contemporary Italian design, and the spaces he left behind, each distinctly and deliberately elegant. For Gordon, Palazzo Rocca is not merely a home but a testament to a partnership—one that transformed materials and spaces with instinctive, effortless grace.

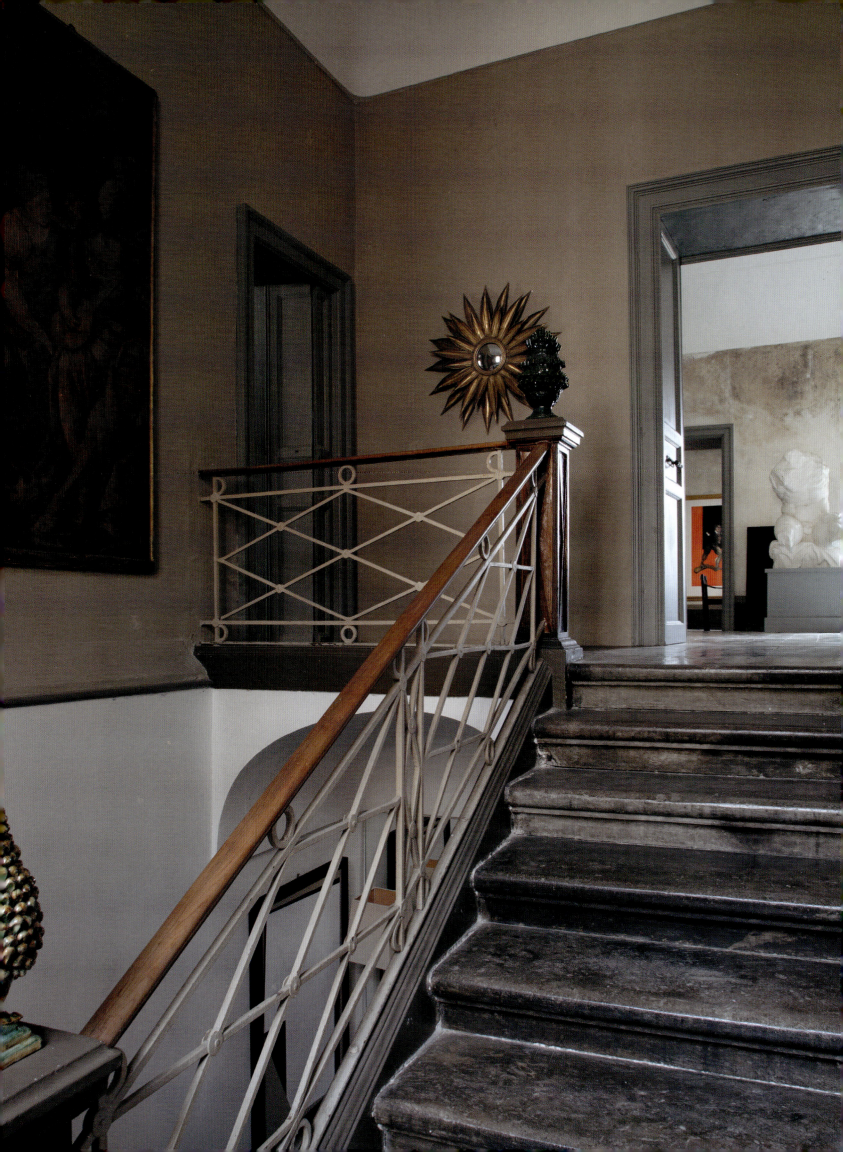

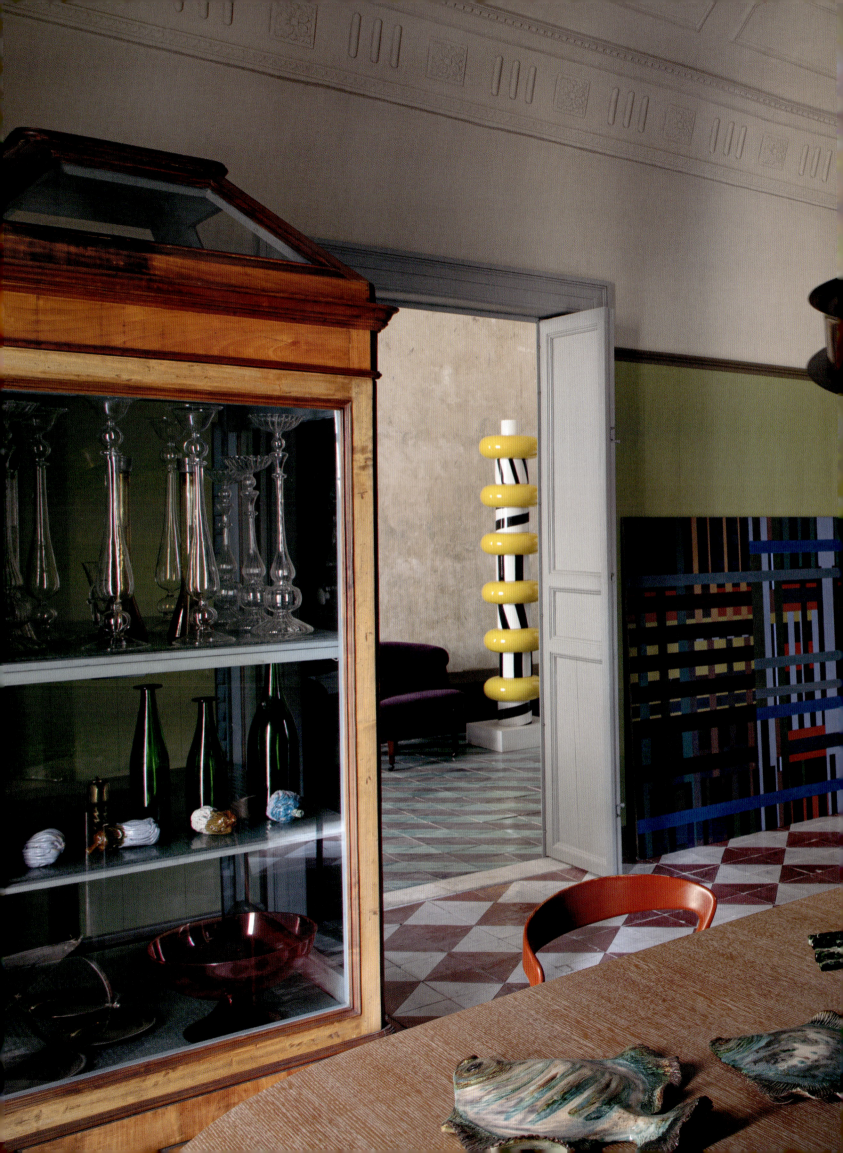

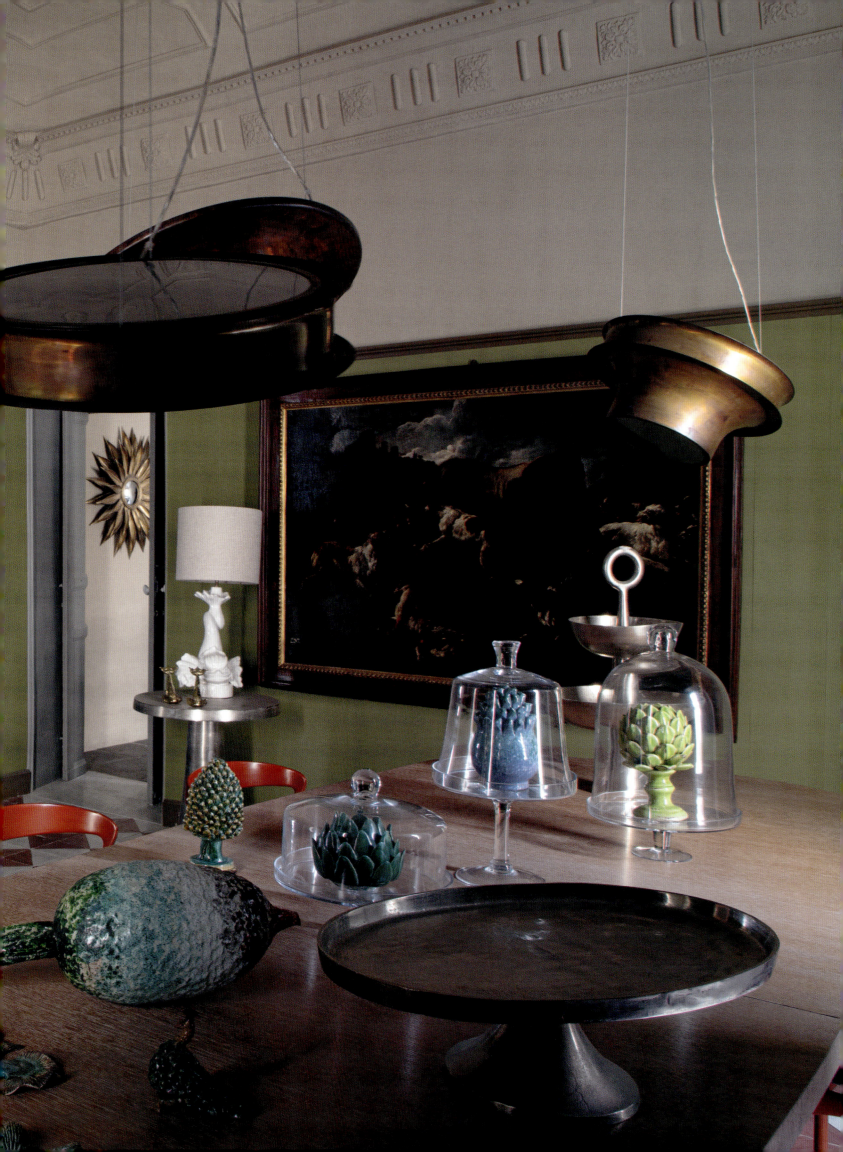

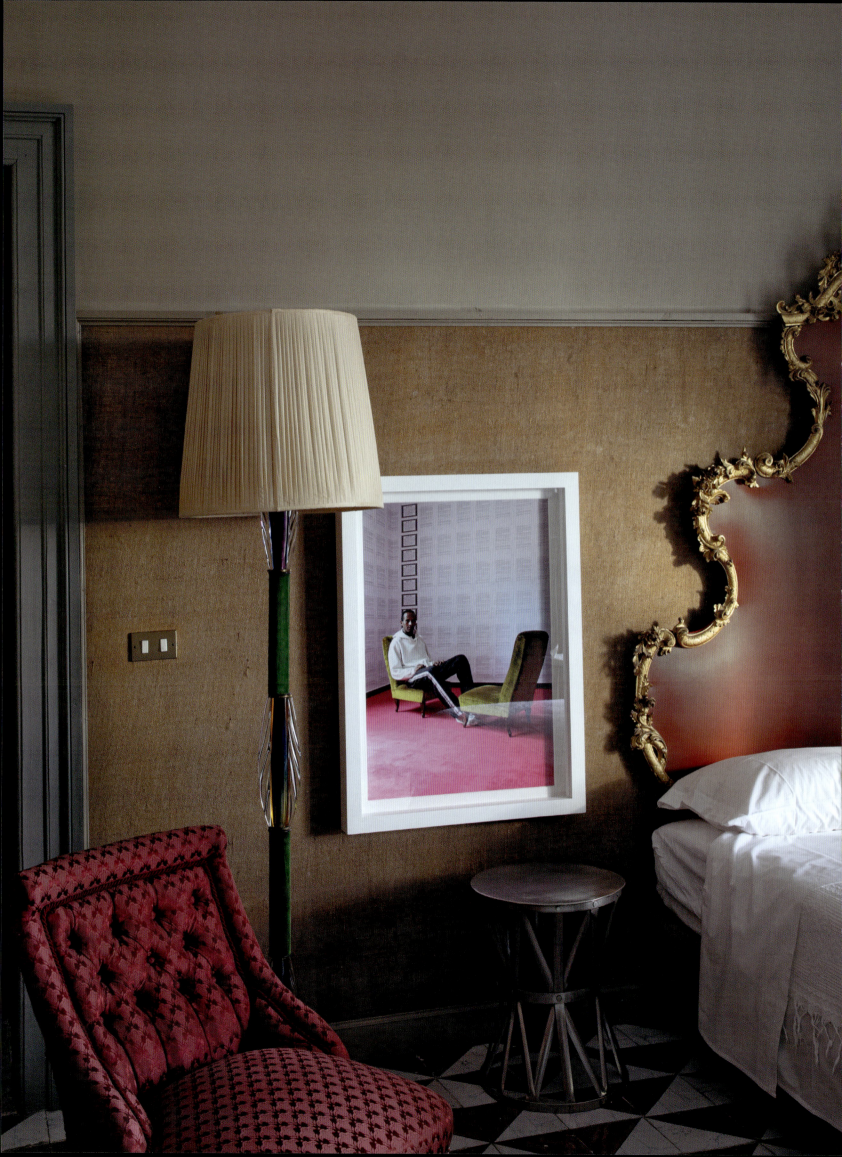

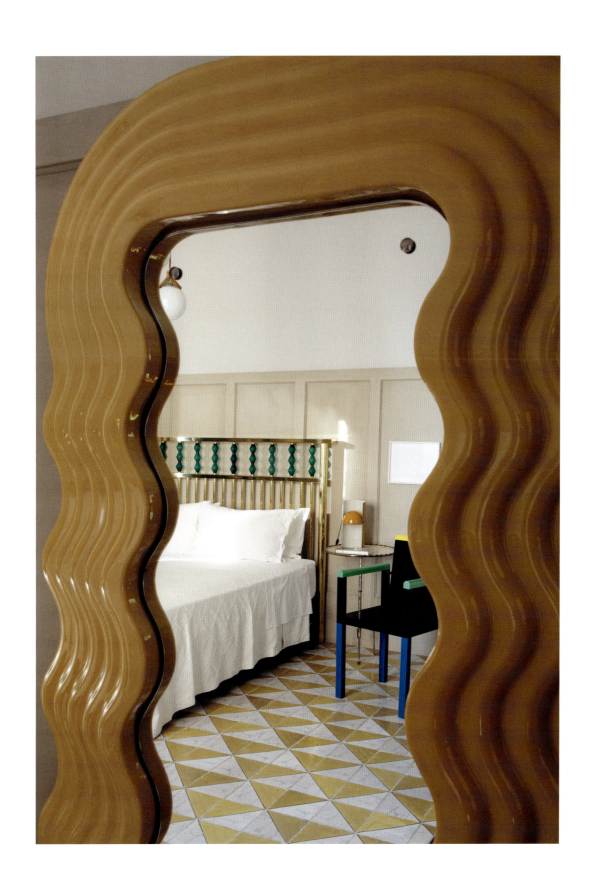

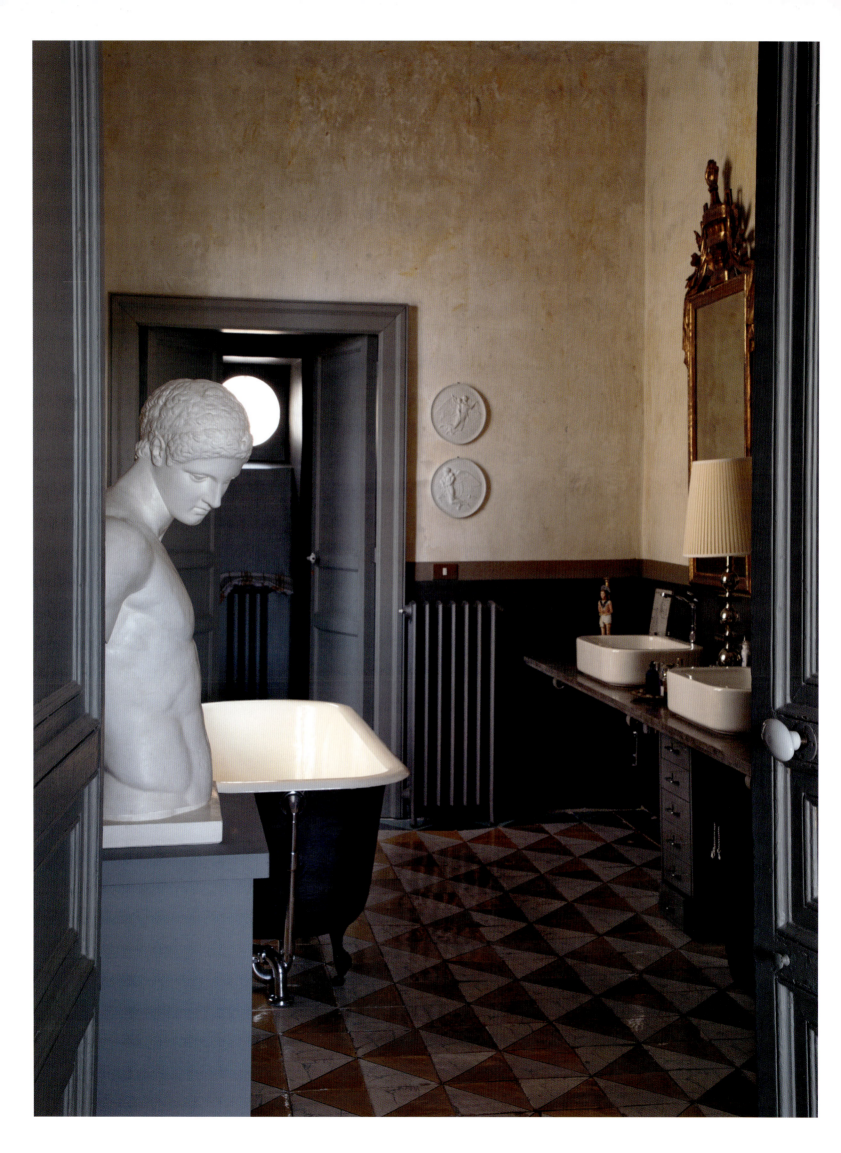

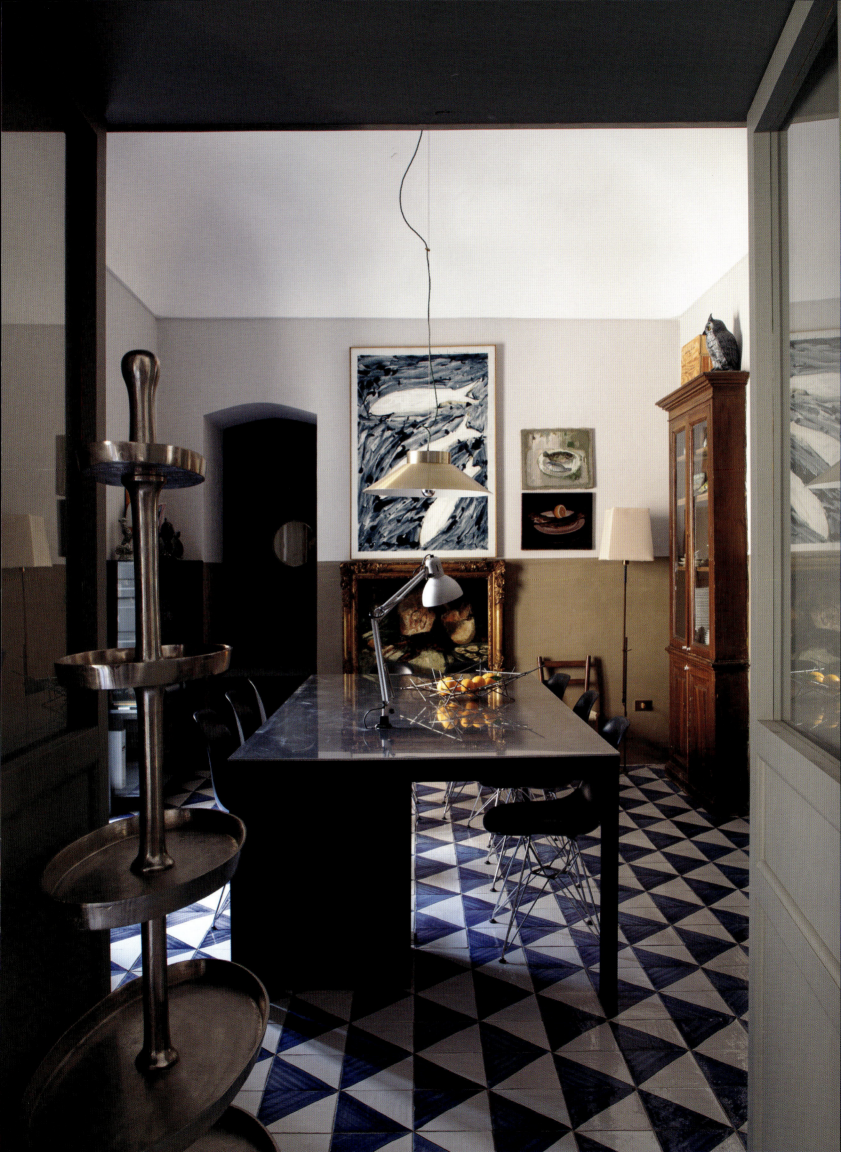

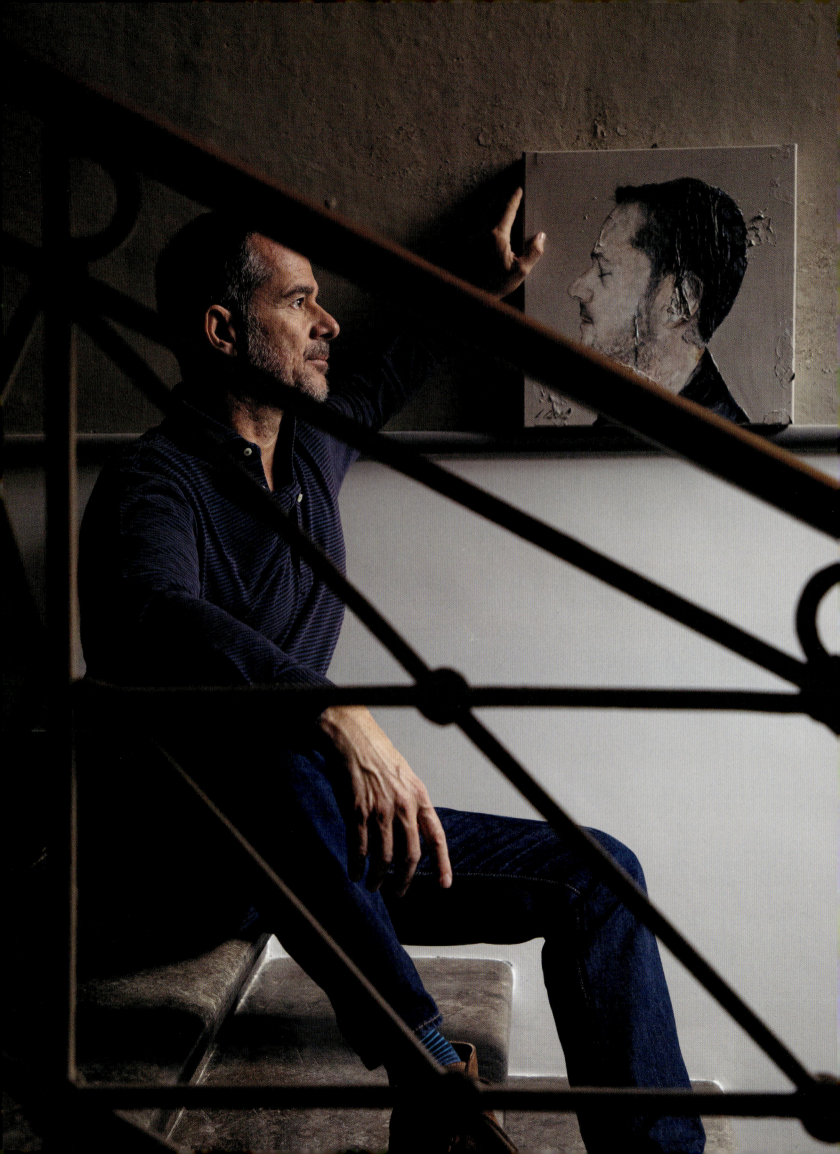

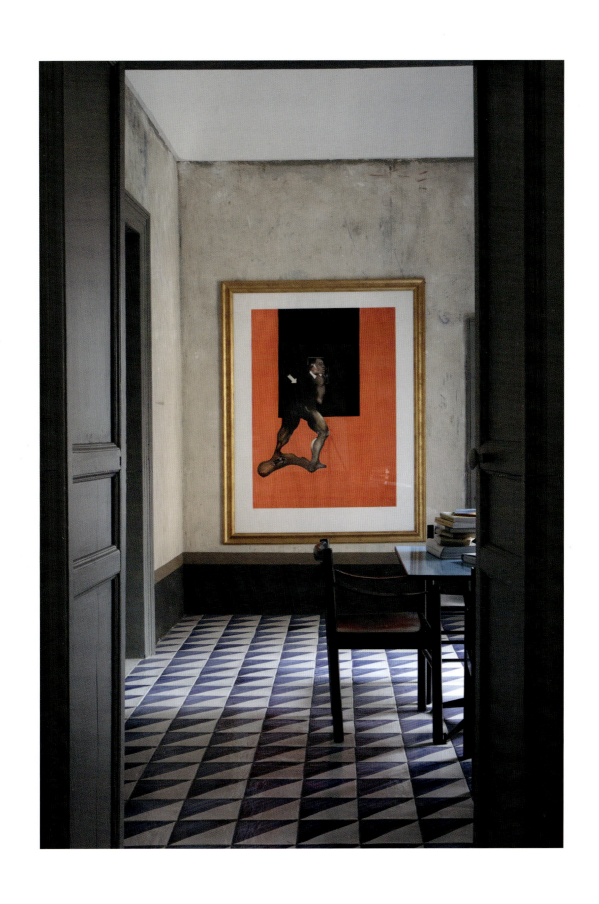

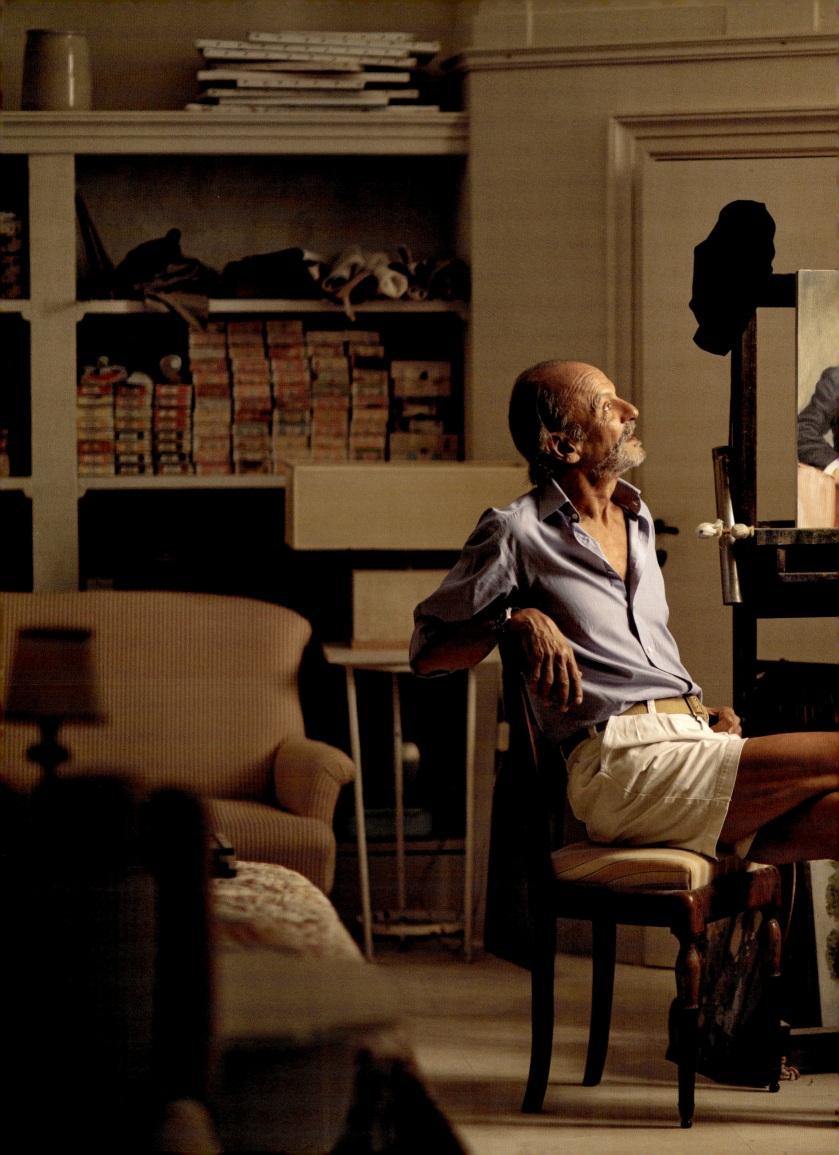

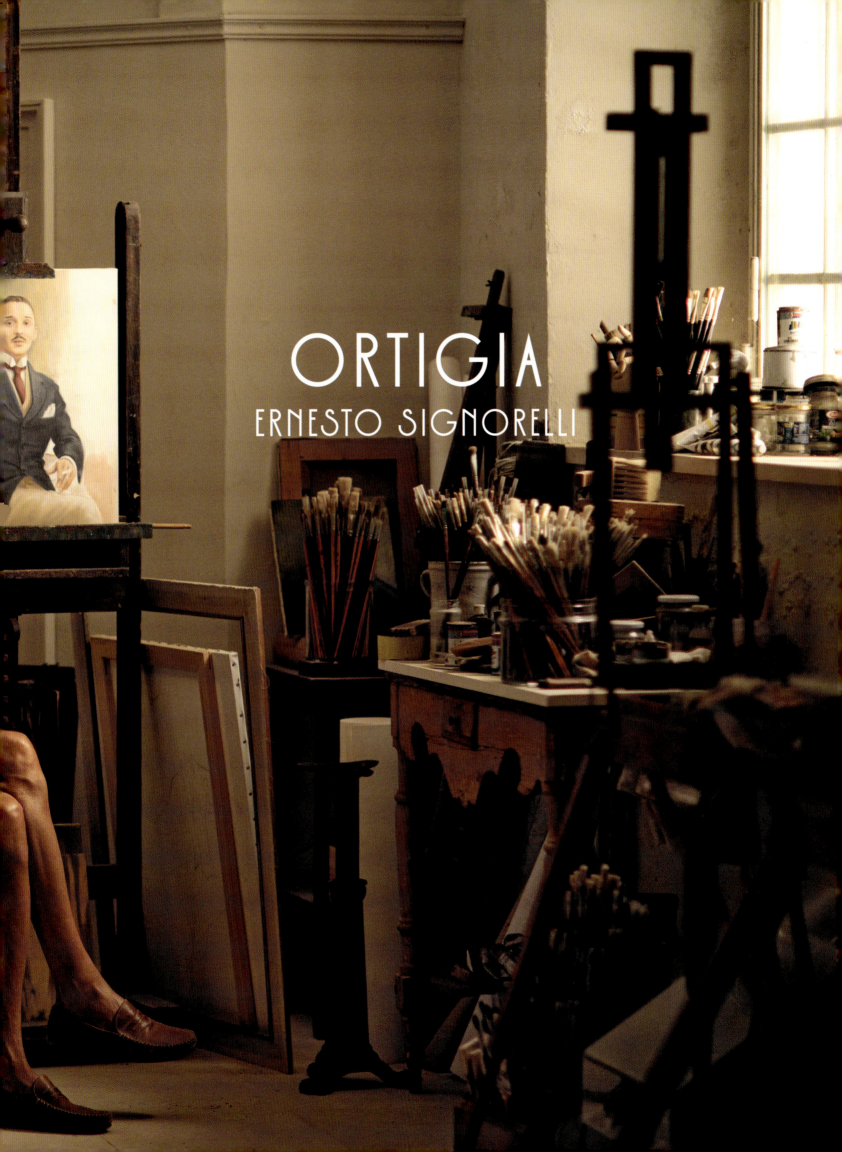

Although it has been years since the painter and decorative artist Ernesto Signorelli moved to Ortigia—the island that makes up the historic center of Syracuse—only a few of the paintings that line his walls have been hung. Most sit on the backs of chairs or along the floor, perfectly placed should they ever decide one day to climb the plaster and affix themselves at their desired height. It adds to the casual, unpretentious elegance of the artist's home.

Known primarily for his intricate faux marble and other *trompe l'œil*, Ernesto has painted decorative effects in apartments, villas, and palaces throughout Europe. After largely retiring, he discovered the pleasure of Syracuse, where a cosmopolitan set of residents linger in cafés throughout the day and extol the pleasures of their daily swims in the clean water that surrounds this ancient city.

Tucked away in a narrow street near the Piazza Duomo, behind the front door of a decadent building, is a sun-drenched courtyard where crumbling plaster, checked black-and-white marble floors, and ancient coats of arms, some topped with crowns, adorn the apartment doors. A small arched loggia frames the landing of Ernesto's top-floor apartment. The final capital shows the carved face of a smiling court jester, offering a benevolent welcome from centuries past. Inside, a collection of rugs from North Africa to Turkey and beyond grounds the rooms with swaths of color. While much of the northern Italian furniture reveals his long life in other parts of the country, Ernesto is in fact Sicilian.

Despite the thick walls, the summer sun warms up the otherwise airy apartment. When he needs to escape the heat, Ernesto heads out through his kitchen terrace and downstairs to where a small garden leads to his atelier. The walls of the studio are entirely covered with bookshelves, and in the corners he has created angled niches concealing storage and even a bathroom. The effect is wide open and multifunctional. The neoclassical shape of the corner cabinets, topped with urns, adds symmetry to a room filled with color and detail.

During our visit, Ernesto was contemplating a piece he had begun during the Covid-19 lockdown: a portrait of his grandfather, inspired by several photographs he had found. Ernesto is a slow and meticulous worker, and one can imagine that this act of conjuring the past was a calming exercise during that unusual time. But Syracuse itself has that effect. The Doric columns on the nearby Duomo have held up the city's temple since the fifth century BC, defying war, earthquake, corruption, and even benevolent rulers that might have brought them down. Such an ancient city seems to give its residents permission to go slowly; great things are built with time.

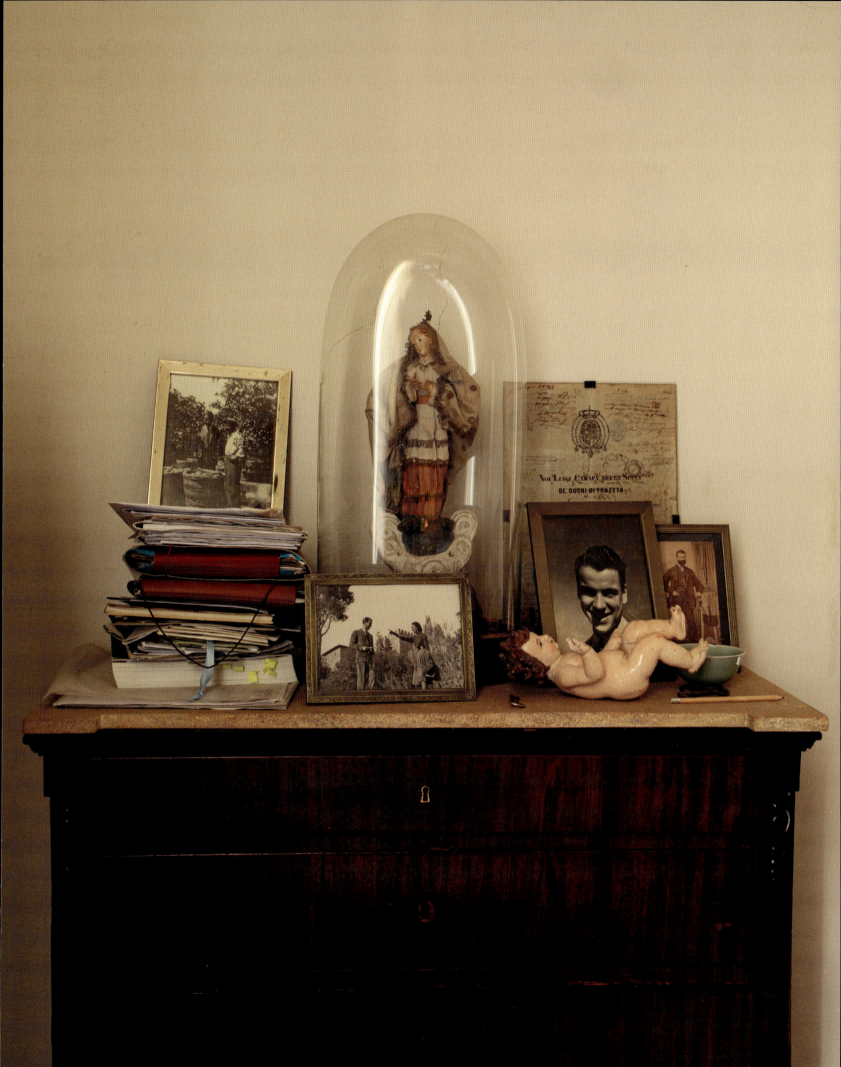

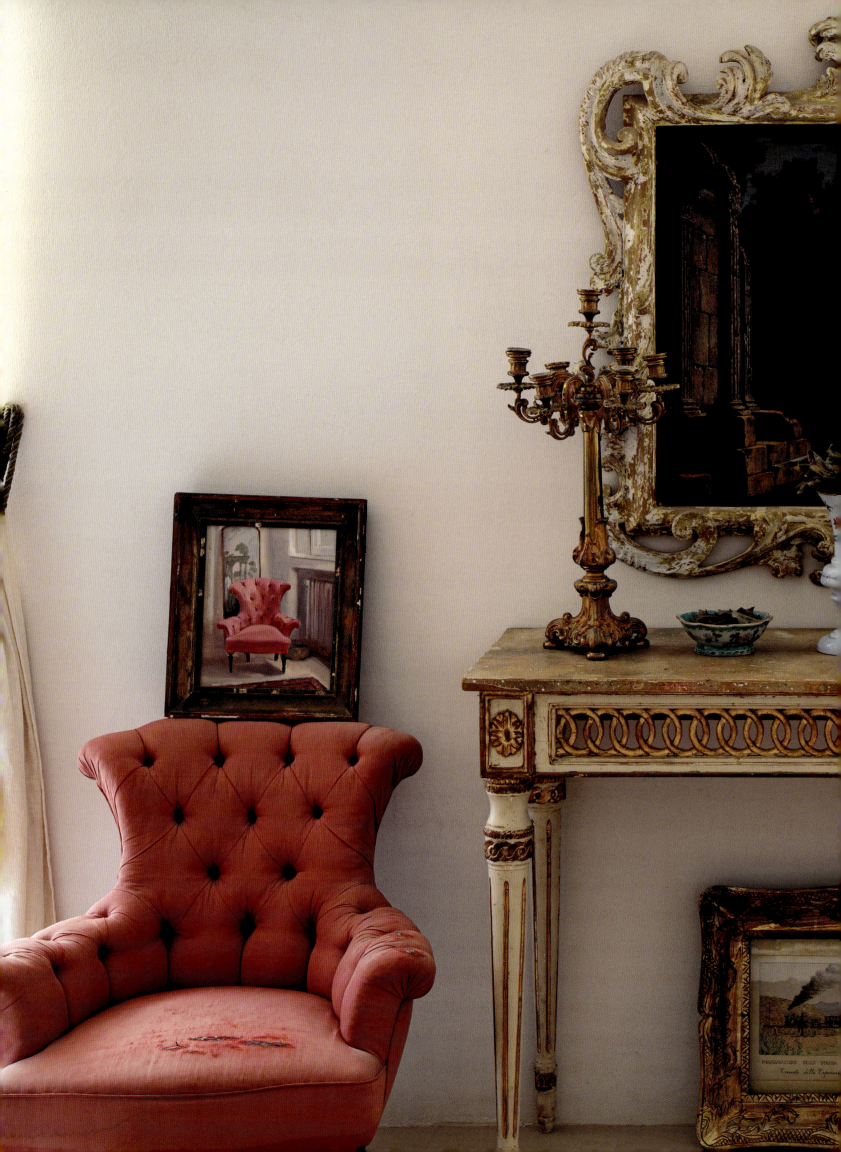

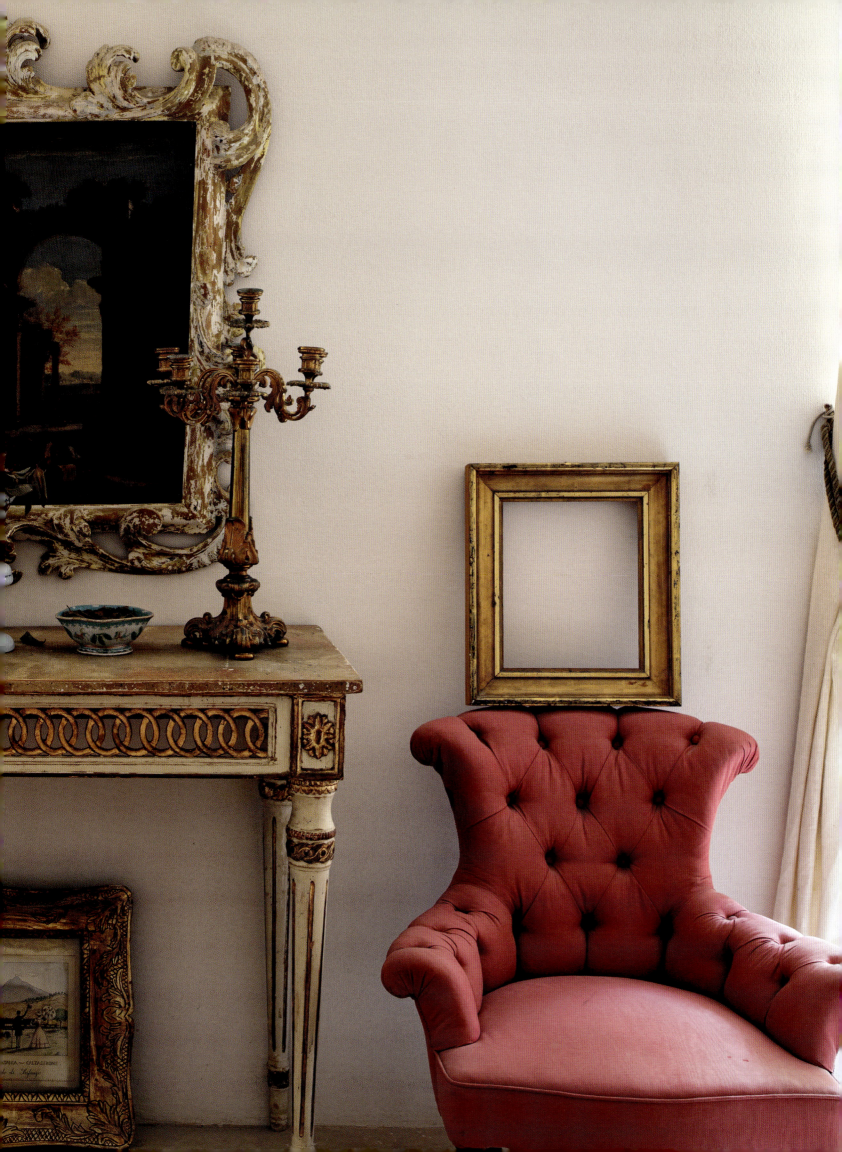

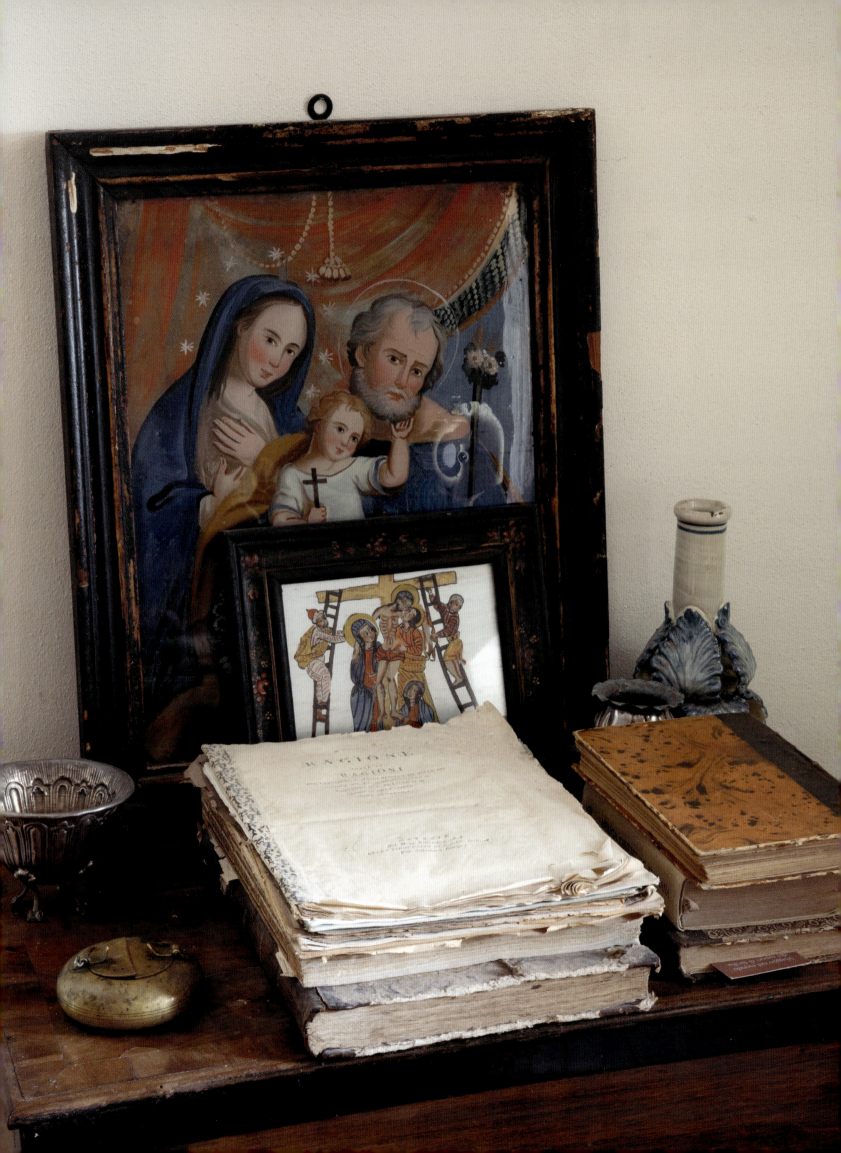

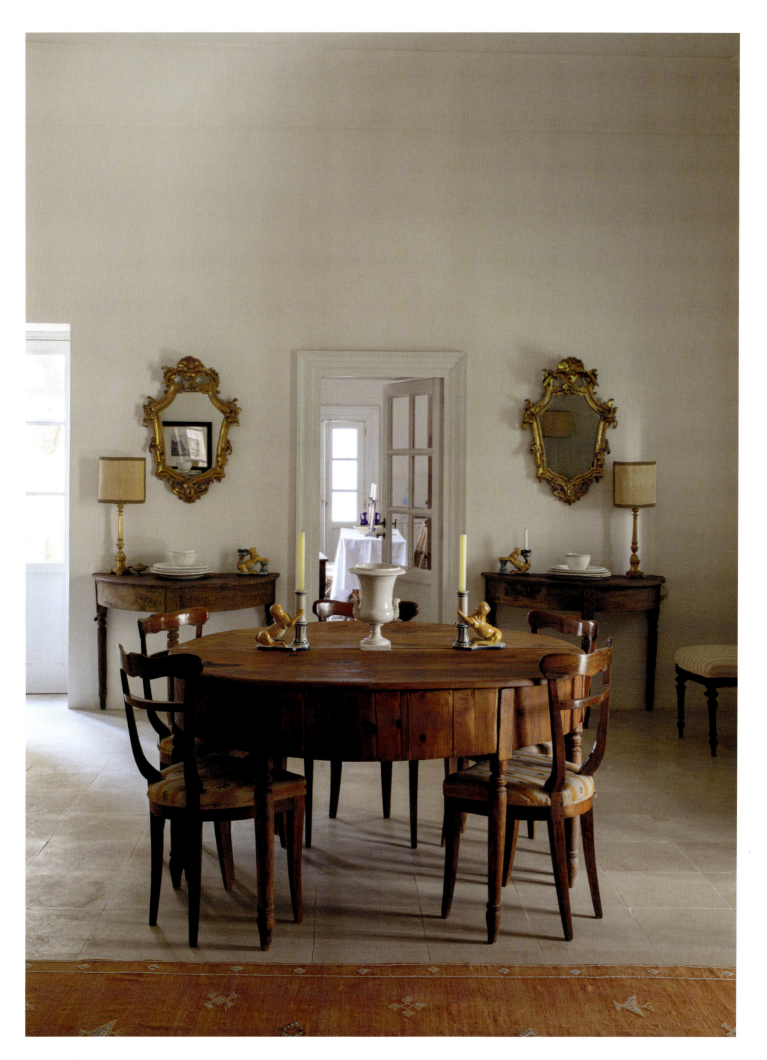

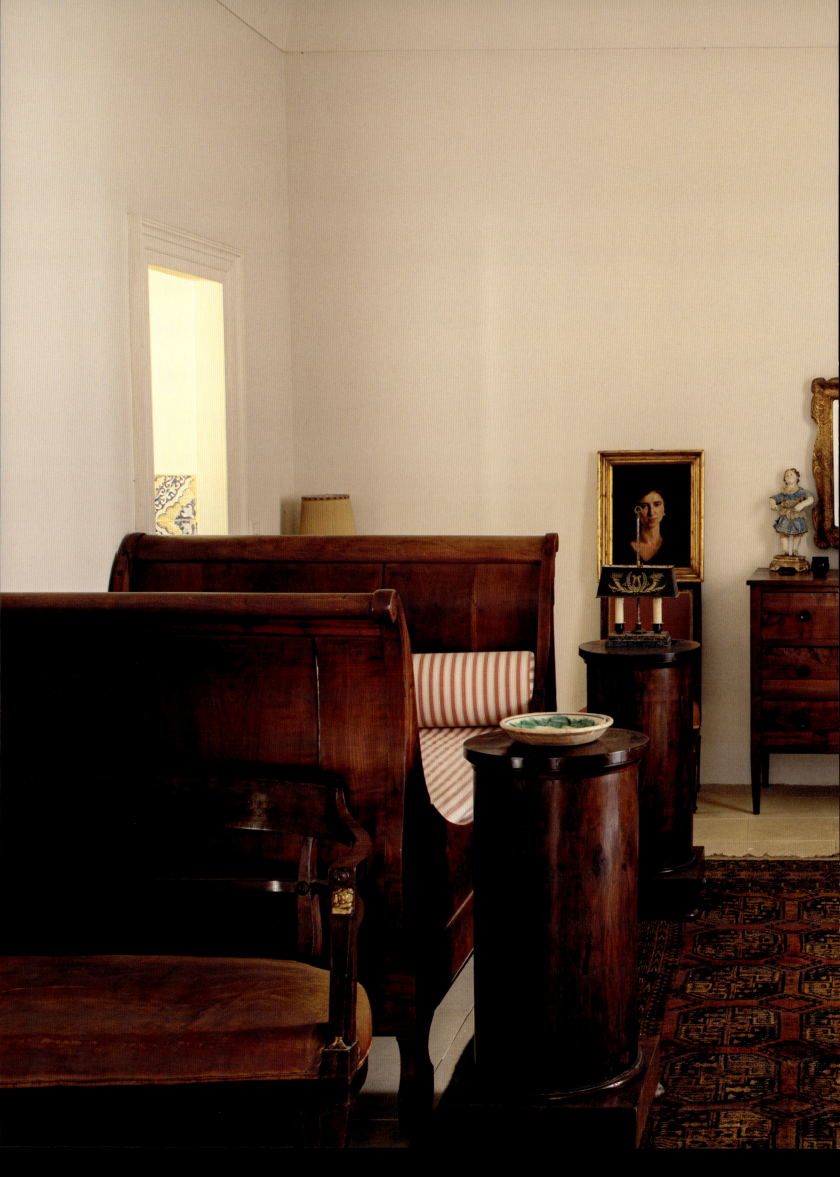

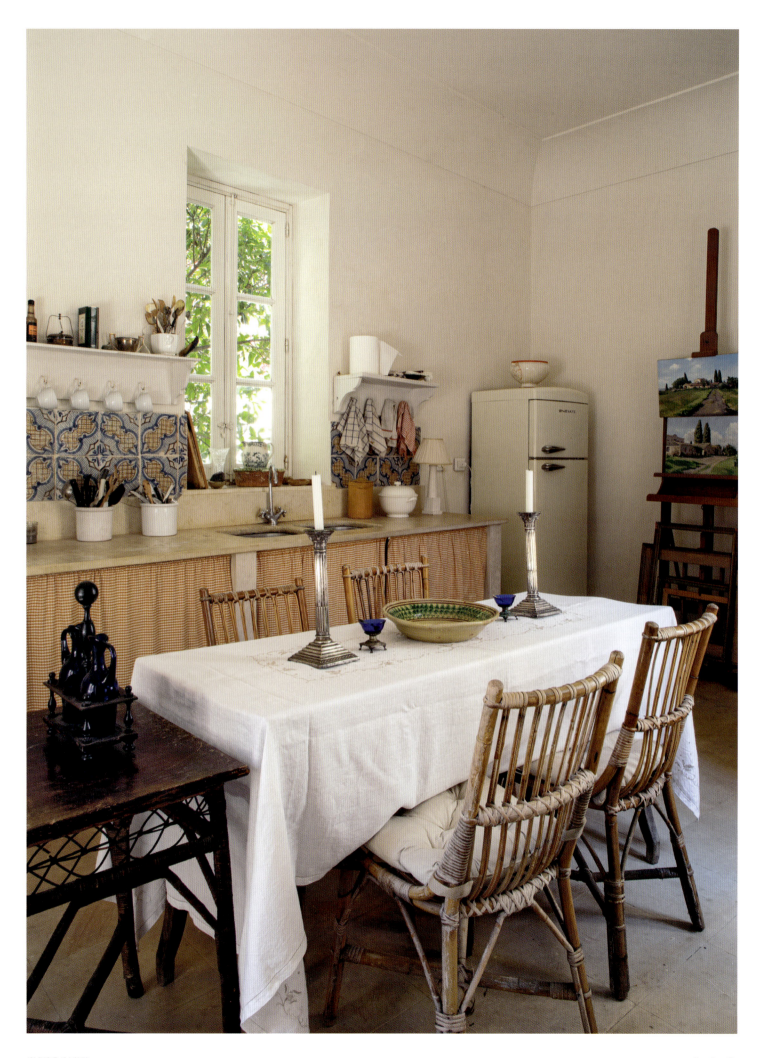

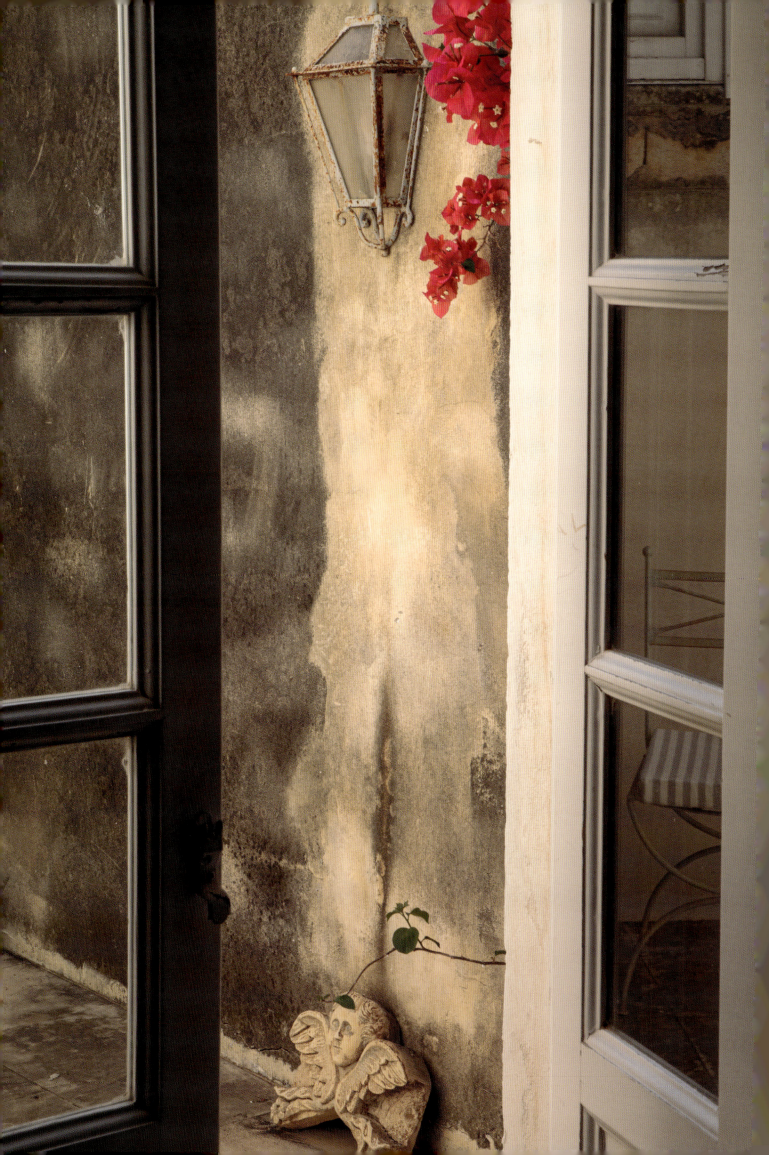

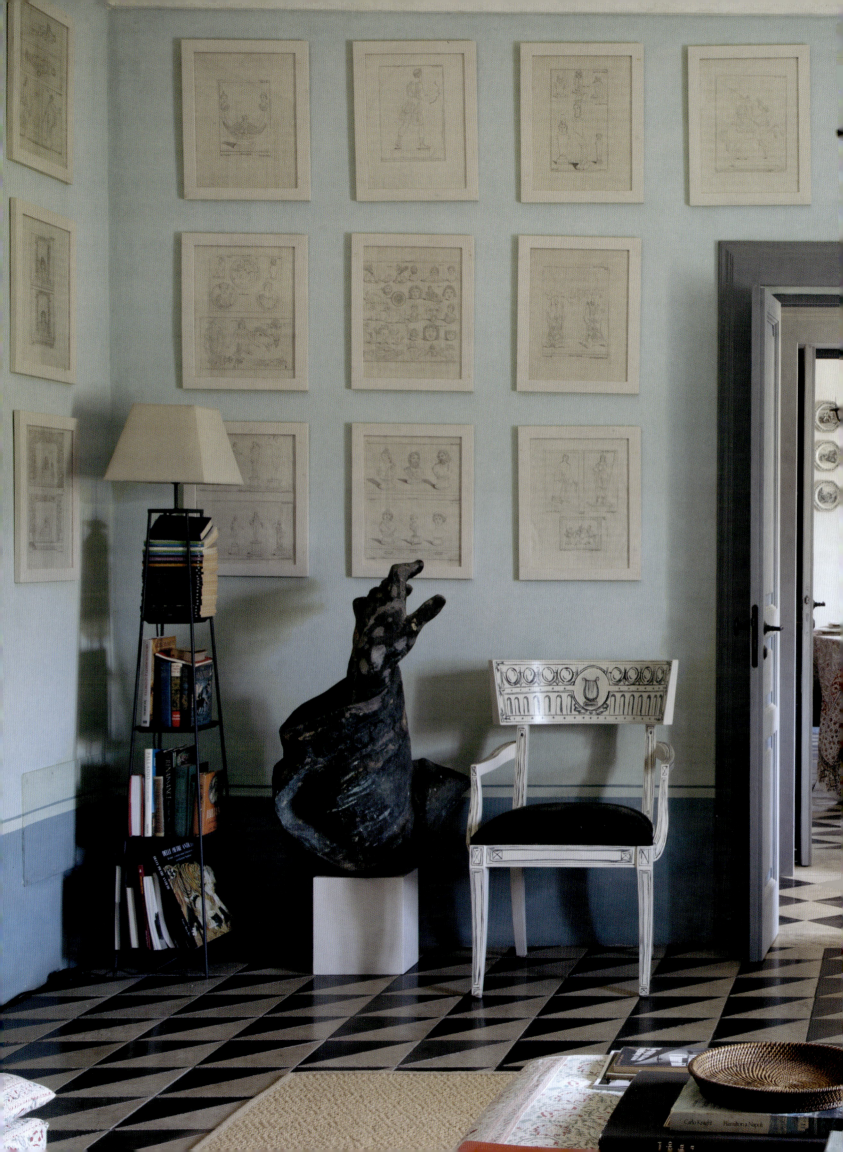

# MASSERIA CARDINALE
## RICCARDO PRIOLISI & JOHN HOOKS

Perched above its eponymous brook high on a river-carved limestone plateau in the Hyblaean Mountains, the Masseria Cardinale, a small fortified farmhouse, sat empty for generations. Fragments of its delicately carved white-gold limestone, used throughout southeastern Sicily, had been looted over the years and repurposed into nearby farmhouses, so that when Riccardo Priolisi (pictured, left) and John Hooks (right) found it, little remained. Its roofs had caved in, and the terrace that overhangs the underlying Bronze Age caves needed new supports. An ambitious overhaul was clearly necessary to transform the ruin into something livable.

The idea of a house in Sicily had been bubbling up for years in the couple's minds after successful careers in the fashion industry—Riccardo as a designer, and John as a business director turned consultant. The island was a natural choice because Riccardo is a native of Palermo, but in the end they opted not for his hometown, but for the Baroque triangle between Syracuse, Noto, and Modica. "We loved the sense of surprise the house offered," remembers Riccardo, "both in the courtyard and on the terrace." Indeed, stepping out from the wide, comfortable library, an oblique patio built over the ancient foundations seemingly floats above the gorge, where even in the driest summer the sound of the brook echoes upward.

The first step of the renovation was to reproduce the stonework details that surround the doors and windows in the courtyard. A small piece of the original frieze remained, and from it, masons chiseled replicas and buried them in the earth for a year to patinate the soft limestone. Engineers, meanwhile, devised a plan for the structure, and builders installed scaffolding. "When we saw the scaffolding up, it seemed a natural fit for the space," says John, who asked the builders to make it a permanent feature in a few rooms. The couple appreciated the way the parapet provided additional space for books and storage while keeping the height that would be lost with a dropped plaster ceiling.

From the library at the western end of the house, an enfilade of dining rooms, a small chapel, bedrooms, and an office overlook the ravine, while the drawing room, kitchen, and boot room face the courtyard. Throughout, Riccardo and John have played with patterns of triangular black and white limestone to both differentiate and unify the spaces, while pulling decorative inspiration from the full scope of their interests, including Picasso ceramics, a collection of plaster cameos, eighteenth-century engravings, an Andy Warhol above the fireplace, and Riccardo's own homage to Jean Cocteau in the bedroom.

In the kitchen, glazed tiles salvaged from a nearby ruin surround an overly refined marble wellhead. During construction, they came upon an old record of the well serving as an escape route for the Baron of Musso, who would have been fleeing kidnapping brigands. This was shortly after the newly minted baron had established his *Case Grandi* (Big Houses), as the place was then known, on the ruins of an older Massaria Cardinale in 1860. While they haven't yet been able to confirm the story, or investigate whether the tunnel exists, it adds to a sense of adventure, and is another chapter in the long history of these limestone hills.

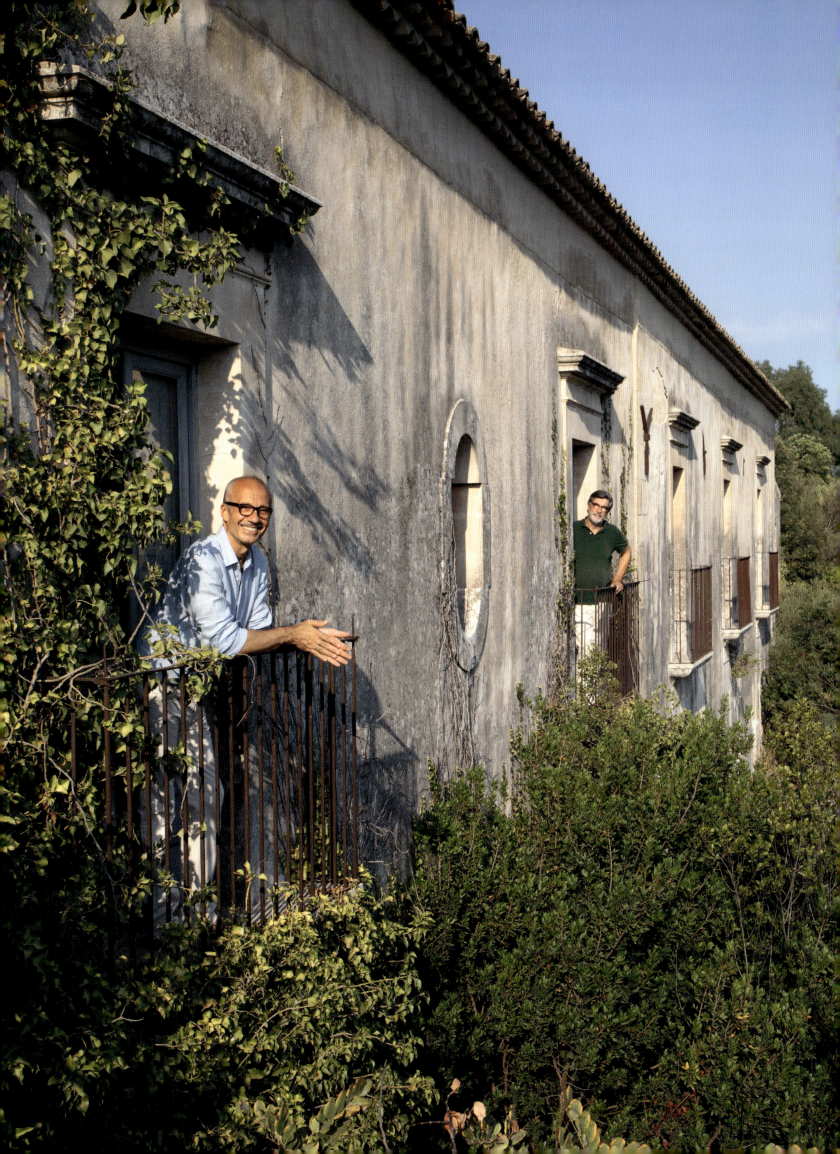

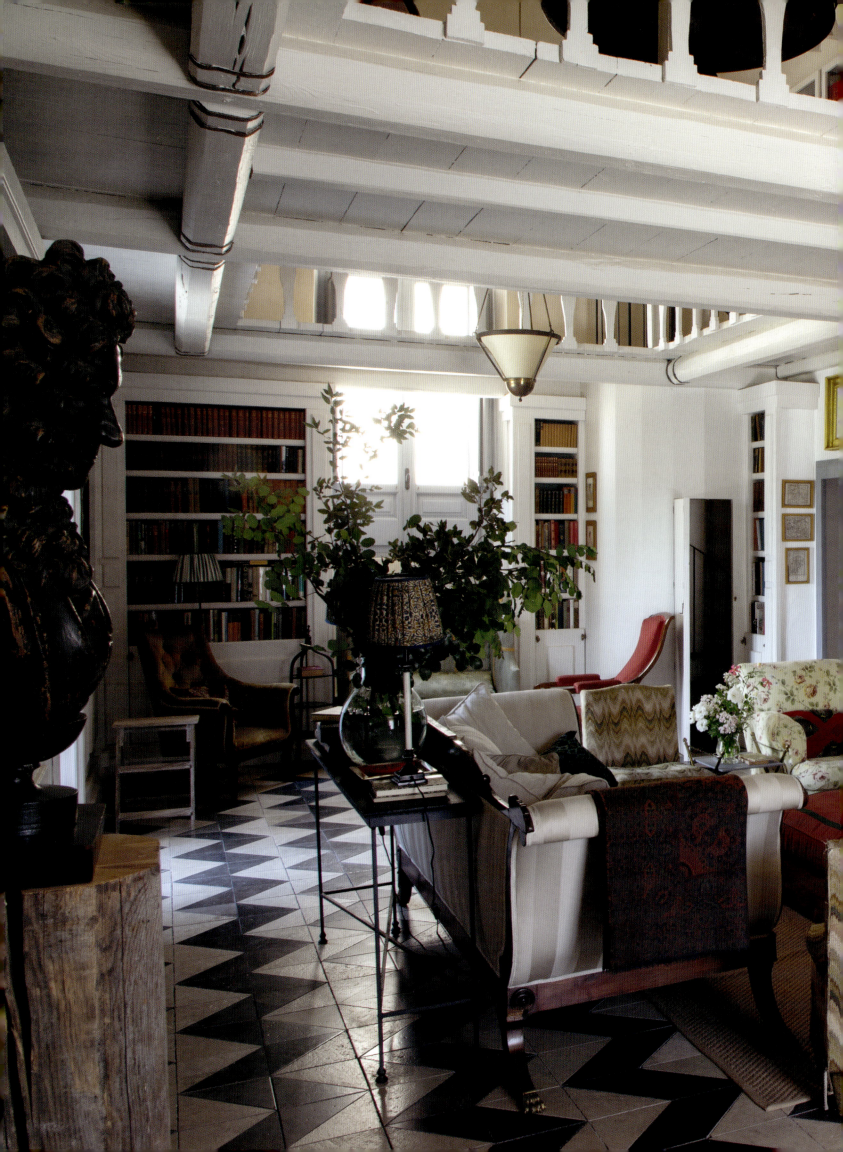

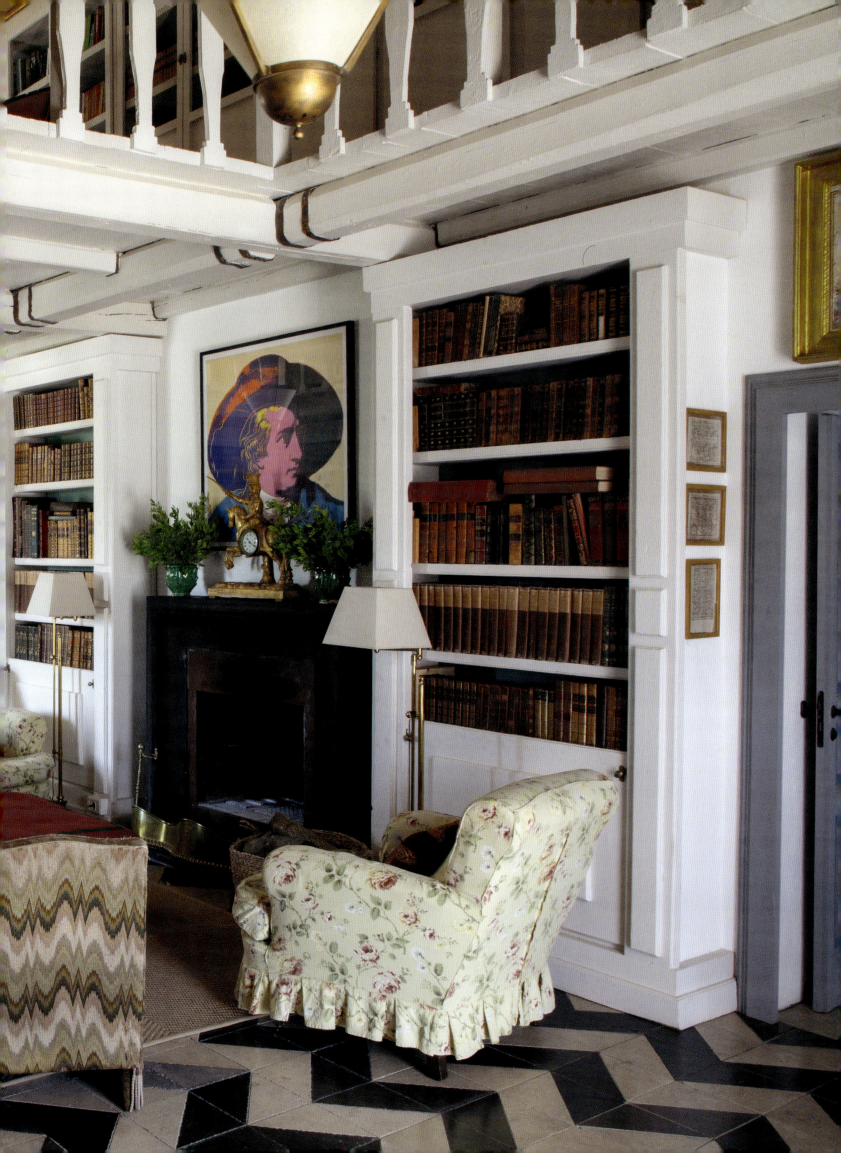

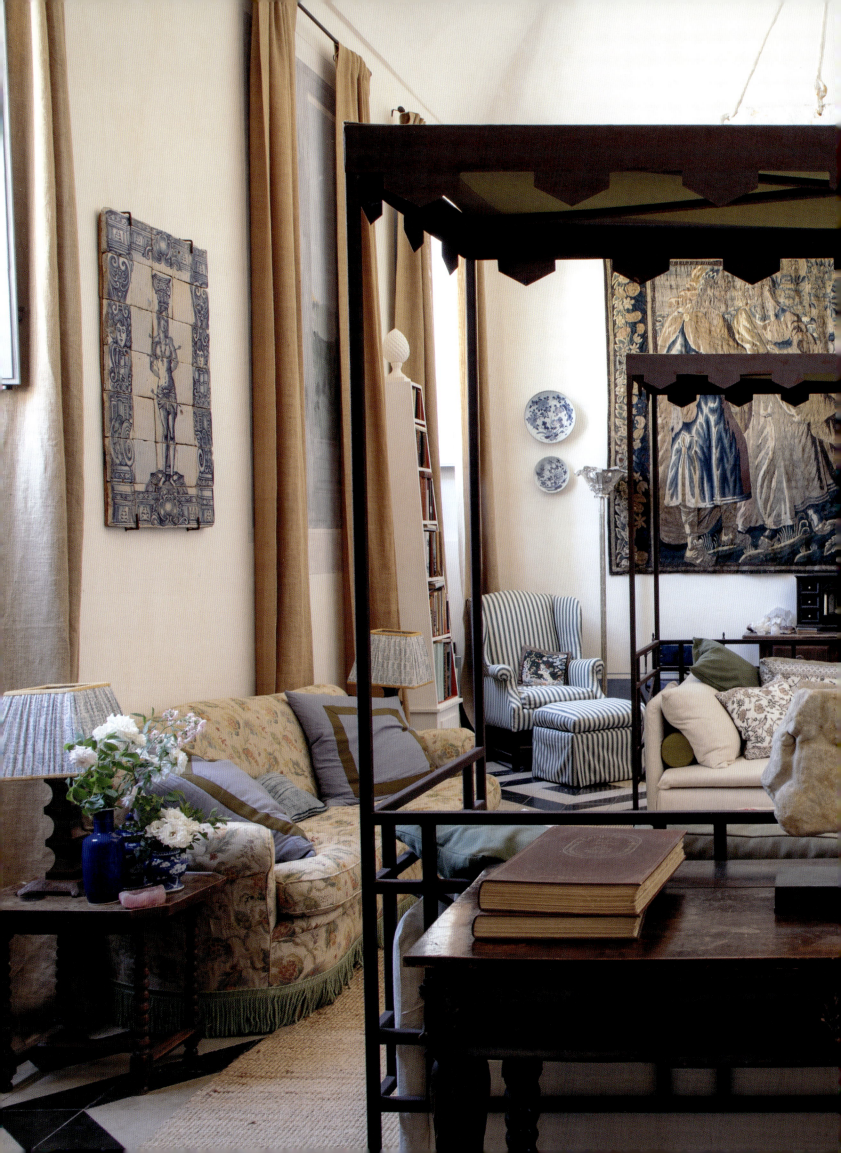

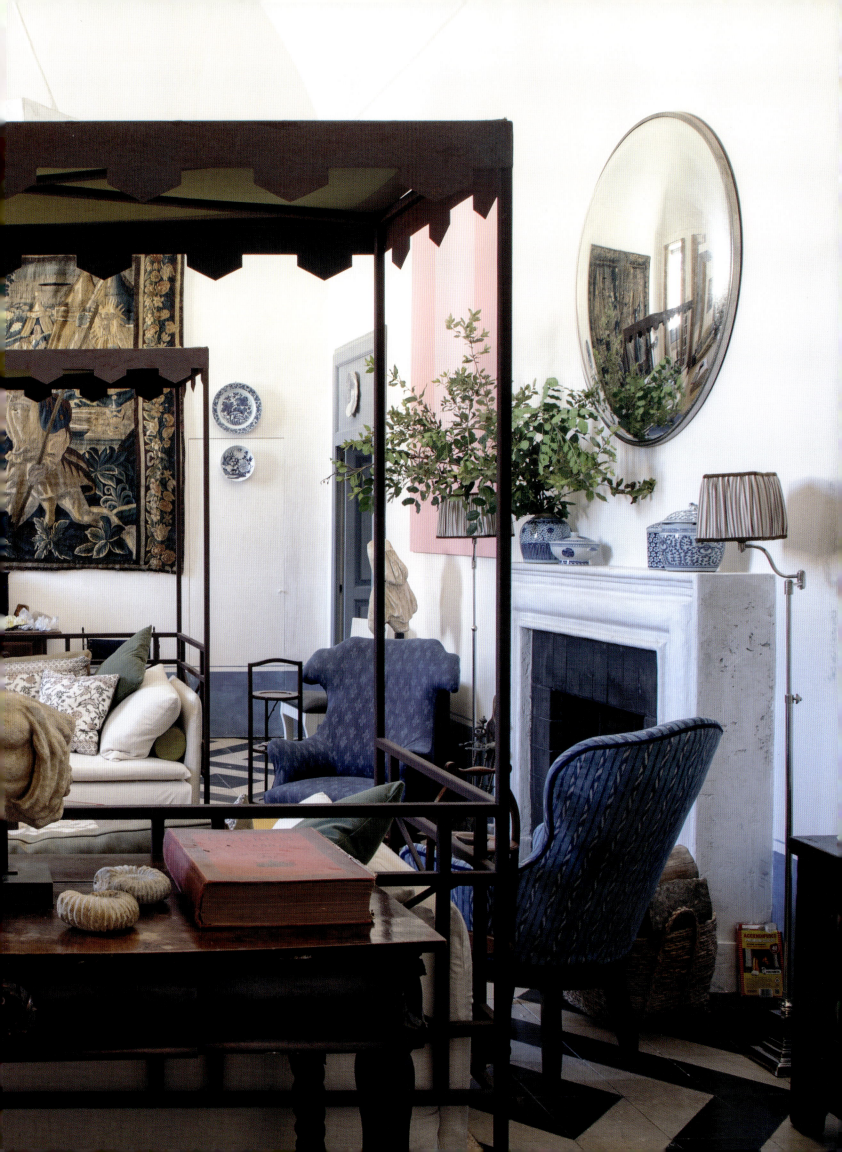

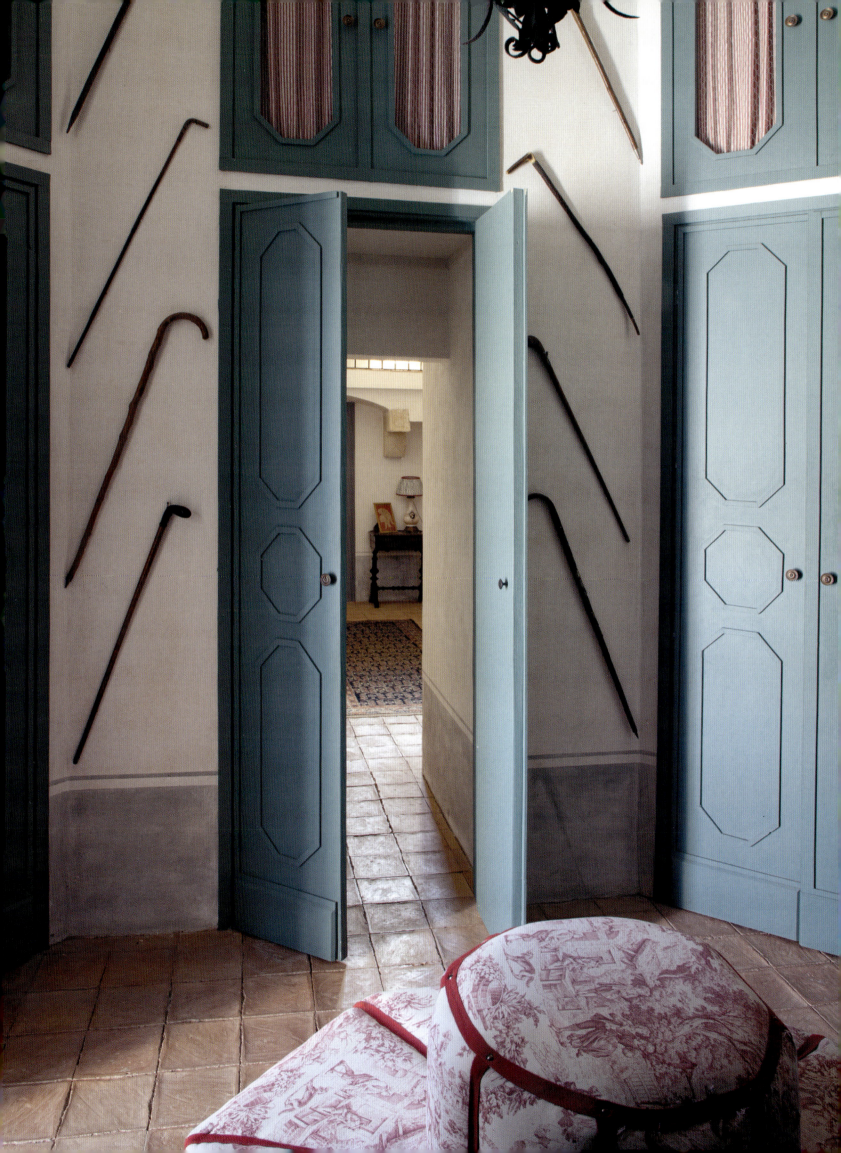

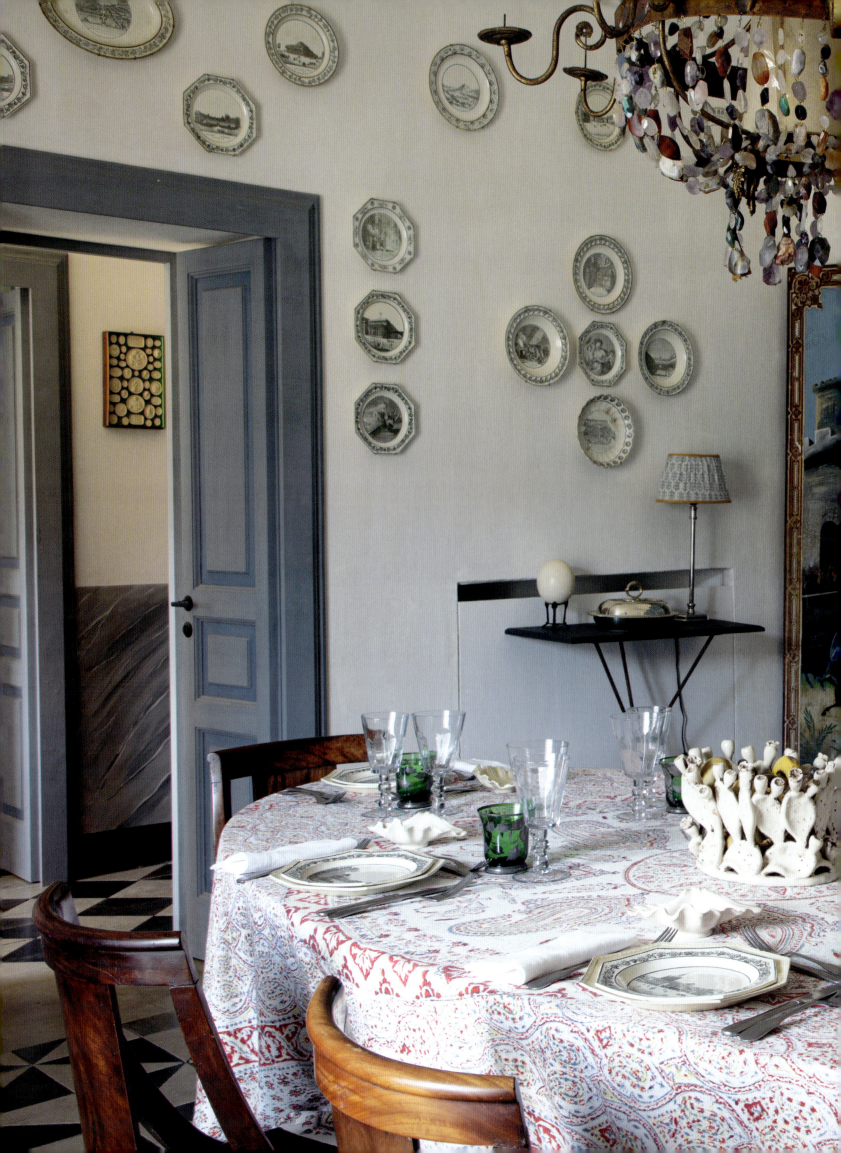

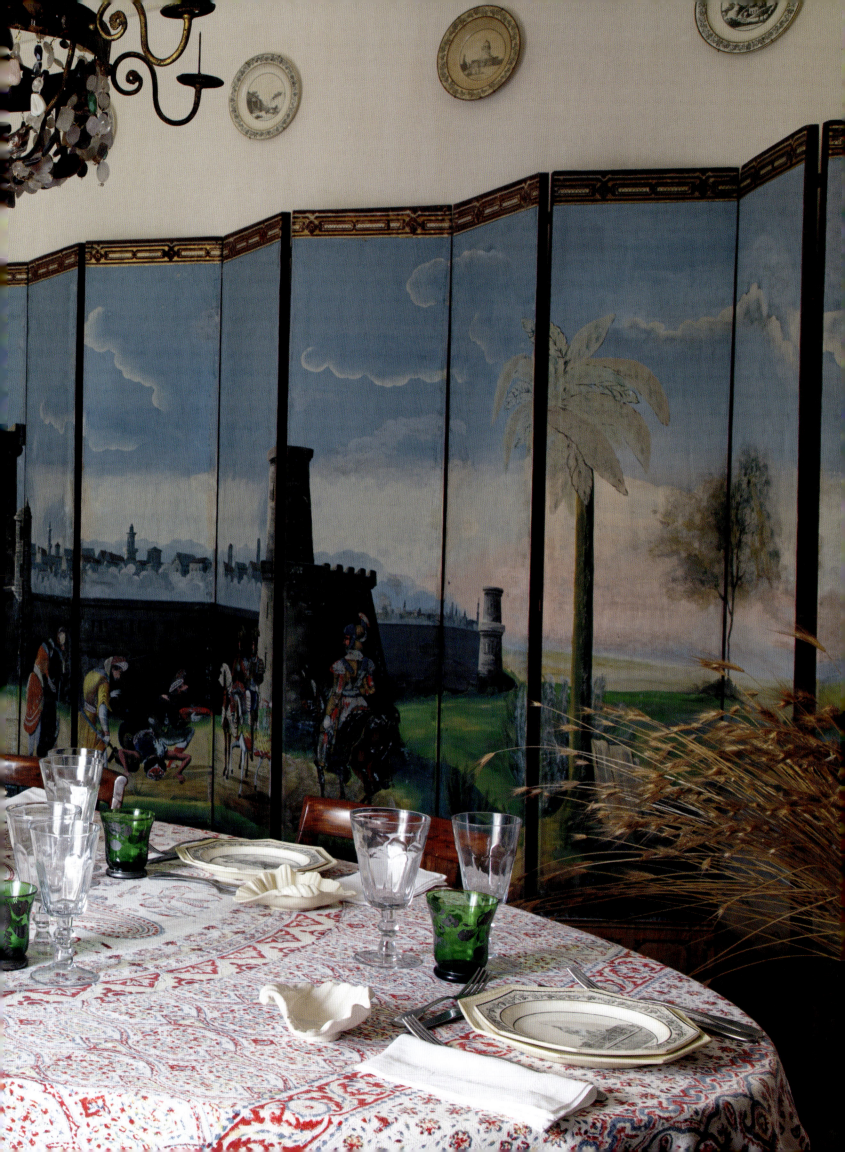

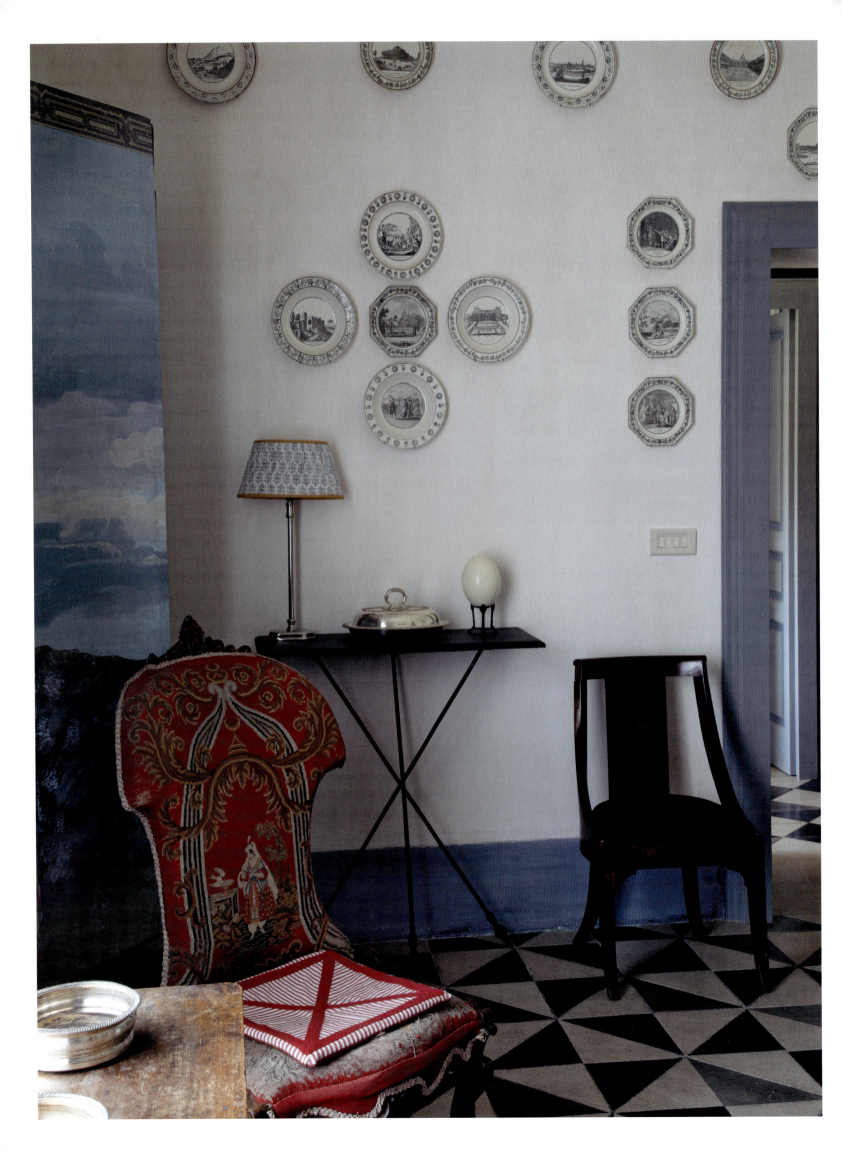

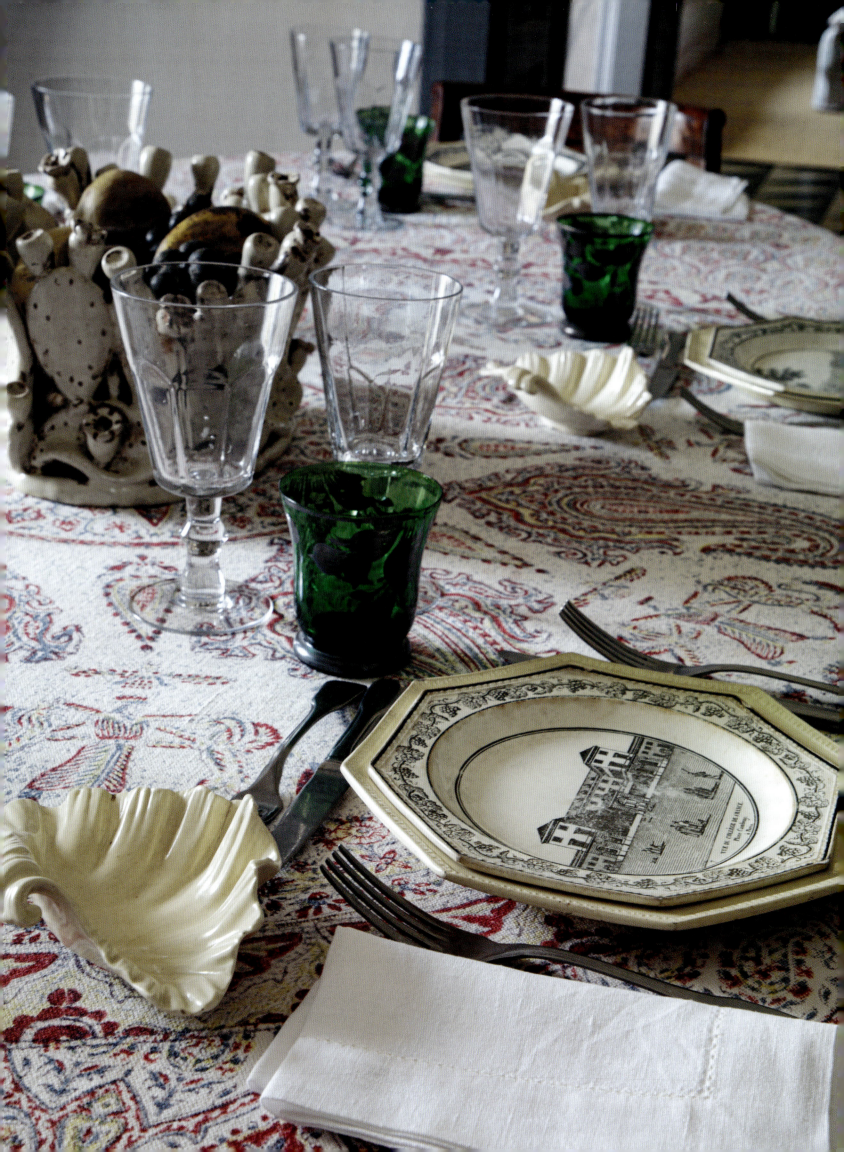

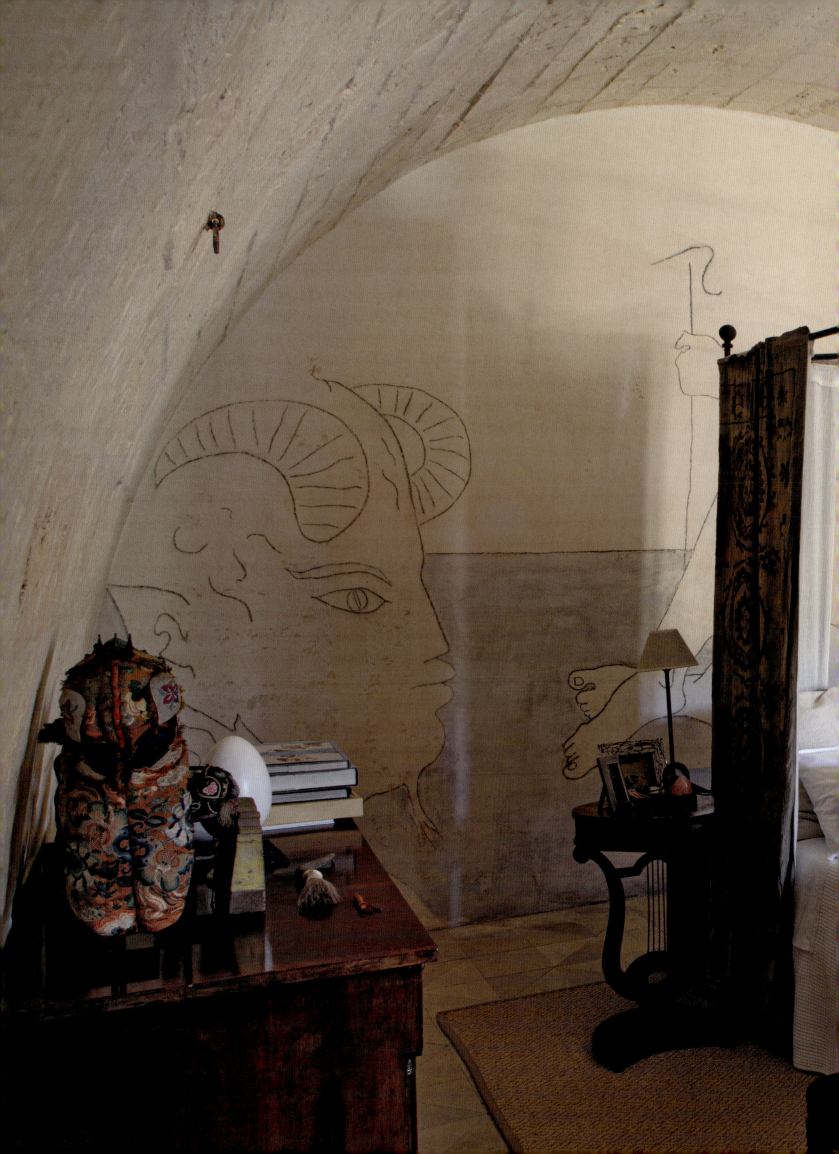

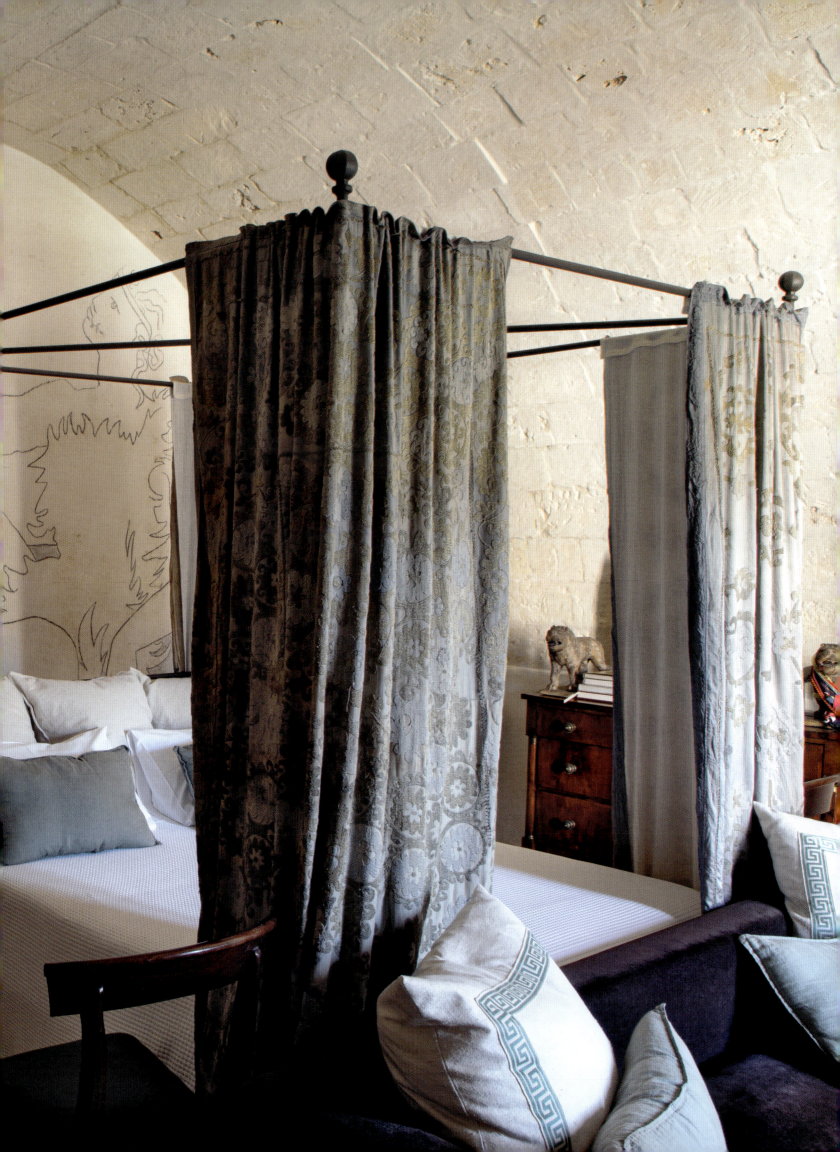

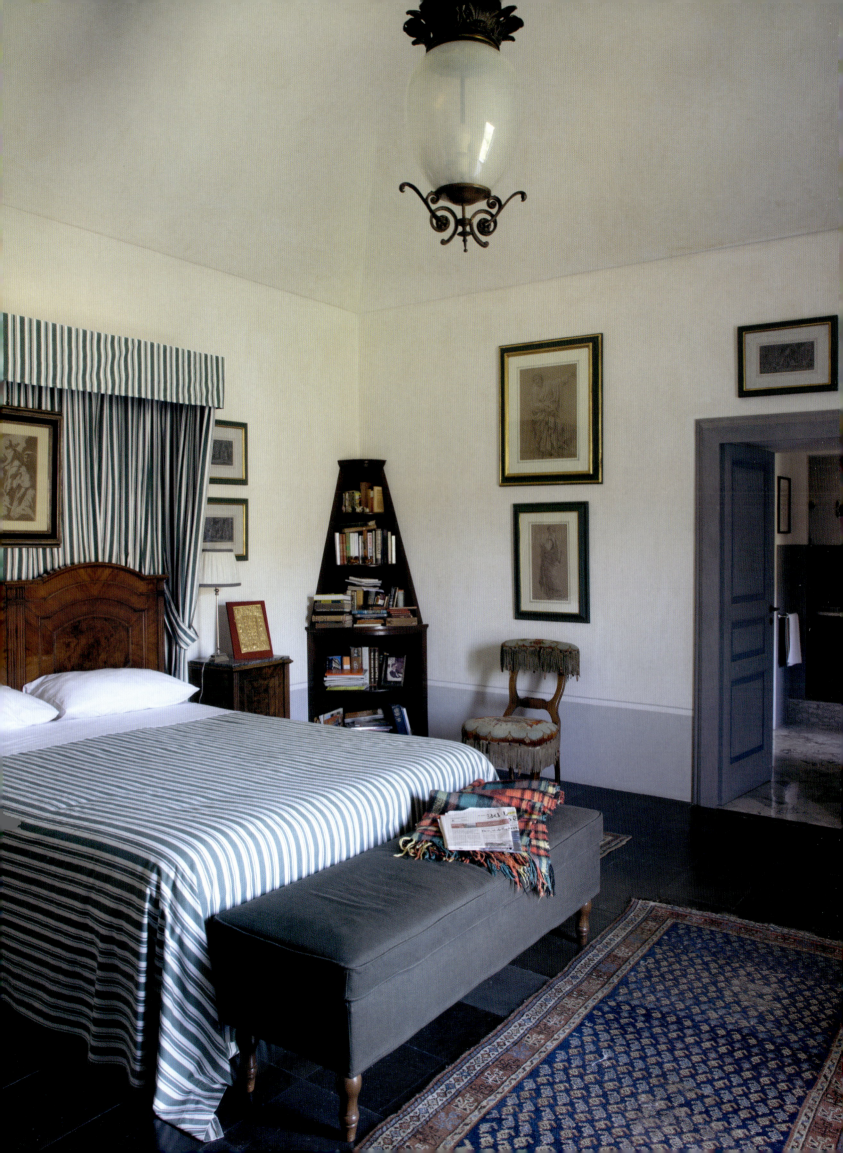

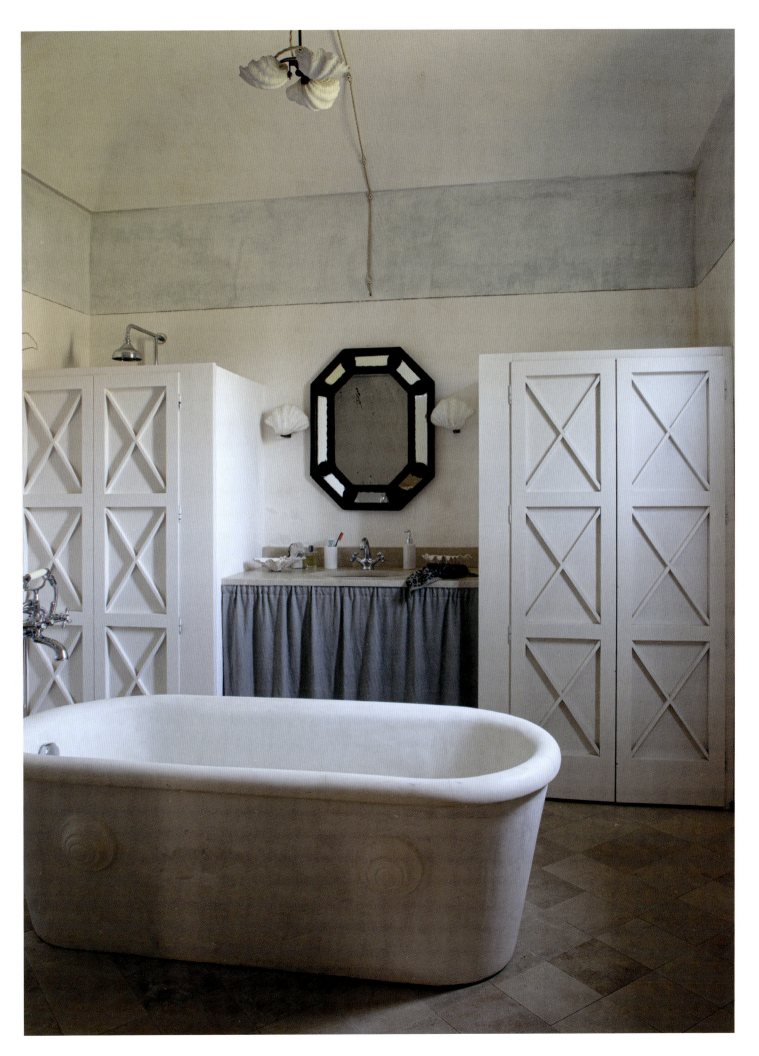

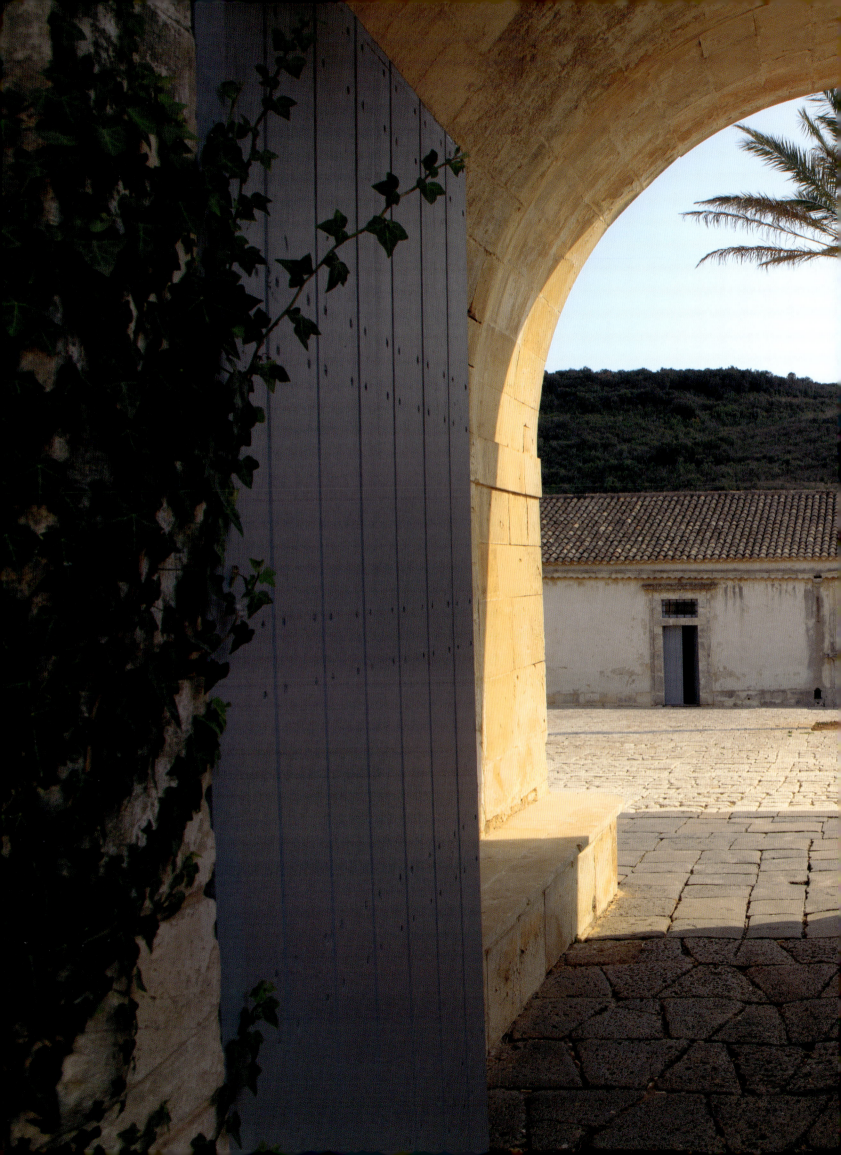

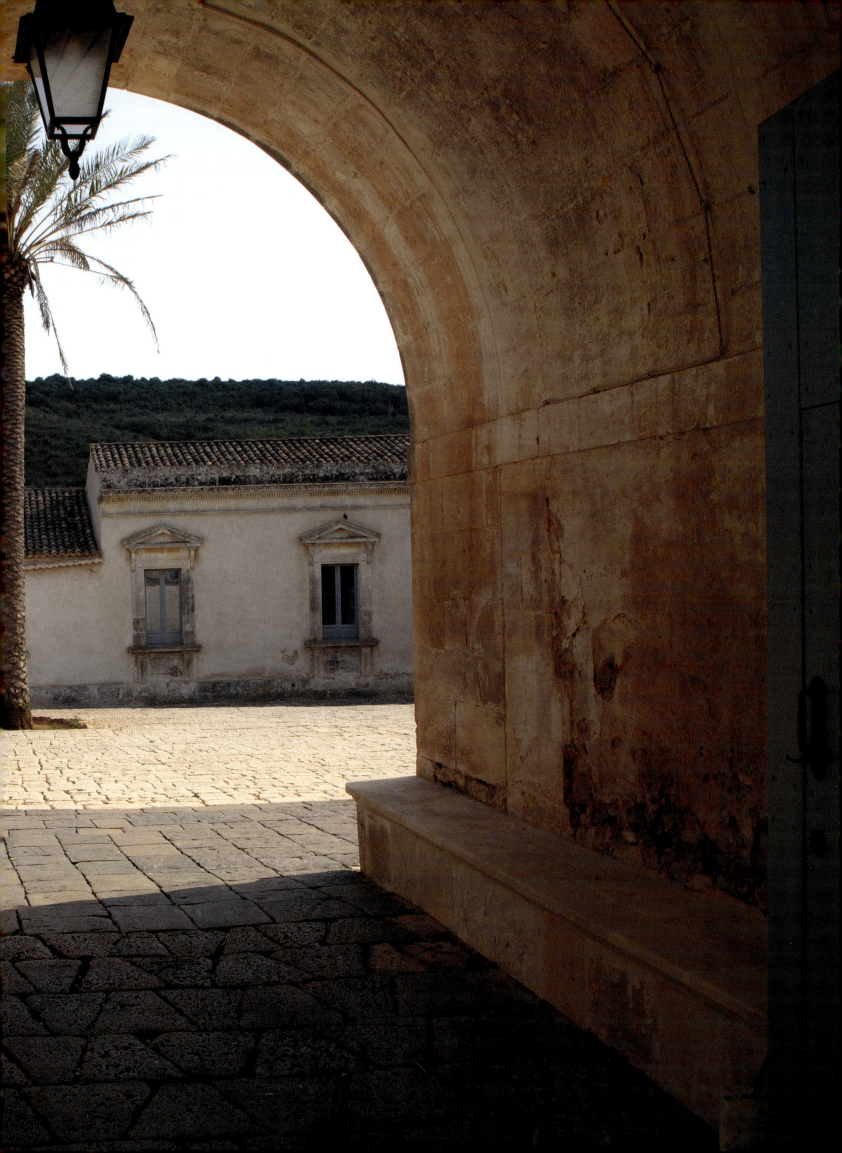

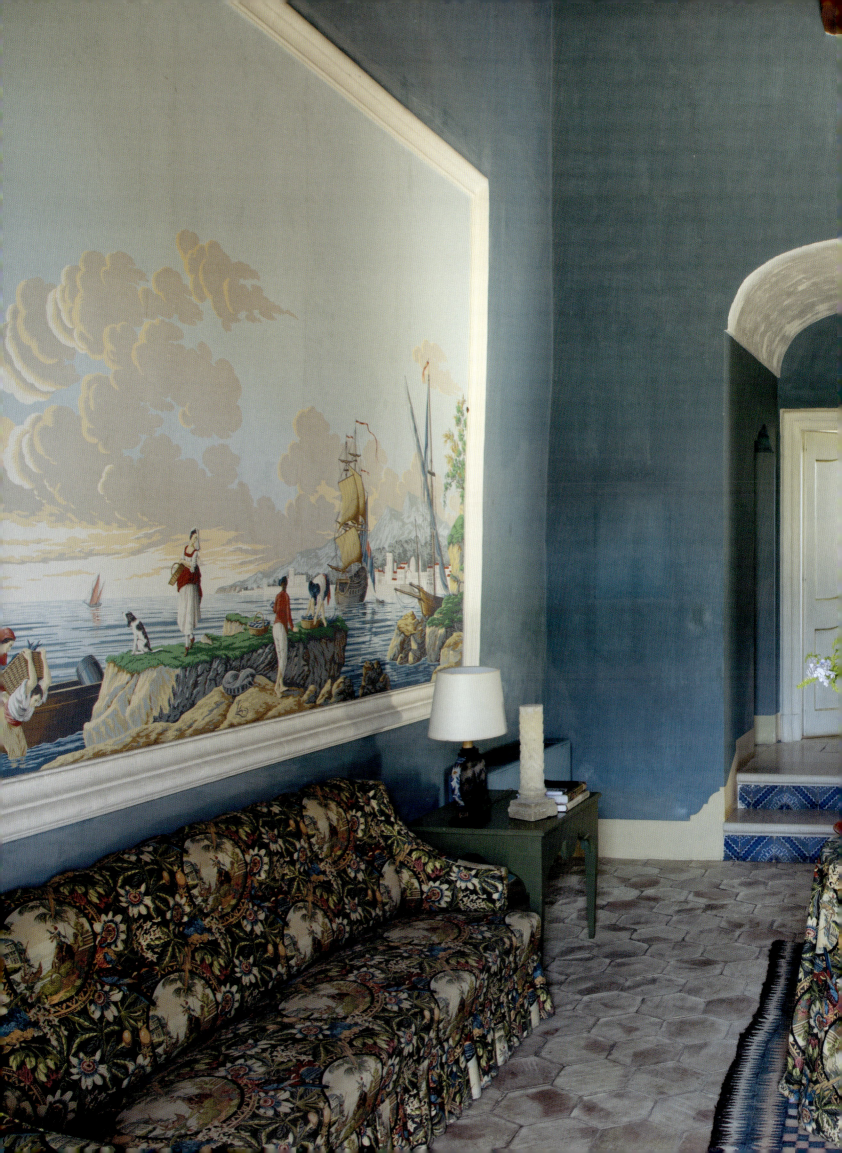

In the sun-drenched landscape between Syracuse and Catania sits the Commenda di San Calogero, an extraordinary fourteenth-century property that has been in the Matarazzo family since the 1830s. Over generations, it has evolved from a monastery into a working farm and now—under the careful stewardship of Pierfrancesco and Gabriella Matarazzo—a refined country estate.

Originally fortified during the period of Spanish rule, it bears the marks of its layered past in the arched cloisters and thick stone walls. Its orchards, abundant with lemons, blood oranges, clementines, almonds, and olives, continue to form the backbone of its agricultural output, while a vegetable garden supplies the estate with bushels of tomatoes and other produce.

The Matarazzos' son Andrea (pictured opposite with his sister Carla) is a trained architect who found his true calling in landscape design and spent years working in England before returning to Sicily to reconnect with his ancestral home. His first major intervention, two decades ago, was to create a garden that feels both timeless and in keeping with its starkly beautiful surroundings. Where monks once walked in quiet contemplation, now lavender, pelargoniums, salvia, and Balearic Island sage (*Phlomis italica*) flourish, and jasmine and roses scent the air, their tendrils creeping along the weathered limestone.

Beyond the courtyard, the land opens into a series of diverse gardens. The rigorously structured Italian Garden is inspired by family visits to the Royal Palace of Caserta, and defined by cypresses, palms, and jacarandas. Fountains gurgle softly, their water carried by an ancient irrigation system that harks back to Sicily's Arab past. Farther on, reflecting pools bordered by Seville orange trees frame a pair of striking Indian pavilions painted in rich blue oxide mixed with lime, an homage to the Alhambra in southern Spain. This is a place of movement and stillness, of cultivated beauty and wild abandon. To one side, a small woodland of native oak, myrtle, bay, and arbutus trees bridges the transition from the formality of the garden to the raw, open landscape beyond.

Andrea has not merely preserved the spirit of the Commenda, but also subtly adapted it for modern life. Over the years, the property has become a setting for elegant, understated gatherings, from intimate celebrations to weddings where guests dine beneath ancient trees with the silhouette of Mount Etna glowing softly in the distance. Inside, the former monks' cells, once stark and spare, were converted into guest rooms by Andrea and his parents. In the dining room, family meals are still presided over by Gabriella, an exceptional cook who blends Sicilian and Neapolitan traditions with effortless grace.

Although its history stretches back centuries, the Commenda di San Calogero is very much alive. It continues to evolve, not as a rigidly preserved relic, but as a living, breathing place, shaped by the land and the people who call it home. "I haven't imposed my vision on this place," Andrea reflects. "I've simply listened to what it has to say." In doing so, he has ensured that its story—of resilience, adaptation, and quiet splendor—will continue for generations to come.

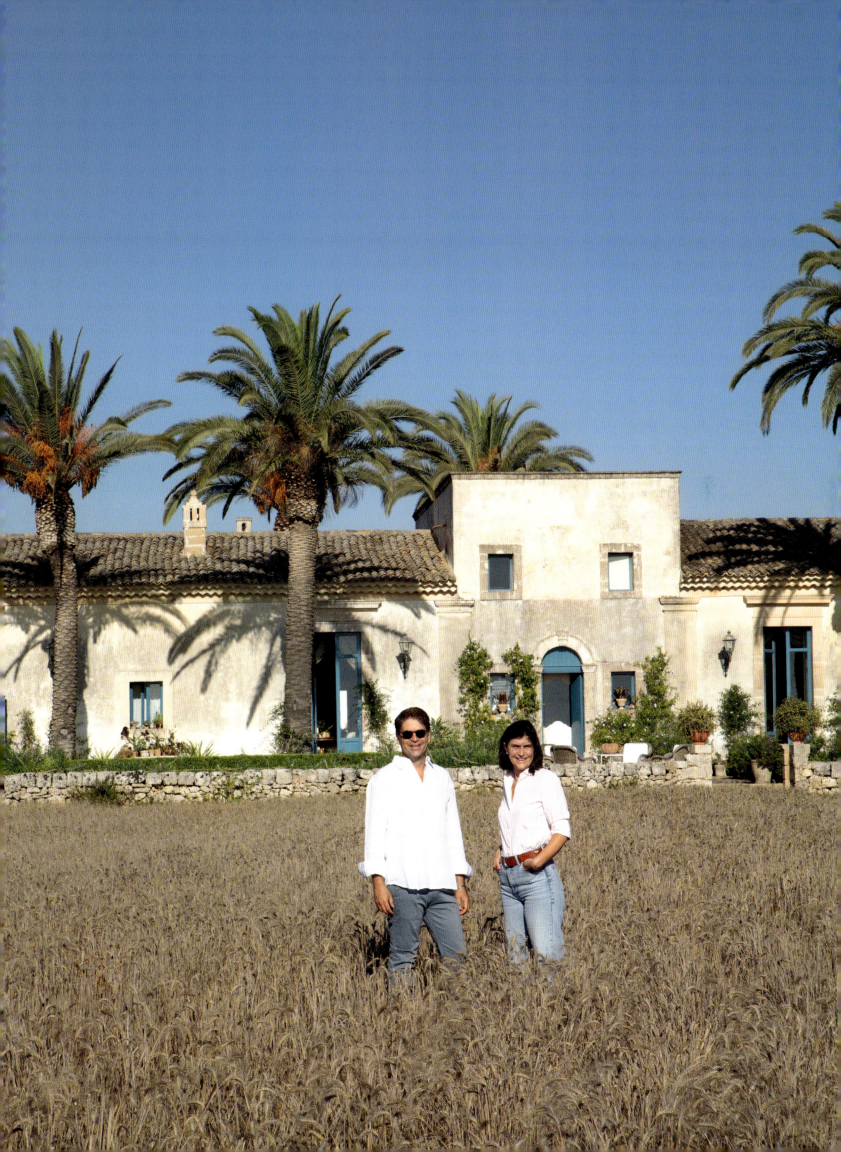

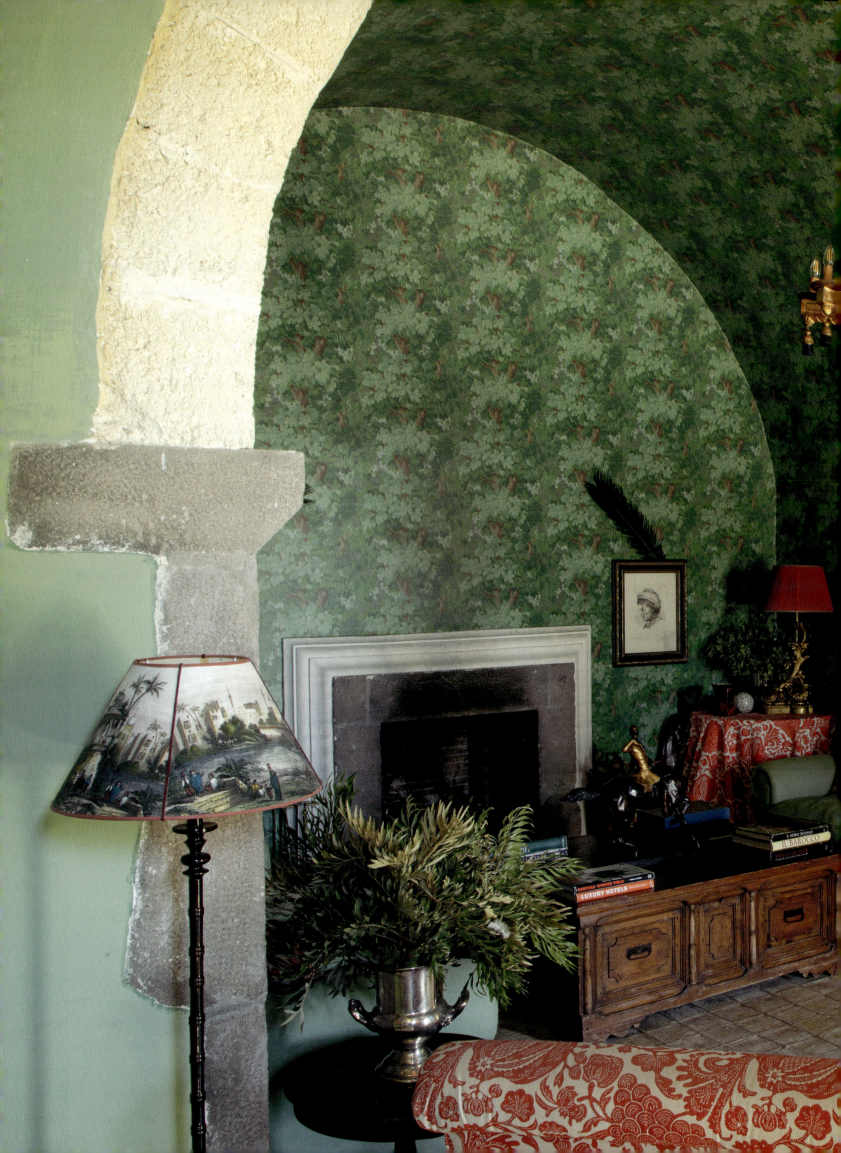

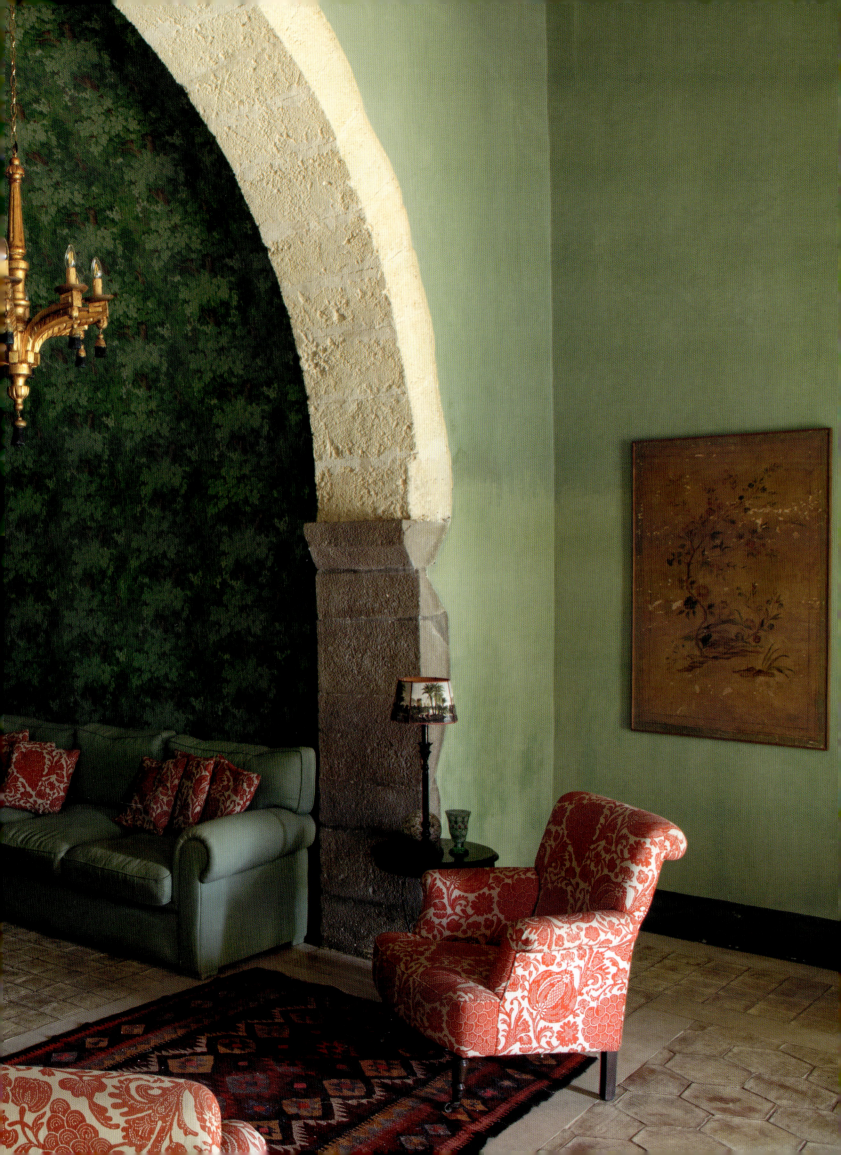

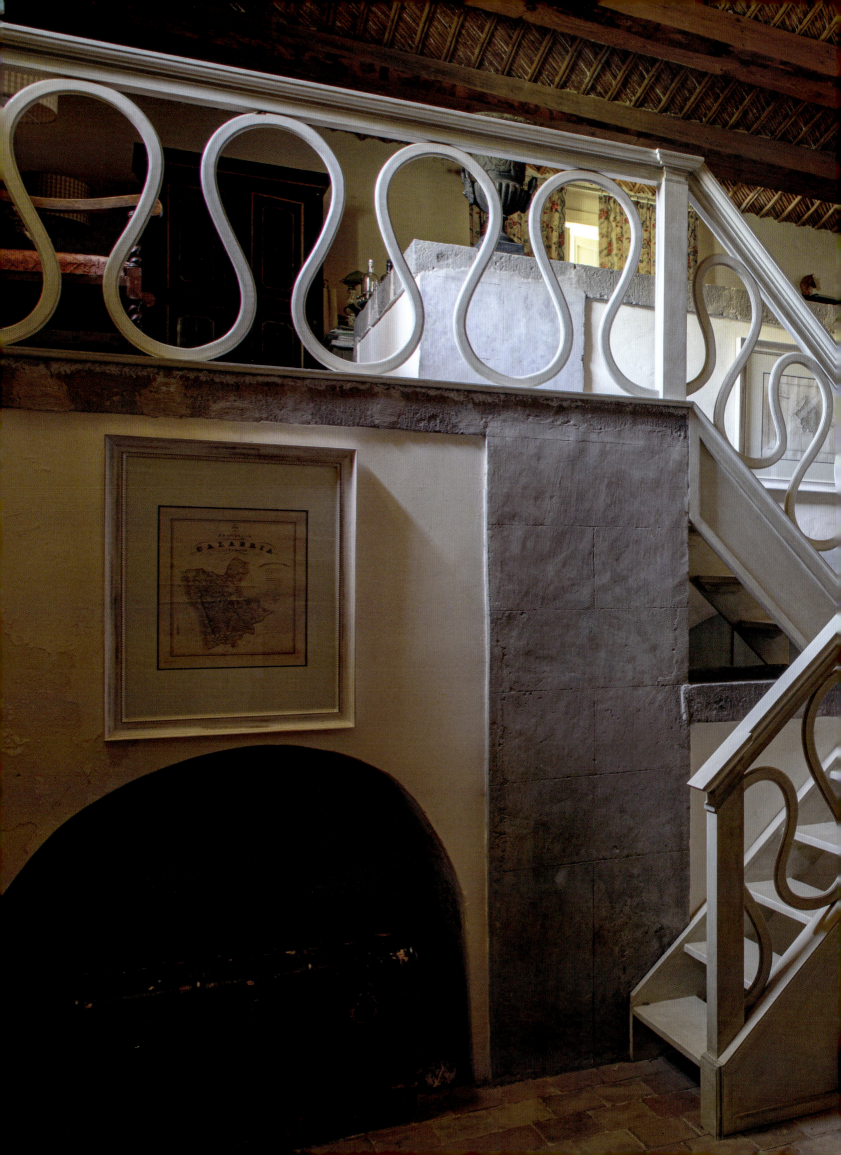

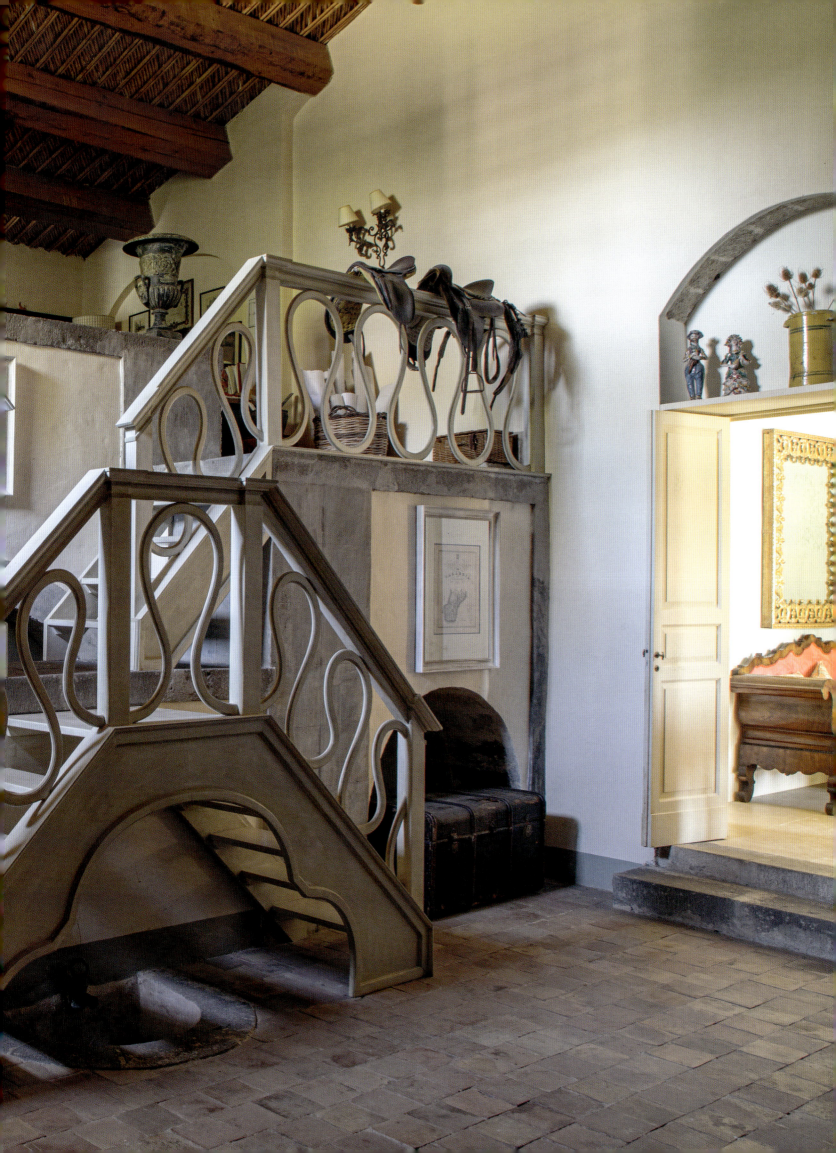

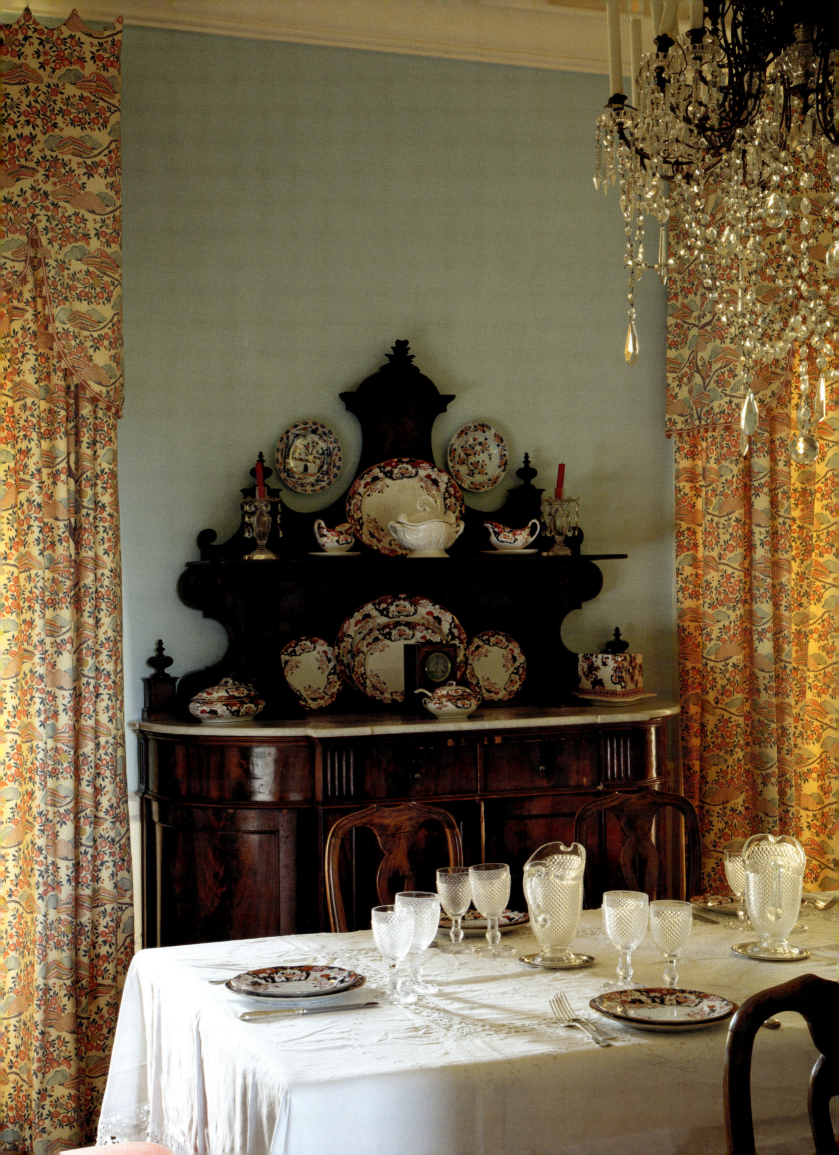

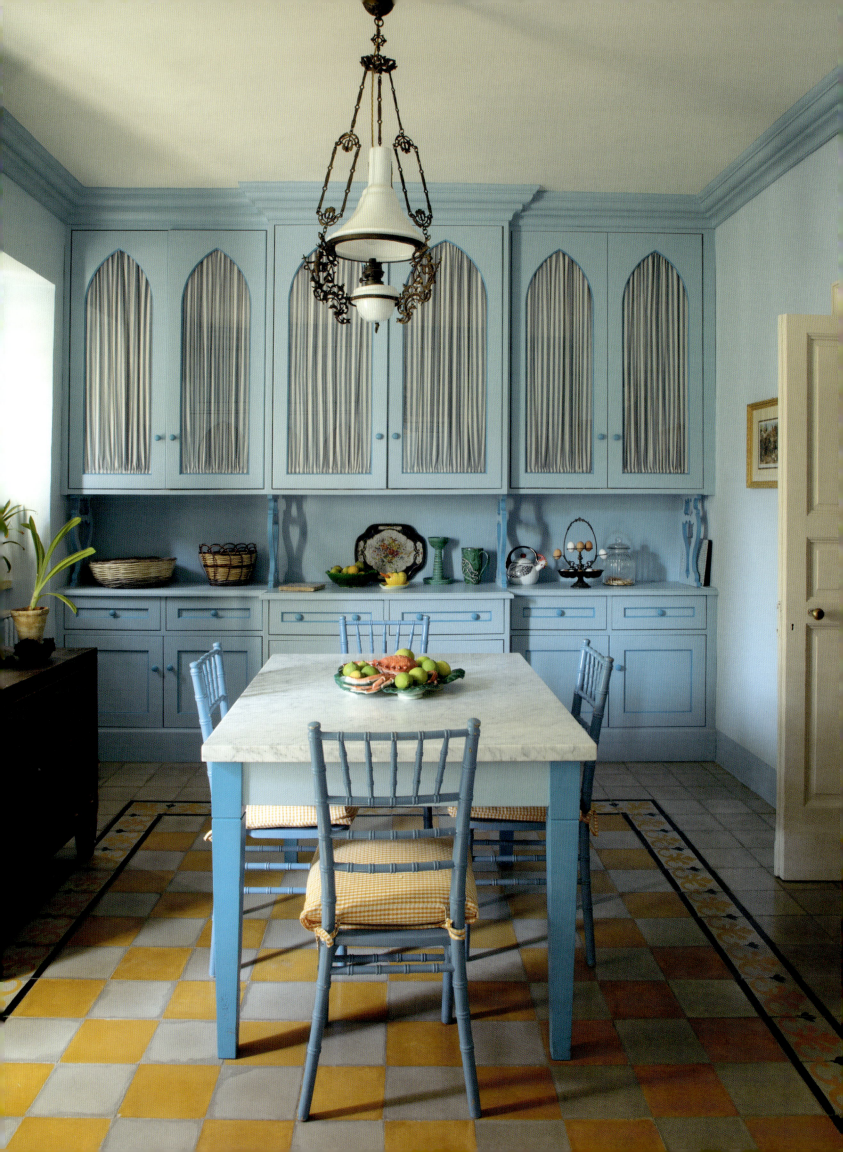

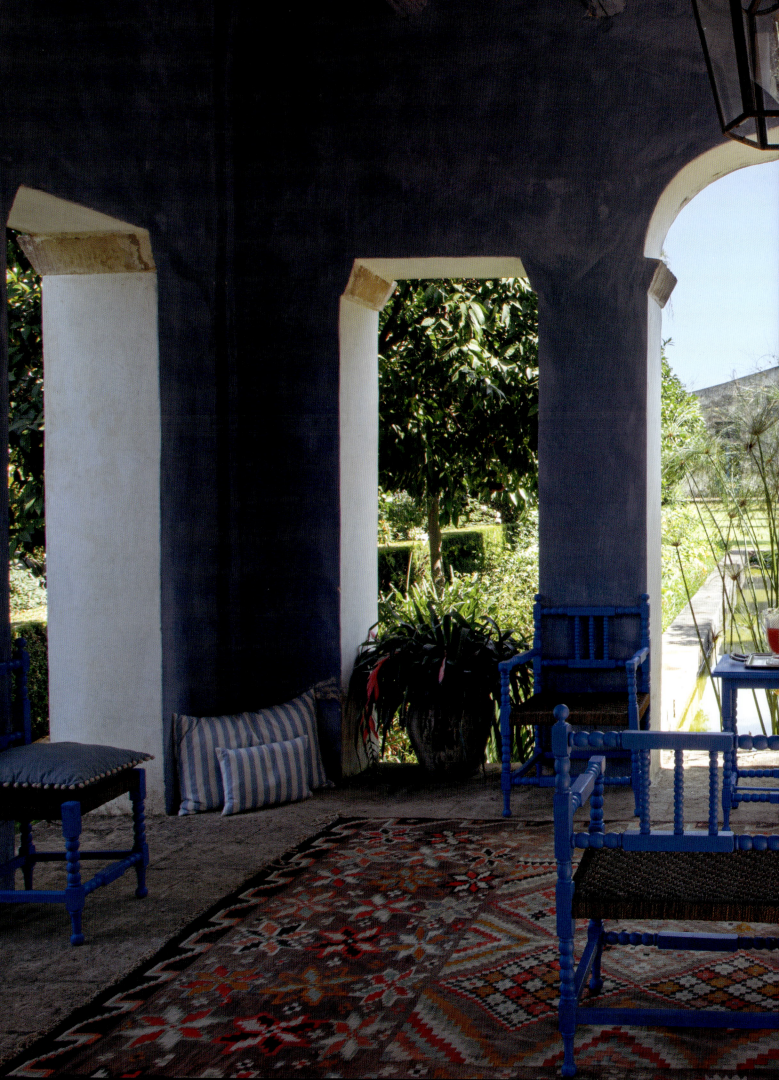

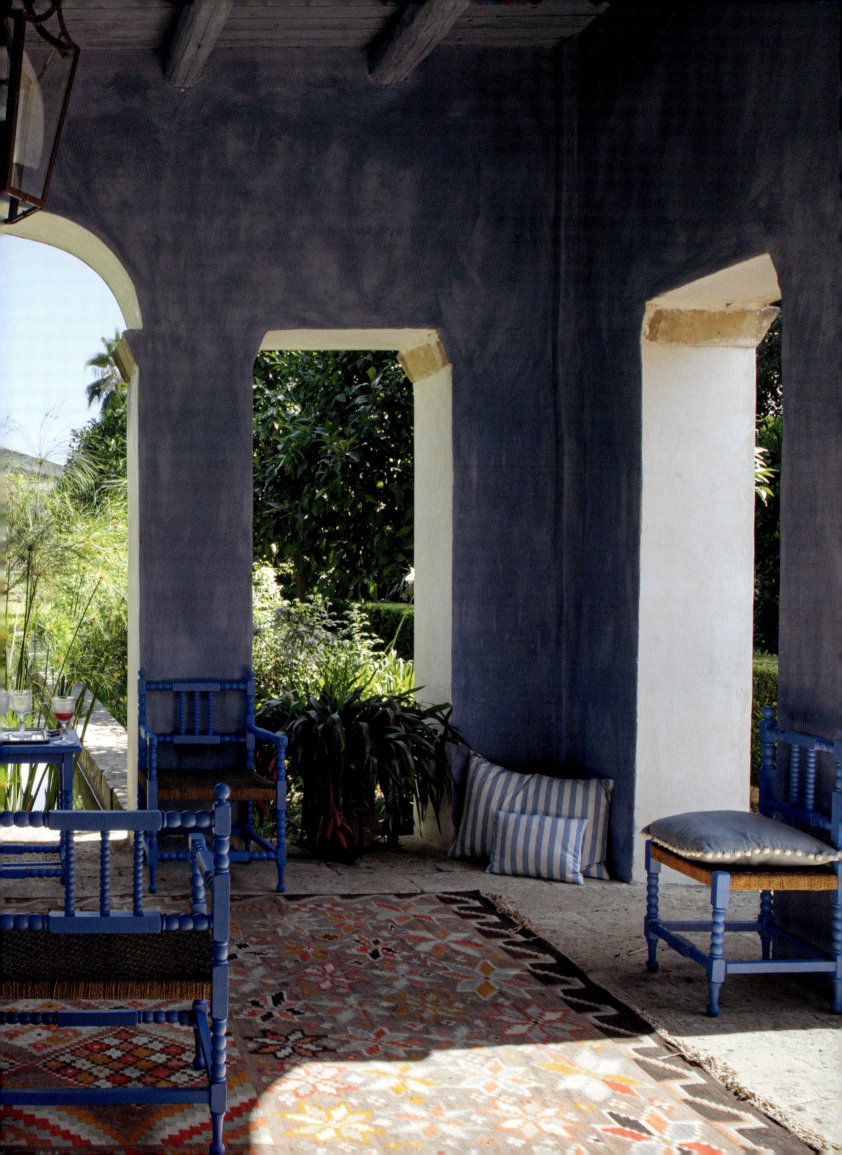

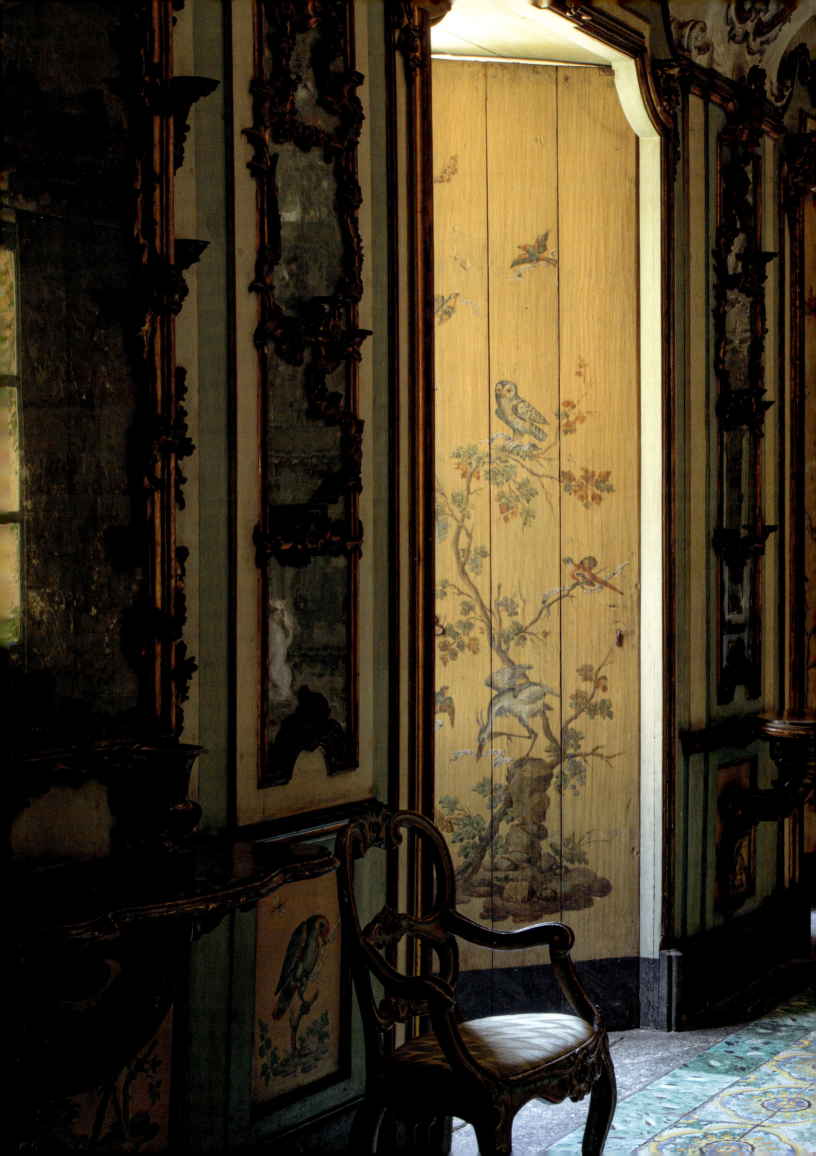

It was just days after Mount Etna's most recent eruption that Guido and I stepped out onto the roof of Palazzo Biscari. Black volcanic ash glittered against the white stones, and from this vantage point, we could take in the expanse of Catania. Although now set back from the bustling port, the centuries-old building once stood at the water's edge, a strategic and symbolic position from which to oversee the life of a port city that was a Mediterranean hub of trade and culture for centuries.

Palazzo Biscari, the most important private Baroque palace in Catania, was built after the devastating earthquake of 1693 that reshaped the city. Ignazio Paternò Castello, the 3rd Prince of Biscari, was granted permission by the Duke of Camastra, who led the city's reconstruction efforts, to build the palazzo on a section of Catania's sixteenth-century walls. What emerged, completed by his son and grandson over decades, is a masterpiece of Baroque and Rococo architecture.

Today, Palazzo Biscari remains a family home, lived in by several members of the Moncada Paternò Castello family (descendants of the original Biscari line) and managed by Ruggero Moncada di Paternò and his wife, Nicoletta. The palazzo's *piano nobile* is often used as an event space, but each private apartment contains beautiful decorative elements, such as the Galleria degli Uccelli (Gallery of Birds).

From the dusty courtyard, the raised entrance has all the typical Sicilian grandeur, and it is easy to imagine the impression it would have made on the German writer Johann Wolfgang von Goethe when he visited in 1787, welcomed by Prince Ignazio V in a series of sumptuous rooms filled with innumerable collections. At the heart of the palace lies the extraordinary Salone dell'Orchestra (Orchestra Hall), a Rococo marvel inspired by Neapolitan design. Its oval ceiling is adorned with frescoes celebrating the glory of the Biscari family, and a hidden musicians' gallery sits above, blending seamlessly into the room's opulent décor.

As we stood on that ash-dusted roof, with the city's domes and Etna's smoking summit in view, it was impossible not to feel the weight of the stories held within these walls—a testament to the vision of the Biscari family, and to the enduring spirit of Catania, the "Black City" of Sicily.

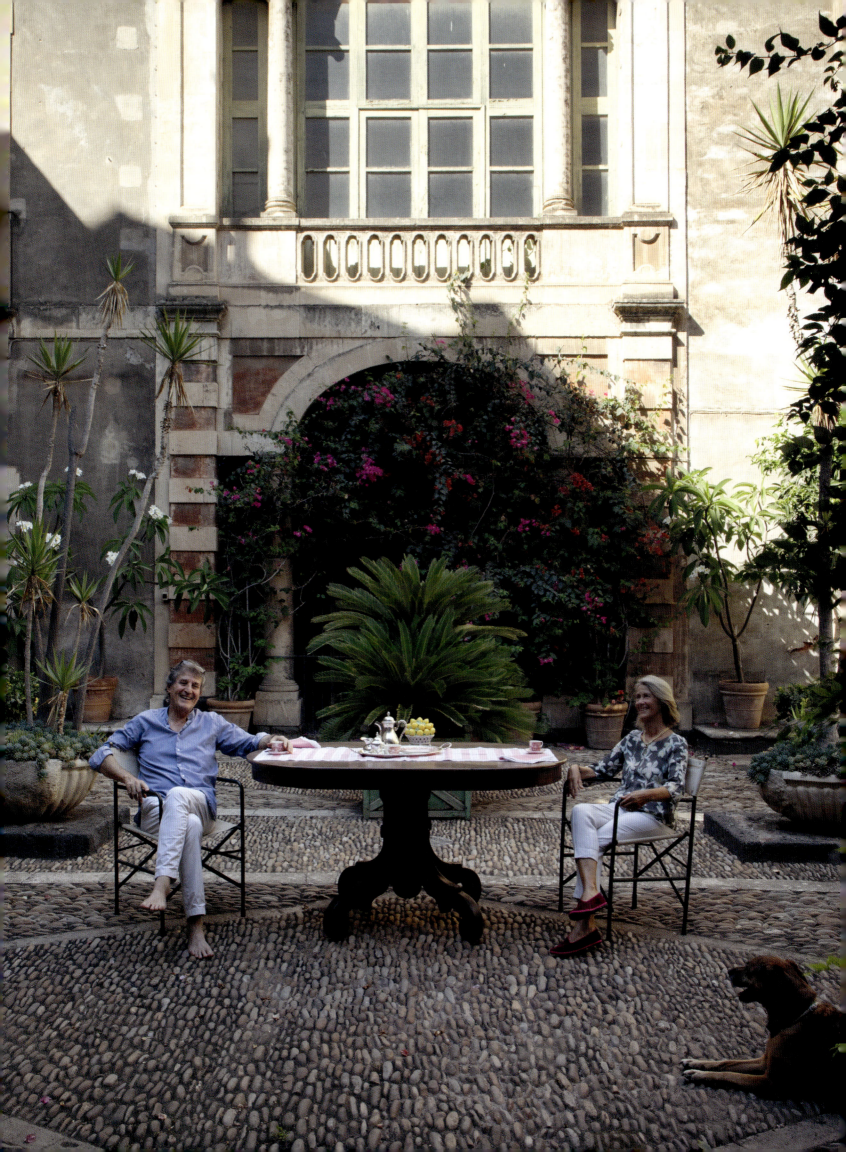

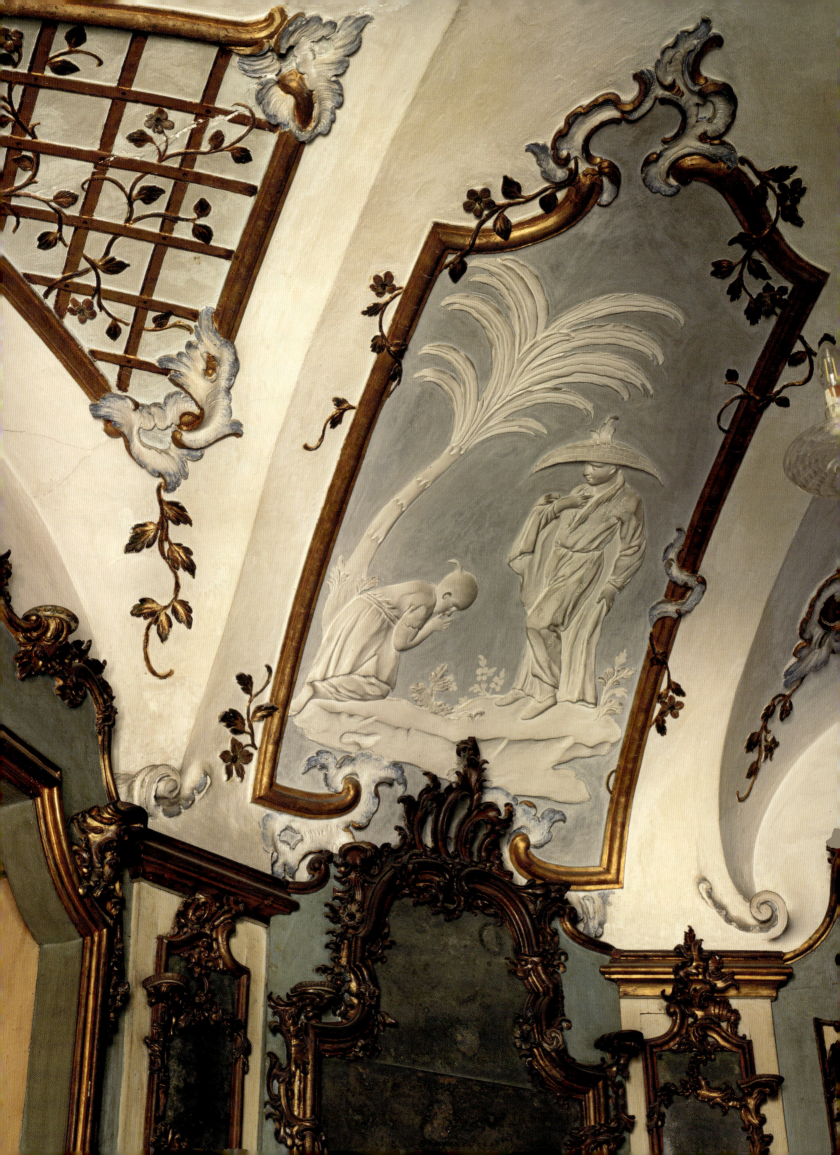

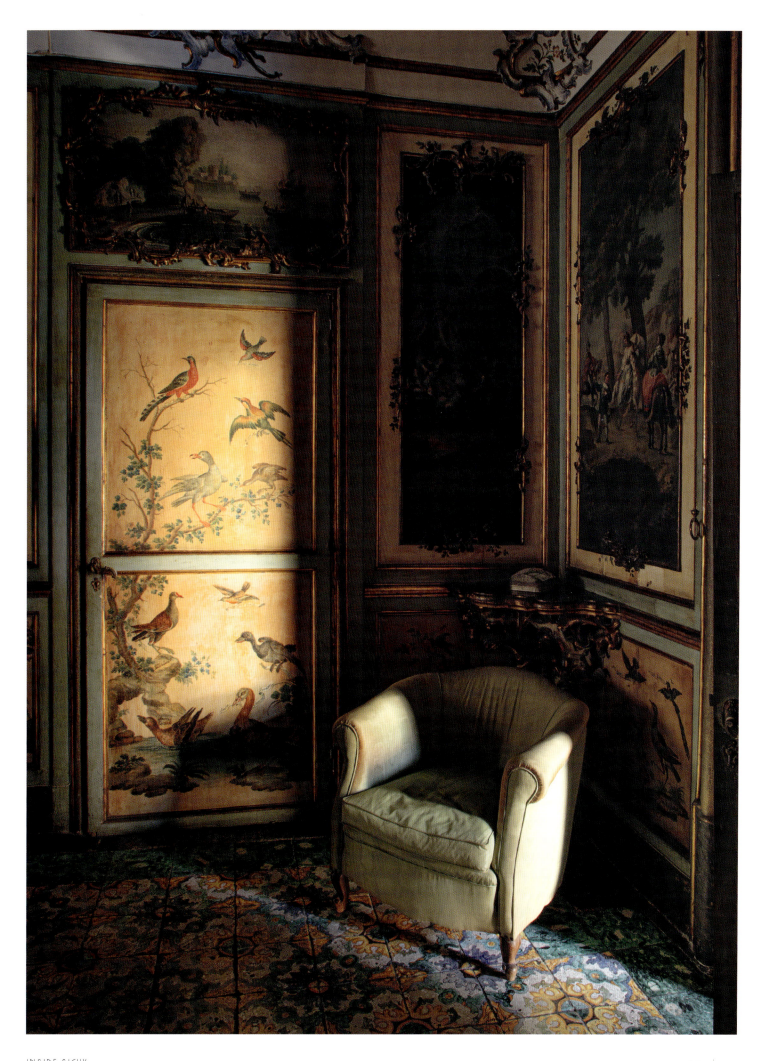

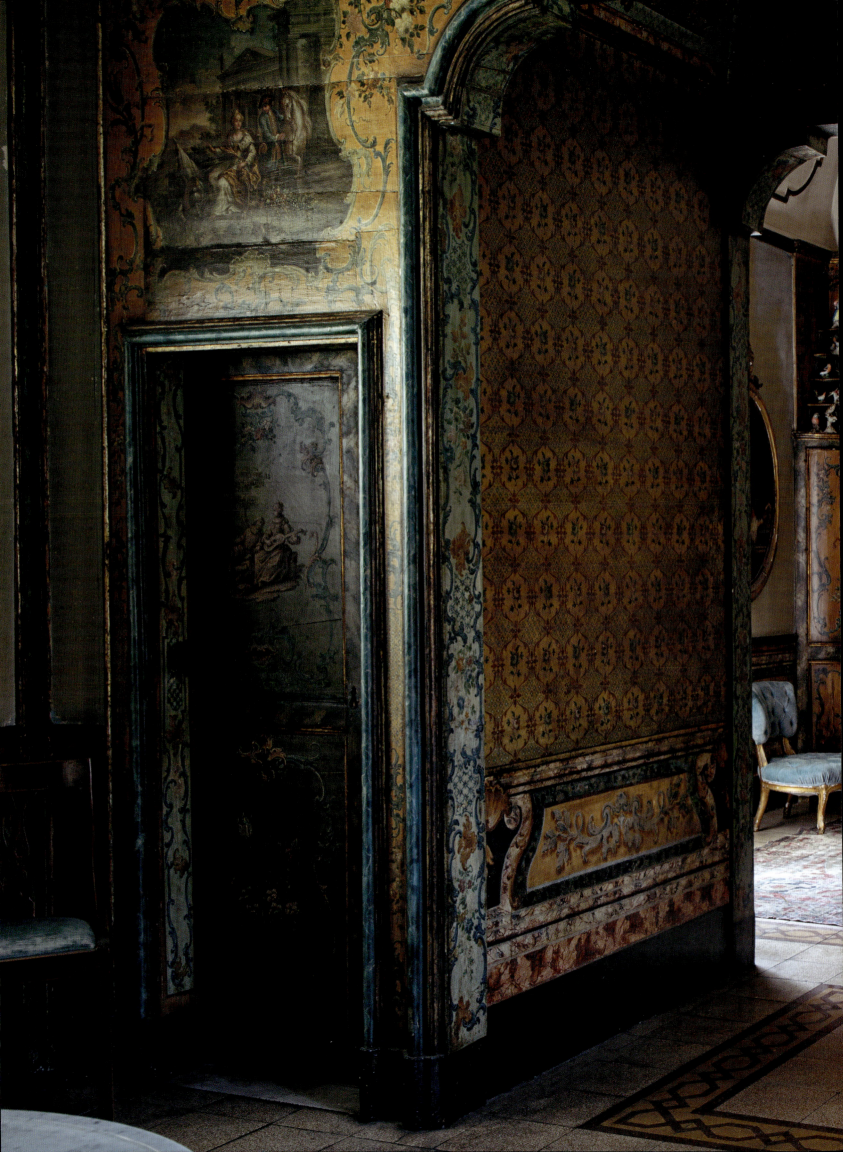

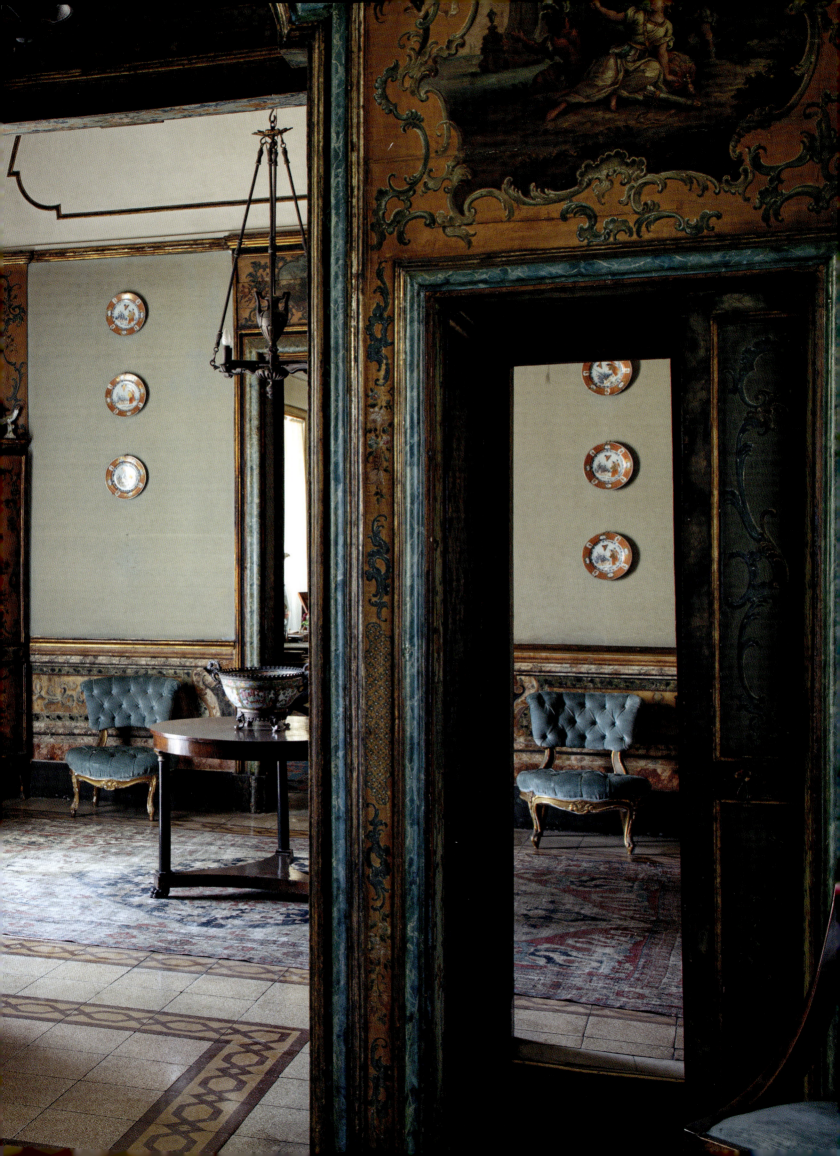

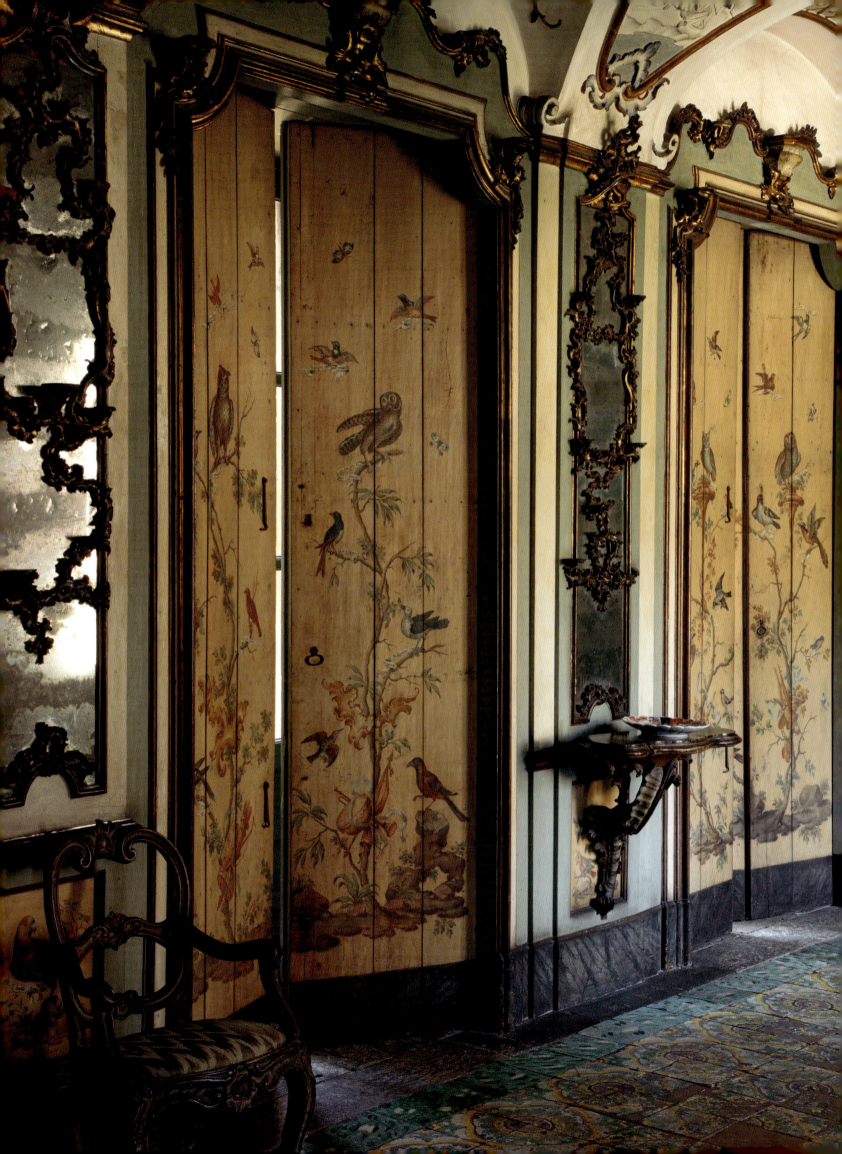

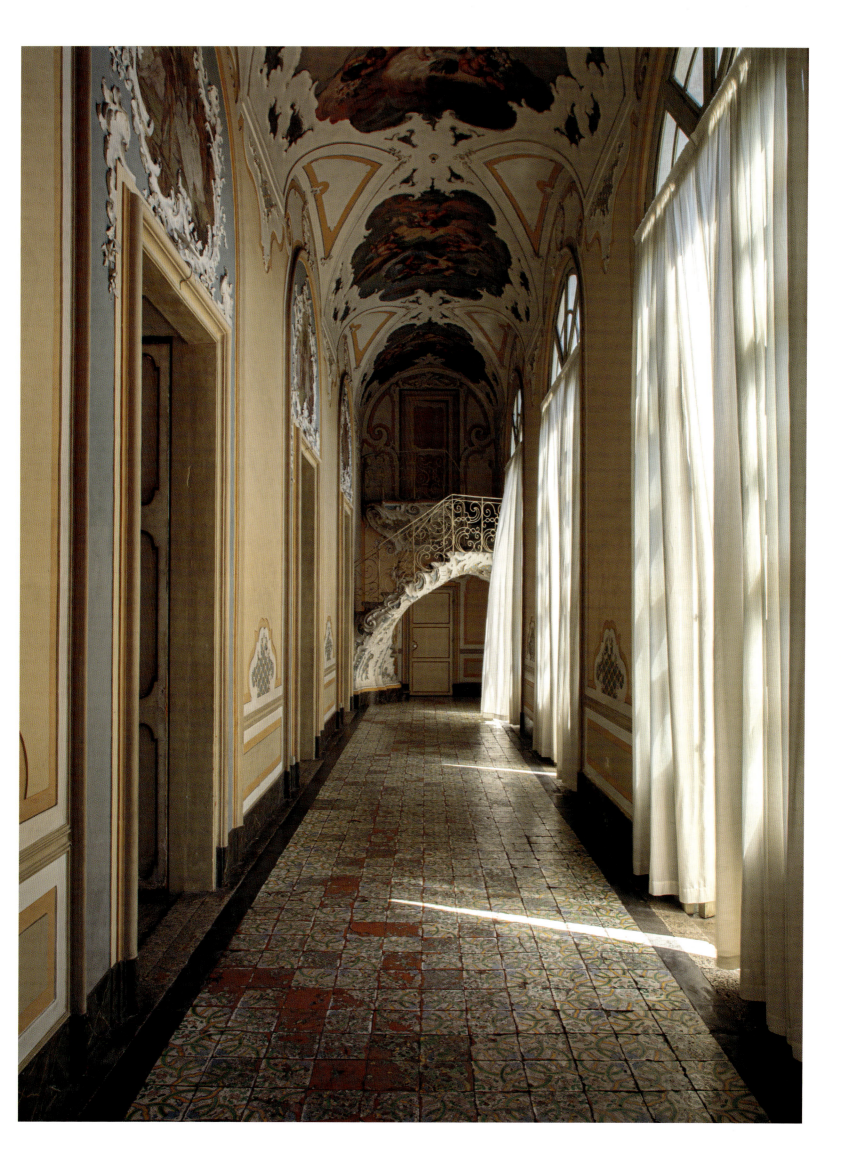

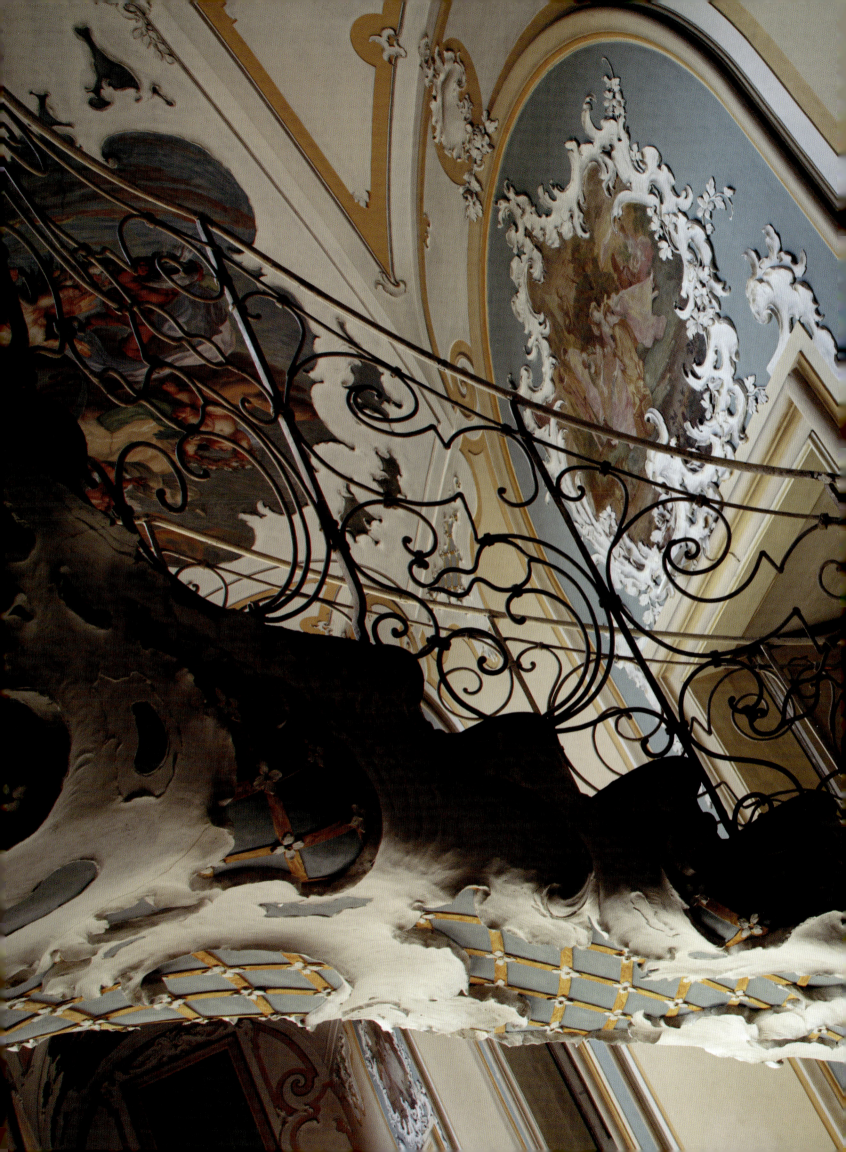

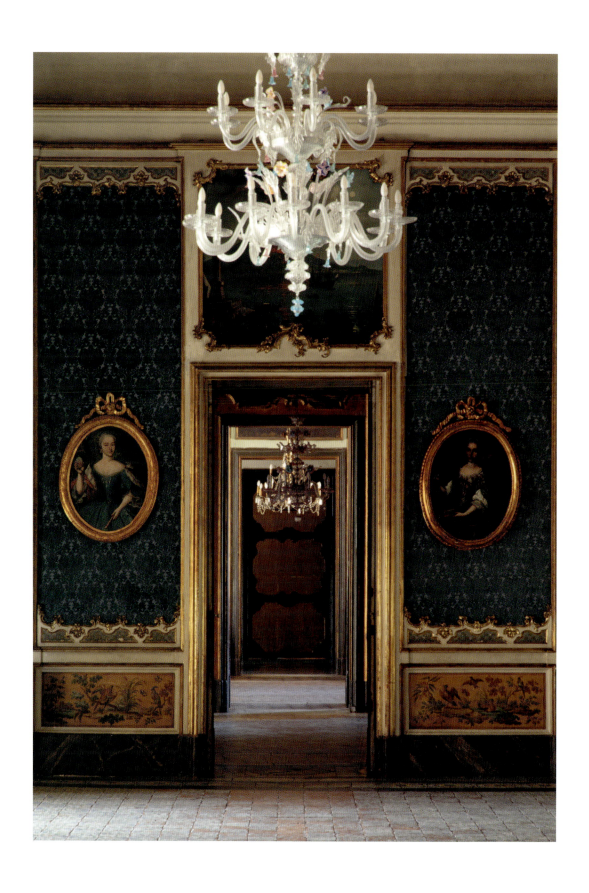

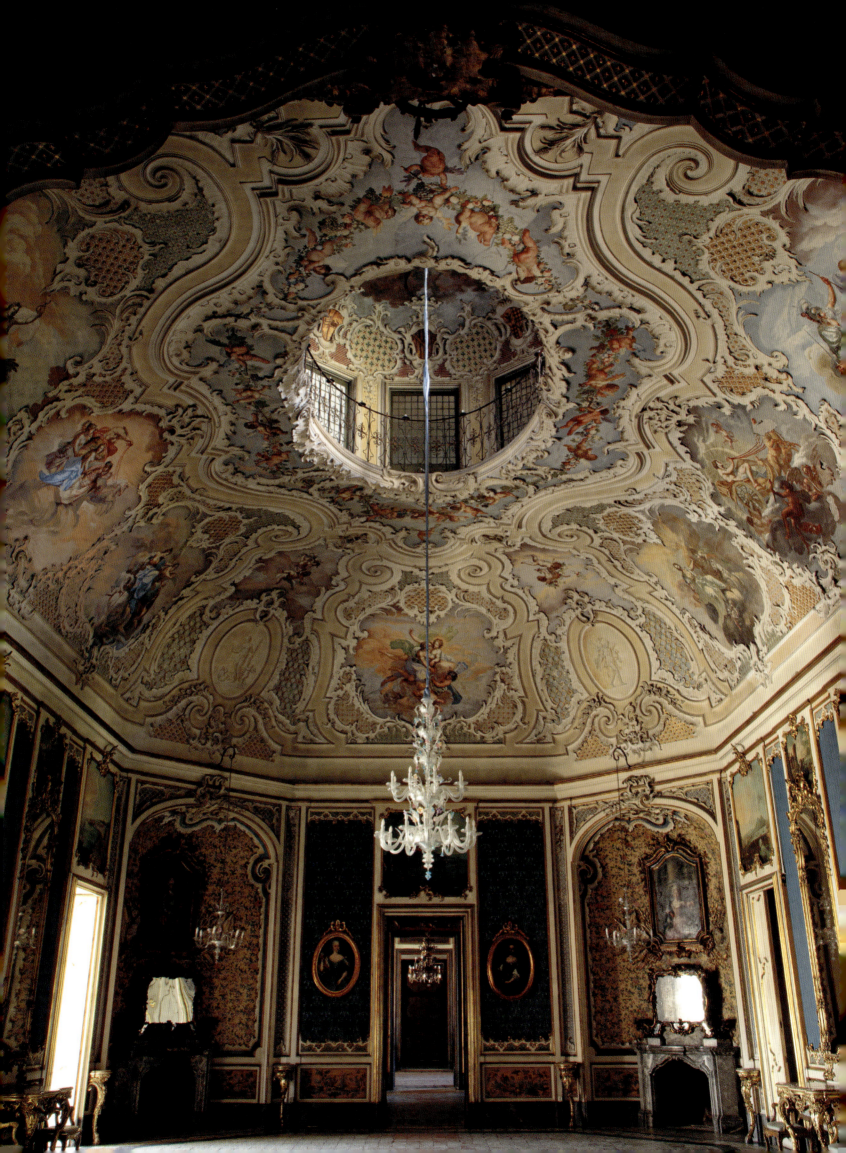

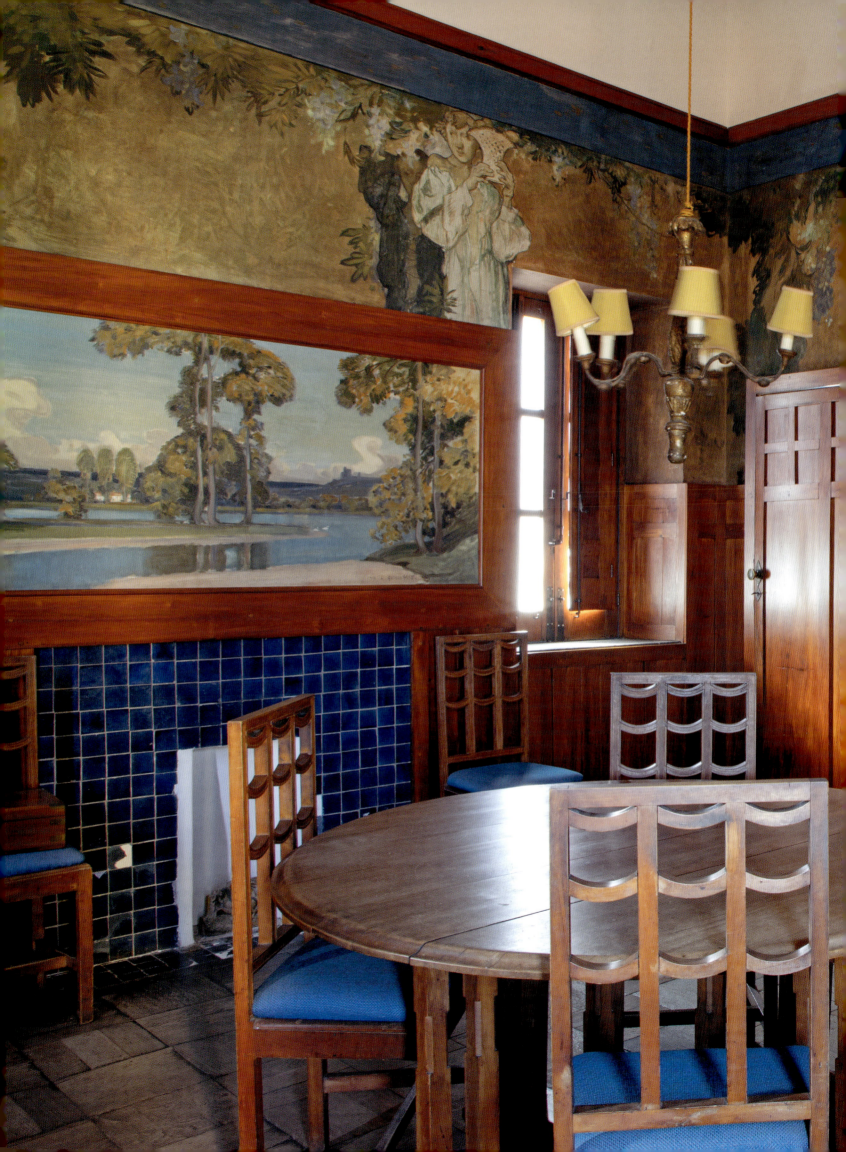

# CASA CUSENI
## MIMMA & FRANCESCO CUNDARI

As dawn light floods the dining room of Casa Cuseni, the watery earth tones of Frank Brangwyn's mural *The Sicilian Wedding* (1910) come to life and the scent of citrus wafts in from the garden. The original owner of this exceptional house was Robert Hawthorn Kitson, who first visited Taormina at the end of the nineteenth century. Today, like so many resort towns, Taormina has succumbed to its own beauty, suffering from heaving streets and choked roadways. Yet in a few corners it is still possible to find traces of what made it remarkable, and the spirit of an earlier, freer age, when the city was a refuge for artists, dreamers, and exiles.

In the nineteenth century, the institution of the Grand Tour was beginning to fade. Trains allowed easier travel, expanding the typical itinerary to remoter regions, but it wasn't until after Italian unification in 1861 that Taormina began to transform from a provincial backwater into an international destination.

By the time Kitson began building his home, in 1905, Taormina was becoming a magnet for a particular kind of traveler. Kitson—a painter and heir to a Yorkshire industrial fortune—sought both a Mediterranean retreat and an escape from the repressive attitudes of Edwardian England toward homosexuality. In Taormina, he found a community of like-minded expatriates, including the pioneering German photographer Wilhelm von Gloeden, whose sensual photographs of local youths both scandalized and enchanted European art circles.

Casa Cuseni encapsulates Kitson's vision and the cultural exchange fostered by this unique milieu. Designed in the Arts and Crafts style, it combines English elegance with Sicilian craft—nowhere more evidently than in the dining room, where Brangwyn's mural radiates a Mediterranean warmth and vibrancy. The surround, set above oak paneling, is part of the Welsh artist's design for this room, for which he was commissioned to create a Gesamtkunstwerk, designing even the salt and pepper cellars. The room itself, with its high ceilings and commanding views, was conceived as a space for artistic collaboration and indulgent gatherings.

Equally remarkable are the gardens. Laid out in terraces that echo the classical divisions of Dante's *Divine Comedy* (ca. 1308–21), and conceived with input from the Futurist artists Giacomo Balla and Fortunato Depero, they lead visitors on a symbolic journey from the symmetry of paradise to the almost chaotic plantings representing hell. The interplay of lush Sicilian flora and avant-garde design makes this living artwork as captivating today as when it was first created.

Over the decades, Casa Cuseni has hosted an extraordinary array of guests. D.H. Lawrence and Tennessee Williams sought inspiration within its walls, while Pablo Picasso, Greta Garbo, and Bertrand Russell found solace in its tranquil surroundings. The house's guestbook reads as a who's who of twentieth-century culture, a testament to Kitson's hospitality and the magnetism of Taormina's creative energy.

After Kitson's death, his niece Daphne Phelps inherited the property. Despite initial plans to sell, she too fell in love with Taormina, writing the book *A House in Sicily* (1999) and opening a guesthouse on the property. At her passing in 2005, she left the house to the family of Mimma Cundari and her husband, Dr. Francesco Cundari, who have faithfully kept the story of Robert Kitson and Casa Cuseni alive.

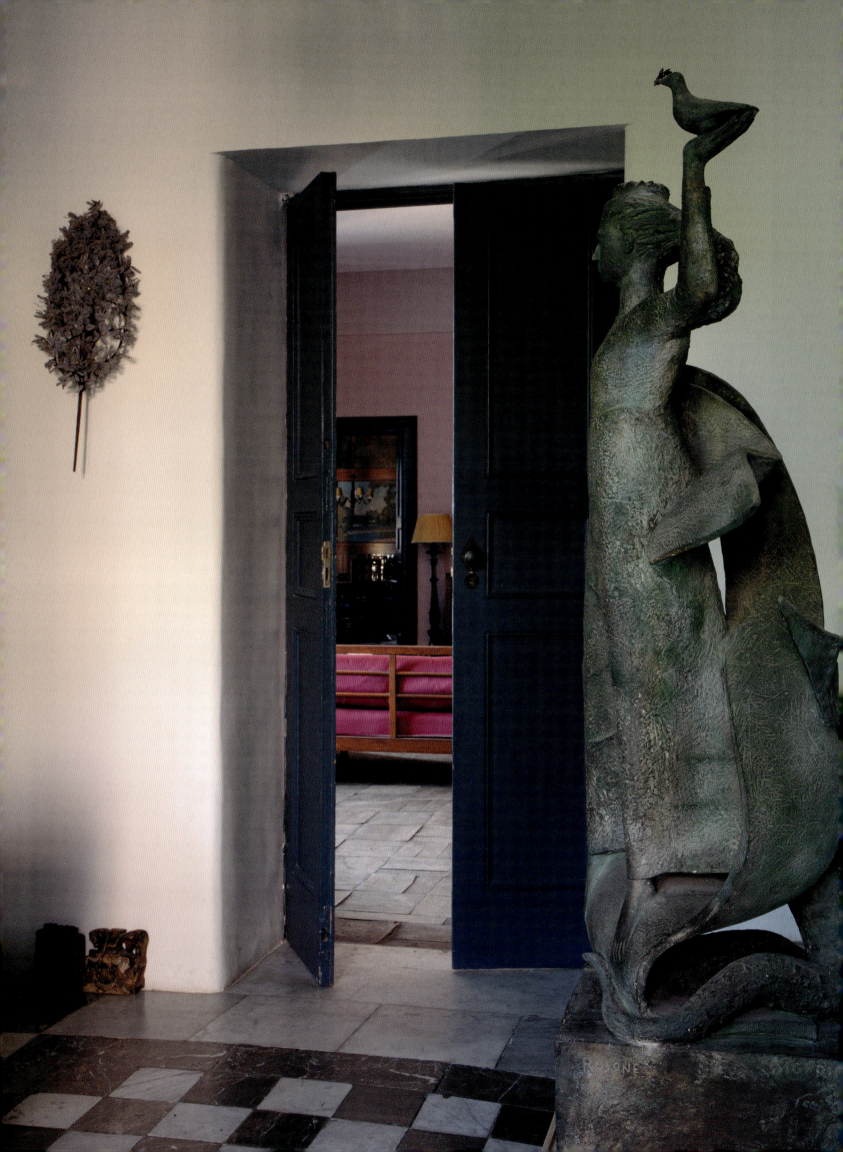

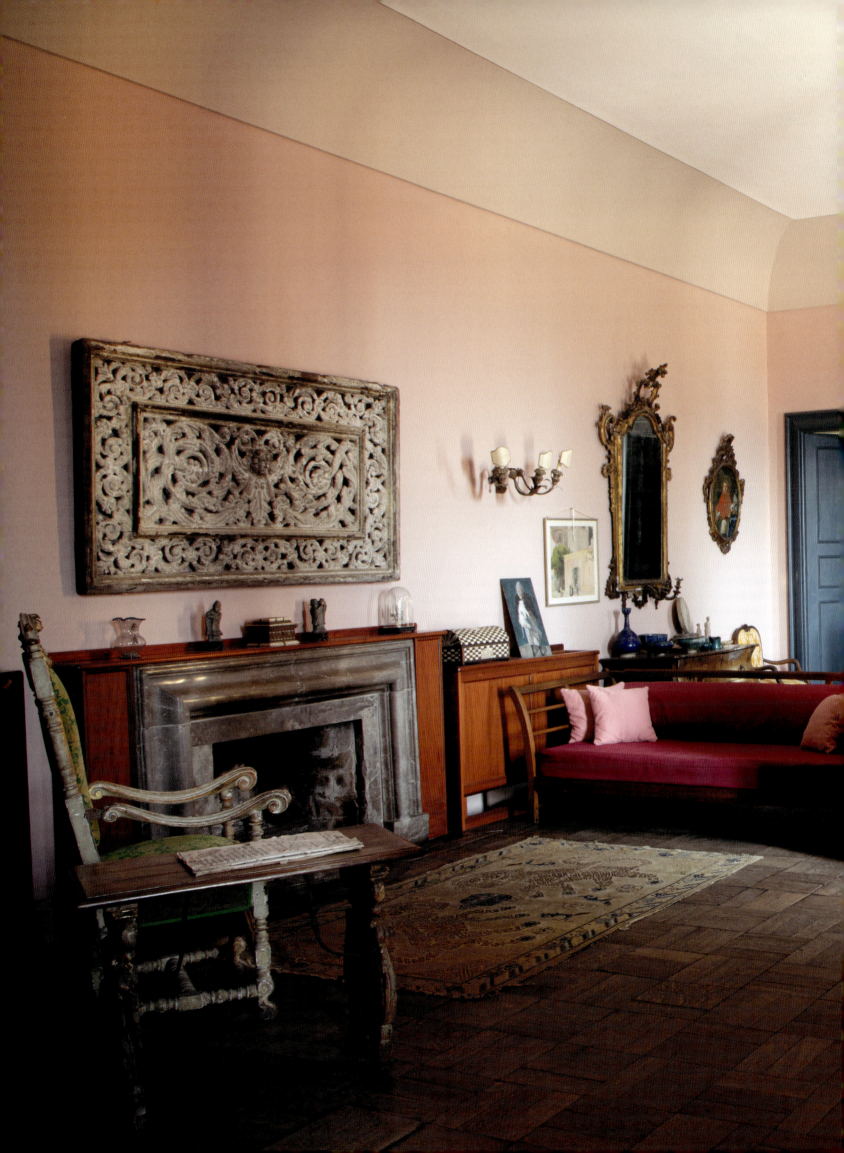

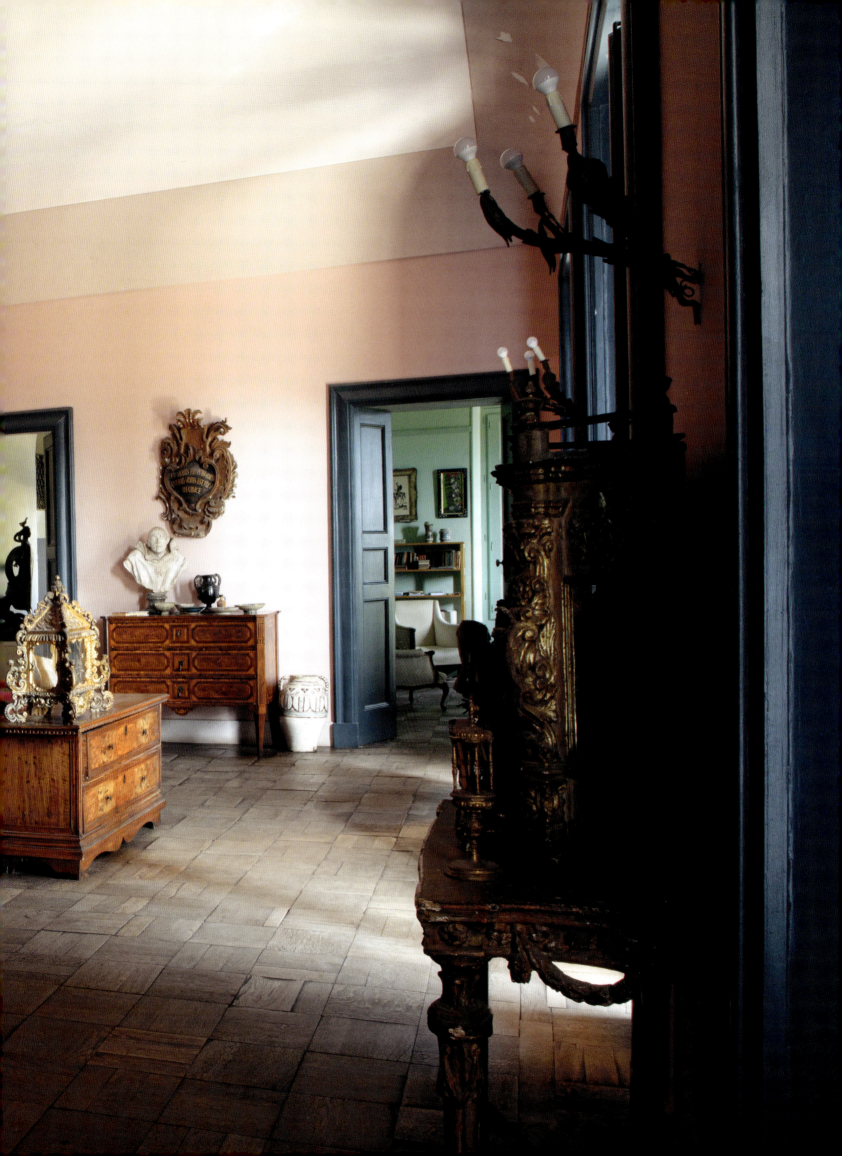

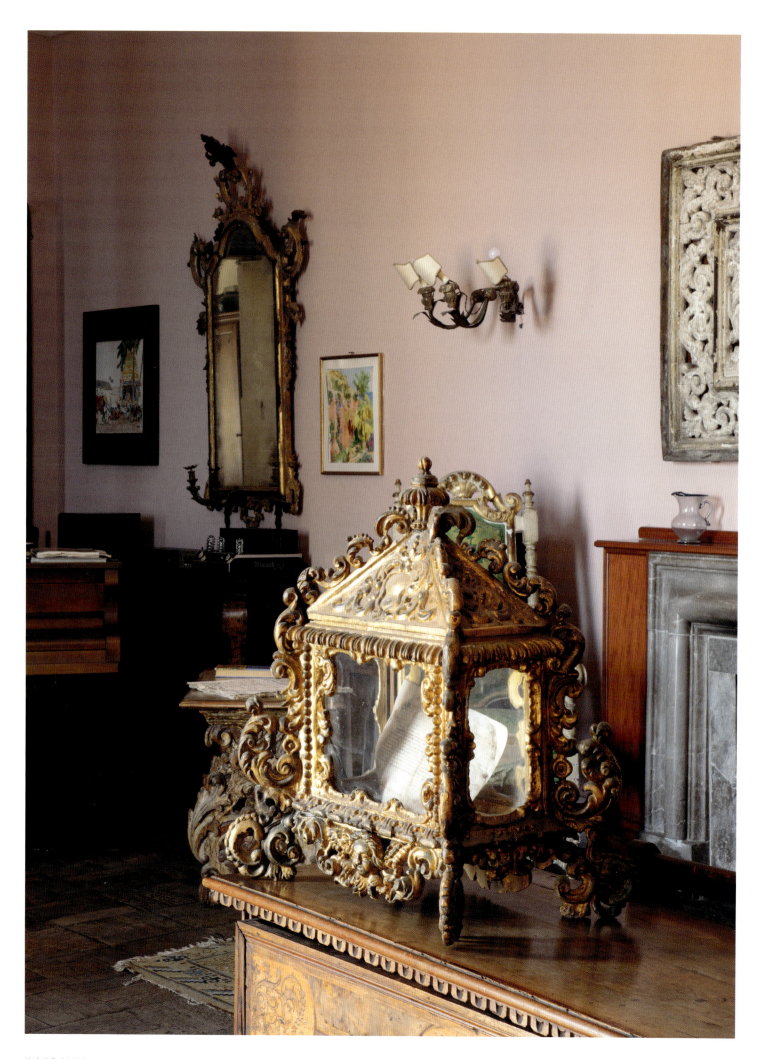

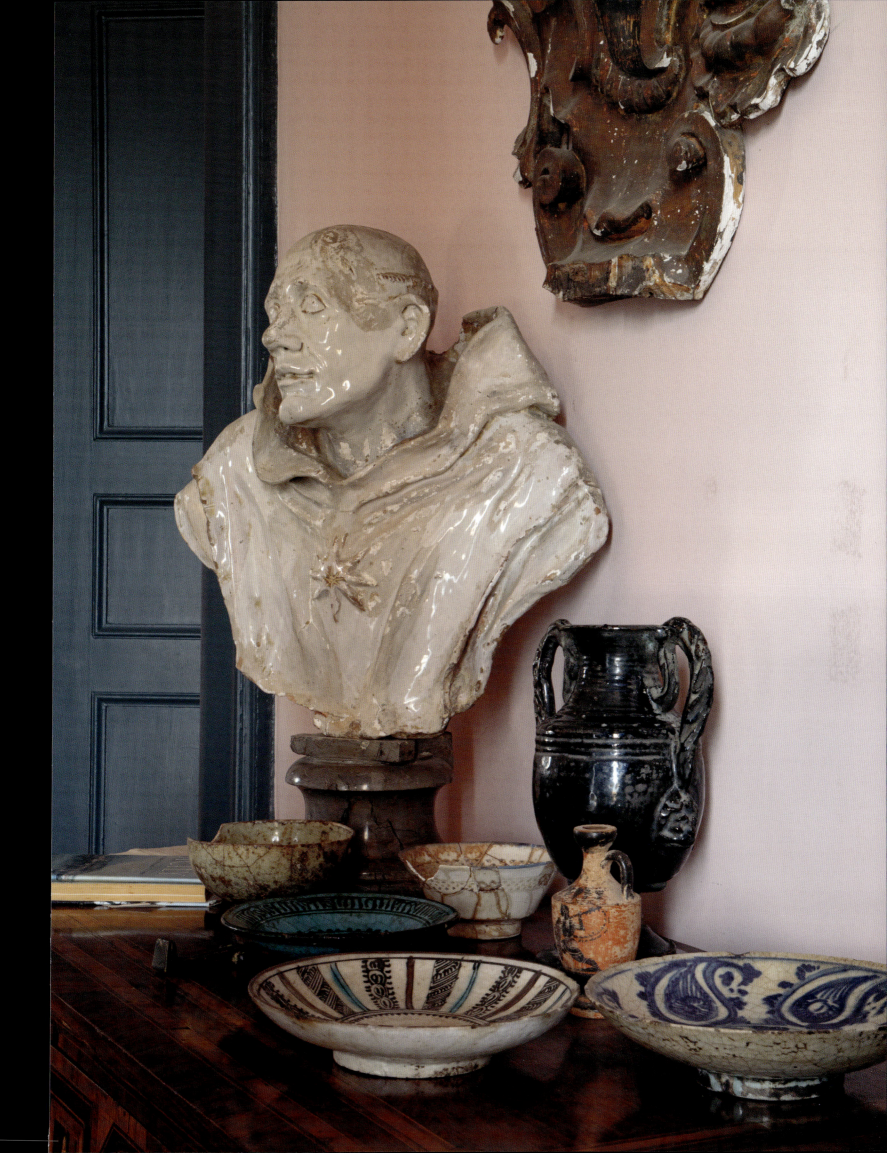

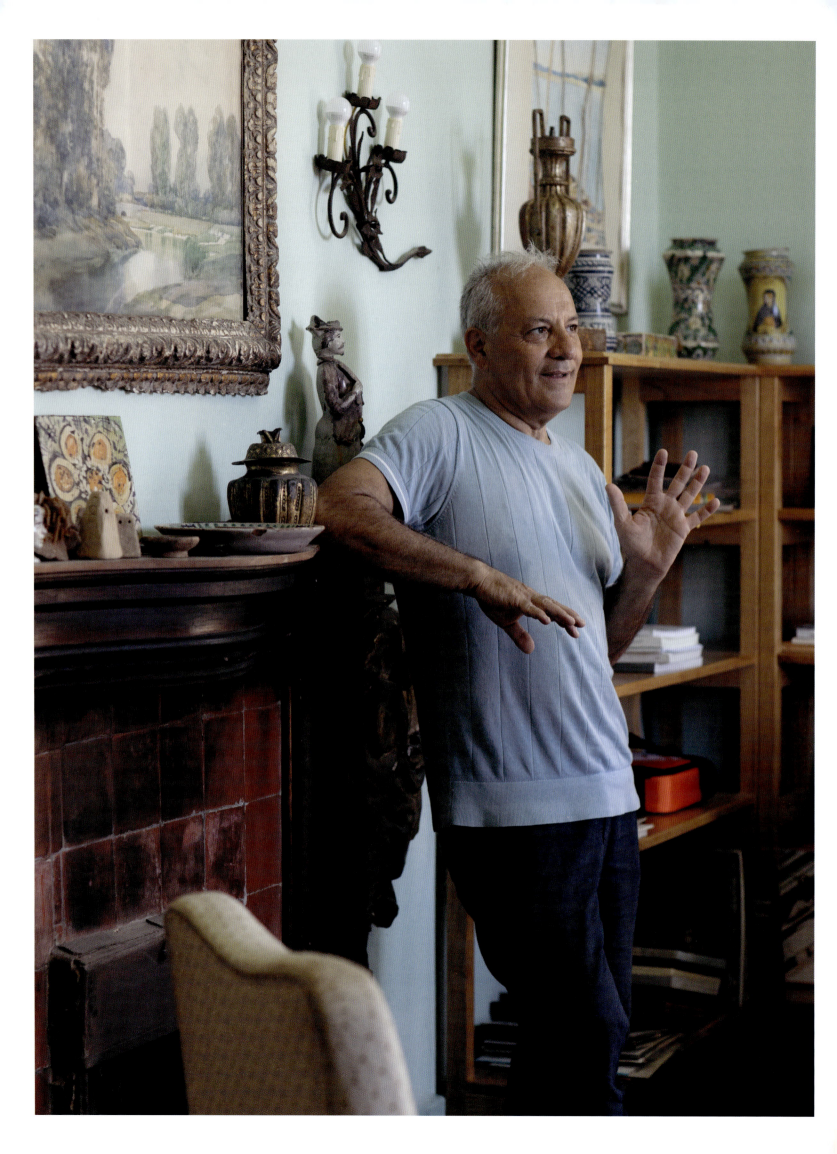

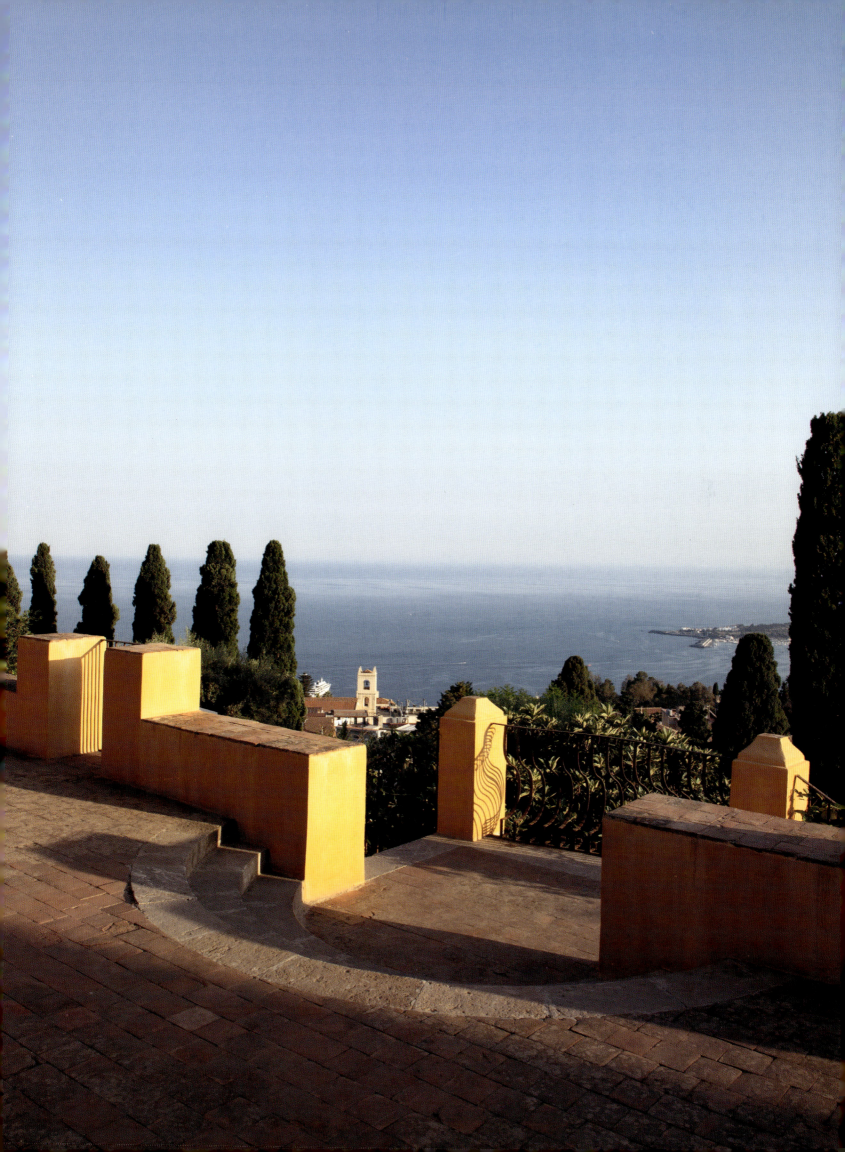

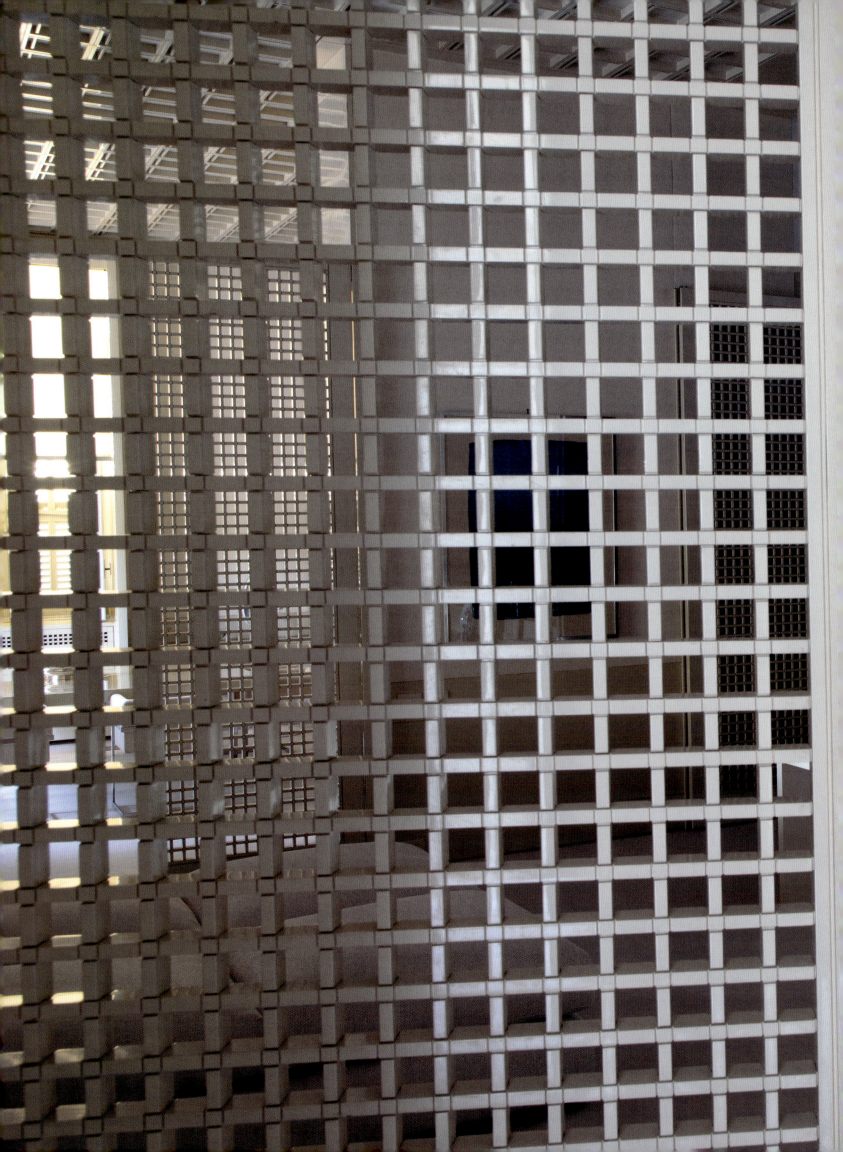

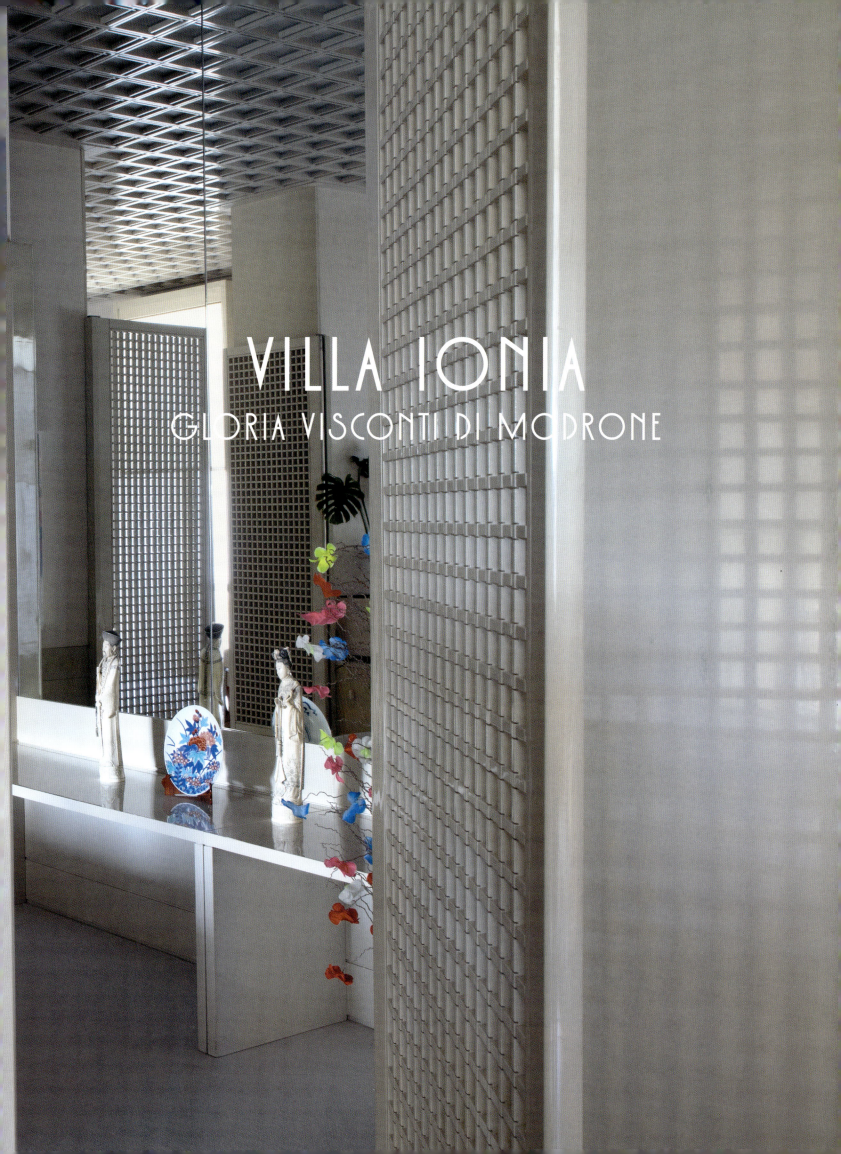

# VILLA IONIA
## GLORIA VISCONTI DI MODRONE

The home of Gloria Visconti di Modrone, perched above Isola Bella in Taormina, is a striking example of Modernist architecture. Built in 1969–70, it was designed by the architect and artist Paolo Tommasi, who was selected by Gloria's father, Francesco Gorgone. Tommasi, who was known for his work in theater and film scenography, incorporated influences from India, Japan, and Jungian psychology into the design, and the house reflects his unique vision, blending Modernist elements with a great sensitivity to landscape.

The architecture may be bold, but it remains grounded by its integration into its surroundings. The design takes full advantage of the dramatic setting, with large windows that frame sweeping views of the coastline. The use of stone and wood, alongside clean geometric lines, creates a connection between the interior and the natural environment. The house's open layout encourages a seamless flow between indoor and outdoor spaces, characteristic of Tommasi's work.

Tommasi's influence is visible in every detail of the building, which embodies his interests and experiences, drawing on his travels and his study of psychology. His background in theater and his interest in Jungian theory led him to design dramatic spaces that feel more like stages than typical homes, carefully curated and full of purpose. Rooms are arranged in a way that invites movement and interaction, each carefully composed to create a specific atmosphere. The integration of art and architecture was a hallmark of his work, and here his vision comes to life through the use of screens, which frame rooms, obscure views, and even provide a single illuminated ceiling that links the entire ground floor. This cinematic light source leaves the large walls free for the family's extensive collection of paintings.

For Gloria, the house has always been more than just a retreat. It has been a home for her and her late husband, Guido, and a frequent gathering place for their children, Francesca Pallavicini (pictured opposite with Gloria) and Raimondo Visconti di Modrone. The family's connection to Taormina is long-standing; Gloria's father purchased the property years before, and until recently the family kept a boat in the bay below. The house remains a place for the family to connect with their history and the landscape of Taormina. Although much has changed over the years, it continues to offer a retreat from the outside world, a place where family traditions are passed down and new memories made. Its design, by one of Italy's most original architects, endures as both a functional home and a work of art.

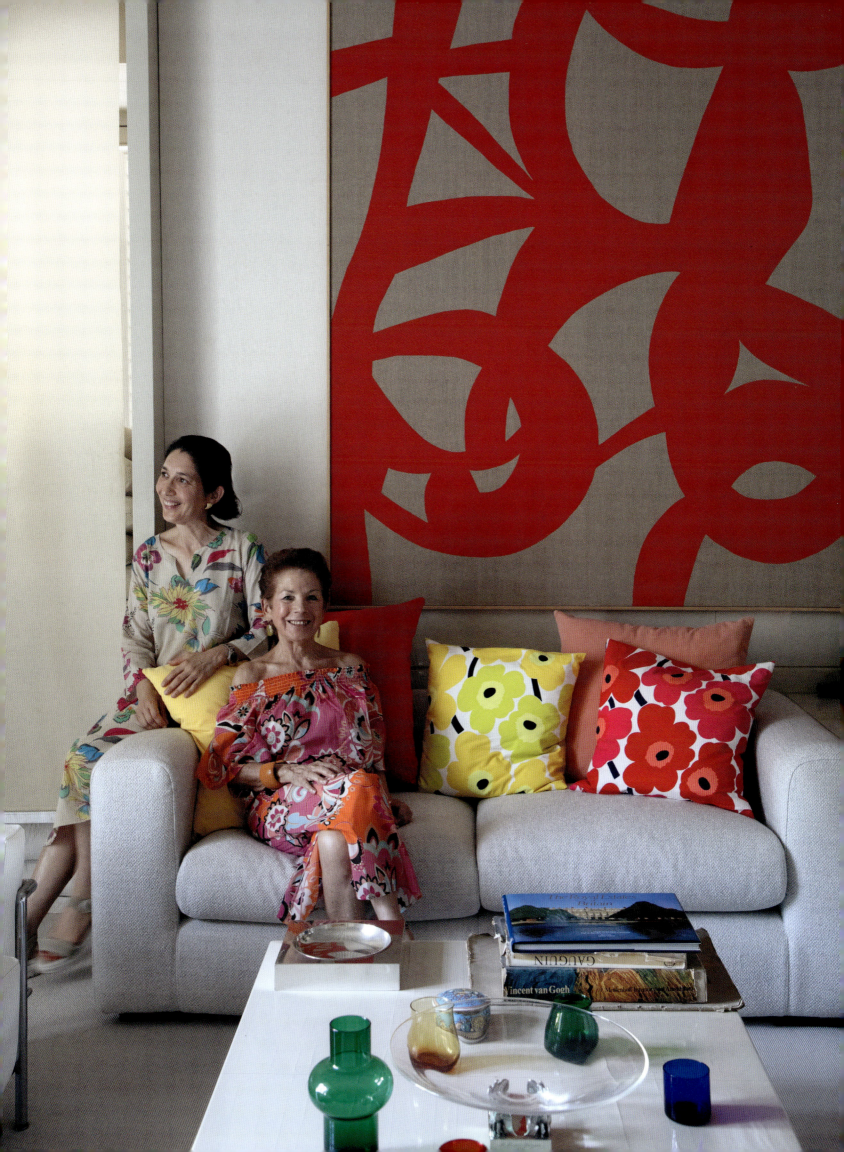

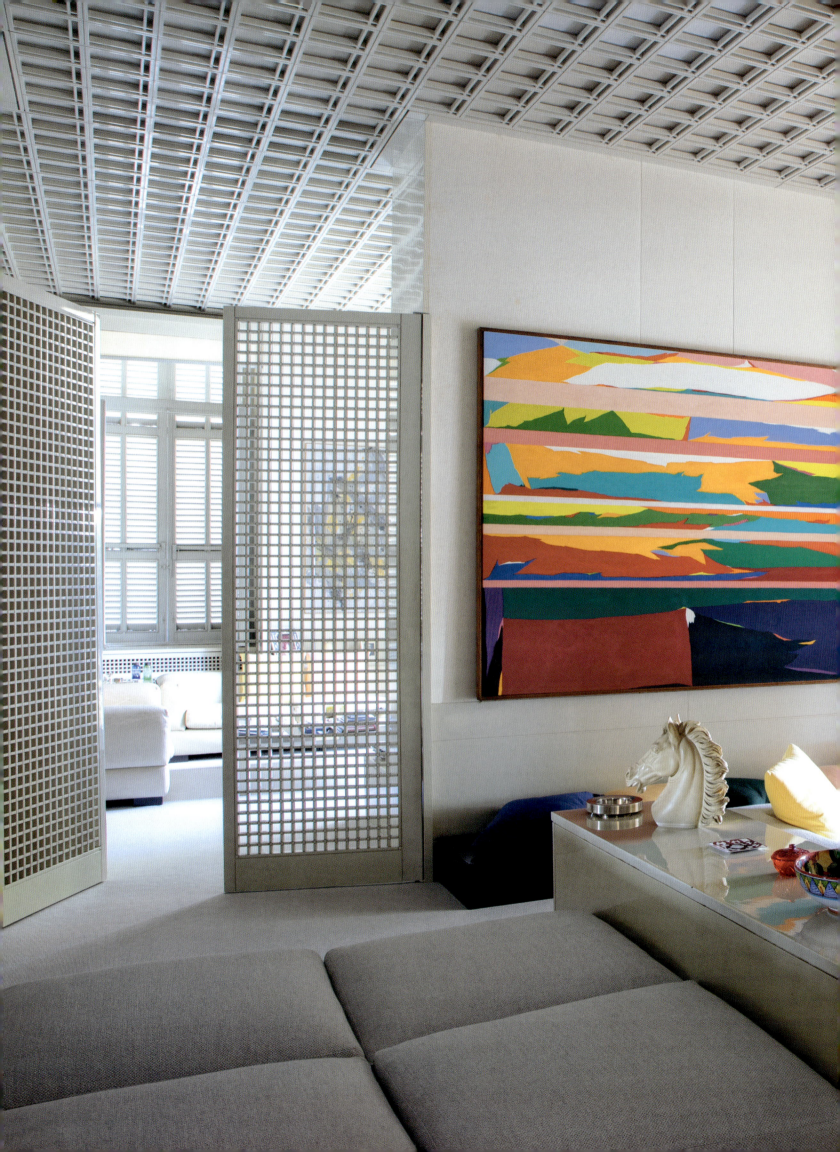

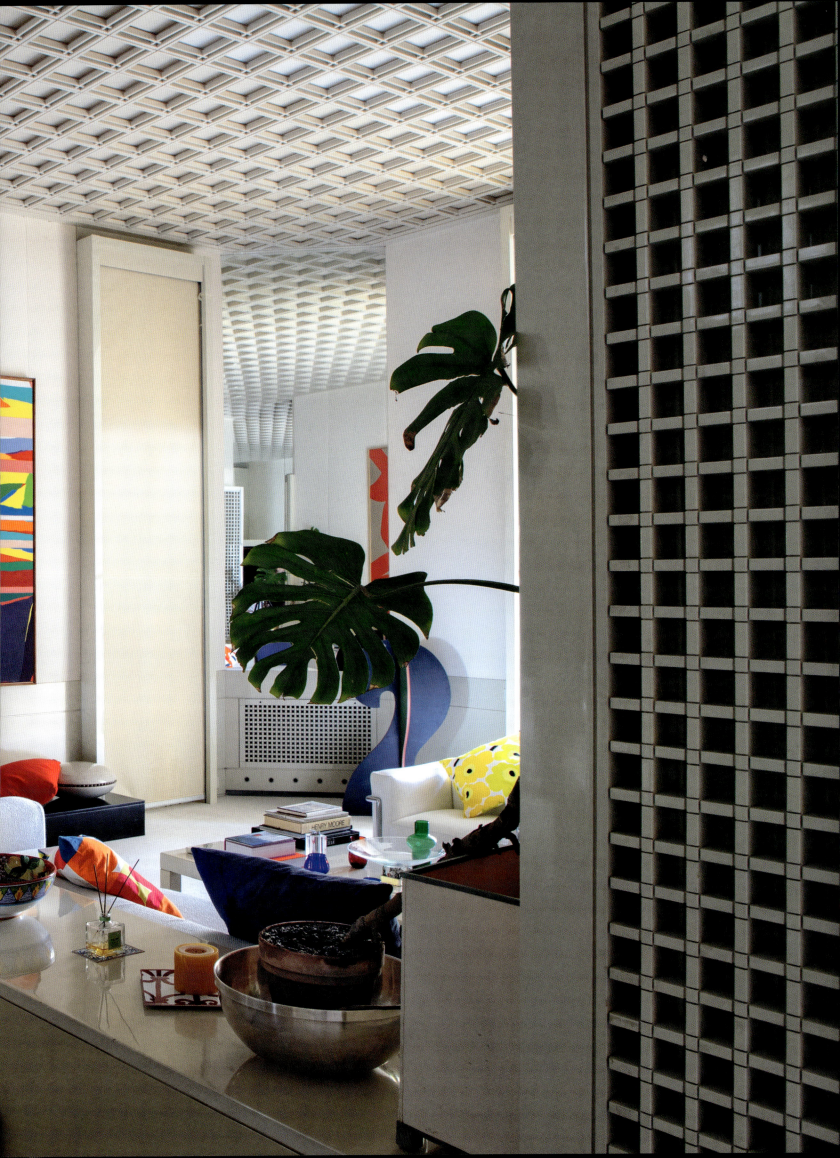

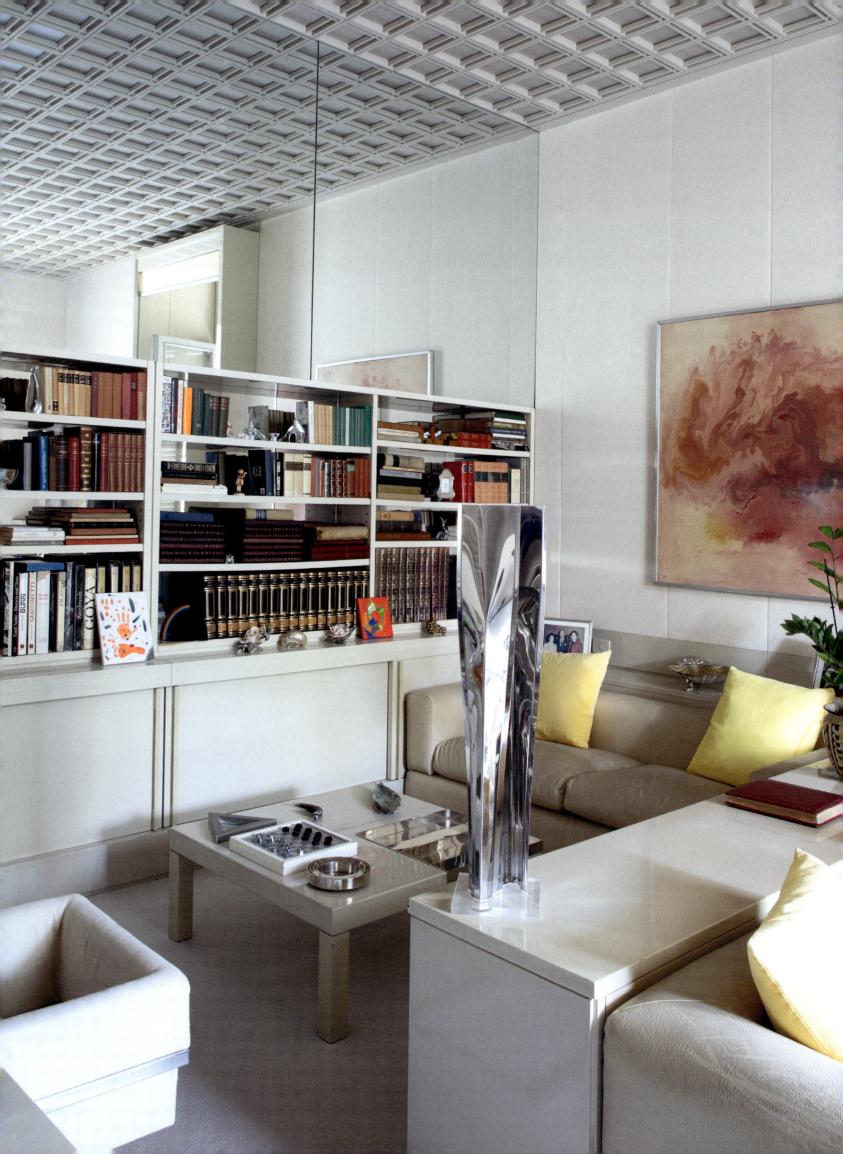

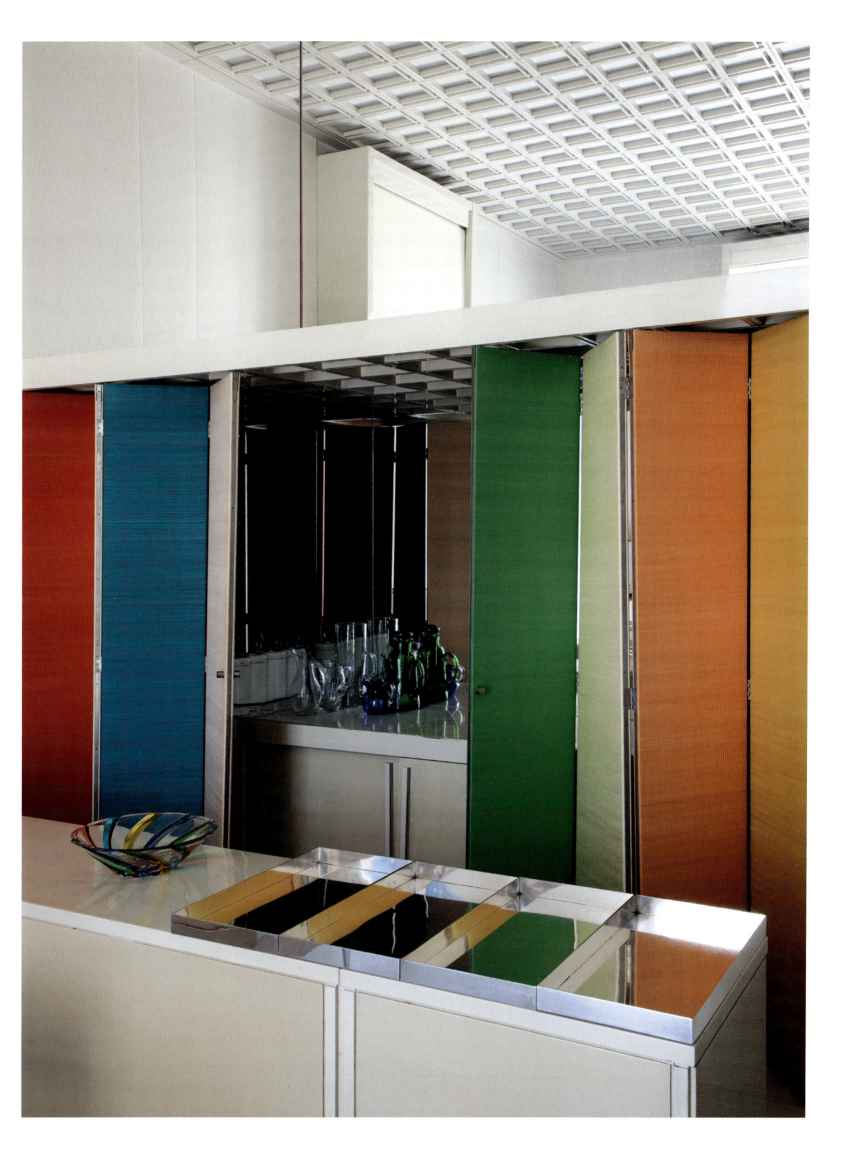

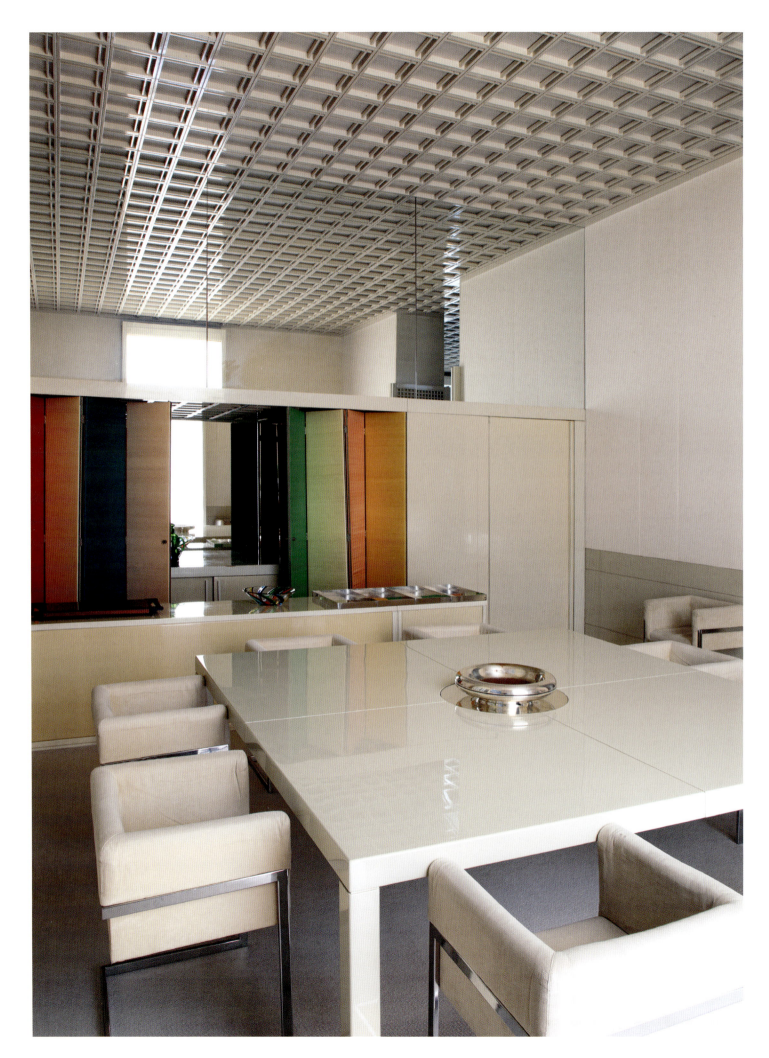

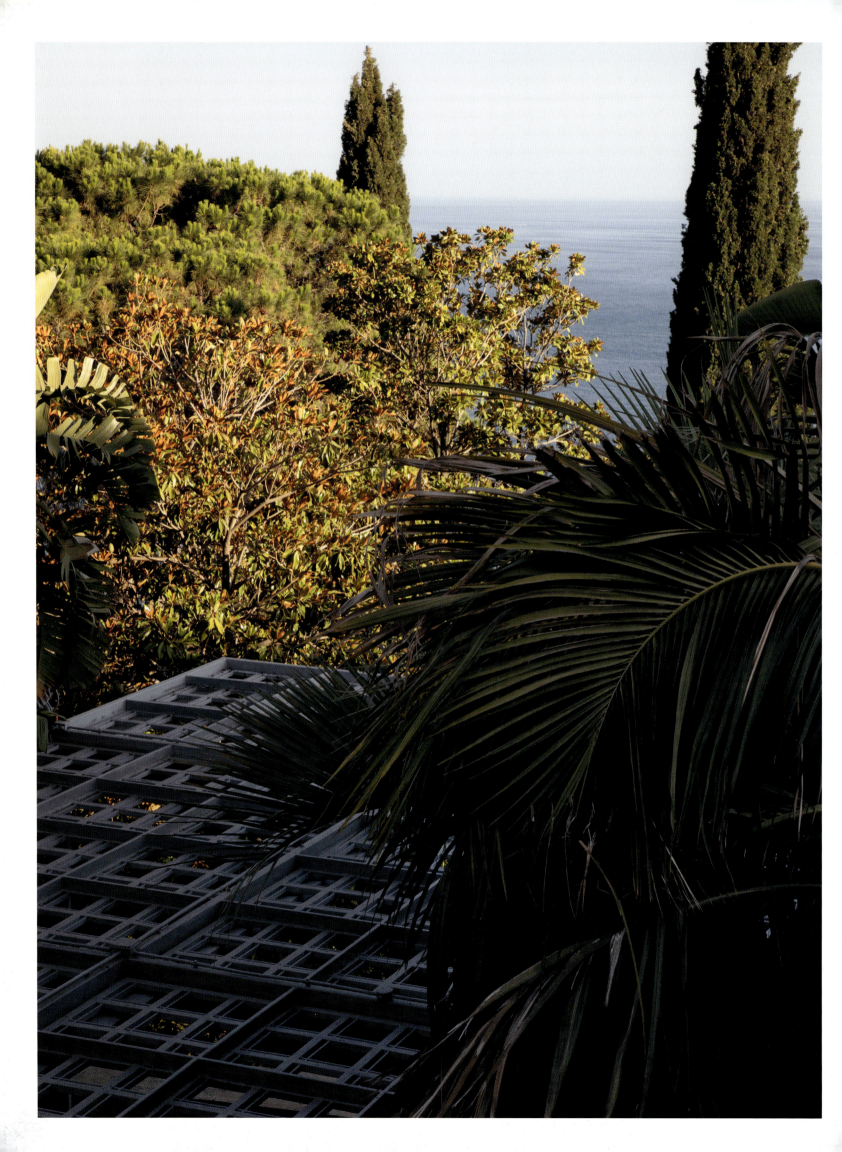

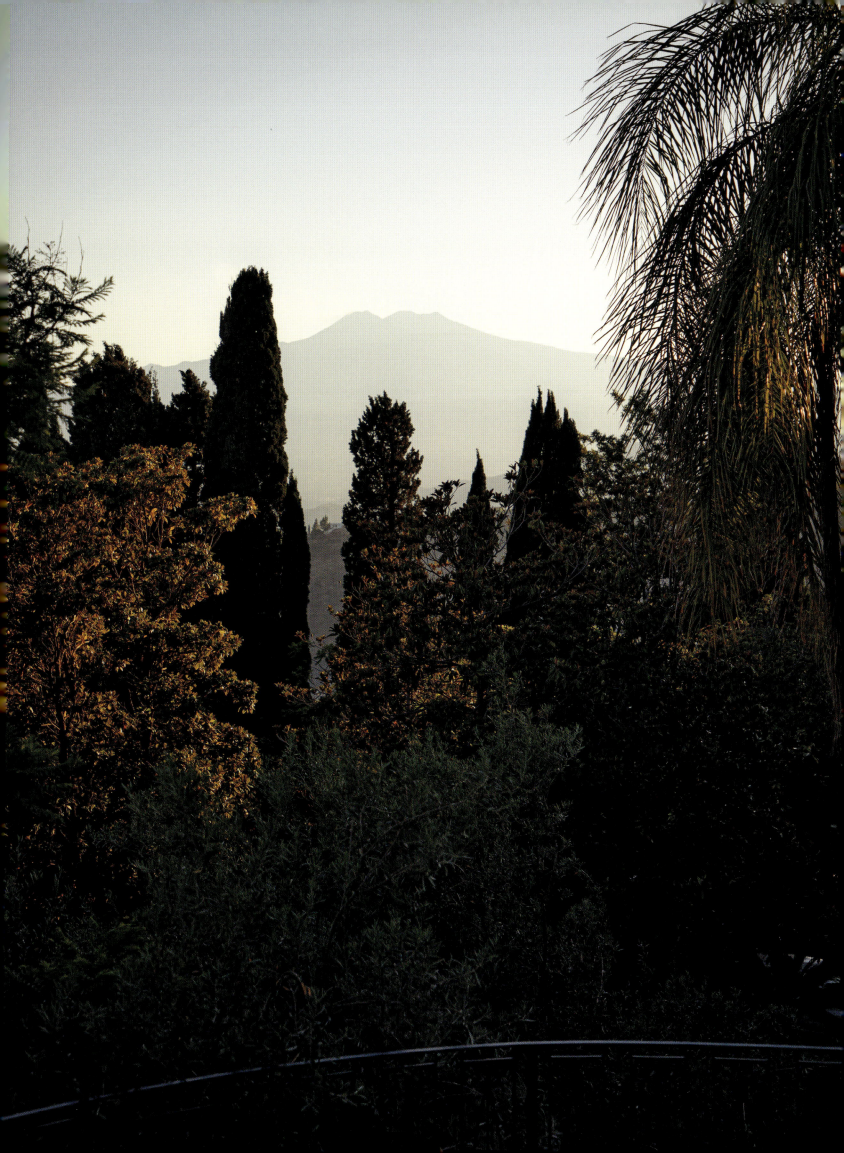

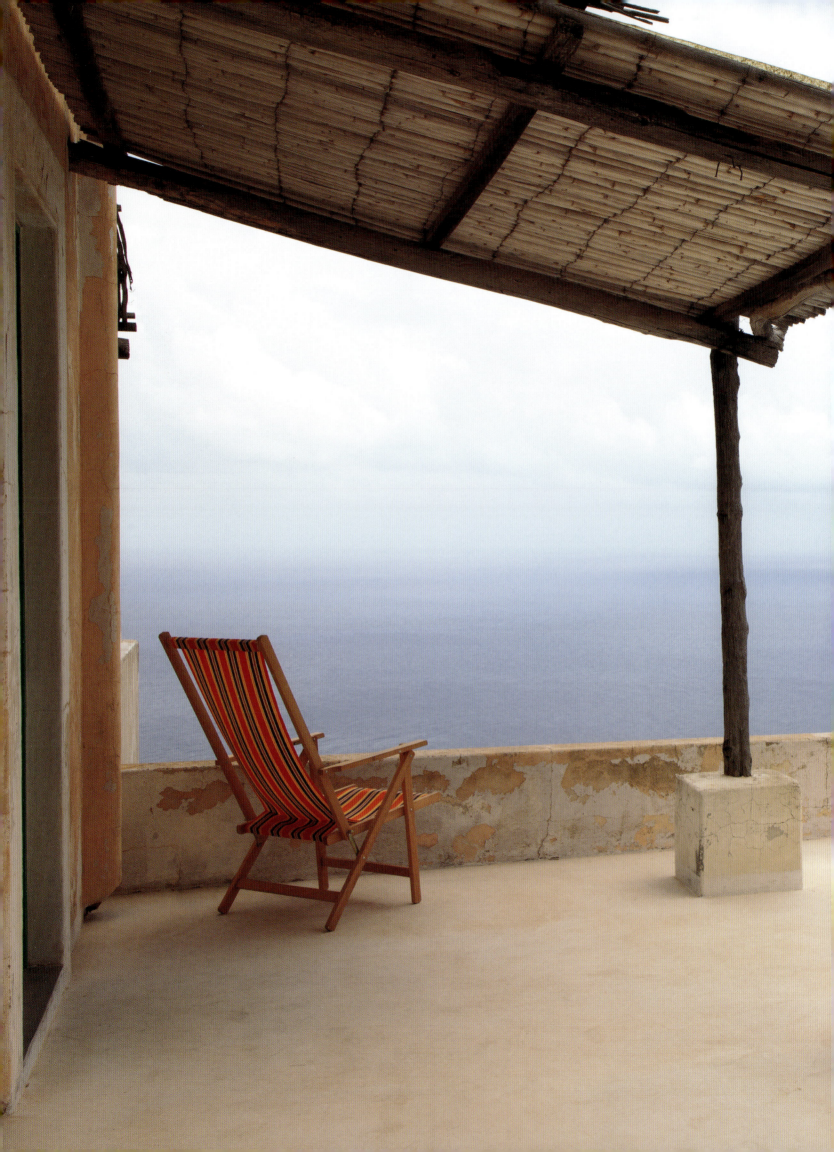

Perched on Monte Giulio, one of the highest peaks on the Aeolian island of Filicudi, the summer house of Ettore and Barbara Sottsass commands a sweeping view of the sea and the surrounding islands.

The house, which they built, is in the traditional Aeolian style, its rooms connected by open-air walkways and the kitchen a separate structure. The thick walls of local volcanic stone protect against the intense sunlight of summer and the punishing winter winds. Fresh water is precious, so the flat roofs collect rainwater. Beside the house is a thriving field of *Aeonium* — a tough succulent plant that survives year after year, unattended during the winter and waiting for its owners' return, much like the house itself.

The couple shared a life shaped by curiosity, humor, and a deep creative bond. In 1982, when they bought the land, Filicudi was largely unknown to outsiders. Some Florentines had come in the 1960s and 70s, but the wave of Romans and Milanese had yet to arrive. That is why Ettore and Barbara were effectively pioneers, drawn to the island's raw beauty and its sense of distance from the world.

The architecture echoes centuries-old Aeolian traditions, and traces of the island's history are evident in several details, among them the window niches inside the rooms. However, what is preserved here more than anything else is a way of living – or the hope of it.

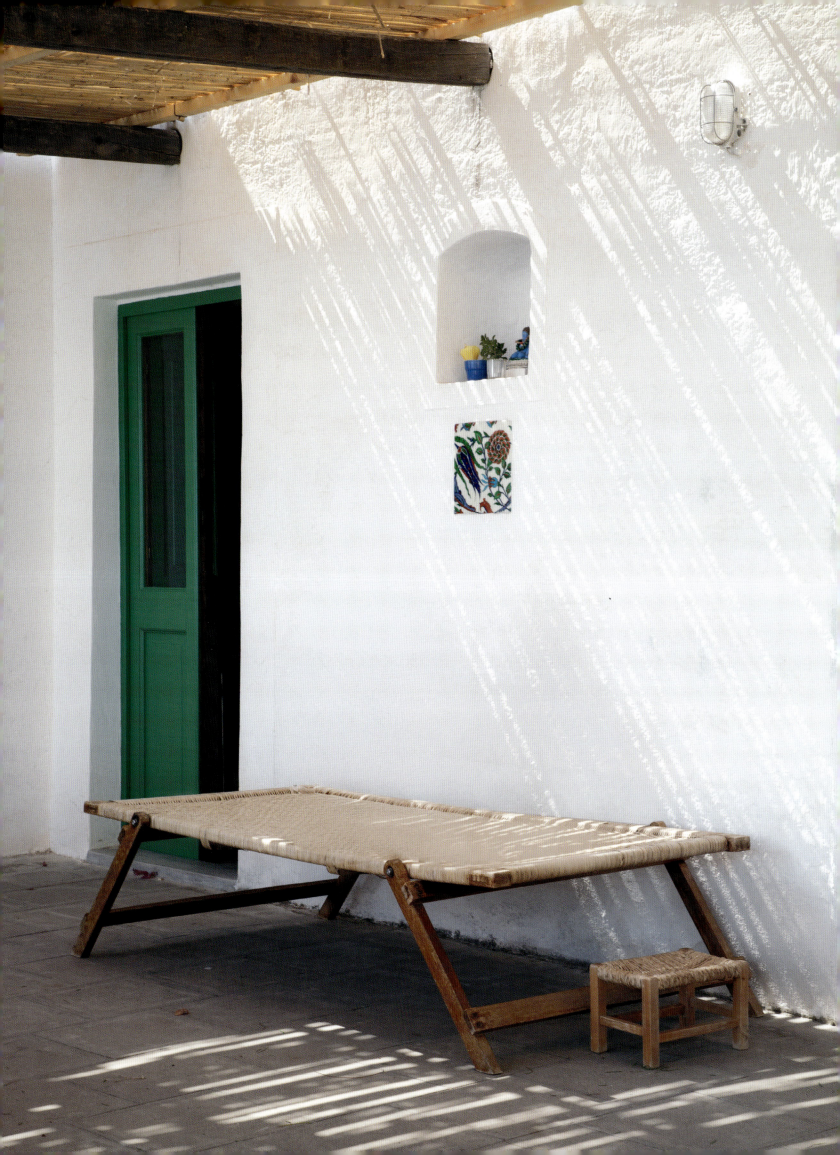

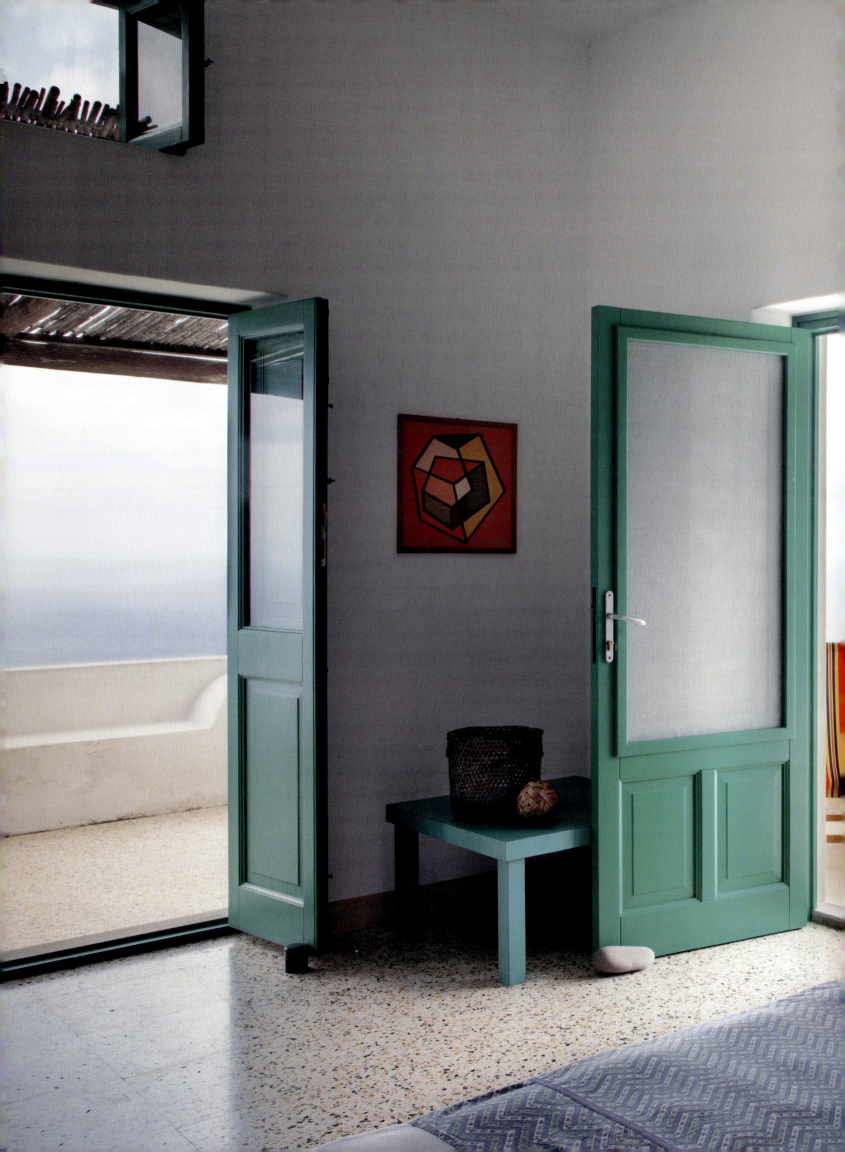

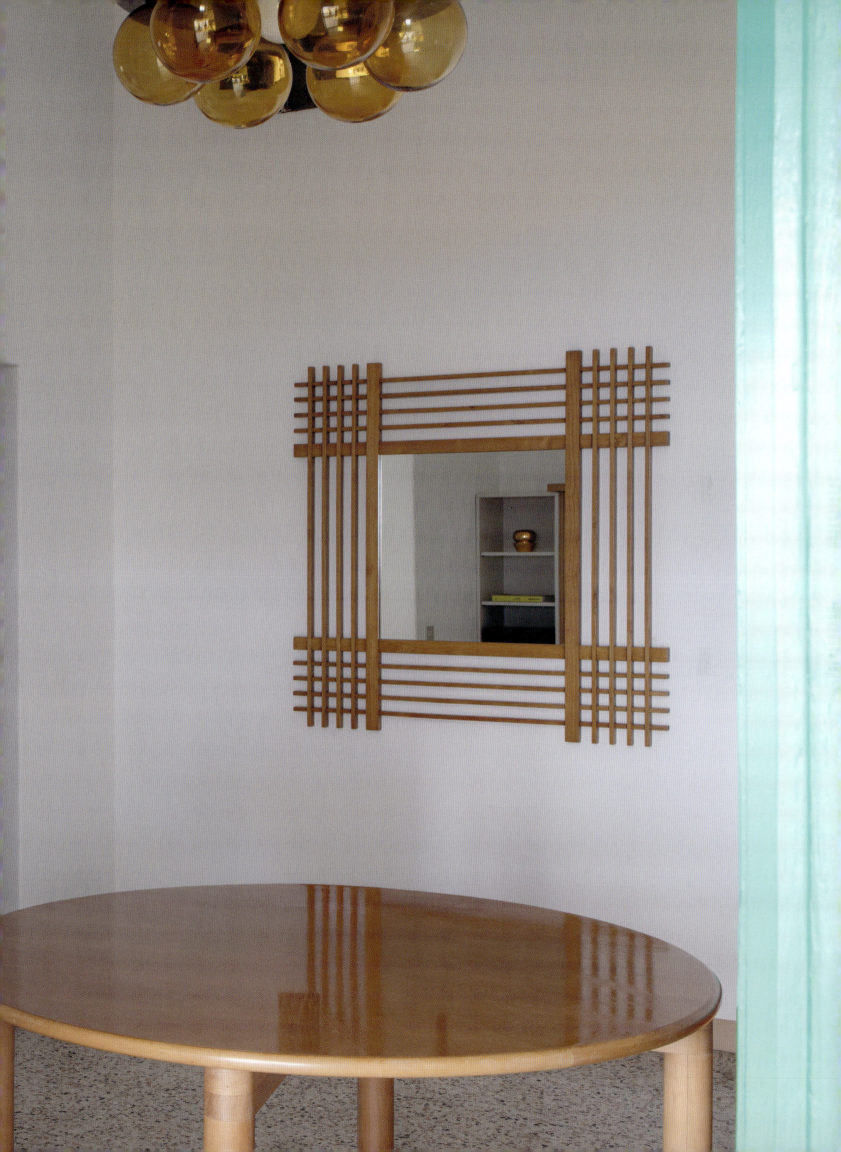

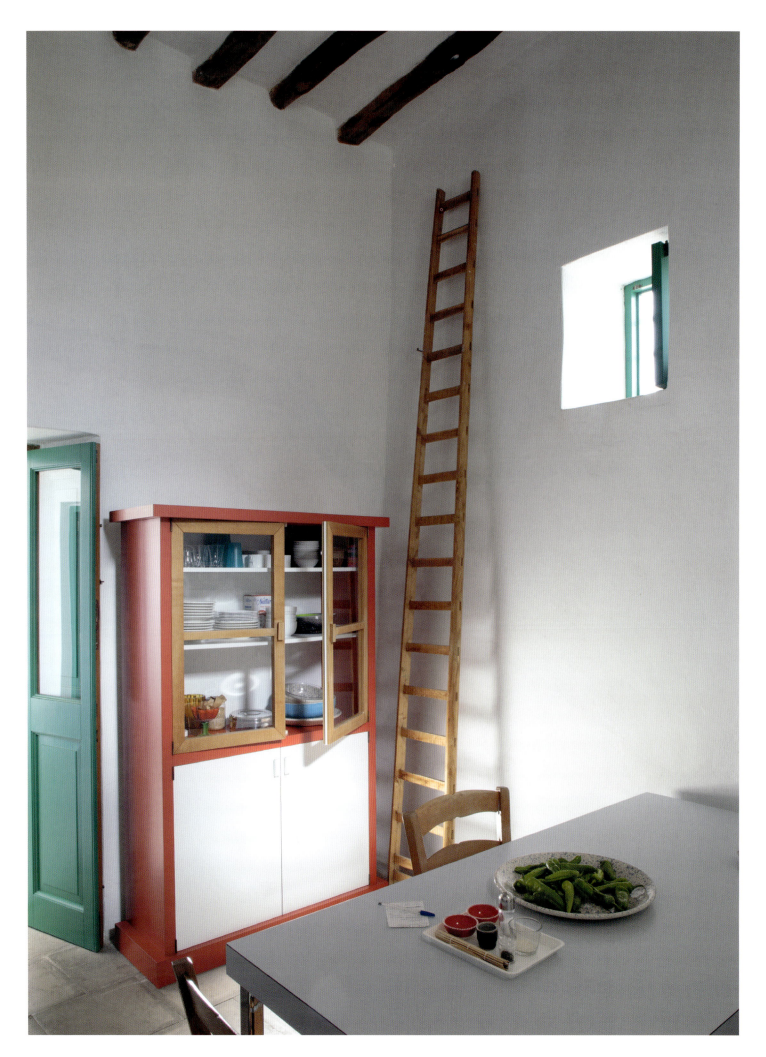

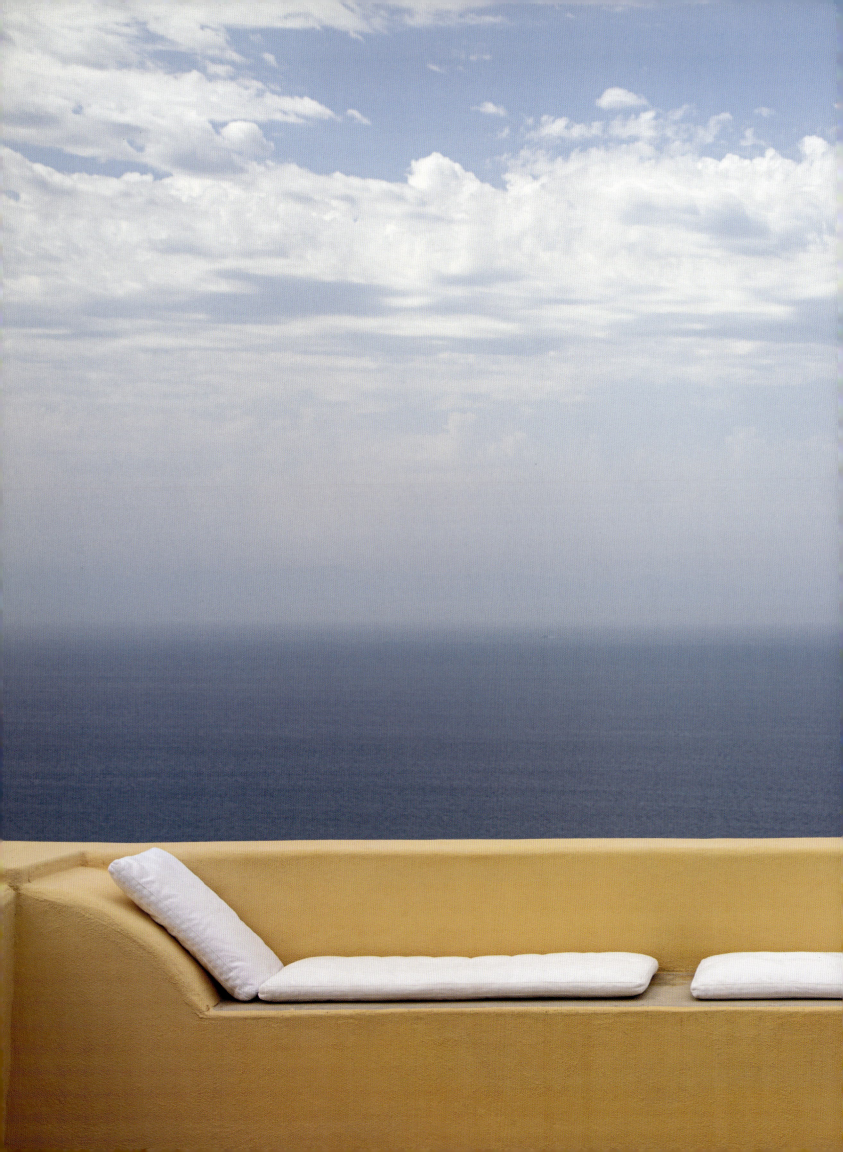

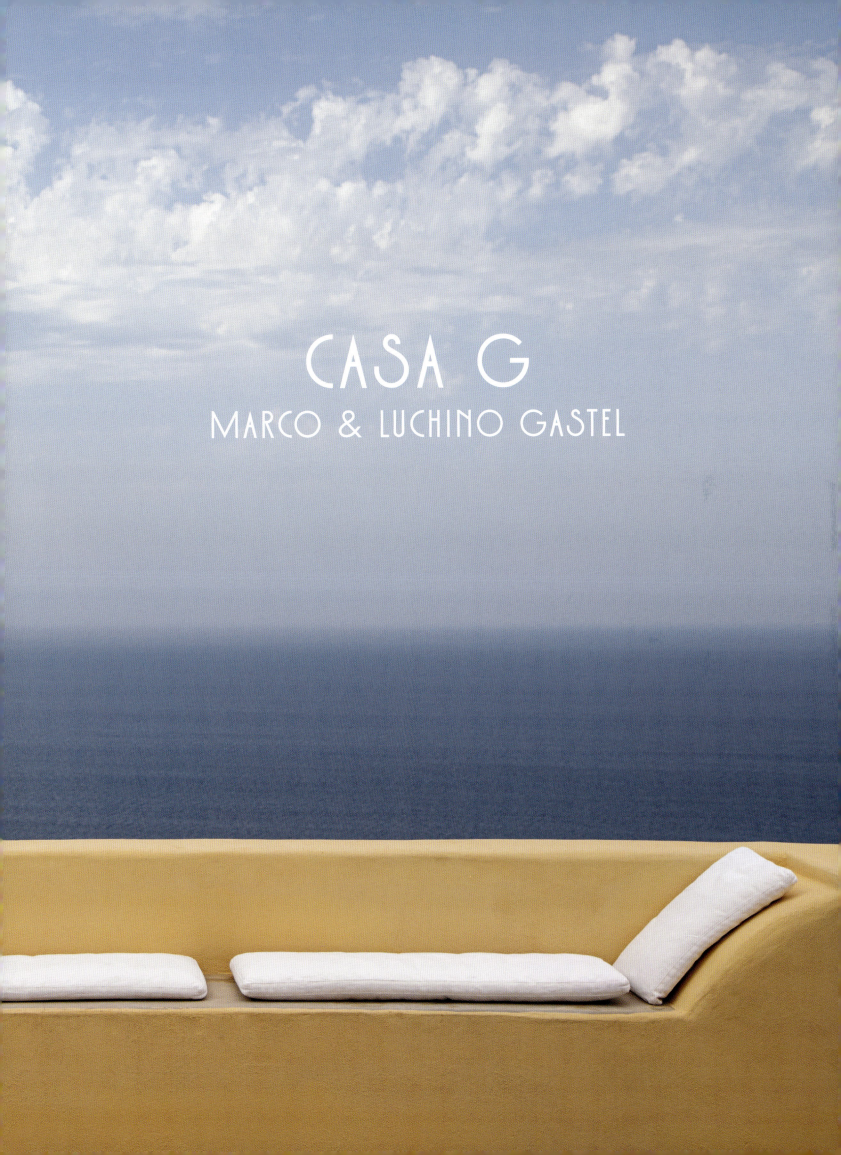

From this lookout above the port of Pecorini on Filicudi, it can sometimes be difficult to determine where the sea ends and the sky begins. "My father called it *Parad'isola*," recalls Marco Gastel, who grew up coming to Casa G with his brother Luchino, his mother, Anna, and his father, the late photographer Giovanni Gastel.

After purchasing the ruin in 2004, Giovanni set about renovating it with the help of his friend Franco ("Kin") Raggi, an architect who lives just around the bend of the bay below Casa G. There are strict building codes on the Aeolian Islands, which were named a UNESCO World Heritage Site in 2000, and while each house has its own personality, they share an architectural vocabulary. The large, terraced buildings are edged with banquettes that slope upward gently at the corners, while the jagged igneous rock found on the islands is smoothed over with a generous application of plaster.

When it came to picking the color of the plaster, Giovanni was looking for a cream with a hint of yellow, to give the house a slight tone that wouldn't be as strong as the zinc-like gesso more common in the area. Returning to the house for the first time after construction, he was taken aback by the yolky color and asked Kin what happened. After a few seconds, Kin replied, "But, Gio—yellow is yellow!" Giovanni laughed at the attempt to mollify him, and quickly fell in love with the strong hue, which both blends into the dry summer landscape and intensifies in contrast with the sea.

Inside the house, beautifully glazed terra-cotta tiles blend seamlessly with terrazzo floors to anchor the whitewashed walls and antique furniture. In the kitchen, an oak cupboard and turned-leg dining table sit before a masonry kitchen counter, accented in bold, bright blues. A collection of locally produced glazed tiles adds colorful charm to the otherwise simple, toned-down interiors, where color is used sparingly—in contrast to the sunny exterior. In the bedrooms, antique beds recycled from past houses further imbue the space with memories and family ties.

About ten years after the house was built, Giovanni added a studio and darkroom so that he could work on the island. This allowed him to arrive earlier in the summer and delay his return to Milan by a few days each year.

When the Gastel family first came to Filicudi, it was as a retreat from their busy life in Milan. The island is one of the more remote ones of the volcanic archipelago. There are few roads, a handful of restaurants, and a small community of people who come each year. This is a place for people who prefer the luxury of having no obligations and nothing to do. Now that the family is no longer anchored in Milan, this escape from home has become an emotional center of gravity. Luchino now lives in Madrid, and Marco—who met and married his wife, Guenda, on Filicudi—now lives in Veneto. But each summer they all return to Casa G, on the steep hill above Pecorini.

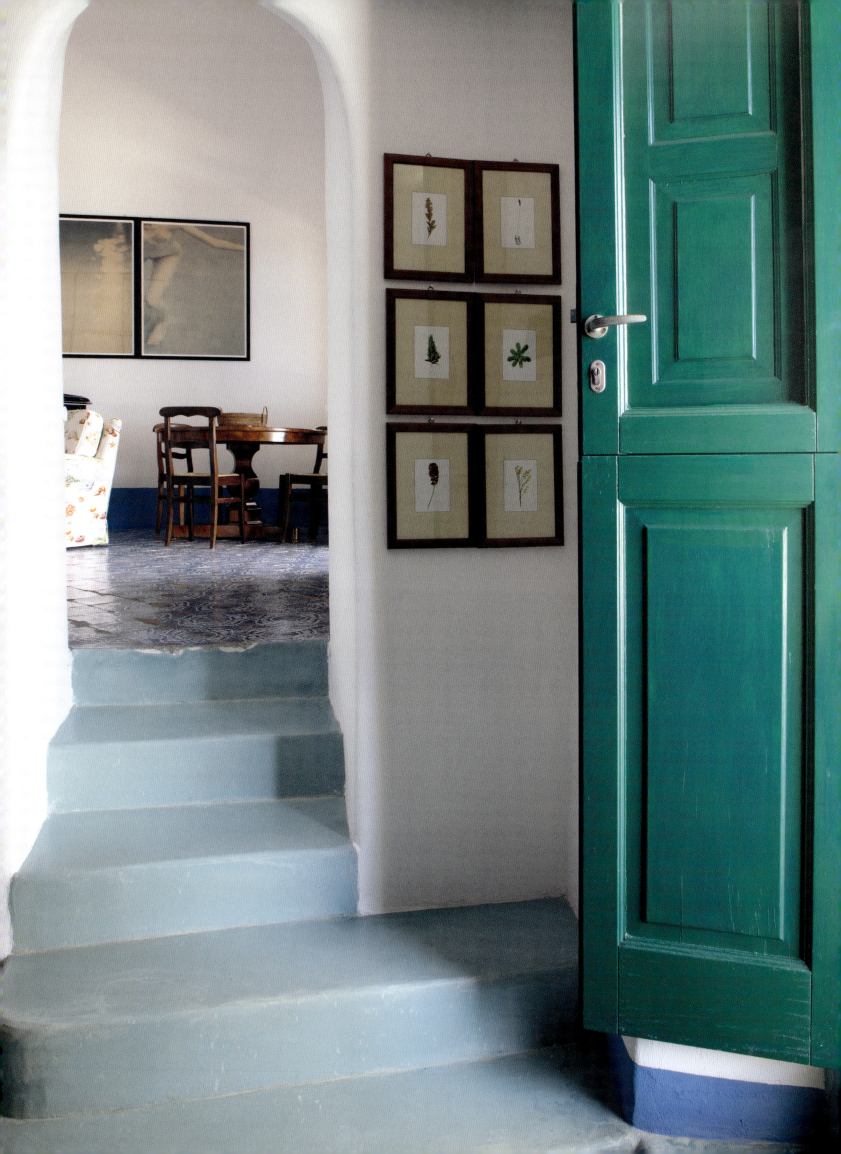

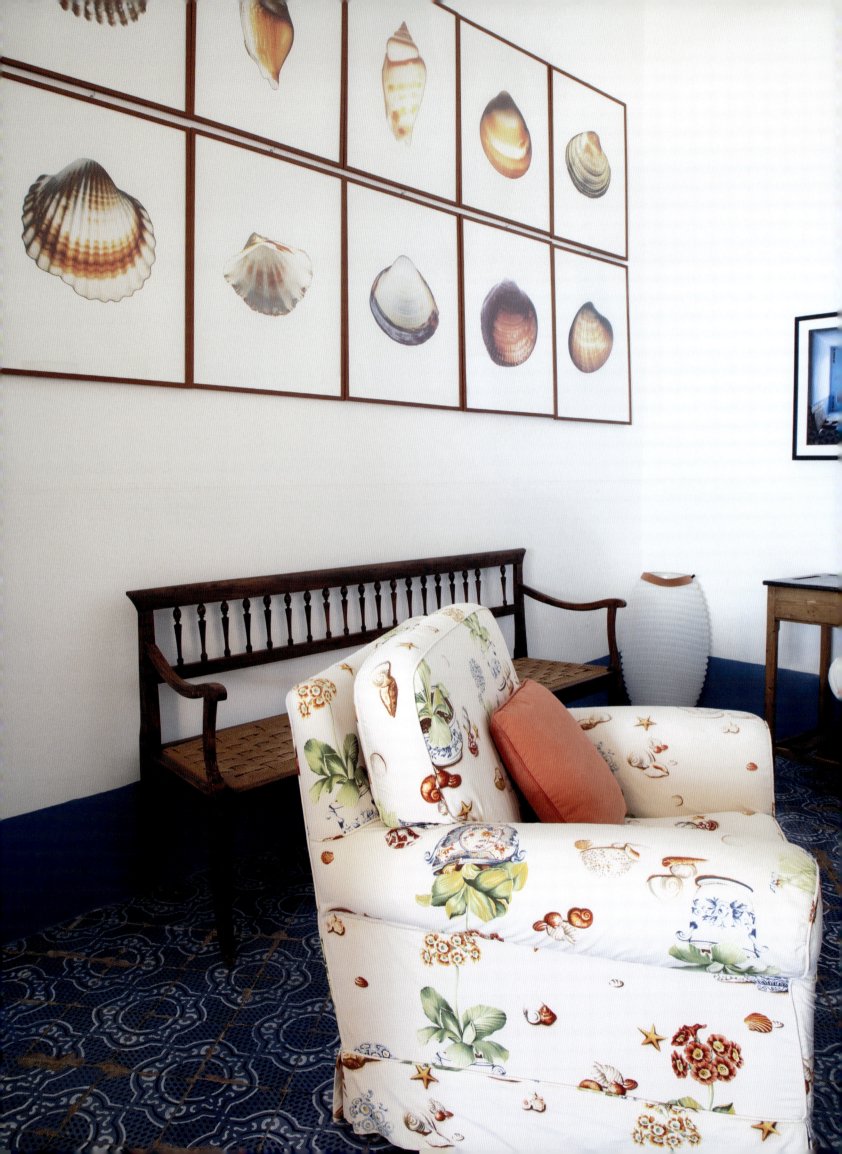

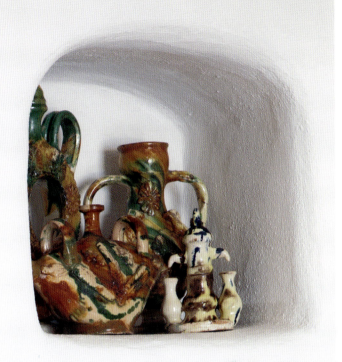

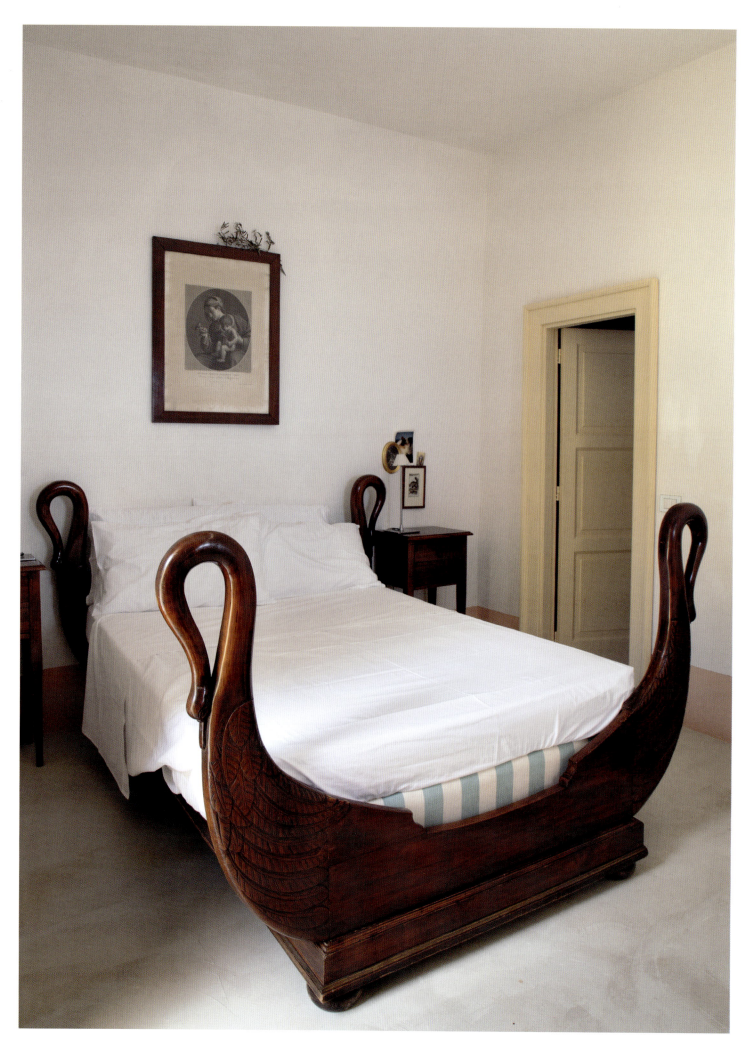

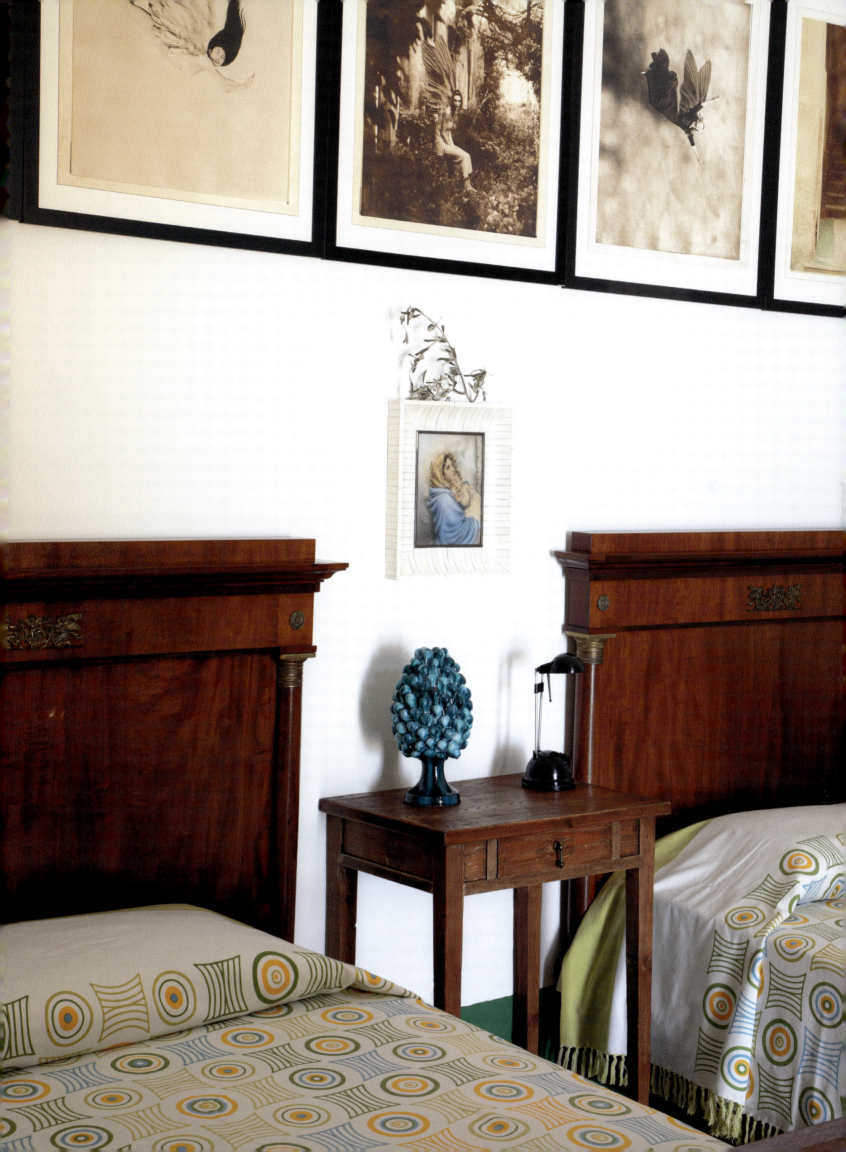

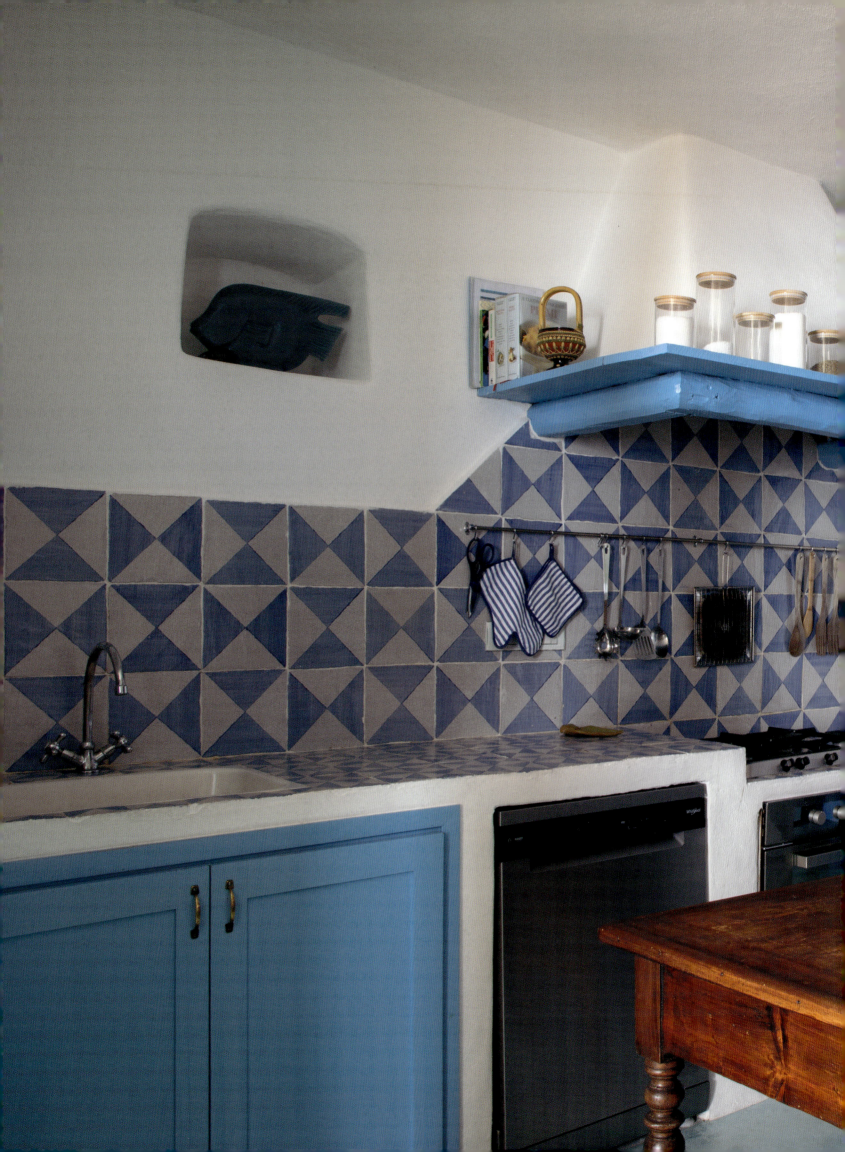

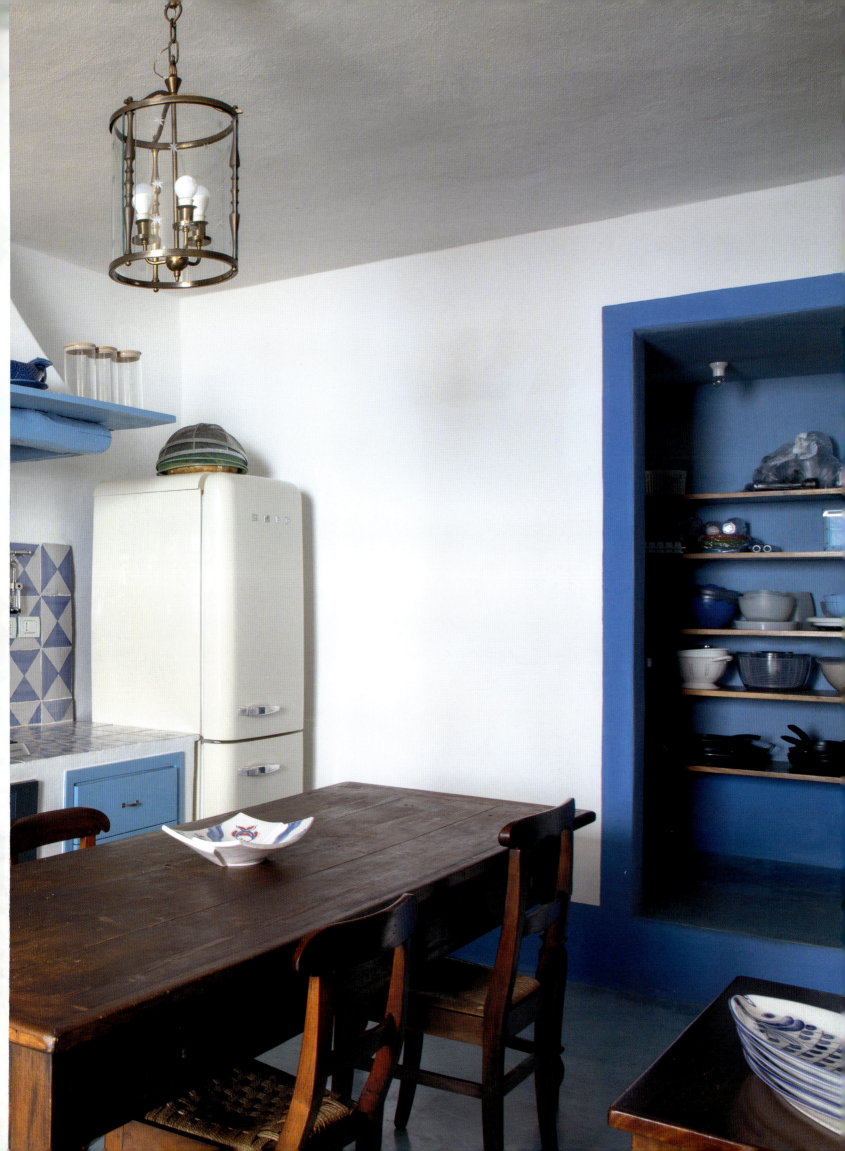

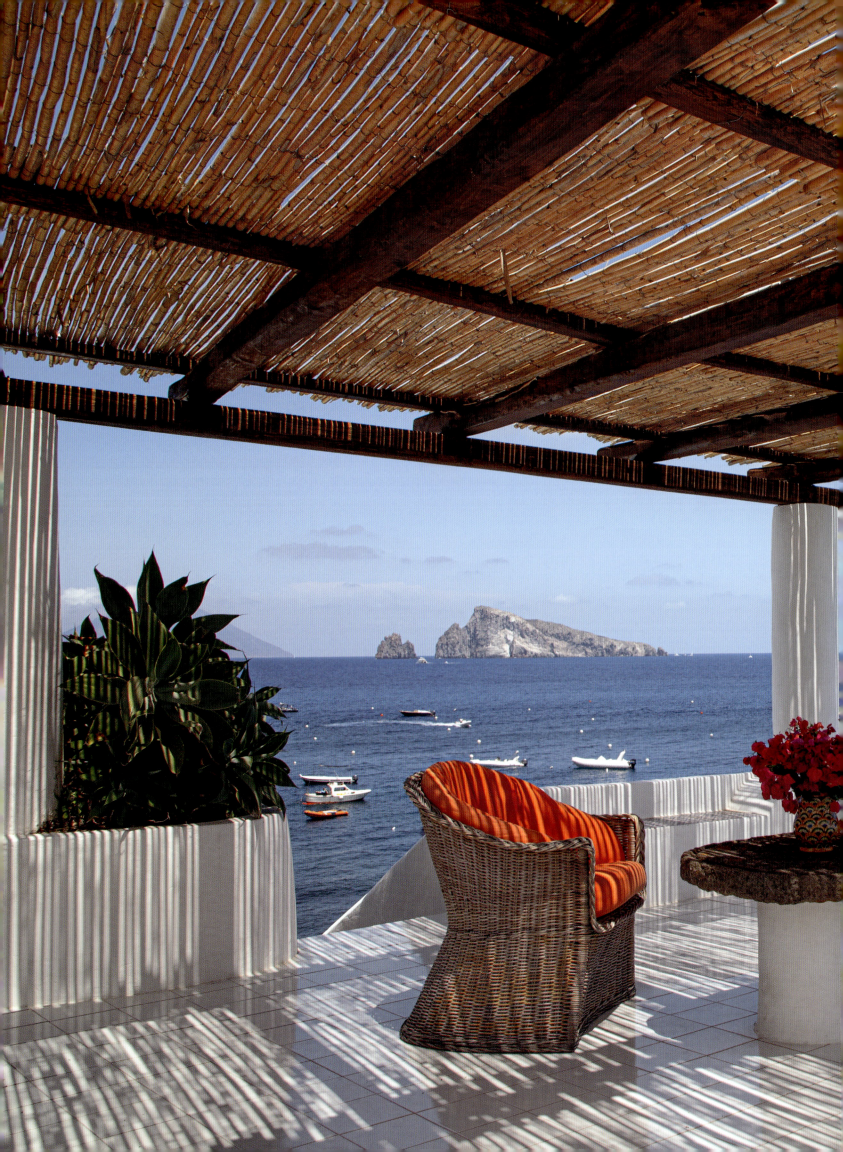

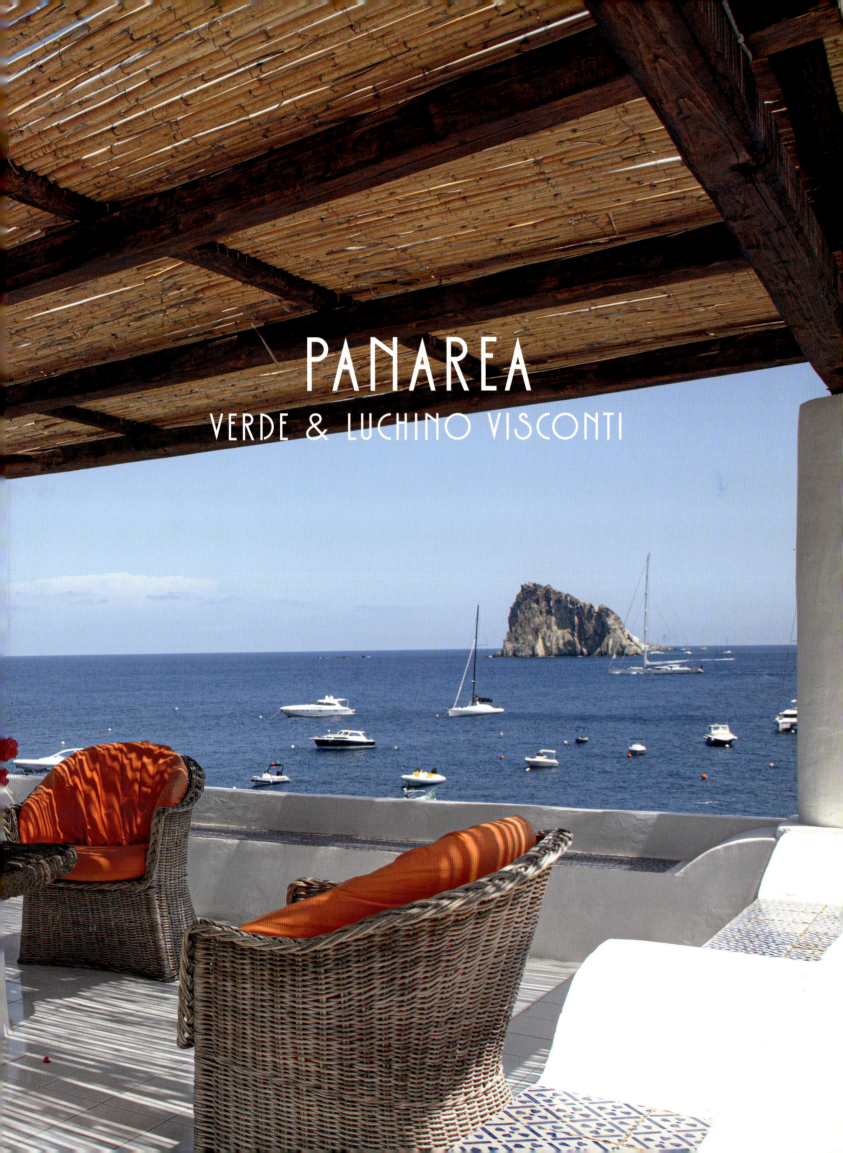

# PANAREA
## VERDE & LUCHINO VISCONTI

On the tiny island of Panarea, north of the Sicilian mainland, where volcanic cliffs rise from the sea and bougainvillea tumbles over whitewashed walls, the home of Verde Visconti and her brother Luchino Visconti is a quiet study in understated elegance. The smallest of the inhabited Aeolian Islands, Panarea is often considered the archipelago's most cosmopolitan island, a place where aristocrats, fashion insiders, and Hollywood stars mingle against a backdrop of dazzling sea views. But for those who know it best, the island is something else entirely: a secretive, down-to-earth refuge where time slows and simple pleasures take precedence over spectacle. This dual identity, somewhere between glamour and quiet restraint, is embodied in Verde herself.

A Milanese by birth, Verde is known for her long tenure at Prada, where she has shaped the brand's narrative from behind the scenes with quiet authority. In many ways, her approach to fashion mirrors her approach to Panarea. She isn't interested in the island's ostentatious summer scene, with its influx of superyachts and paparazzi-friendly guests. Instead, she retreats to a world of unpretentious beauty, where the sea, the silence, and the island's elemental landscape dictate the rhythm of life.

Verde's house, perched among the island's winding paths, is a reflection of this sensibility. On arrival—it's a two-minute ride by golf cart up from the port—the view is immediately striking. Looking eastward over a patio ready for entertaining is a view of the Isola di Basiluzzo, the little Panarelli islands, Le Guglie, and Isola di Lisca Bianca. Stromboli smokes away in the distance, a reminder of the careful balance of nature that preserves the island's raw beauty. Under the patio, a few bedrooms are tucked into the rocks, while a long, bougainvillea-covered pergola leads to the living room and more bedrooms. In back, at the end of a pergola, is a wild garden filled with herbs and citrus trees, and beyond that a kitchen, where pops of cobalt-blue and dusty pink contrast with the whitewashed walls. Throughout the house, ceramic tiles typical of those seen across the Aeolian Islands add vibrant texture and character.

Although Panarea has long been a place of escape for Italy's elite, its real charm lies beyond the social whirl. There are few proper beaches and no flashy lidos. Instead, there are rocky coves with crystalline water, a smattering of family-run trattorias, and the ever-present silhouette of Stromboli, its glowing eruptions visible at night. For Verde, the island's beauty is in its contrasts: the wild cliffs and cultivated terraces, the hum of cicadas and the hush of a siesta, the occasional night of dancing at Hotel Raya, and the solitary pleasure of a morning swim in an empty *cala* (cove). Her connection to Panarea is neither fleeting nor seasonal; it is a place to which she returns year after year, drawn by its quiet magnetism. She believes one must wait for the island's perfect moments, and that it will reveal itself fully only to those who are willing to look beyond the surface.

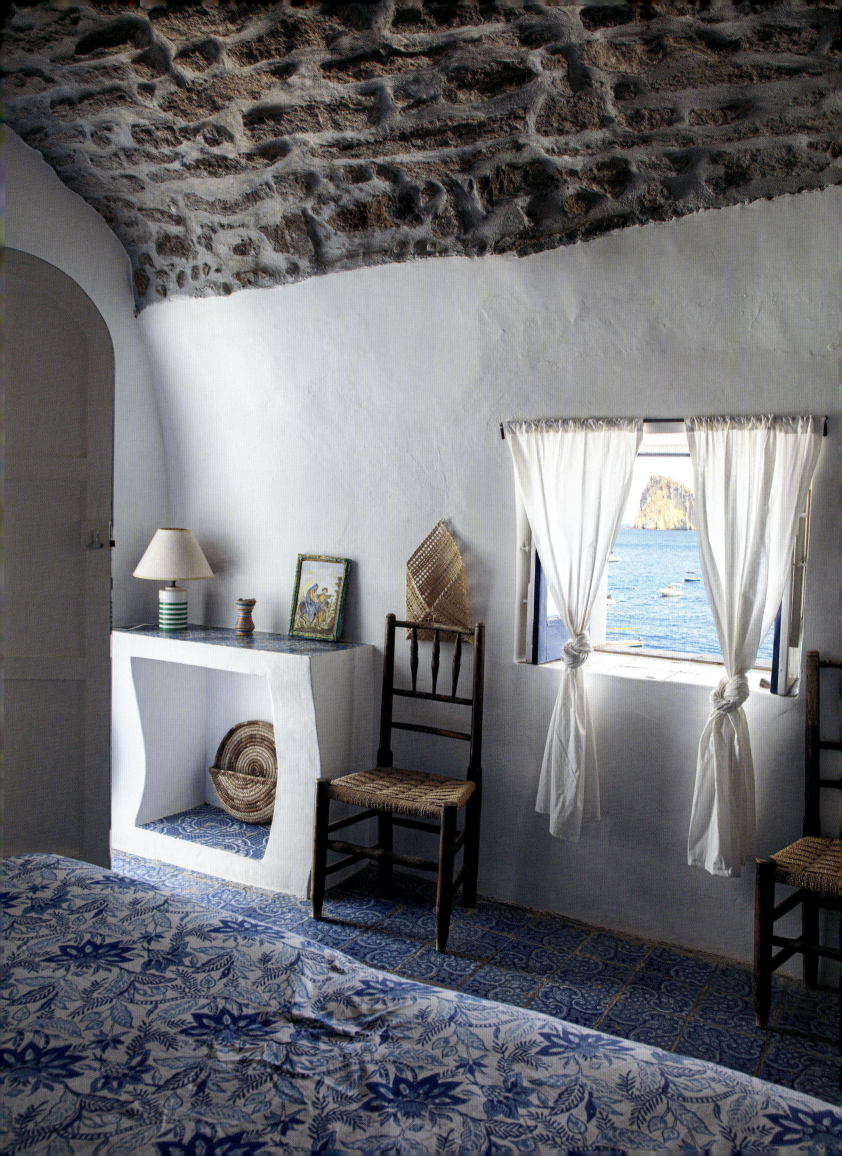

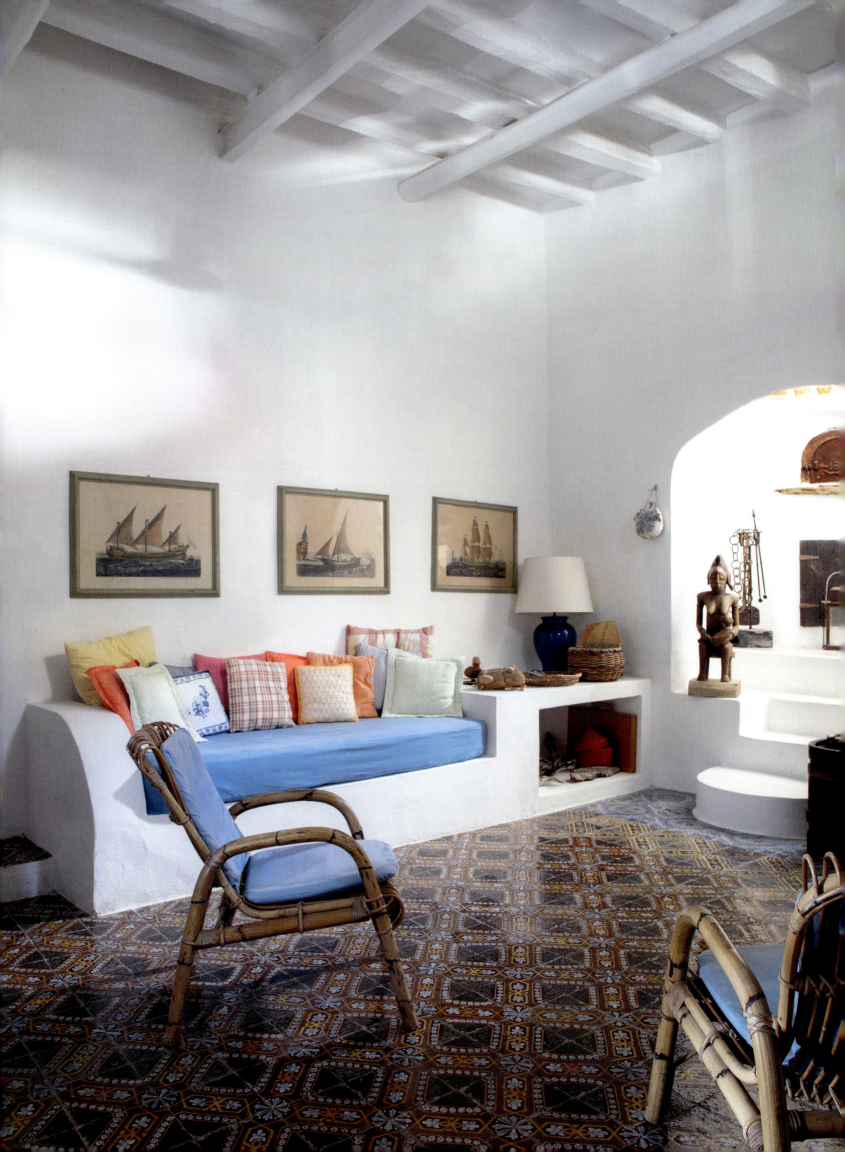

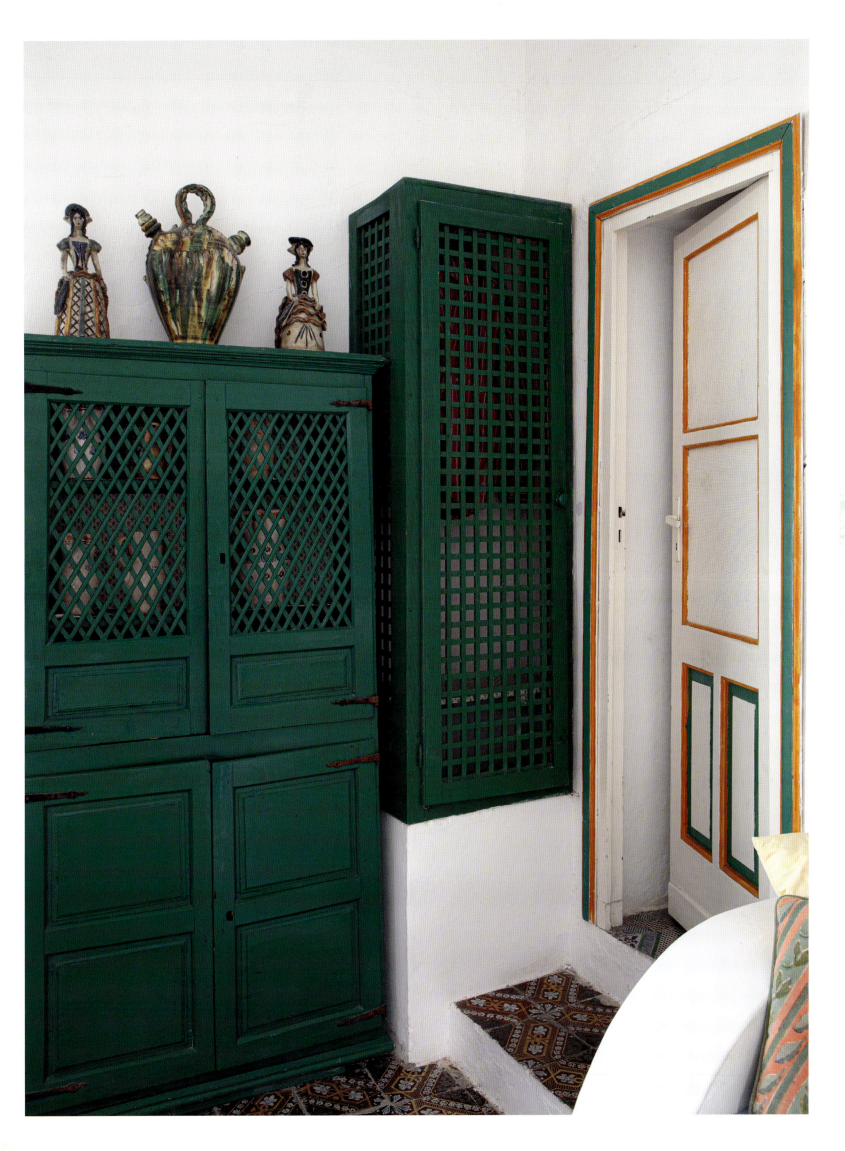

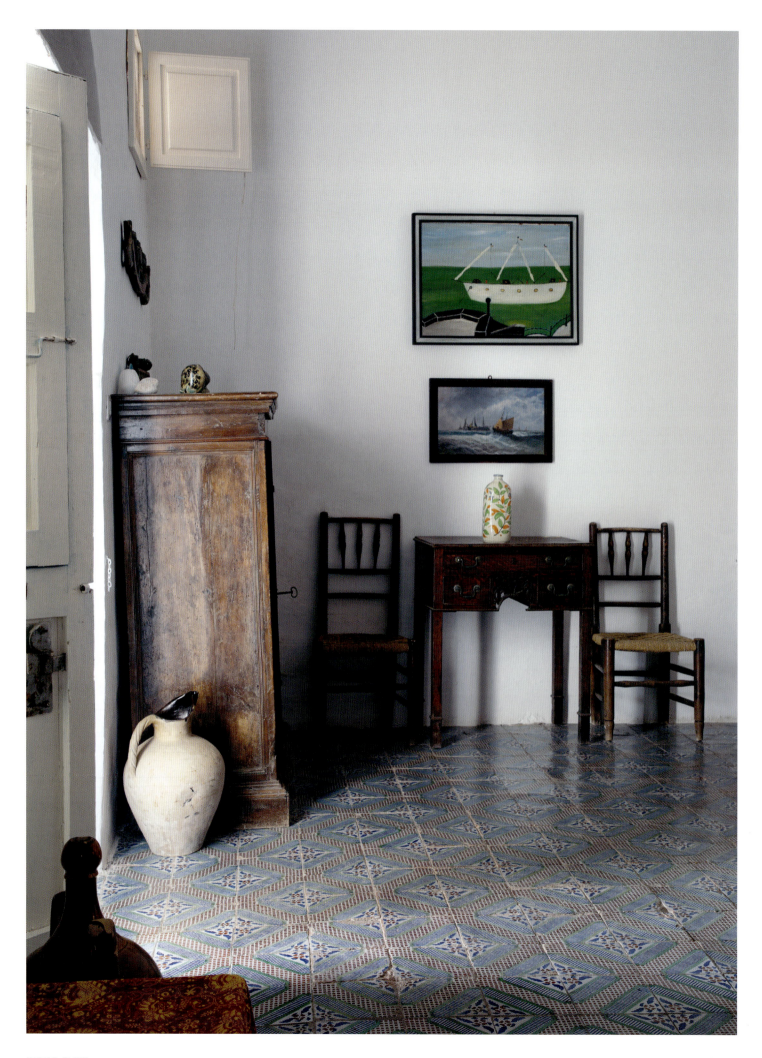

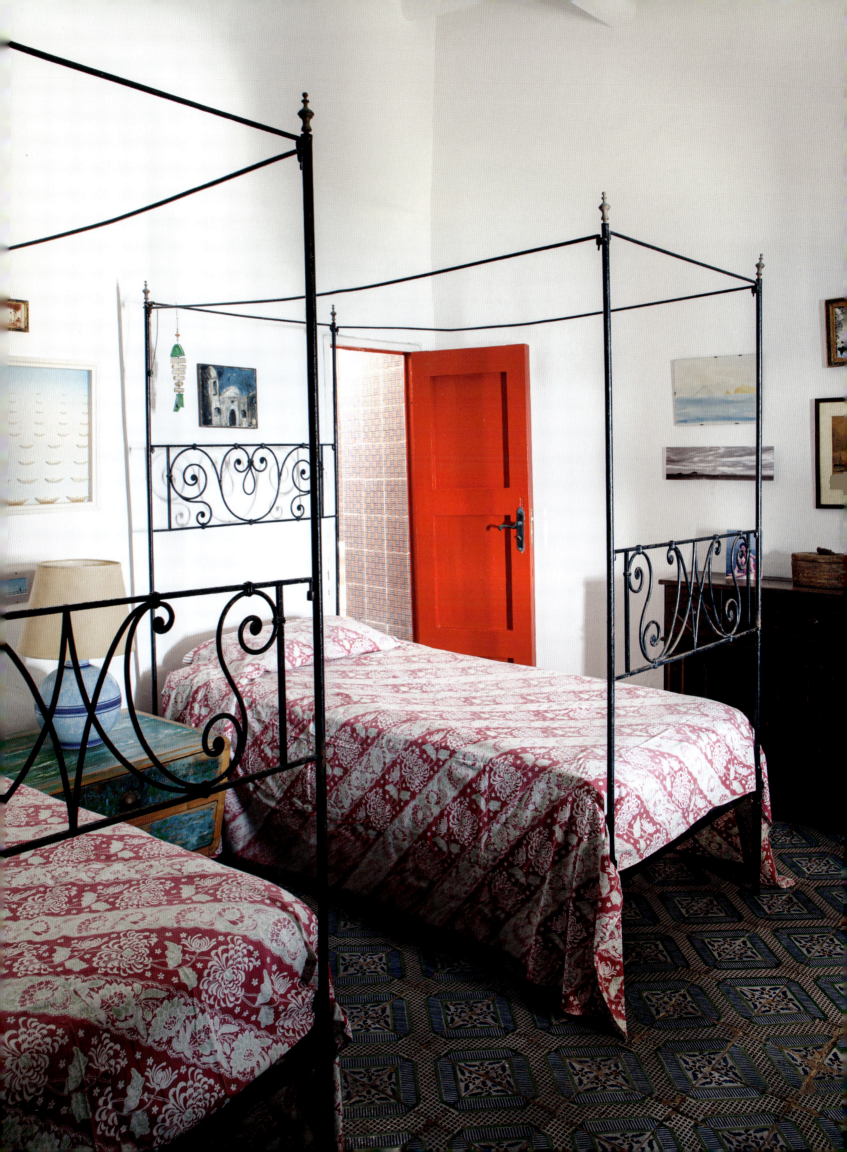

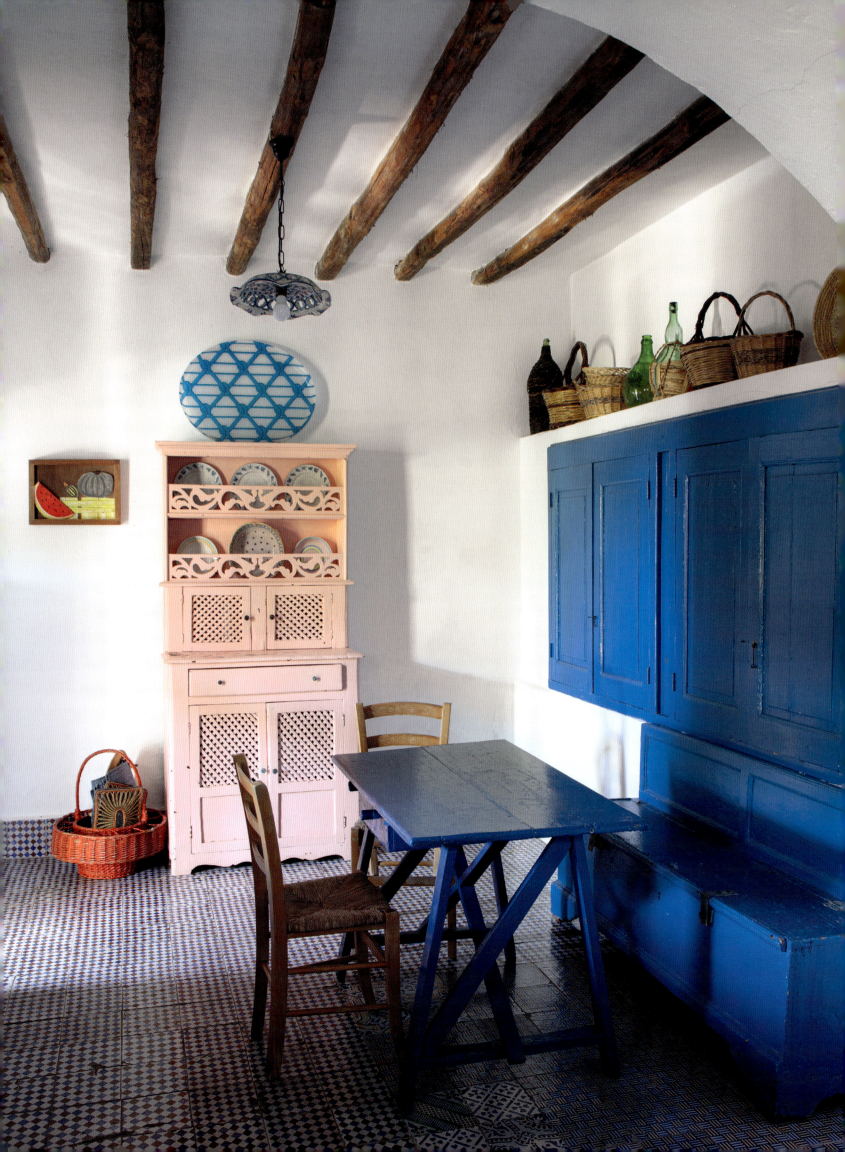

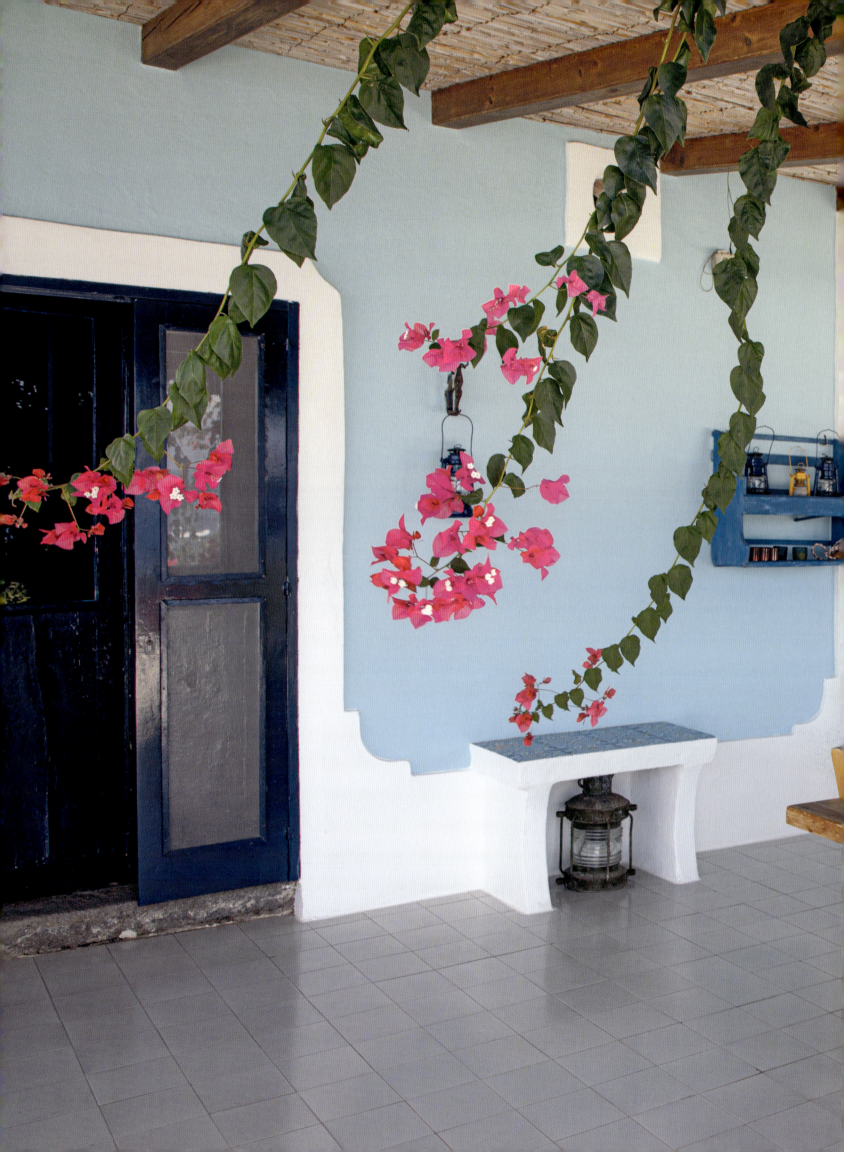

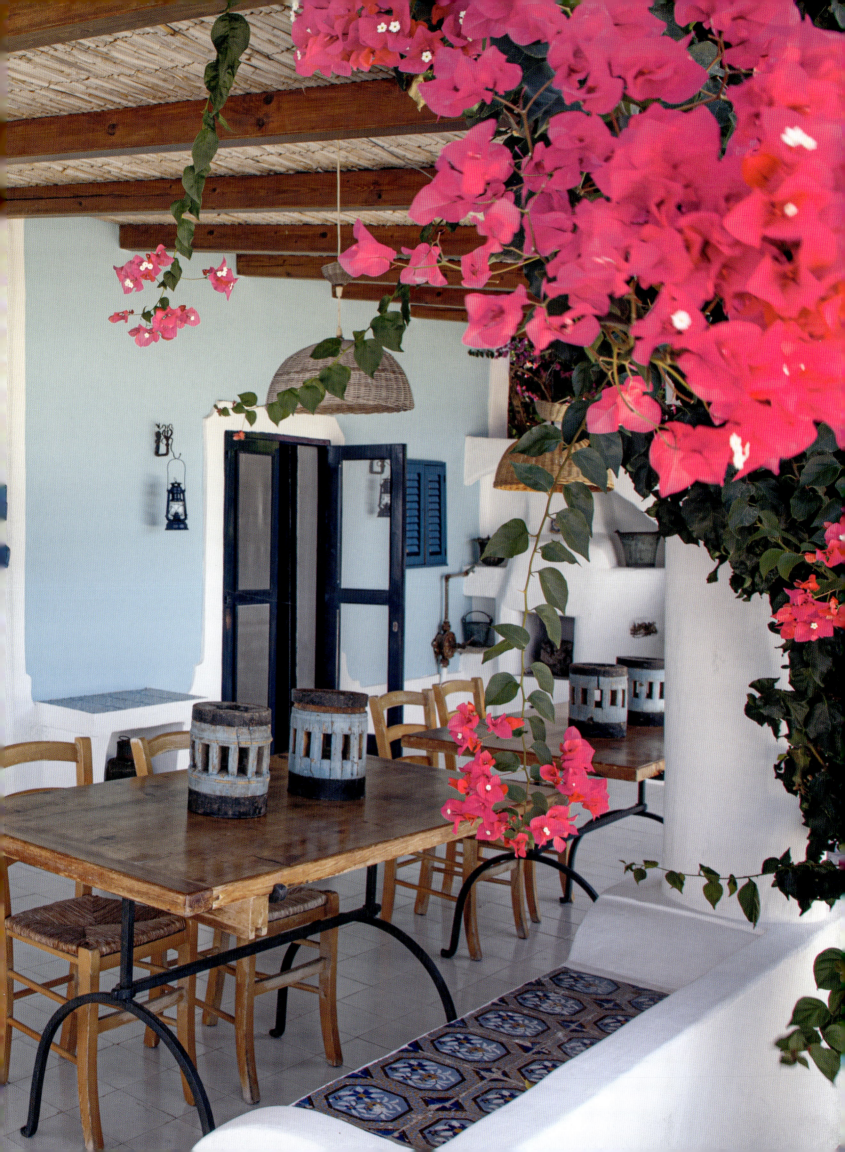

# ACKNOWLEDGMENTS

This book is the result of a wonderful collaborative process. First, I would like to thank Guido Taroni, whose beautiful work is the star of this project. His flexibility, attention to detail, and desire to produce the best possible result were an engine of encouragement throughout. His collaboration with the designer Fabrizia Caracciolo, which she kindly allowed us to include, added texture and depth to this story.

I am grateful to the owners of these gorgeous properties, who generously invited us into their homes and allowed us to share this visual exploration of Sicily. Your creativity, interiors, and overall style gave us the subject of this book.

Early on, I was helped by Alfio Bonaccorso, whose deep knowledge of Sicily proved to be an early foothold of knowledge on which I could build. Not only that, but also his introductions proved invaluable in finalizing the list of homes for inclusion. As well, Aloisa Moncada di Paternò, Alessandra Borghese, Federica Musco of the Thinking Traveller, Francesco Meda, Alvise Orsini, and especially Alessandro Genduso and Jacopo Etro all provided insights and crucial connections that made the project happen.

During production, none of this would have happened without the extreme patience and outstanding work of my editor, Rosanna Fairhead, the book's designer, Peter Dawson, and the rest of the Vendome Press team, including Amy Tai, Arabella Fenwick, Amanda Mackie, Marti Malovany, and Gerry Scott. Thank you especially to Beatrice Vincenzini and Mark Magowan for the opportunity. Bea, I couldn't have done this without you; thank you for teaching me about this business, giving me a chance, and helping me to see this project through.

I am indebted to my family for their support. Thank you to my parents, Adair and Brooks, who are always there to listen to a work in progress.

Most importantly, I would like to thank my wonderful partner of over ten years, Nicolò Castellini Baldissera. I have learned so much from his love of architecture, design, and history, and his generous spirit and supportive strength were and are my lodestar—both in work and in life. Thank you, Nicolò.

OPPOSITE On the road inland from Noto, Guido and I frequently passed this ruin on the way to Mandara Vecchia (page 151). Its crumbling blue façade, Baroque details, and decadent charm hint at Sicily's rich past and the many stories the islands have to tell.

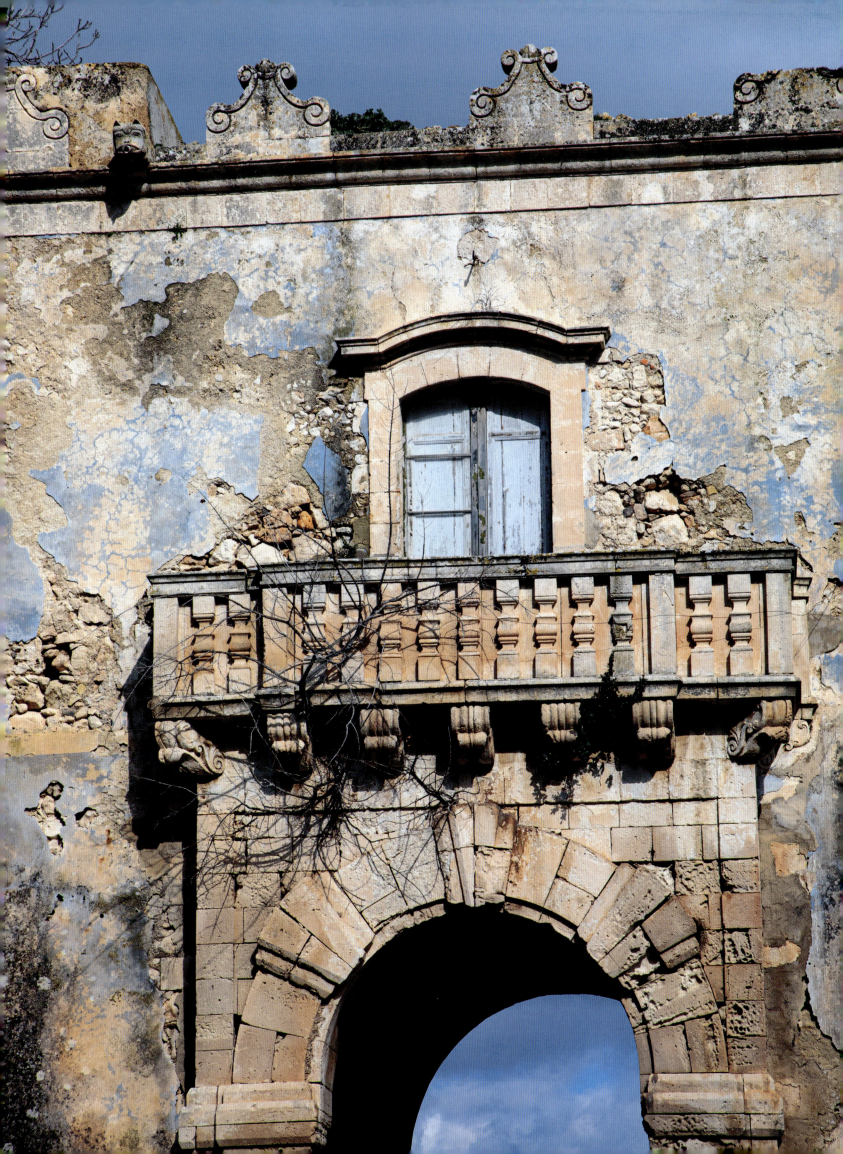

*INSIDE SICILY*

First published in 2025 by The Vendome Press
Vendome is a registered trademark of The Vendome Press LLC

VENDOME PRESS US
PO Box 566
Palm Beach, FL 33480

VENDOME PRESS UK
Worlds End Studio
132–134 Lots Road
London SW10 0RJ

www.vendomepress.com

Copyright © 2025 The Vendome Press LLC
The *INSIDE* Series copyright © 2025 The Vendome Press LLC
Text copyright © 2025 Christopher Garis
Photography copyright © 2025 Guido Taroni

All rights reserved. No part of the contents of this book may be reproduced in whole or in part without prior written permission from the publisher.

Every effort has been made to identify and contact all copyright holders and to obtain their permission for the use of any copyrighted material. The publisher apologizes for any errors or omissions and would be grateful if notified of any corrections that should be incorporated in future reprints or editions of this book.

Any use of this book to train generative artificial intelligence ("AI") technologies is expressly prohibited. Vendome Press, their authors, and their photographers reserve all rights to license uses of this work for generative AI training and development of machine learning language models.

ISBN 978-0-86565-425-9

Publishers: Beatrice Vincenzini, Mark Magowan, and Francesco Venturi
Editor: Rosanna Fairhead
Production Manager: Amanda Mackie
Designer: Peter Dawson, www.gradedesign.com

Cover photography by Guido Taroni
Front cover: Villa Elena (page 179)
Back cover: Mandara Vecchia (page 151)
The image on pages 168–69 is reproduced courtesy of Italy Sotheby's International Realty

Library of Congress Cataloging-in-Publication Data available upon request

Distributed in North America by:
Abrams Books
www.abramsbooks.com

Distributed in the rest of the world by:
Thames & Hudson Ltd.
6–24 Britannia Street
London WC1X 9JD
United Kingdom
www.thamesandhudson.com

EU Authorized Representative:
Interart S.A.R.L.
19 rue Charles Auray
93500 Pantin, Paris
France
productsafety@vendomepress.com
www.interart.fr

Printed and bound in China

FIRST PRINTING

THE INSIDE SERIES

Discover and purchase our *INSIDE* series and many other titles by visiting:
www.vendomepress.com/collections/inside-series
or by scanning the QR code below:

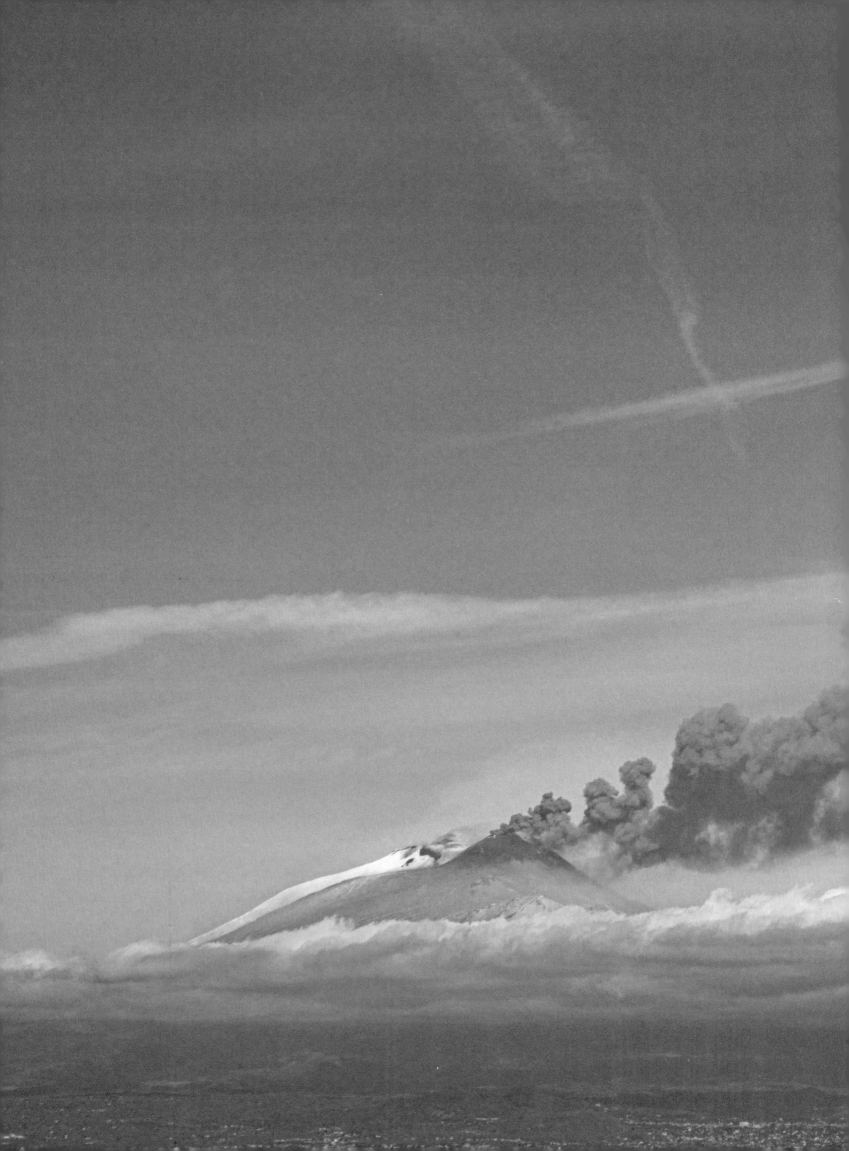